TATE WOMEN ARTISTS

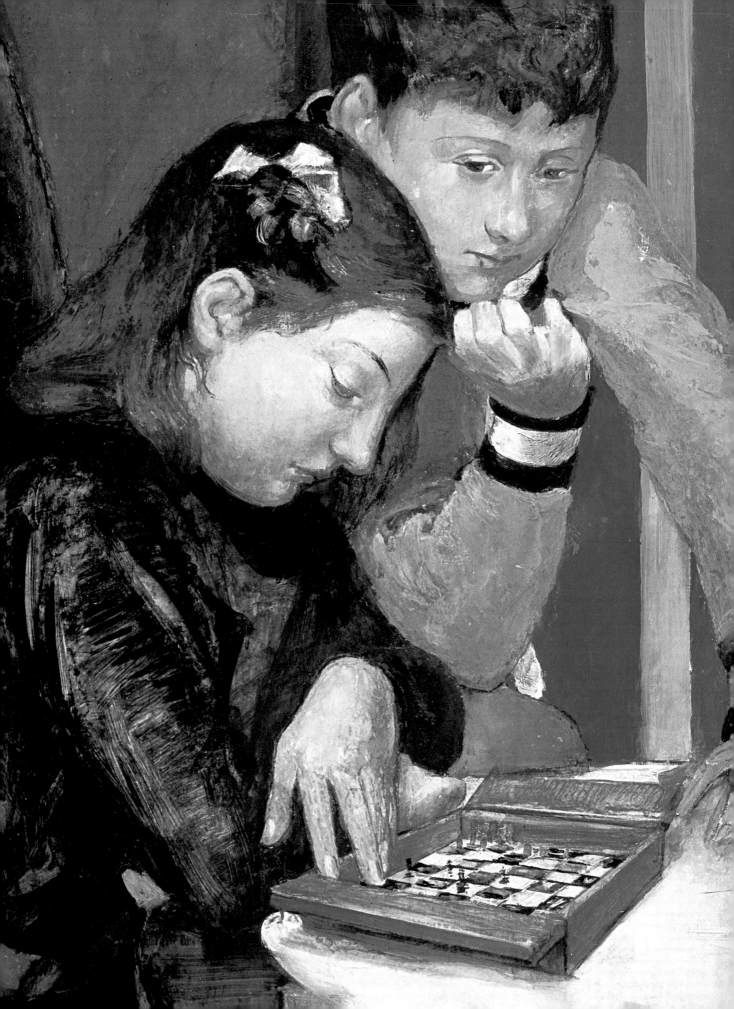

TATE WOMEN ARTISTS

Alicia Foster

TATE PUBLISHING

For my mother, Annette Foster, 1944–2002

Acknowledgements

At Tate Publishing, my gratitude to Celia Clear for suggesting the project to me, to Nicola Bion and Sarah Derry for their exemplary work as editors, to Gill Metcalfe for research on the many illustrations, to Lucy Richards for her beautiful and painstaking design work, and to Sarah Tucker for managing the production process with such meticulous care. Among the Tate staff who offered advice and comments on the text, thanks particularly to Lorna Healy and Tania Barson.

Research was made productive and pleasurable by the incredibly helpful and knowledgeable Tate librarians, and by staff at the British Library, the British Museum, the National Portrait Gallery, the Westminster Art Library and the Imperial War Museum. Finally, my thanks to Kate, Liz, Oliver and Edward Foster for at various times giving support during the writing of this book, and to John Meredith, for seeing it all through.

First published 2004 by order of the Tate Trustees by Tate Publishing, a division of Tate Enterprises Ltd, Millbank, London SW1P 4RG.
www.tate.org.uk

British Library Cataloguing in Publication Data
A catalogue record for this book is available from the British Library

ISBN 1-85437-311-0

Distributed in the United States and Canada by Harry N. Abrams, Inc., New York

Library of Congress Cataloging in Publication Data
Library of Congress Control Number: 2003101078

Designed by Lucy Richards, Edinburgh
Printed in spain by Grafos S.A.

Front cover details (from left to right, top to bottom): Berthe Morisot, *Girl on a Divan*, c.1885; Nan Goldin, *Nan one month after being battered*, 1984; Hilda Carline, *Self-Portrait*, 1923; Fionnuala Boyd and Les Evans, *The Wall*, 1986; Angelica Kauffman, *Portrait of a Lady*, c.1775; Lisa Milroy, *Shoes*, 1985; Dora Carrington, *Farm at Watendlath*, 1921; Helen Saunders, *Abstract Multicoloured Design* c.1915; Barbara Hepworth, *Pelagos*, 1946; Bridget Riley, *Nataraja*, 1993
Frontispiece: Mary Sargant Florence, *Children at Chess*, c.1903 (detail)

Measurements of artworks are given in centimetres, height before width, followed by inches in brackets

CONTENTS

WOMEN AND THE TATE

Surveying all the work by women artists in the Tate Collection, familiar names, such as Angelica Kauffman, Berthe Morisot, Barbara Hepworth and Louise Bourgeois, mix with lesser-known figures and those who have fallen into obscurity. *Tate Women Artists* gives each of these women and their work a space. But before the artists are looked at individually, we should step back to the moment when the first Tate Gallery opened its doors, a little over a century ago, to trace the history and development of the presence of women in the Tate Collection.

In summer 1897 the first visitors entered the imposing new gallery on Millbank. Although formally named the National Gallery of British Art, many were already referring to it as the Tate Gallery (after Henry Tate, the sugar tycoon who had funded the project and whose collection formed the nucleus of the new gallery's holdings). The *Sunday Times Short Guide to the Tate Gallery of Contemporary Art* describes a walk through the collection during those early weeks. According to the guide, among the works of particular note were John Millais's *Ophelia* (1851–2), 'an astonishing and memorable masterpiece', and Albert Moore's *Blossoms* (1881), a 'fine study of the female figure in a harmony of rosy draperies'. The high point of the collection was Dante Gabriel Rossetti's *Beata Beatrix* (*c.*1864–70), whose importance was such that it made the new gallery 'a place of pilgrimage for all lovers of fine art'.

The official *Descriptive and Historical Catalogue of the Pictures and Sculptures in the National Gallery of British Art* sold at the gallery and, in its third edition by 1898, gives a more detailed account of the collection. There were works owned by Henry Tate, art given by the Chantrey Bequest, George Frederick Watts's gift of a number of his own works, and loans from the National Gallery. Henry Tate's collection consisted of sixty-five pieces, only two of which were by women, Elizabeth Butler's *The Remnants of an Army* (1879), and Dorothy Stanley's *His First Offence* (1896). In the whole of the rest of the gallery,

there were only three more works by women artists, Anna Lea Merritt's *Love Locked Out* (1889), Lucy Kemp-Welch's *Colt Hunting in the New Forest* (1897), and Mildred Anne Butler's *Morning Bath* (1896). Altogether, only five of the 253 pictures housed in the new gallery were by women, and none of the sculpture. Both the *Sunday Times Guide* and the official catalogue describe a space in which women were to be looked at. Appearing as nudes, in portraits, or as characters in historical, literary or religious scenes, they were rarely present as artists in their own right.

Today's visitors to the gallery on Millbank, re-named Tate Britain in 2000, can encounter work by women from widely different historical periods, and in a great variety of media, from Angelica Kauffman working in the eighteenth century, to Winifred Knights painting 150 years later, and the contemporary artist Cornelia Parker, who makes installations. Rooms at Tate Modern have been devoted to the work of women, including Susan Hiller, Sarah Lucas and Bridget Riley. At St Ives, Tate runs a museum devoted to the work of Barbara Hepworth, preserving her studio as she left it, and her garden, now filled with her sculptures, and recently there have been individual exhibitions at Tate St Ives of work by Wilhelmina Barns-Graham (2000) and Sandra Blow (2002). At Tate Liverpool there have been solo shows of the work of Rachel Whiteread and Susan Hiller (both 1996), Paula Rego (1997) and Lisa Milroy (2001).

Women artists may seem to be a strong presence in Tate galleries in the early twenty-first century, but a look at the composition of the collections changes the picture. At the time of writing Tate owns work by 316 women. But this compares to nearly 2,600 men whose art is represented. Altogether, a total of just under 11 per cent of Tate artists are women, and their works make up only approximately 7 per cent of the collections (and this calculation does not include the Turner Bequest of over 30,000 works).[1] The proportions of

Mary Beale
Portrait of a Young Girl, *c.*1681

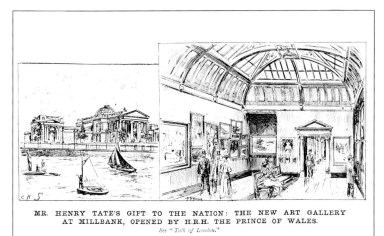

MR. HENRY TATE'S GIFT TO THE NATION: THE NEW ART GALLERY AT MILLBANK, OPENED BY H.R.H. THE PRINCE OF WALES.
See " Talk of London."

'Mr Henry Tate's Gift to the Nation:
The New Art Gallery at Millbank',
The Penny Illustrated Paper, 24 July 1897
Tate Archive

artists from different periods indicate how historical bias against women artists has affected their presence in Tate galleries. There are few women from periods earlier than the twentieth century, but the number of twentieth-century women artists represented is near to being matched by the entire collection of work by women working now.

The women artists in this book have been brought together because their work is housed in the Tate Collection, but there are other ties between them. As women, during the past and into the present day, they have had to negotiate social, political and economic status different from and unequal to men's, which has affected both their abilities and the opportunities open to them. Tate women artists have worked during a period stretching from the late seventeenth century to the beginning of the twenty-first, a time in which concrete limitations have mingled with ideologies of femininity that many women internalised. What women have been able to achieve as artists shifts over different locations and cultures. But as the great majority of Tate's women artists are of British origin, or work or have worked in Britain, and a smaller group are from other European countries and North America,[2] and pressures of space prevent a wider exploration, the history of women as artists discussed in *Tate Women Artists* focuses on the British and western context.

Back into history, restrictions have been placed on women artists by the institutions of the art world, such as the European Academies in which artists were trained, and through which their work was promoted. These institutions usually made women's lower status within their ranks clear, if they admitted them at all. In London, the two women who were among the founder members of the Royal Academy in 1768, Angelica Kauffman and Mary Moser, were not included among the group of artists portrayed in Johann Zoffany's *Life Class at the Royal Academy* (1771–2, collection of Her Majesty the Queen), but as portraits hanging above the heads of their male colleagues. The French Academy allowed women members, but it reduced the number admissible to four during the 1780s, and forbade them from copying in the Louvre (an important part of professional training) on the grounds that their presence distracted the male artists working there. The basis of teaching in the Academies was working from the life model, and this remained the key aspect of fine art study and practice until well into the twentieth century. Women were barred from the life room until the late nineteenth century, meaning that they could not compete in history painting and representing the nude, the most prestigious aspects of professional practice.[3] Many women enjoyed art as 'amateurs' during the eighteenth and nineteenth centuries, and although their creativity may have been confined to leisure pursuits, they did help pave the way for those who were later to work as professional artists.

By the end of the nineteenth century women could train in the life room, but a major strand of modernism had coalesced around the female model as a sign of the power (creative and sexual) of the male artist.[4] Ideologies of sexual difference which have permeated society across different periods and locations have often positioned the female as 'other' to the male, his opposite, nature to his culture, confined to the private sphere rather than taking part in the public world of professional work.[5] These could be translated into the art world, so that the female was often represented as image/ object/model and muse for the male viewer/subject/artist. Such demarcations have historically had a profound impact on the lives of many would-be women artists, as they were absorbed and acted upon. For example, the idea that a woman's identity was defined around a familial domestic role, rather than a career, continued to shape the lives of many women into the twentieth century.

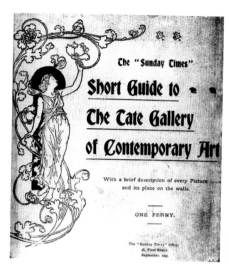

Cover of *The Sunday Times Short Guide
to the Tate Gallery of Contemporary Art*, 1897
Tate Library

But some women did manage to achieve success as artists. During the late-Victorian period, Elizabeth Thompson, Lady Butler was not made a Royal Academician, but still managed to build a phenomenal career (her talent was allowed to develop as she could afford private tuition, and her parents and husband were supportive). More recently, Lee Krasner's work foundered in the macho world of mid-twentieth-century American Abstract Expressionism, as her husband, Jackson Pollock, became a celebrated figure. But after his death she became a distinguished artist. And if being part of a family stymied some women, it also provided one of the sole means to learn to be an artist for others during the Victorian period and earlier, when professional training was nearly impossible to obtain. Those whose fathers or brothers were artists (including Angelica Kauffman and Mary Severn Newton) could find that this was a way into the studio whose doors would otherwise have been shut against them. Some women avoided trying to negotiate being both artist *and* wife and mother by choosing to remain unmarried and childless. And women artists also created their own networks and organisations, providing practical support, training and patronage, and campaigning for better treatment.

The category 'women artists' as it is used in this book summons up the history of women as artists, which is distinct from that of men as artists. But what is *Tate Women Artists'* relationship with art history, with the canon, the established account of great artists and their masterpieces? Women have been excluded from the canon, and so books on women artists have a troubled relationship with much mainstream art history, as Griselda Pollock has discussed in *Differencing the Canon: Feminist Desire and the Writing of Art's Histories* (London and New York 1999). Pollock traces the strategies adopted by art historians and critics trying to rewrite art history to take account of women's work. Some have attempted simply to add women artists on to the canon, while others have tried to create a separate sphere of women's work outside it, arguing for an identifiably 'feminine' form of art. While both approaches provide much-needed information about women artists, as Pollock points out, they also leave the canon unchallenged. Women are either a supplement to art history, or completely cut off from its main thrust. Pollock advocates instead a 'third position' from the 'space off' of the woman's movement, which, she writes, is not 'a place apart' but 'a movement across the fields of discourse and its institutional bases.'[6] From this space the art historian can explore not only the work of women artists, but also the ways in which they have encountered the institutions of art and art history, and been positioned and represented by them.

Tate Women Artists has been shaped by a desire to bring the women artists in the Tate Collection to the fore, and an awareness of the pitfalls of writing about them. As many of the women are little known, there has had to be a strong emphasis on providing basic information. But because *Tate Women Artists* only includes those whose work is housed in Tate galleries, a small, patchily represented group, it cannot be read as an uncritical appendix to the canon of male artists who dominate the Tate Collection.[7] A significant influence on the Tate Collection is revealed to be discrimination against women, rather than an impartial celebration of artistic achievement. And the many women artists missing from Tate galleries, and the diversity of those who are represented, also prevents interpretation of *Tate Women Artists* as a seamless, chronological story of a distinct category of 'women's art'. Rather, the work of those women artists who are included in Tate collections is examined in the light of the history of women as artists.

Tate Women Artists is not, then, predicated on the idea that women artists produce 'feminine' work and are a homogenous

Annie Swynnerton
Dame Millicent Fawcett,
CBE, LL, exh.1930
Tate

Photograph of
Kathleen Kennet
from her autobiography,
Self-Portrait of an Artist (1949)

group. There are differences of social and economic position between the women, despite the restriction of opportunities to train and practise as artists to the middle and upper classes for most of the period covered by this book. Racial difference also divides them. Artists who are not white Europeans and North Americans are present (albeit marginally) in the Tate Collection. Given the difficulty of defining racial and national affiliation for many individuals, determining the number of these artists is not easy. However, it is estimated that women make up around 20 per cent of this group.[8] Although, once again, male artists are in the majority, interestingly, the proportion of women is higher than that in the collection as a whole, suggesting that once marginal groups begin to enter the Tate Collection, women do start to be included in greater (although not equal) numbers.

A key example of the diversity of the women artists in this book is their varying interpretation of their own identities, and the ways in which this, in turn, has informed their art. During the late nineteenth and early twentieth centuries, ardent advocates of women's rights such as Annie Swynnerton contrasted with women such as Kathleen Kennet. Swynnerton's work in the Tate Collection includes a portrait of the campaigner for women's suffrage, Dame Millicent Fawcett. Kennet, a successful sculptor who moved in the highest political circles in London during the 1910s, a period of heightened campaigns for women's suffrage, regularly discussed policy with her friend the Prime Minister, but was firmly opposed to women being given the vote: her sculptures celebrated the powerful men of her age. And, while for some women working during the late twentieth century and into the twenty-first the idea of a separate category of 'women's art' is untenable, others have embraced the perception of women and their work as innately different.

Looking at Tate history in relation to women artists, what are the landmark moments? The first solo exhibition of a woman's work was that of the Victorian painter Joanna Mary Boyce Wells, held in 1935. There was to be a gap of a further seventeen years before the next exhibition of work solely by women. In the 103 years between the opening of the first Tate Gallery and the publication of the biennial report in 2000, only around 10 per cent of individual exhibitions have been given to women artists.[9] But there has been progress in recent years. The number of women artists represented in the Tate Collection has increased by eighteen in the time spent writing this book. And, although in 1897 the National Gallery of British Art had no sculpture by women in its collection, just over a century later both Tate Modern and Tate Britain celebrated their launches with specially commissioned work by two women taking centre stage. Louise Bourgeois's three towers (*I Do, I Undo, I Redo* 2000) stood in the Turbine Hall at Tate Modern, while her spider (*Maman* 2000) sat on the platform above. Mona Hatoum's *Homebound* 2000, *Mouli-Julienne (x 21)* 2000 and *Continental Drift* 2000 filled the Duveen Galleries at Tate Britain.

The history of women artists' work in the Tate Collection is bound up with the wider history of women working for Tate Galleries. Curators do not necessarily promote the work of artists of the same sex, and so the historical lack of women curators cannot be seen as directly responsible for the low number of women artists, but under-representation in both areas suggests a pervasive discrimination during much of Tate's lifetime. Some aspects of Tate history are difficult to uncover: the Thames flood of 1928 destroyed early records. But piecing together the story of women within the institution, it seems that the first woman curator was Mary Chamot. Chamot did some lecturing for the gallery from 1923, and rose

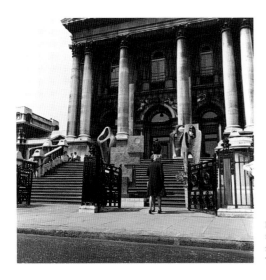

Barbara Hepworth's sculptures
installed on the steps at Millbank
for her 1968 retrospective.
Tate Archive Photography Collection

to the position of Assistant Keeper in 1949. She compiled the concise catalogue of the British School (1953), and collaborated on the catalogue of Modern British Paintings (1964). Chamot also drew on her Russian background and skills as a linguist, contributing ground-breaking work on Natalia Goncharova, curating exhibitions and writing monographs on the artist which revived her reputation.[10] Chamot's assistant on the British School catalogue, Judith Cloake, later moved into the administration of the gallery, and rose to the position of Assistant Director.

Today, although all four Tate Directors are men (there has not yet been a woman appointed at this level), the new Curator of Tate St Ives is Susan Daniel-McElroy, and many women work at senior levels in Tate teams. In recent years, women curators have organised exhibitions specifically to highlight marginal groups in the Collection. Judith Collins mounted *Writing on the Wall* in 1993–4, featuring seventeen women artists chosen by twenty contemporary women. An accompanying book collected together the selectors' literary responses.[11] Among these were poet Wendy Cope, who chose Vanessa Bell's *Nude* (c.1922–3), and actor Eleanor Bron, who settled on Rita Donagh's *Long Meadow* (1982) and Evelyn Dunbar's *Winter Garden* (c.1929–37). Two years later, in the winter of 1995–6, Virginia Button organised *Picturing Blackness in British Art, 1700s–1990s*, showcasing work from the Collection representing black people, and by artists of colour. The exhibition included both eighteenth-century paintings in which black servants are shown tending to white masters, and work by two contemporary black women, Sonia Boyce and Lubaina Himid.

Addressing the gaps such exhibitions reveal in the Tate Collection through targeted collecting is difficult given the sheer laboriousness and complexity of procedures. Sourcing work and raising funds is painstaking and problematic, and large museum collections such as Tate therefore often lag behind developments in art history which have uncovered overlooked artists from the past, and find it difficult to keep up with new currents in fine art practice. And positive discrimination can be a minefield, generating accusations of tokenism and the opposition of some women artists, wary of the implication that their work is being acquired solely because they are women, rather than because of its merit. Positive discrimination can also seem to contradict Tate's aim to collect 'works of outstanding aesthetic and historical significance'. As this has often meant work by canonical artists, being clear about what Tate's priorities should be, balancing collecting key works by established 'great names', and those who are not part of the Western canon, is not easy.

These difficulties put into context the fact that there is no Tate policy aimed at augmenting holdings of women's work,[12] a situation which is perhaps also determined by the belief that the situation within the Tate Collection today is a reflection of the 'natural' evolution of women as artists – historically they barely existed, hence their low numbers, whereas now their proliferation is reflected in the thriving collection of contemporary women artists. But while women artists working now are a strong presence in Tate galleries, this does not mean that there is no longer a need to be concerned with the sexual politics of culture (as will be discussed in the later essay 'Women Working Now'). And women artists were active in the past in far greater numbers than a visit to Tate galleries would suggest. The under-representation of women artists in the Tate Collection remains to be specifically addressed, and it is to be hoped that this can begin to be done without insinuating that this is the *only* reason that their art is being brought into the museum.

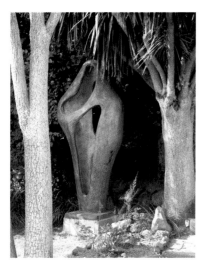

Barbara Hepworth
Figure for landscape, 1959–60
Tate

Wilhelmina Barns-Graham
Red Form, 1954
Tate

The debates about whether to or how to increase the presence of art made by women in Tate galleries, and the slowness and difficulty of collecting, have led curators to use other means of highlighting women's work. The changing programme of displays of the permanent collections can give women artists a platform by dedicating space to individual artists (the press coverage of the launch of Tate Modern was full of photographs of the Queen talking with Bridget Riley in the room devoted to the artist's paintings). The ways in which some women artists have challenged canonical forms of representation have been explored through the arrangement of work. Tate Modern's display *Nude: Action: Body* has included a section, 'Naked and Nude', in which two paintings of female models by Picasso have been juxtaposed with Alice Neel's painting of a naked man, *Jo Gould* (1933), lent to the gallery by her sons. Borrowing for exhibitions has been a useful way of highlighting the work of women whose art is not part of the Tate Collection, for example Tate Modern's exhibition of the work of Katharina Fritsch in 2001.

There has also been a change in the Board of Tate Trustees that may multiply the numbers of women artists in the future. All prospective additions, purchases, gifts and bequests have to be approved by the Board. It is telling that suitable candidates for the first board, created in 1917, were defined as 'gentlemen with a knowledge of or interest in modern and contemporary art'.[13] By contrast the sex of the catering staff had been made clear soon after the opening of the gallery: they were to be 'some lady or ladies'.[14] The sexual divisions instituted in the Tate's early years appear to have been taken to heart through a large part of the twentieth century. The first woman trustee, Barbara Hepworth, was not appointed until 1965 (Rita Donagh became the second in 1977). Since Tate's foundation there have been only ten women trustees, and 114 men. But the board is now nearing parity; in 2000 it comprised seven men and five women, among them Gillian Wearing.[15]

But the different position of women, and their distinct experience as artists, has actually influenced Tate collecting policy in their favour in one instance, the case of the group of women who were training at the Slade School of Art in London at the time the gallery first opened underlining the influence of the personal preferences of trustees on the Tate Collection. During the late nineteenth century women were a major presence at the Slade. This generation of students are well-represented in the Tate Collection, which include works by Clare Atwood, Beatrice Bland, Evelyn Cheston, Edna Clarke Hall, Florence Engelbach, Gwen John, Lady Kathleen Kennet, Louise Pickard, Mary McEvoy, Madge Oliver and Ursula Tyrwhitt. Women enrolled at the Slade in large numbers in the 1890s as, unlike the Royal Academy (the other prestigious London art school), it gave them access to the life room, and did not require previous extensive formal study to produce an entrance portfolio. That a proportionally large number of these women are represented in the Tate Collection must have been influenced by the fact that during the early twentieth century, among the men building the museum's holdings were some with strong links to the Slade, and to the New English Art Club, where many ex-students and tutors of the school exhibited. D.S. MacColl, Keeper and trustee of the Tate, had lectured at the Slade and was an early member of the NEAC. Muirhead Bone, another NEAC member, was also a Tate trustee. And two ex-Slade students held positions of influence at the Tate: Sir William Rothenstein and Augustus John (perhaps the best known Slade student of the 1890s) were both NEAC members and Tate trustees (Rothenstein's son, John, was later to become Director of the Tate).

Although this is a case of the history of women artists putting them for once in an advantageous position, it is also a cautionary tale. Scanning through the list of Slade-trained women, few names are recognisable today. A combination of factors is likely to be responsible for these 'disappearing

Paule Vézelay
La Danseuse sur la Corde, 1923
Tate

women'. Some found combining a career as an artist with marriage (even to another artist) problematic, if not impossible. It was much more difficult for women to exhibit and sell their work. And a number who did build professional careers have since been written out of the history of art, so that the one name that is still familiar today, Gwen John, is often seen as completely isolated as a woman artist of her age. For the woman artist, working professionally has often neither guaranteed attention matching that of male contemporaries during her lifetime, nor ensured continued visibility after her death. The words of Louise Bourgeois, whose career has spanned much of the twentieth century, and continues into the twenty-first, are apt here. Asked by critic Cindy Nemser to voice her opinion on the position of women in the art world, Bourgeois responded: 'A woman has no place as an artist until she proves over and over that she won't be eliminated.'[16]

If women have historically been denied a major presence as artists in Tate galleries, they have had an influence on the Collection by other means, as consumers of culture, art collectors, patrons and benefactors. Dr Rosa Schapire, an art historian who fled the Nazis in 1939 and came to England, presented the painting *Woman with a Bag* (1915) by her friend Karl Schmidt-Rotluff in 1950 (Tate later accepted three more of the artist's works from her estate). In 1940 Miss Alice Cardew bequeathed her collection of fourteen works by William Blake. Fourteen years later Mrs A.E. Pleydell-Bouverie showed her collection of paintings, including Impressionist works, at the Tate, and then made a bequest including Cézanne's *The Avenue at the Jas de Bouffan* (c.1874–5) and Berthe Morisot's *Girl on a Divan* (c.1885). The collector of modern art, Peggy Guggenheim, mounted an exhibition of her collection at the Tate Gallery that opened on New Year's Eve, 1965. In 1977 Ethel Hodgkins left twenty-one pieces from her collection of St Ives artists to the Tate, among them works by Wilhelmina Barns-

Graham and Barbara Hepworth. The building of the Clore Gallery, which opened in 1987 to house Turner's work, was made possible by Mrs Vivien Duffield, who offered to fund the project on behalf of the Clore Foundation. And in 1996 Janet de Botton presented an important part of her collection, including works by Avis Newman, Nancy Spero and Cindy Sherman.

A number of women artists have given their own work to the Tate Collection. Barbara Hepworth made extensive gifts of her art, supervised her Tate retrospective in 1968, and her studio and garden in St Ives is now in the care of the Gallery there. Natalia Goncharova presented her painting *Gardening* (1908) in 1961, and (with Eugene Mollo) then gave two further works. On a visit to the Tate in 1965 Louise Nevelson was so pleased with the display of her work that she presented her sculpture *An American Tribute to the British People* (1960–4), and later gave four further pieces. In the 1970s Paule Vézelay presented a number of abstract works and three figurative prints from the beginning of her career; she also bequeathed three oil paintings. More recently, Wilhelmina Barns-Graham gave three of her works, and Rebecca Horn has augmented Tate's fine collection of her art by presenting videos of her early performance pieces and a new sculpture, *The Raven's Half Moon* (2001). Cornelia Parker gave her installation *Room for Margins* to Tate in 2000. The following year Veronica Ryan presented her sculpture *Quoit Monserrat* (1998) and three works on paper. And after Paula Rego's painting *The Dance* (1988) was bought by Tate, she presented a series of eleven preparatory drawings.

Paula Rego is among the women artists to have been nominated for the Turner Prize. Instituted in 1984, the award has become one of the most high-profile events showcasing contemporary art in Britain. Of the sixteen prizes awarded up to 2000 (the prize was suspended in 1990), fourteen were given to male artists. Rachel Whiteread became the first

Paula Rego
Drawing for The Dance, 1988
Tate

woman prize-winner in 1993, followed by Gillian Wearing in 1997. For the first three years of its life, no women artists were short-listed (one woman curator was nominated, as the prize was initially for anyone, critics and arts administrators included, who was thought by the jury to have made a major contribution to British art). Women nominees have regularly been outnumbered by their male colleagues (as they have on the jury). Up to and including the year 2000, men have made up fifty-seven of the nominations, and women twenty-four (Alison Wilding and Rachel Whiteread have each been nominated twice). And while work solely by male artists has been considered on three occasions, there has only been one year in which only women were nominated, 1997.

The 1997 shortlist, of Gillian Wearing, Christine Borland, Angela Bulloch and Cornelia Parker, followed a year in which only men had been considered. Responses from members of the art world to the 1996 shortlist were solicited by *Make, the Women's Art Magazine*.[17] These ranged from the accusation that it was a case of 'prizes for the boys', to suggestions for suitable women candidates, and speculation about the possible motives for the complete exclusion of women. Perhaps it was owing to 'male panic' at the recent successes of women artists? The *Independent*, covering the story under the headline 'Turner judges reject politically correct shortlist', reported the argument that to include a woman artist, at the expense of a male artist, would have meant that the Turner Prize judges were discriminating against men.[18] The following year, when only women were nominated, patronising headlines appeared such as 'The jury's still out, but where's the spice, girls?'[19] and 'Women behaving badly'.[20] The most surprising aspect of the 1997 Turner Prize was not that four women artists merited nomination, but that, at the end of the twentieth century, a women-only list was still unusual. It underlines the fact that the work of those art critics, historians and curators who call into question continuing discrimination and recover obscure women artists from history remains crucial (and I have drawn heavily upon their work in writing this book).

A note on the structure of *Tate Women Artists*

Some artists' careers move across the time divisions set up in this book, especially from the twentieth century into the twenty-first. If they maintain their practice today, even though they may be advanced in years, they have been included in the section 'Women Working Now'. Although some women have been given longer entries, restrictions of space have meant that the majority have shorter pieces. The decision as to how much attention to give each artist has been informed by a mixture of my own preferences, a desire to emphasise the variety of work by women, and, sometimes, in order to draw attention to strong collections of particular artists in Tate galleries. A small number of women do not have their work illustrated. This is due either to restrictions of space or, in the case of ten artists, because their work has deteriorated to such an extent that it could not be photographed. And, although there is, unfortunately, no room to include the eighteen women whose work was acquired while this book was being written, they have been listed at the back, along with women whose prints are held in the Tate Collection (although there are some exceptions, notably among the eighteenth-century women artists, a number of whom were printmakers). Essays at the beginning of each section sketch women's history in relation to the wider society and art world of their time, a backdrop against which the work of Tate women artists comes into focus.

BEGINNINGS

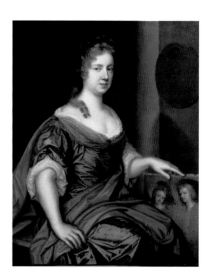

Mary Beale
Self portrait, c.1665–6
National Portrait Gallery,
London

The earliest work by a woman in the Tate Collection is a seventeenth-century oil painting by Mary Beale. But this is not when the history of women's work as artists begins. Women have been recorded making art objects (including illuminated books and embroidered textiles) early in the middle ages, and certainly during the mid-sixteenth century they were working in artists' guilds, or as court painters, and featured in publications on art. During the 1600s some women did work in business and the crafts, contributing to the household finances, and a few are documented as artists, so the fact that Beale painted 'upon profitable account' is not unprecedented. At this time, artists would show their work in their own studios and this meant that Beale did not have to submit her paintings to the professional bodies which later women artists often found so intractable. Women could learn to paint portraits using family members as sitters, and by copying the works of other artists. And as a portraitist Beale was able to capitalise on the social fluidity of a period in which there was the turbulence of the Civil War and the Restoration, and found a ready market among landowners like her own family, the clergy and court circles, all eager to make their mark upon the changing times.

Beale died as the eighteenth century was about to dawn, a period in which life for ladies (and it is the relatively wealthy we are concerned with) was largely confined within their familial roles and circumstances. Boys were sent away to school and given an education that was an induction to high office, the professions and public life. Girls were not, and their sphere of influence in culture and society was rarely as wide as their brothers'. In common law women were under the control of male relations; wives had no legal power over their children or property. But domesticity was not the total sum of a lady's existence. Being a member of polite society meant that you could keep abreast of current thought, reading the periodicals and novels that had began to proliferate. Women corresponded

regularly, and enjoyed the public diversions available in the growing towns and cities. There is even evidence of the existence of debating societies and coffee houses specifically for women in late eighteenth-century London. And although there were as yet no organised groups of women campaigning for change, there were individual voices. In *A Vindication of the Rights of Women* (1792), Mary Wollstonecraft argued that women should be allowed 'to share the advantages of education and government with man, see whether they will become better, as they grow wiser and become free. They cannot be injured by the experiment, for it is not in the power of man to render them more insignificant than they are at present.'

Women artists working in eighteenth-century Britain (as all of the Tate women of this period did) negotiated the art organisations founded in London during the period. The economy was growing, Britain was a major military power both abroad and at home (quelling the Stuart uprisings in Scotland), new industries were being born and trade expanding. Culture began to be organised along commercial lines, with an eye to promoting the products of the country to its inhabitants and in rivalry with other nations. This was the age of the club, the forum for civilised social engagement. Artists used them to network and find patrons; but women were excluded. Organisations were created so that art could be regularly exhibited and sold. The Society of Arts (full name, Society for the Encouragement of Arts, Manufactures and Commerce) was founded in 1754 to help to improve the economy partly through promoting the visual arts, followed by professional groups such as the Society of Artists of Great Britain and the Free Society of Artists. The number of women who exhibited at the latter two organisations during the thirty-one years of their existence is surprising; over 180 are named, and others recorded anonymously as 'ladies'. They worked in a range of media, drawing, painting, watercolour

Clara Maria Pope
Camellia (single white and red)
from *A Monograph on the
Genus Camellia* (1819)
Royal Botanical Gardens, Kew,
London

Angelica Kauffman
Self portrait in the
character of painting
embraced by poetry,
1782
Iveagh Bequest,
Kenwood

(ready-made paints were increasingly available), printmaking and sculpture. They also practised decorative arts, shell-work, hair-work, needlework and cut paper. A number are obviously from the same family, sharing a name and address, such as two young painters, Miss Mary Turner from Liverpool and Miss Peggy Turner, who each exhibited a work titled *A study from a group of objects in a painting room in 1773*.

Although the leading artists of the day, such as Reynolds, Gainsborough and Wright of Derby, showed with these societies, there were soon moves to create a loftier organisation that would reject embroideries and pictures made of hair, and The Royal Academy of Arts was founded in 1768. It was immediately clear that keeping out lesser art and artists meant keeping out most women. Angelica Kauffman and Mary Moser, the flower painter, were the only two among the first forty members (and there was not to be another woman member for the next 154 years). Their situation mirrored the wider position of women in Europe's academies of art. The French Academy did accept a small number of women over the century, and in Italy Kauffman was the exception in being elected to academies in both Florence and Rome. But admittance did not mean equal status. Women were prohibited from study from the nude life model, necessary to undertake history painting (considered by many influential figures the highest art form and the mark of professional stature). In order to circumvent this they worked from secondary sources or a draped model, and sometimes faced ridicule for their lack of academic training. Those who became artists were often only able to do so because other members of their family were already involved, giving them a sympathetic environment. This had been the case for Mary Beale, and remained so for Angelica Kauffman and her contemporaries.

Despite the difficulties faced by a woman artist of Kauffman's time, a letter to Goethe, written in Rome on 5 August 1788, gives a sense of the stature she managed to attain:

You want to know what I am working at. I have the following pieces finished, I think: The portrait of 'Lady Hervey,' the portrait of 'Cardinal Rezzonico before the Senate'. Today I am finishing 'Virgil,' the subject you will remember. I am very well pleased with the effect of the 'chiar-oscuro' . . . I have also commenced the two for the Shakespeare Gallery . . . Soon I must consider the subject of my large picture for Catherine of Russia . . . My portrait . . . which I presented to the gallery in Florence, has been accepted . . . they have placed me in a good light and beside a very famous man – no less than Michel Angelo Buonerotti. I wish I could stand near him, not in effigy alone, but in his works.[1]

In addition to the women for whom art was paid work, many more enjoyed it as a polite pastime. The majority of women artists in the Tate Collection from the time of Beale until the Victorian period are amateurs from the upper classes, who are so well represented owing to the recent acquisition of the Oppé collection of works on paper.[2] The exhibition *A Noble Art: Amateur Artists and Drawing Masters c.1600–1800*, curated by Kim Sloan for the British Museum in 2000, featured a number of women, and was the first to look at the subject in depth. From the seventeenth century onwards, courtiers, both men and women, had considered drawing and miniature painting a desirable accomplishment (it later spread to being a fashionable activity for the middle classes). Being an amateur did not mean that you had no training at all. Some amateurs were wealthy enough to pay for tuition with the masters of their age. Julia Bennet (Lady Gordon) was tutored by J.M.W. Turner, and, in common with Amelia Long (Lady Farnborough) and Elizabeth Leveson-Gower (Duchess-Countess of Sutherland), was also taught by Thomas Girtin. Some women amateurs exhibited with the art societies, and it seems likely that these organisations were happy to exhibit

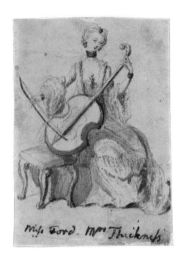

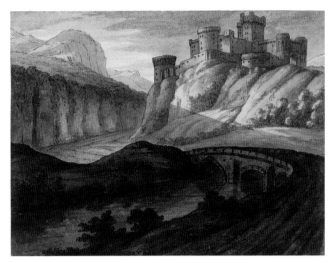

Frances Scott,
Lady Douglas
A Castle above a River,
among Mountains,
after Robert Adam
Tate

Susanna Highmore
Duncombe
Mrs Thicknesse
Playing a Viol, c.1762–5
Tate

their work as a way of gaining favour with the upper classes. They could also find their work collected in albums such as Richard Bull's *Etchings and Engravings by the Nobility and Gentry of England; or by persons not exercising the art as a trade* (British Museum). The second volume was dedicated to fifty-eight women, including a number of artists now in the Tate Collection.

The work of these women crystallises the concerns of their class. The prosperity of the second half of the eighteenth century meant that many country seats were built or renovated. Houses were decorated with art collected by family members (men and women) on the fashionable Grand Tour, usually to Italy, which gave amateurs work to study and copy. New pleasures and luxuries could also become the subject of art, the exotic plants being imported, and theatre and concerts, not only in the playhouses but also in private performances by and for the ruling classes. But it is landscape which figures most often among works by Tate women of this period. The increasing appearance of landscape as an artistic subject went hand in hand with wider interventions in and representations of the land in social and political practices. Gardeners who worked on a grand scale were employed to beautify the extensive grounds of great houses. Drawing and topography were taught in military schools so that accurate representations of terrain were available for military campaigns, and touring and sketching became seen as a tasteful and personally improving activity.

The rise of landscape art, aided by publications such as William Gilpin's series of works offering advice to amateur artists, can be understood, therefore, in the context of the organisation and representation of land as tied to power, politics, economics and identity. This becomes clear leafing through *Delices de la Grande Bretagne*, a bound volume of etchings of landscapes published in London in 1791 (British Museum), which includes one print after a work by a Tate woman artist, Mary Hartley. The date of *Delices*, and the

fact that the title is in French, are significant. Funded by subscribers including members of the Royal family, its introductory essay described the pleasures of viewing the 'British Landscape'. The nobility are praised for making improvements to the country, in which the 'combination of art and nature' can 'effect wonders'. Peasants are 'picturesque', and happily enjoy a unique 'liberty and ease'. Through the dissemination of images of land and the people who worked it, the message is clearly transmitted: in Britain class and country are stable and ordered, unlike revolutionary France. Drawing and painting the country was a way of recording and celebrating family estates, or subscribing to contemporary tastes for the picturesque or gothic. Aristocratic amateurs did not portray a land scarred by conflicts or new industries.

The early nineteenth century, before Queen Victoria's accession, encompassed the impact of the industrial revolution, and the rise of capitalism and of 'democracy', and can be characterised as a reactionary time for women. Femininity was redefined in relation to a bourgeois domestic ideal, while Romanticism glorified the male cultural producer at the expense of women writers and artists. At the first exhibition of The Society of Painters in Watercolours in the spring of 1805 there were no women members, associates or exhibitors; the society's aim, to raise the status of the medium by keeping out amateurs, meant, in reality, excluding women artists. The Society of British Artists, founded in 1823, conferred on women the lesser status of 'honorary' membership. Both art in specific media, and art defining British cultural identity, were made masculine. But because most of the earliest women in the Tate Collection did not (because they could not) train and work as professionals, does not mean that we should dismiss them as without talent and intelligence. And the fact that art had become an acceptable amateur accomplishment for women was to prepare the ground for them to push for professional art education and status in the later nineteenth century.

MARY BEALE
1632/3–1699

On 27 April 1681 Mary Beale's husband, Charles, recorded the successful outcome of a portrait sitting: 'This day my Dearest Heart finisht ye face of our most worthy friend Dr Tillotson Dean of Canterbury, upon a 3 qtr Sacking and has made it extreamly like him and coloured it exceeding rarely & made it very forcible and strong. She bestowed the whole day upon it, & the most obliging Dean satt with admirable and unvariable patience being one of the readiest persons in this world to gratify, & serve his friende.'[3]

Charles Beale's surviving notebooks and journals give us a glimpse through the studio door of an artist who was, by 1671, working successfully as a portrait painter in London's fashionable Pall Mall. Although nothing is known of Beale's training, her father was an amateur artist and miniature painter. He, and then Beale herself and her husband (also an amateur artist), were all painted by Sir Peter Lely, and owned a self-portrait by him. Lely later advised Beale on her work, and lent her his paintings to copy. She could also study from her family's collection, which included works by Rubens and Van Dyck. Charles Beale wrote of family visits to view portraits by other artists: 'My D. Heart, sself and Son Charles saw at de Waltons in Lincolns Inn Fields ye Lady Caernarvons pict a H.L. done by Sir Ant Van Dyck, in blew Sattin, a most rare faire complexion exceeding fleshy, done almost without any shadow ... Also a rare head done by Holbin of ye Lord Cromwell.'[4]

Among the subjects of Beale's paintings were men such as Edward Stillingfleet, later Dean of St Paul's and Bishop of Worcester, Gilbert Burnet, author of *History of the Reformation*, and Dr Thomas Sydenham, whose portrait by Beale is in the collection of the National Portrait Gallery, London. The society figures she painted included Lady Leigh, whom she portrayed as a shepherdess, and Catherine Thynne, Lady Lowther. Both paintings relied upon poses and compositions that Beale had studied in Lely's work, and she found a useful source of income in making copies of portraits, the originals often by Lely, for such ladies to give to each other as gifts.

Beale also celebrated her friendships, and her companionable marriage would have been included in this definition, in her work. She painted her family, portraits of herself with her husband and son, and members of their circle. She wrote of the profound moral and religious importance of these close ties in her *Discourse on Friendship* of 1666/7, which reflected widely held contemporary beliefs, as Tabitha Barber has discussed in her catalogue of the exhibition of Beale's art held at the Geffrye Museum, London (1999–2000). As to the question of her position as a woman within the family, according to Barber, 'Mary would never wish to assert her superior role as artist and

Mary Beale
Portrait of a Young Girl, *c*.1681
Oil on canvas
53.5 × 46 (21⅛ × 18⅛)
Purchased 1992

breadwinner', believing in obedience to her husband's wishes, as was common at the time. Although we may assume that her career as a woman artist was somewhat radical, this must be balanced by Beale's own beliefs, and by the fact that she gained the patronage of establishment figures, clergymen and the aristocracy. And although she may have been unusual, Beale was not unique in being a successful female artist during the late seventeenth century. Another portrait painter in oils, Joan Carlile, received the recognition of royal patronage.

Beale used her studio assistants, at least two of whom were women, as models for paintings in which she experimented with portrait compositions and techniques. *Portrait of a Young Girl* is likely to be such a work. Charles Beale was involved in the technical operation of the studio, making pigments for his wife to use and for sale. His notes contain lists of 'Pictures done by my Deare Heart upon account of Study and Improvemt'. Among them he describes 'Miss Woodfords pict upon ye onion bag was done over before she finisht it,

with white poppy oils, as thin done over as she could qu: how it settles.'[5] Beale's self-portraits can also be understood as test pieces, and as advertisements. They sometimes emphatically represent her as an artist. She showed herself holding a palette (c.1670–5, St Edmundsbury Borough Council) or with her hand resting on a canvas on which there is an unfinished portrait of her two sons (c.1665–6, National Portrait Gallery, London), perhaps a visual metaphor for her role

as a mother, bringing her children into existence on canvas as in life. Beale trained her son Charles, and her assistants. One of these, Sarah Curtis, had some success, and her portrait of her husband Benjamin Hoadly, Bishop of Salisbury, is in the collection of the National Portrait Gallery, London. Charles Beale's diary for 4 June 1681 suggests the burgeoning ambition of another, Keaty Trioche; he recorded her purchase of half an ounce of one of the most expensive pigments, ultramarine.

Beale was buried in Sir Christopher Wren's St James's Church, Piccadilly, not far from her Pall Mall studio, although no monument to her has survived. But her home and studio in the country has been rediscovered. Beale took her family to Allbrook Farmhouse near Eastleigh, Hampshire, to escape the plague in the 1660s. Three centuries later, in the 1950s, inhabitants of the house found her racks for storing canvases still in place.

BARBARINA BRAND, LADY DACRE
1768–1854

Mary Hartley is credited with encouraging the artistic talent of Barbarina Brand (née Ogle). According to Carl Barbier in *William Gilpin: His Drawings Teaching and Theory of the Picturesque* (Oxford 1963), Hartley reportedly visited the Ogle family in Winchester in the winter of 1781. Admiring the fourteen-year-old Barbarina's wax sculpture of a horse, she enlisted the advice of her friend Gilpin, and his brother Sawrey (known for his animal painting), who both began to correspond with the young artist. William Gilpin was still writing with his critical comments in 1793: 'Modelling is certainly yr forte: only I am afraid, if I were to look into yr modelling room, I should think you too ambitious in showing yr skill in anatomy, I wd aim more at character than attitude. In character you excel.'

In 1789 Brand married her first husband, Valentine Wilmot. They separated in about 1796 and in 1819 she married Thomas Brand, Baron Dacre. Drawing and modelling horses and cattle remained her chief interest as an artist. Five of her etchings of horses and donkeys are included in Richard Bull's album of etchings and engravings. The publisher John Murray owned her sculpture *A Wounded Horse*, with its

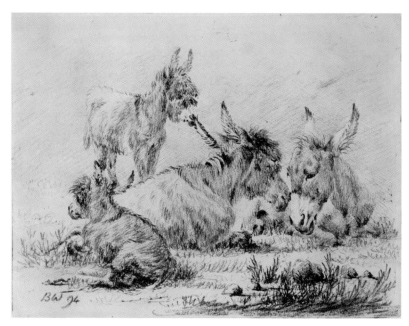

Barbarina Brand, Lady Dacre
Four Donkeys
Etching on paper, print
14.9 × 19.8 (5⅞ × 7¾)
Purchased as part of the Oppé Collection with assistance from the National Lottery through the Heritage Lottery Fund 1996

dramatic curved craning neck and stamping foot. His company published a book on Lady Dacre, *A Family Chronicle*, edited by Gertrude Lyster (London 1908), which reproduces examples of her work, such as the bas relief *Phaeton*, in which four horses come careering and plunging out of the background, on which the charioteer is drawn. She is also recorded as having made portraits, sculpting a bust of the Duke of Gloucester in wax. Like a number of amateurs, she used wax during its

high point of popularity in England.

Brand was also a writer and translator. Her two-volume *Dramas, Translations and Occasional Poems* (privately printed in 1821) included plays such as *Xarifa*, a tragic drama, translations of Petrarch, and her own poetry, including a composition on the death of her sister. Brand also edited two books published by her only daughter in the 1830s, *Recollections of a Chaperon* (London 1833) and *Tales of the Peerage and the Peasantry* (London 1835).

Attributed to
ANNE SEYMOUR DAMER
1748–1828

According to her biography, *Anne Seymour Damer: A Woman of Art and Fashion* (London 1908), the historian David Hume spurred Anne Damer's interest in sculpture. Incensed by his declaration that women could not sculpt, she began to work with wax, and then marble, and the results excited his surprised praise.

Following an unhappy marriage (her husband committed suicide in 1776) Damer began to travel, became involved in politics (canvassing for the election of Charles James Fox), and pursued her art in earnest. By the end of her life, art had apparently become so important to her that she asked to be buried with her sculpting apron and chisel. Among Damer's documented works are a self-portrait bust made for the Uffizi, a bust of Fox which she presented to Napoleon, a bust of Lady Elizabeth Foster, and Portland stone heads of Thames and Isis designed in 1785 as the keystones of Henley Bridge in Oxfordshire. She also made busts of ladies of her circle. Her portraits of Elizabeth Countess of Derby (*c*.1788) and Mary Berry (*c*.1793) are in the collection of the National Portrait Gallery, London.

Damer exhibited at the Royal Academy from 1784 to 1818. Her bust

Attributed to
Anne Seymour Damer
Landscape with Horseman and Trees
Pencil and watercolour on paper
23.5 × 35 (9¼ × 13¾)
Purchased as part of the Oppé Collection with assistance from the National Lottery through the Heritage Lottery Fund 1996

of Nelson, shown there in 1804, was noticed by the critic of the *Morning Post*, and described in the paper on 5 May: 'Notwithstanding its modern costume, this portrait of Lord Nelson displays more of the true spirit of the antique, than most of the sculpture worthies that grace the circle formed round its base; spite of all the advantage they enjoy of Roman togas, or bared bosoms. It possesses that breadth of style which, carefully discarding every incidental minutiae of the feature ... prevents the truth of the resemblance from being diminished.' Damer's most famous admirer, Horace Walpole, bequeathed his gothic villa, Strawberry Hill, to her in 1797 (at a later sale of the contents, Damer's wax busts of Caesar and Voltaire were listed as housed in the closet Walpole had built to display Lady Diana Beauclerk's work). The great actor Mrs Siddons is said to have enjoyed sculpting alongside Damer in her studio there.

SUSANNA HIGHMORE DUNCOMBE
1725–1812

Turning the pages of Susanna Highmore Duncombe's sketchbook (Tate Archive) the viewer comes across a calling card, decorated with a hand-painted red and black feather, confirming a meeting between the artist and a female friend. The sketchbook is filled with drawings of scenic views mostly of places which the artist is likely to have seen on her travels in England, such as 'Ramsgate Lighthouse' or 'Rotten Dean near Brighton', executed in a mixture of pencil, ink and wash and often delicately tinted. Although they appear to be drawn from direct observation, they are composed with a clear feeling for their design possibilities; a view of a castle in ink, for instance, with sea and ships behind, is enclosed in a decorative oval.

In many ways Duncombe exemplifies the woman amateur artist of the eighteenth century, producing small-scale, prettily delicate work.

Susanna Highmore Duncombe
Vignette with Two Ladies Conversing in a Park,
with Athena Chasing Away Cupid
Pencil, pen and ink and wash on paper
9.7 × 11.1 (3⅞ × 4⅜)
Presented by Mrs Joan Highmore Blackhall
and Dr R.B. McConnell 1986

Nevertheless, her access to cultural circles through her father, the successful painter Joseph Highmore, and her parents' enlightened attitude towards the education of girls allowed her to develop her talents more than many other women of her class and time. She was taught to draw by her father, whose studio was at the family's London home in Lincoln's Inn Fields. Her parents also gave her an entrée to the literary circles in which she was to make her name, and not only as an illustrator. She learned languages, including Latin, French and Italian. Both her parents wrote poetry and she followed their example, composing her own verse and publishing translations of Italian poets.

Through her father, who had illustrated Samuel Richardson's novel *Pamela*, Duncombe met and became a friend of the author. The second volume of his correspondence (London 1804) contains a group of letters between Richardson and Duncombe, and also between the latter and her close friend Hester Mulso. It is prefaced by an engraving after a drawing by Duncombe showing Richardson reading aloud from his novel *Sir Charles Grandison* at his home, North End, in the mid-1750s. Those listening attentively include

Duncombe's friends Mulso and Mary Prescott, and also the artist, who portrayed herself sitting at the front of the scene, sketchbook in hand. In a letter to Duncombe of 1751, Hester Mulso wrote: 'yet is my fancy never so well pleased as when it places me amongst the dear circle at North End, which your pencil so prettily described. You do not know how much pleasure I take in surveying that sketch, nor how often I contemplate every figure in it, and recal the delights of that day.'[6] Mulso, later Mrs Chapone, became a bluestocking, whose works were published in four volumes in 1809.

The artist and her circle enjoyed the pleasures available to their class. Her correspondence mentions visits to the theatre and excursions to the countryside. A drawing in her sketchbook entitled *View at the entrance of Kew Gardens* reflects the contemporary fashion for the garden and for the Orient. A stream snakes around the foreground of the scene; in the distance is the Kew pagoda. Through the centre of the drawing walks a lady wearing a pink dress and hat, perhaps representing the artist who enjoyed such diversions.

Duncombe's drawings housed in the Tate Collection show an imaginative

variety of styles and subject matter. There are airborne monsters and unicorns, classical figures such as Athena, and also gothic works, including the ghost scene from *The Castle of Otranto*, an illustration for the popular novel by Horace Walpole (London 1764). She also made many drawings of women, including a female sitter in Turkish dress, *A Lady before a Medallion Bust of Handel*, and, on the back of a dinner invitation, a sketch of the musician Ann Ford (Mrs Thicknesse) playing her viol (Ford was also portrayed with her instrument by Gainsborough). Her skills at the 'polite' accomplishment of cut paper work are evident in tiny, exquisite, coloured cut-outs of women wearing fashionable dress.

Following her marriage to a clergyman in 1761 Duncombe moved to Kent. She produced designs for engravings, and made topographical studies of the area, such as those illustrating *The History and Antiquities of Reculver and Herne* of 1779. Her only child, a daughter, was born in 1765. According to a poem by Duncombe, she had passed on her love of literature to the girl, whom she described wandering alone in the Kent countryside with a book.

JULIA BENNET, LADY WILLOUGHBY GORDON
1775–1867

Julia Bennet engaged J.M.W. Turner to give her lessons. Writing about her in *Country Life* in 1939, the collector Paul Oppé reproduced a drawing of Cowes Castle, inscribed 'first with Mr Turner, 1797'. She was also tutored by Thomas Girtin, in common with two other Tate women artists, and by David Cox, bequeathing a painting by him to London's National Gallery.

Drawings, watercolours and lithographs by Lady Gordon made up most of the two exhibitions of art by her family held in Carisbrooke Castle Museum (1972) and Southampton University Library (1974). Among the works on show were sketches of scenes in Southampton and Dover and views along the Thames. She also pictured notable London events, the opening of Waterloo Bridge, and a balloon flight: *Ascent of Mr Sadler and Miss Thompson from Burlington House July 29 1814*. These were both lithographs. The technique had only been invented in 1798, and she could have been encouraged to use the medium by the example of Angelica Kauffman who had made prints, and Lady Cawdor who made some of the earliest lithographs produced in England. Bennet's marriage in 1805 to General Sir James Willoughby Gordon,

Julia Bennet, Lady Willoughby Gordon
Cottage at Wigmore, Kent, 1803
Watercolour and pencil on paper
24.3 × 31.5 (9⅝ × 12⅜)
Purchased as part of the Oppé Collection with assistance from the National Lottery through the Heritage Lottery Fund 1996

a veteran of Wellington's Peninsular War campaign against Napoleon, helps to explain the watercolour *Landing from the first French Packet after the peace of 1814 Brighton*.

Lady Gordon also pictured her family homes on the Isle of Wight (Turner used some of these sketches as studies for an oil painting). It was at one of the houses, Northcourt, that the poet Algernon Swinburne, her son Henry's nephew by marriage, spent time with the family, writing during his visits. Both Henry and his sister Julia Emily Gordon inherited their mother's interest in art.

LADY LOUISA AUGUSTA GREVILLE
b.1743

The eldest daughter of Francis, first Earl of Warwick, Louisa Augusta grew up during the period when her father was transforming Warwick Castle. Having spent five years in Italy on a Grand Tour, he had returned a great admirer of Italian art, and in the late 1740s commissioned Canaletto to paint a series of views of the castle and its surrounds, then being landscaped by Capability Brown.

Greville is believed to have studied under Joseph Goupy, who made watercolours and etchings of landscapes, and etchings of religious subjects. This seems to fit with her surviving work, which also clearly shows the effect of the Earl's taste. It is recorded that she made prints after works by Caracci and Rosa (showing a landscape after Rosa in 1762). A fine etching, *A View Taken from the Priory at Warwick* (1757), one of ten of her works included in Richard Bull's *Etchings and Engravings by the Nobility and Gentry of England* (British Museum), was perhaps influenced by Canaletto, who had

drawn the castle from the same vantage point.

Both the British Museum and the Tate have prints made by Greville after Guercino, who was admired as one of the finest Italian painters by the English aristocracy during the mid-eighteenth century. By the early 1760s George III owned a painting and a series of drawings by the artist, and to celebrate their acquisition Bartolozzi made etchings after these works. It would appear that Greville's British Museum etching is a copy after one of Bartolozzi's most ambitious prints, a 'long landscape' with figures crossing a bridge. The Tate etching is clearly inscribed 'Guercino delin.' and carries Greville's intertwined monogram LAG. It is bound in the same volume of prints, *Etchings by Various Masters*, as work by Mary Hartley and Amelia Long, Lady Farnborough. Greville was awarded gold medals by the Society of Arts in 1758 and 1759 for landscape drawing, and in 1760 for a figure subject after Guercino.

Lady Louisa Augusta Greville
[title not known] 1765
Etching on paper, print
15.5 × 25.7 (6⅛ × 10⅛)
Purchased as part of the Oppé Collection with assistance from the National Lottery through the Heritage Lottery Fund 1996

MARY HARTLEY OF BATH
fl.1757–1803

An engraving after Mary Hartley's painting *View in Wentworth Park, Yorkshire*, once owned by Lady Charlotte Wentworth, has in the distance the house and observatory, the foreground occupied by deer under spreading trees. *Delices de la Grand Bretagne* (British Museum), in which the print appears, describes the picture as 'taken from a retired spot near the mill', 'possessed of the finest effects', and 'by a lady whose freedom of pencil, and principle of light and shade, cannot be excelled.'

Hartley was the daughter of philosopher David Hartley. In 1775, from an address in London's fashionable Golden Square, Soho, she sent in six landscape drawings to the Society of Artists, including a chalk drawing of a

Mary Hartley of Bath
[title not known] 1762
Etching on paper, print
18.4 × 13.5 (7¼ × 5⅜)
Purchased as part of the Oppé Collection with assistance from the National Lottery through the Heritage Lottery Fund 1996

coastal scene, and a wash drawing of a castle. The recent British Museum exhibition (see page xx) included her drawing of Fountains Abbey, a shadow falling across its ruins. Kim Sloan's research has revealed that it probably dates to after 1780. Around that date Hartley met and began a long correspondence with William Gilpin, having read some of his publications advising the amateur artist on how best to capture the 'picturesque'

beauty of landscape while touring Britain. Hartley and Gilpin discussed composition and technique and their meaning. In a letter of January 1789 (published in Carl Barbier, *William Gilpin*, Oxford 1963), Hartley declared: 'indeed I do not think that I am myself quite so fond of the rough stile as you are. I like to see the objects a little made out; tho I wou'd not, for the sake of that, abate one jot of spirit & genius, nor lose the least effect of light & shade.'

Hartley's subject matter was not restricted to landscape. In addition to the Tate etching, she is recorded as having made a portrait of Buxton, an arithmetician, in 1764. And among her five works in Richard Bull's *Etchings and Engravings by the Nobility and Gentry of England* (British Museum) is *A Sketch of a Beggar from the Life* of 1770.

ANGELICA KAUFFMAN
1741–1807

Angelica Kauffman won international acclaim as a painter, printmaker and decorative artist. She was a founder member of London's Royal Academy of Arts, and friend of some of the leading cultural figures of her age, including Goethe and Reynolds, whose portrait she painted, and who, in turn, portrayed her.

Kauffman was born in Switzerland, but had her earliest art training in Italy. She was taught by her father, who was a painter, and also copied and learnt from the works of art in the great museums such as the Uffizi. Kauffman came to know the major artists and historians of early Neoclassicism working in Italy, including Benjamin West, Pompeo Batoni and Nathaniel Dance, and she began to establish her reputation by painting fashionable gentlemen on the Grand Tour.

Arriving in London in 1766, Kauffman remained for fifteen years. She became hugely successful, taking a house with a studio in Golden Square and marrying the decorative artist Antonio Zucchi. In her biography of Kauffman (Gerrards Cross 1972) Dorothy Moulton-Meyer quotes a letter in which Goethe wrote about his friend's demanding career: 'She is tired of commissions, but her old husband

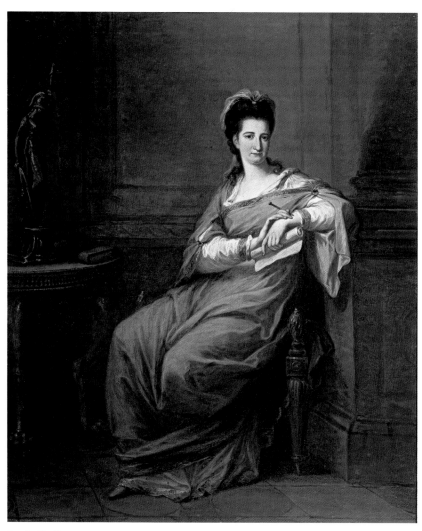

Angelica Kauffman
Portrait of a Lady, *c*.1775
Oil on canvas
79.2 × 63.5 (31⅛ × 25)
Presented by Mrs M. Bernard 1967

thinks it wonderful that so much money should roll in for what is often easy work. She would like to paint to please herself and have more leisure to study and take pains.' Kauffman's success was made possible by the expanding European market for consumable culture among the upper, and growing middle, classes, founded on the wealth pouring in from the colonies and the slave trade. She painted for wealthy patrons, and engravings of her work sold in the burgeoning print market to those with less money.

Culture was not simply pleasurable. It was a badge of class status for the consumer, and could also be a means of proclaiming the superiority of the Western world, with its roots reaching back to classical antiquity. Kauffman's stay in London coincided with the height of the taste for the Neoclassical. Her knowledge of the most current understanding and representation of classical culture placed her at the centre of the London art world. It gave her the grounding to undertake history painting, considered in some influential circles to be the highest form of art, a field of practice closed to most women, who were not able to undertake sustained study of classical culture and were usually barred from the study of human anatomy. The botanical artist Mary Delany described viewing Kauffman's history painting in London in 1771: 'This morning we have been to see Mr West's and Mrs Angelica's paintings . . . My partiality leans to my sister painter. She certainly has a great deal of merit, but I like her history still better than her portraits.'[7]

One of Kauffman's most important history subjects was taken from classical literature: the story of Penelope, wife of Odysseus, heroine of the *Odyssey*. This was an extremely unusual choice, and in *Angelica Kauffman: A Continental Artist in Georgian England* (London 1992) Wendy Wassyng Roworth argues that the artist's motivation lay in the fact that, rather than being a passive victim or an eroticised bare-breasted figure, Penelope was 'a suitable character through which Kauffman could advertise her talents', having been 'gifted by Athena herself with a talent for womanly handicraft and a clever, crafty mind'.[8] Left by her husband, who was fighting in the Trojan wars, Penelope fought off rapacious suitors, anxious to get their hands upon Odysseus's estate, and his wife. She declared that she would not remarry until she had finished her weaving, and secretly unravelled her work each night.

Kauffman's self-portraits celebrated her gifts. In *Self-Portrait at the Age of 13* (1754, Tiroler Landesmuseum, Innsbruck), the young girl holds up sheet music, drawing attention to the diversity of her talents, and a painting of 1791 shows her hesitating between two female figures symbolising the arts of music and painting (Nostell Priory, West Yorkshire). In a self-portrait painted for the Uffizi collection (1787), Kauffman sits with portfolio and paintbrush, wearing a cameo at her waist, symbolising her knowledge of classical culture. Also figuring large in Kauffman's oeuvre are portraits of some of the most celebrated people of her time. These include the society beauty Elizabeth Foster (later Duchess of Devonshire) and the novelist Cornelia Knight, who supported herself and her mother through her writing. Kauffman also portrayed a young woman, Miss Conway, who would later become known as the amateur artist Anne Seymour Damer. The *Portrait of a Lady* of c.1795 is typical of Kauffman's work, showing the sitter with the signs of culture, writing implements, a book, and a statue of Minerva, Roman goddess of intellectual and artistic activity. Several of her female sitters were painted in Western versions of 'Turkish' dress, which was fashionable, and also suggested the harem, a female world that could have resonated with the female sitter's experience of a woman artist's studio.

Kauffman also designed decorative schemes. Her four oval paintings for the new Royal Academy (which moved to Somerset House on the Strand in London in 1779) are now set into the ceiling of the Academy's current home, Burlington House, Piccadilly. They show allegorical female figures representing Invention, Composition, Design and Colour. Kauffman's designs were used to decorate everything from porcelain to books, fans and furniture. Her decorative skill and the elegant delicacy of her style have sometimes led to Kauffman's dismissal as a minor artist. But it must be remembered that decorative design was not merely the province of 'frivolous' women. Kauffman's husband made his living in this way. And in a journal entry of 1781, the novelist Fanny Burney described visiting Reynolds's London home especially to see 'some beautiful fans . . . from designs by Sir Joshua Reynolds, Angelica, West and Cipriani'.[9] Kauffman's contribution to eighteenth-century culture was reassessed in the exhibition *Angelica Kauffman: A Continental Artist in Georgian England* held at the Royal Pavilion Art Gallery and Museums, Brighton in 1992.

AMELIA LONG, LADY FARNBOROUGH
1772–1837

Amelia Long (née Hume) drew, painted in watercolour and oil, and etched. Her father was an amateur artist, collector and authority on Titian. As a girl she spent time travelling with her parents in Italy. She copied work by Gainsborough and Raphael, and her watercolour after a Raphael *Madonna and Child* (*c.*1792) was included in a recent British Museum exhibition of amateur artists (2000). She also had some training, being tutored by Thomas Girtin. According to Hugh Stokes in his book *Girtin and Bonington* (London 1922), the Duchess of Sutherland remarked that Long had been Girtin's favourite pupil.

In 1793 she married Charles Long (later Lord Farnborough), a politician who on retiring as Paymaster-General helped to create the National Gallery. Amelia Long accompanied the allied troops on their march on Paris following the victory at Waterloo and made etchings of scenes in Holland and France on the way. Her six works in the Tate Collection include an etching of the ramparts of Montreuil with marching soldiers (1817) and a water-colour of Dover castle with soldiers at its gate. A view of the sweep of Dover bay from the heights of the castle is in the collection of the National Galleries of Scotland. Soldiers on horseback are among the crowds thronging Long's painting of the Parisian park, St Cloud (1815, Anglesey Abbey, National Trust), with its distinctive alley of trees.

Long was also interested in horticulture and planned the gardens of the Longs' home, Bromley Hill Place in Kent, which housed their fine

Amelia Long, Lady Farnborough
Dover Castle
Pencil and watercolour on paper
24.6 × 22.6 (9⅝ × 8⅞)
Purchased as part of the Oppé Collection with assistance from the National Lottery through the Heritage Lottery Fund 1996

collection of art. Her own work was exhibited at the Royal Academy between 1807 and 1822, and is represented in the collections of the Victoria and Albert Museum, Norwich Castle Museum and Leeds City Art Gallery.

LADY ELIZABETH SUSAN PERCY
(1782–1847)

Daughter of the first Earl of Beverly, Lady Elizabeth Percy was from a family with a history of interest and involvement in art, both as amateurs and collectors. Her elder brother, Algernon Percy, painted miniatures. Her grandfather, the first Duke of Northumberland, had commissioned Canaletto to paint his three houses, Northumberland House in London, Syon House and Alnwick Castle. The fourth Duke, her cousin, was also an admirer of Italian art, renovating Alnwick in an Italian Renaissance style, and assembling a collection in Italy which included works by Titian and Tintoretto.

Lady Elizabeth made landscape sketches in pencil, chalk, wash and watercolour. A bound volume of her work and that of Elizabeth Drummond, dated 1817, is now in the collection of Northumberland Estates, as is an album of forty-three views of 'Rome & its Environs' by Percy, dated between December 1833 and April 1834. Among her work in the Tate Collection there are Italian scenes picturing the Boboli Gardens and Orvieto, in addition to English castles, cottages and the countryside.

Her interest in Italy and choice of subject matter united Lady Elizabeth's taste with that of her friend, the amateur artist and collector Sir George Beaumont. Beaumont played host to a circle of artists and writers at his home, Coleorton Hall, in Leicestershire, including, in addition to Lady Elizabeth, the poet William Wordsworth and his sister Dorothy, and John Constable. When Sir George died his wife gave Lady Elizabeth many of his drawings.

Lady Elizabeth Susan Percy
[title not known]
Pencil and watercolour on paper
26.2 × 18.7 (10⅜ × 7⅜)
Purchased as part of the Oppé Collection with assistance from the National Lottery through the Heritage Lottery Fund 1996

CLARA MARIA POPE
1769–1838

Clara Maria was the daughter of an amateur artist, Jared Leigh, and she married a painter, Francis Wheatley. She first exhibited at the Royal Academy in 1796, showing portraits and miniatures. She also exhibited the type of genre scenes that had made her husband's reputation, and *Pedlars' Rest* could be a copy of his work. Following Wheatley's death in 1801 she married the Shakespearean actor and miniature painter, Alexander Pope.

Clara Pope began to focus on flower painting. During the eighteenth century botany became a subject of much interest. Plants were imported from the colonies and along trade routes to botanical gardens including Kew, classified according to the Linnean system, studied by amateurs and advertised in books. This, and the rise of commercial printmaking and decorative embroidery, meant there was a ready market for images of flowers. Pope was employed by Samuel Curtis, the botanical publisher, to illustrate *The Beauties of Flora* (London 1806–20). The British Library has a copy of his *Monograph on the Genus Camellia* (London 1819), again illustrated by Pope, in which the pages look almost as if the plants are alive and resting on them, the blooms and leaves fleshy and glossy, with fat, unfurling buds. Like Mary Moser and Mary Lawrance, Pope exhibited her flower paintings at the Royal Academy, showing there until

Clara Maria Pope
Pedlars' Rest
Watercolour on paper
23.2 × 29.7 (9⅛ × 11¾)
Purchased as part of the Oppé Collection with assistance from the
National Lottery through the Heritage Lottery Fund 1996

the year of her death. Flower painting, perceived by some as an insignificant branch of art, was thought, therefore, to be a suitable subject for women and as a result they were allowed to study seriously, and could excel. Pope passed her skills on to the aristocratic young ladies she taught to draw.

Pope combined her botanical painting with an interest in drama in two watercolours shown at The Royal Academy in (respectively) 1818 and 1835. *Composition of Flowers in the Vase Presented to Edmund Keane* (Nottingham Castle Museum) portrays a gift given to the actor by the Garrick Club and other Drury Lane artists. *The Flowers of Shakespeare* depicts a bust of the playwright behind a basket of blooms and was bought by the architect and collector John Soane. And, like Lady Wharncliffe, Pope drew Madame Catalini, the most celebrated soprano of her age. Pope's life and work are described in Mary Webster's article 'A Regency Flower Painter, Clara Maria Pope', (*Country Life*, May 1967).

ANN SANDERS

Nothing is known of Ann Sanders beyond the fact that she seems to have been the earliest pupil of the watercolour artist Francis Towne, after whose work she made this drawing in the late 1770s. She featured in the exhibition *Francis Towne* held at the Tate Gallery, Millbank, and Leeds City Art Gallery in 1997–8. Towne was known for his landscapes, with their curving foliage outlined in curling strokes of the pen and watercolour washes, and light effects which created a sense of freshness and immediacy. He worked at a time when watercolour painting was coming to the fore as an art practice in its own right and followed the principles of art training of his age. His students made copies from prints, and then from drawings and watercolours.

But rather than faithfully reproducing Towne's example, Sanders has reworked her teacher's monochrome drawing to add a compositional complexity of her own. Her delicate lines describe a new addition, a figure with a horse, which gives her drawing

Ann Sanders
Wooded Landscape with Traveller and Packhorse, after F. Towne, 1778
Watercolour on paper
27.5 × 38.7 (10⅞ × 15¼)
Purchased as part of the Oppé Collection with assistance from the
National Lottery through the Heritage Lottery Fund 1996

greater interest and spatial depth in the contrast between the foreground and the trees than was present in Towne's original. And she has illuminated her scene with rays of light falling from the left, demonstrating to her teacher that she could both successfully emulate, and move beyond, his practice.

FRANCES SCOTT, LADY DOUGLAS
1750–1817

Frances Lascelles was the daughter of the first Earl of Harewood. Her family seat, Harewood House, near Leeds, was being decorated by John Carr and Robert Adam during the 1760s and the gardens redesigned by Capability Brown. Frances may have seen the work in progress, and may have come across Angelica Kauffman, who was commissioned to paint the roundels in the music room.

In 1784 she married John Douglas, son of the Earl of Morton, and moved to his estates in Scotland. Her position as an English aristocrat transplanted north of the border helps to explain her continued interest in Robert Adam. Following the unification of England and Scotland and the crushing of the subsequent rebellions, ambitious Scots such as Adam had come to London to make their mark. But he had retained his interest in Scotland, renovating and designing castles for Scottish lords (and there has been some speculation as to whether there was a patriotic motive in this, an attempt to raise the status of the Scottish nobles). The Tate Collection includes one of Lady Douglas's copies after Adam, a pen-and-wash drawing of a bleak, impregnable castle. The other three drawings are of the atmospheric ruins, waterfalls and gorges of the south-west coast of Scotland.

The politics of representing Scotland also informed the work of an artist who is believed to have tutored Lady Frances. Paul Sandby had taught military drawing at the first Royal

Military Academy at Woolwich, and had also been involved in the English army's major mid-century project to map Scotland. In a watercolour by Sandby (*c*.1780, Yale Center for British Art, New Haven), Lady Douglas is shown drawing out of doors in the company of a female friend, using a camera obscura, a device used to translate a view accurately into two dimensions.

Frances Scott, Lady Douglas
Dunskie Castle near Port Patrick
Pencil, pen and ink, watercolour wash and
ink and brush on paper
31.4 × 50.5 (12³/₈ × 19⁷/₈)
Purchased as part of the Oppé Collection with
assistance from the National Lottery through the
Heritage Lottery Fund 1996

LADY SPENCER

The identity of this Lady Spencer is not certain, but there is one candidate who is more likely to be responsible for the drawing of General Mordaunt, the *Gallant and Gay Lothario*, than any of her namesakes. Lady Diana Beauclerk (1734–1808) was the daughter of the Duke of Marlborough and grew up at Blenheim Palace where she made studies after her family's art collection. Known to her friends as 'Lady Di', she first married Viscount Bolingbroke in 1757, who divorced her. Her second husband, Topham Beauclerk, was a friend of Dr Johnson. According to Kim Sloan of the British Museum, the General Mordaunt in question could be Sir John Mordaunt, who had some connections with the men of Lady Diana Beauclerk's family.

Mrs Steuart Erskine's book *Lady Diana Beauclerk: Her Life and Work* (London 1903) reproduces an ink caricature of the eminent historian Edward Gibbon, a friend of her second husband. He is portrayed, in profile, as a ridiculous figure with a double chin, wearing a laurel wreath (British Museum). The clumsiness of the drawing is similar to that of the

Lady Spencer
Gallant and Gay Lothario
Caricature
Pencil, brush and ink
and ink wash on paper
18.8 × 11.5 (7³/₈ × 4½)
Purchased as part of the
Oppé Collection with
assistance from the
National Lottery through
the Heritage Lottery Fund
1996

Lothario. Prints of Lady Diana's drawings of her daughters, and of Georgiana, Duchess of Devonshire, were made by Bartolozzi. She also painted in watercolour and black wash and modelled in wax. Her designs for Wedgwood featuring infant cupids were used on clocks and wine coolers,

and her friend Horace Walpole decorated his 'Beauclerk closet' at Strawberry Hill with some of her Wedgwood designs and drawings.

But there are other women members of the Spencer family who cannot be completely discounted, including Countess Lavinia Spencer

(1762–1831) who married the second Earl Spencer in 1781. Also an amateur artist, she painted and drew, made miniatures and skilful etchings, and was a friend of Reynolds. Her work was engraved by Bartolozzi and Gillray.

MARIA SPILSBURY
1777–c.1823

In 1792, at the age of fifteen, Maria Spilsbury made her debut at the Royal Academy. Her father was an artist and engraver, and their careers are traced in Ruth Young's *Father and Daughter: Jonathan and Maria Spilsbury* (London 1952). Among the works she exhibited at the Academy were portraits and religious scenes. Her *Christ Feeding the Multitude*, shown in 1804, was admired by the *Monthly Mirror* critic: 'The figures are very numerous, disposed in groups with great address, distinguished by the variety of action. This is Miss Spilsbury's greatest performance.'

Spilsbury was celebrated above all as a genre painter in oils, and her success in this field can be understood as part of a contemporary taste for scenes of ordinary life. Developed from the art of the Netherlands, which had found favour in England with the Prince Regent (a keen patron of Spilsbury's work), genre painting also reflected the rise of bourgeois society and popular taste. It was not only women who painted such scenes; but compositions filled with small-scale clothed figures are likely to have been more accessible to them at this time than the large-scale nudes and great events of history painting.

Maria Spilsbury
The Schoolmistress, *c.*1803
Oil on canvas
76.2 × 91.4 (30 × 36)
Presented by Miss Ruth Young 1937

With her painting of a female teacher, Spilsbury was representing an area in which women worked (Mary Wollstonecraft briefly ran her own school in the 1780s). Opportunities had increased with the growth of charitable schools for the poor during the eighteenth century. Spilsbury was to have first-hand knowledge of this

when she married the philanthropist John Taylor in 1810. Three years later they moved to Dublin where he helped to establish a school and she painted portraits and scenes of Irish life (including rural festivals, and John Wesley preaching to a crowd in the countryside), exhibiting her work at the Hibernian Society.

ELIZABETH LEVESON-GOWER, DUCHESS-COUNTESS OF SUTHERLAND
1765–1839

Elizabeth Leveson-Gower, Duchess-Countess of Sutherland
Composition: Mountain Landscape
Pencil, watercolour and gouache on paper
9.4 × 31.1 (3¾ × 12¼)
Purchased as part of the Oppé Collection with assistance from the
National Lottery through the Heritage Lottery Fund 1996

Painter of landscapes in watercolour and etcher, Elizabeth Leveson-Gower published *Views of Orkney and on the North-Eastern Coast of Scotland* (1807), with forty-three etchings after her drawings, and *Views on the Northern and Western Coasts of Sutherland* (London 1833) with twenty aquatints after her watercolours.

In her article 'Across Sutherland with its Duchess' (*Country Life*, August 2000), Francina Irwin pointed out that it was the artist's intention that some of the *Views* published in 1833 be joined together at their edges so that the viewer could experience a complete circular panorama of the sweeping lands she had inherited as a child (the volume is prefaced by a map of the Sutherland area). The Duchess's tutor, Thomas Girtin, had made such panoramas, and she had also exchanged drawings with William Gilpin. In the Tate watercolour, the depiction of space, light and land, painted in a sombre palette and also creating a sense of drama, suggests a fusion of the accuracy of topography with a taste for the atmospheric and picturesque which is typical of her art.

The Duchess's husband was Ambassador to Paris in the early 1790s, and she is recorded as having made etchings of places connected with the writer Madame Sévigné. She also painted Heidelberg castle. Her daughter, Elizabeth Grosvenor, Marchioness of Westminster, was also an amateur artist, publishing her drawings in the two-volume *Narrative of a Yacht Voyage* in 1842.

CAROLINE ELIZABETH MARY CREIGHTON, LADY WHARNCLIFFE
c.1776–1856

Daughter of the Earl of Erne, Caroline Creighton, Lady Wharncliffe, moved in powerful circles. Her grandfather was the Earl of Bristol and her husband, James Stuart, Baron Wharncliffe, became an MP (his grandfather had been Prime Minister). An account of her life, drawing heavily upon her letters, is given in *The First Lady Wharncliffe and her Family* (London 1927), written by two of her grandchildren, Caroline Grosvenor and Charles Beilby, Lord Stuart of Wortley.

Lady Caroline's grandfather assembled a great art collection, including works by Claude and Correggio. Her mother was involved in the picture-buying, and Lady Caroline perhaps accompanied her abroad, as a sketch by her in the Tate Collection of a classical scene with a female figure is inscribed 'Roma 1789'. Her interest in the collection is documented in *The First Lady Wharncliffe* as having pleased her grandfather, who professed his delight that she had 'resumed her drawing under such good auspices'.

In her letters, Lady Caroline wrote about sketching along with her other pastimes, feeding her bantam chickens, singing, playing the guitar and spinning.

She was also a keen theatre-goer. In a letter of November 1805 (published in her biography), following her description of Nelson's victory and death at Trafalgar she wrote, 'Our excursion to the play last night was like insanity. What do you think of going in a fog so thick that the Doge [her pet name for her husband] was obliged to walk along the flags . . . with flambeau's before the horses . . . if we had not had the stage box, we could not have distinguished the faces on the stage. Think of So's and my fun, in seeing Lady Macbeth sorely put to it to keep her countenance we were so near her, & stared at her so unmercifully!' The Lady Macbeth in question could have been the actor Mrs Siddons. In the album of Lady Caroline's drawings in the Tate Collection, Mrs Siddons is shown in that role, and also at leisure on the beach at Scarborough. The rest of the album is devoted to sketches of performances from the period 1807–9. Actors, singers and dancers are caught in theatrical gestures, wearing contemporary costumes and classical or 'Turkish' dress.

Caroline Elizabeth Mary Creighton, Lady Wharncliffe
[title not known]
Pencil on paper
17.9 × 13.4 (7 × 5¼)
Purchased as part of the Oppé Collection with assistance from the National Lottery through the Heritage Lottery Fund 1996

VICTORIANS

Joanna Mary Boyce Wells
Portrait of Sydney Wells, 1859
Tate

The age of empire, industry and urbanisation has often been seen as a time of restriction for women. Victorian women have been described as suffering a dramatic reversal of earlier freedoms, forced back into a private sphere of domesticity, entirely cut off from the public world of work, politics and city life.

This is not the whole picture. The idea that a woman's place was in the home had existed for centuries before. But it did gain currency during the nineteenth century. The idea that femininity should be centred on fertility, to bolster the burgeoning empire, was disseminated through communication channels that were unprecedented in their proliferation and reach. Across the pages of periodicals, newspapers and novels, and in religious and medical discourse, woman's role was a key subject, played out in the representation of different female types. Images of womanhood completely defined and confined by family duty filled art and the wider culture of the time, such as the writing of Mrs Sarah Ellis, who described women as 'relative creatures' existing only in relation to their family in *The Women of England* (London 1839), *The Mothers of England* (London 1843) and *The Daughters of England* (London 1843).

Women were subject to many political, social and economic inequalities, but they did not always accept their lot, and the Victorian period is populated with figures who orchestrated change. It was not until the Married Woman's Property Acts of 1870 and the early 1880s that a wife was legally acknowledged as an individual with her own money and belongings rather than a 'chattel'. These advances were made largely in response to the campaigning committee founded by the artist Barbara Leigh Smith (later Bodichon). Bodichon was part of the 'Langham Place' group of middle-class activist women, and had been involved in the petition for women's suffrage presented to parliament in 1866 (although it was not until years after Queen Victoria's death that this struggle was won). In North America, the Women's Rights Convention at Seneca Falls in 1848 demanded an end to sexual discrimination, and, as the different states could pass independent reforms, women in Wyoming and Utah won the vote as early as (respectively) 1869 and 1870. Many women had been involved in the anti-slavery societies and petitions of the 1830s, and in 1859 the first woman to speak in public on the emancipation of slaves to mixed groups, the black American lecturer Sarah Parker Redmond, began a two-year tour of Britain.

The desire to control women was manifested through the regulation of the female body through medicine, and the social mores surrounding sexuality and dress. Women were subject to the medical claim that their primary function was reproductive and that serious intellectual activity damaged their health. In fact it was childbirth that was hazardous. The artist Joanna Boyce Wells died aged only twenty-nine from complications following the birth of her third baby. Medical procedures carried out on women could be repressive, intrusive and dangerous. Cumbersome and constraining clothes, crinolines, corsets and bustles, were targeted by reformers later in the century who argued for more comfortable 'rational' dress.

Women's struggle for self-determination, and the conflict this could cause with social convention, became a theme in the work of one famous group of writers, the three Brontë sisters, during the 1840s. For these educated daughters of a clergyman, creativity was an escape from the drudgery of being governesses, one of the few employments open to middle-class women. The heroines they created, women of intelligence and passion, are as much part of their age as Mrs Sarah Ellis's passive creatures. In Anne Brontë's novel

Elizabeth Southerden Thompson, Lady Butler
The Remnants of an Army, 1879 (detail)

Mary Severn Newton
Self portrait, c.1863
National Portrait Gallery,
London

Elizabeth Eleanor
Siddall
Lady Affixing Pennant
to a Knight's Spear
[also known as
Before the Battle] c.1856
Tate

The Tenant of Wildfell Hall (London 1848), Helen Huntingdon, who has left an abusive husband, supports herself and her son through her work as an artist, to the surprise of a visitor:

> '. . . you don't intend to keep the picture?'
> 'No; I cannot afford to paint for my own amusement.'
> 'Mamma sends all her pictures to London,' said Arthur;
> 'and somebody sells them for her there, and sends us
> the money.'[1]

Being able to forge a career and earn a living depended on education, which remained much more difficult (often impossible) for women to obtain, especially at the higher levels. In 1869 a college was founded to prepare women for entry to the University of Cambridge, and a decade later a similar college opened in Oxford (although neither University awarded degrees to women until well into the next century). Becoming an artist still often depended on a history of art practice in the family, and even then the belief that women above the working class should restrict themselves to familial roles led some to struggle against disapproval. In Britain private art schools such as that run by Henry Sass in the 1840s (then taken over by Francis Cary), Dickinson's Academy and Leigh's Academy (later Heatherley's), or private tuition, were the main options for women who wanted art training. In 1842 the Female School of Design was founded (later known as the Female School of Art), primarily to provide a training for working-class women, but also accepting those of higher social standing who had fallen on hard times, to enable them to earn a living.

In 1859 a campaign was mounted to win women the right to admission to the Royal Academy Schools, which was successful a year later. At the centre of the struggle for admission was access to training in life drawing. Being able to represent the nude was one of the hallmarks of the professional artist during the Victorian age. The argument that working from the nude was unsuitable for women prevented them from participating fully across a diverse range of art practices, from academic neoclassicism to the avant-garde. Those who did manage to work from the model sometimes encountered adverse criticism of their work. With the opening of the Slade School of Fine Art at University College London in 1871, women in Britain were finally allowed to follow the same course of fine art training as men, including life drawing (albeit in separate rooms). But it was not until 1893 that the Royal Academy allowed women into its life rooms, and even then the model had to be draped.

In North America, training schools for women in decorative and industrial arts were followed by fine art schools where women studied with men, including The Yale School of the Fine Arts, New Haven (1867), and the College of Fine Arts, Syracuse University (1873), and where they soon made up the majority of the student group. The two Academies founded to train artists at the highest level, the Pennsylvania Academy of the Fine Arts, Philadelphia, and the National Academy of Design, New York, restricted their numbers of female students (and kept them out of life classes until, respectively, 1868 and 1871). However the Art Students League, formed in New York in 1875, promoted equal access to training and the life room for men and women, and gave women positions on its governing boards. In France, the foundation of the Académie Julian in 1868 opened the doors to art training for women painters alongside men (although female students paid higher fees). By 1896, the Union des Femmes Peintres et Sculpteurs, founded by the artist Madame Léon Bertaux, had succeeded in integrating the life classes at the Académie Colarossi in Paris, and gaining women's admittance to the Ecole des Beaux-Arts.

Photograph of
Elizabeth Southerden
Thompson, Lady Butler,
painting at Dover Castle 1898
Art Annual, 1898

The Parisian system of *atelier* or *académie* classes, at which students could pay and enrol (rather than funding expensive private tuition from an artist), and the thriving salons, exhibiting societies and private dealers, made the city attractive to artists from all over Europe and North America, and many Tate women artists travelled to train there. Marianne Preindlsberger Stokes travelled from her home in Austria (where the art academies were exclusively male) to Munich, where there were training and exhibiting opportunities for women, and then on to Paris. Anna Lea Merritt, from Philadelphia, had private tuition from artists in four different European cities, including the French capital. But she continued also to exhibit in her home country and in Philadelphia itself. Philadelphia housed America's most important early exhibition of art by women (organised and funded by women) in the Women's Pavilion at the Centennial Exhibition of 1876.

Some women artists also worked as teachers, either privately or within training organisations, and were important role models for female students. Artists who studied during the Victorian age and who then went on to train the next generation include Lucy Kemp-Welch and Mary Sargant Florence. But surveying the history of gradual progress during the nineteenth century is not intended to downplay the severity of the discrimination women faced. Louisa Anne Stuart, Marchioness of Waterford commented bitterly on its effects in 1880: 'I get rather dispirited at my failures, and the want of that knowledge and *finish* I see in all women's work at exhibitions when they have had good training: there was none in my day.' [2]

Women artists worked across the rich field of styles, subject matter and media that made up Victorian visual culture. They painted portraits, romantic or patriotic scenes, sometimes from history, and celebrated the empire and military strength in their work. Modern life in the form of domestic scenes became a subject for many of them. They were also involved in the movements that are now thought of as the most important of the nineteenth century. The Pre-Raphaelites were a Brotherhood, but two women of their circle have work in the Tate Collection, Georgiana Macdonald, Lady Burne-Jones and Elizabeth Siddall. In France, Berthe Morisot was among the women Impressionists. Towards the end of the century women artists were involved in Aesthetic circles and the Arts and Crafts movement. For the large numbers who enjoyed art as an amateur accomplishment, the idea that the home was a female domain gave creativity an outlet through making and choosing decor.

The wealth brought by Victorian capitalism was reflected in the commodification of art in Britain. Dealers and commercial galleries sprang up, and the promotion of national interests through cultural forms meant that many museums were founded. But women artists were usually categorised as less important within these bodies. They were discriminated against in the formation of civic collections, in exhibitions and in the art market. In response, some created their own organisations such as The Society of Female Artists, founded to show and sell women's work, which held its first exhibition in 1857 (later known as the Society of Lady Artists and then the Society of Women Artists). Some women artists adopted the alternative strategy of refusing any idea of a sexual division in art. They made inroads into private galleries, particularly the Grosvenor Gallery (founded 1877) and the New Gallery (founded 1888). But at the most prestigious venues, the Paris Salon and London's Royal Academy, women remained a negligible presence.

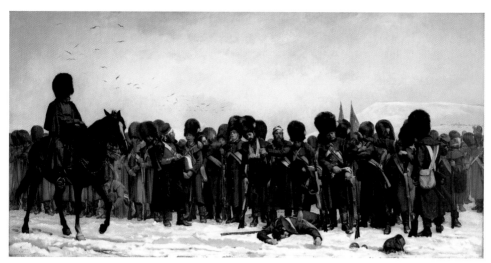

Elizabeth Southerden Thompson,
Lady Butler
Calling the roll after an engagement,
Crimea, 1874
Collection of HM the Queen

One of the few women to make her name in the Royal Academy was Elizabeth Southerden Thompson (later Lady Butler), whose painting *Calling the Roll After An Engagement, Crimea* (1874, Collection of Her Majesty the Queen) was a huge success in 1874. Queen Victoria bought the painting, an example of 'matronage', the culture of women commissioning and purchasing art during the nineteenth century uncovered by Deborah Cherry in her *Painting Women: Victorian Women Artists* (London and New York 1993). A dedication to Elizabeth Thompson, 'In Testimony of admiration for her Genius', prefaces Ellen Creathorne Clayton's two-volume *English Female Artists* (London 1876). A number of women established themselves as art critics and historians during the Victorian period, including Anna Jameson, Elizabeth Rigby, Lady Eastlake, and Elizabeth Fries Ellett, who, in her *Women Artists in all Ages and Countries* (New York 1859, London 1860) mentioned over 550 artists, and even then bemoaned the lack of space to cover all of the women she deemed 'worthy of remembrance'. Ellett made her aims quite clear: 'Should the perusal of my book inspire with courage and resolution any woman who aspires to overcome difficulties in the achievement of honourable independence, or should it lead to a higher general respect for the powers of women and their destined position in the realm of Art, my object will be accomplished.'

By the end of the nineteenth century, types of feminine identity included the 'New Woman', a stereotype drawing upon those women who were now living independently and establishing careers. The term 'feminist' appeared for the first time in the press in 1895. Two years later local women's groups in Britain joined together to form the National Union of Women's Suffrage Societies, and in 1899 London hosted the first International Congress of Women. In North America, the first national conference of black women was held in 1895. Anxiety over the stability of the division of power between the sexes (and classes and races) meant that cultural images of women were used as a political tool. The late-Victorian fashion for high society portraits of 'fair women' wearing sumptuous clothes and jewels can be understood as an attempt to put class and sexual difference firmly back into place, countering the unsettling debates over women's position which would continue into the twentieth century.

JOANNA MARY BOYCE WELLS
1831–1861

Joanna Boyce trained at Cary's and Leigh's art academies. In the London art world she met other young women artists, including Anna Mary Howitt, established figures such as William Powell Frith and Augustus Egg, and also the Pre-Raphaelites, through her brother George, who was also an artist.

The year 1855 marked a breakthrough for Boyce. She travelled to Paris where she trained in the atelier of Thomas Couture and reviewed the Salon of the Exposition Universelle for the *Saturday Review*. She also exhibited for the first time at the Royal Academy, showing an oil painting of the Anglo-Saxon noble-woman *Elgiva*, who, according to history, was branded and exiled when she fell foul of a powerful Archbishop. *Elgiva* was admired by Ford Madox Brown, and by John Ruskin, who declared in his *Academy Notes* that Boyce could hope to attain a position 'in the very first rank of painters'. Boyce's best-known work is her *Head of Mrs Eaton* (1861, Yale Center for British Art, New Haven). The sitter is thought to be a black woman who also posed for the Pre-Raphaelites. But, as Jan Marsh and Pamela Gerrish Nunn argued in their catalogue for the exhibition *Pre-Raphaelite Women Artists* (Manchester City Art Gallery 1998), rather than following their lead and representing the model as a nameless part of a narrative, Boyce painted an elegant, self-contained individual.

In 1857 Boyce travelled through France and Italy. She met and married the artist Henry Wells, although she had expressed doubts about the 'slavery' of marriage in correspondence with him. She painted her growing family in portraits and domestic genre scenes. But following the birth of her third child she died, leaving *Gretchen* unfinished. The painting represents a

Joanna Mary Boyce Wells
Gretchen, 1861
Oil on canvas
73 × 43.7 (28¾ × 17¼)
Presented by the artist's daughters 1923

character from Goethe's *Faust*, a young woman who is seduced and destroyed. For Victorians, the subject matter is likely to have brought to mind contemporary debates over 'fallen' women. Anna Mary Howitt also painted a scene from *Faust*, and in

William Holman Hunt's *The Awakening Conscience* (1853–4, Tate) a woman is shown realising the horror of her loss of innocence. But Boyce's *Gretchen* is a mysteriously serene figure. In 1935 a solo exhibition of her work was held at the Tate Gallery.

HENRIETTE BROWNE
1829–1901

Henriette Browne was born Sophie
Bouteiller and married Comte Jules de
Saux. She adopted her pseudonym from
her debut at the Paris Salon of 1853
onwards. This may have been intended
to distance her work as a painter from
her role as a diplomat's wife, although
the two came together when she used
her travels with her husband (including
to Constantinople, Egypt, Syria and
Morocco) as subject matter for her art.

Browne exhibited mainly in France
and England, and was one of three
women among the founders of the
Société Nationale des Beaux-Arts,
Paris in 1862. In London her work was
exhibited at the Royal Academy, the
French Gallery, Pall Mall, and the Society
of Female Artists. Her reputation in
Britain was such that she was among
the small group of French artists that
the young painter Elizabeth Southerden
Thompson (later Lady Butler) chose to
visit in Paris in 1874. Browne also
showed her work at the Exposition
Universelle in Paris in 1855, and the
International Colonial Exhibition in
Amsterdam in 1883.

Browne's academic paintings of
religious and oriental subjects appealed
to British and French audiences during
the age of empire. A key part of the
mission to conquer and 'civilise' was
the conversion of colonial subjects to
Christianity. Browne painted white
European women as religious figures,
sometimes tending the sick or at their
devotions, as in *The Puritans (La Lecture
de la Bible)* of 1857, which was bought
by Empress Eugénie of France (Robert
McDougall Art Gallery, Christchurch,
New Zealand). She also represented
woman as exotic colonial 'other'. She
painted dancing girls and harems, and
her *Moorish Girl with Parakeet* (1875) is

Henriette Browne
A Greek Captive, 1863
Oil on canvas
92.1 × 73 (36¼ × 28¾)
Bequeathed by C. Fraser 1868

in the Cotes Art Gallery and Museum,
Bournemouth. But Browne only won
second-class and third-class medals at
the Paris Salon. The reason for this
becomes clear looking at contemporary
criticism of her work. In *L'Art Revue
Hebdomadaire Illustrée* in 1877,
T. Chasrel wrote: 'Her touch without
over-minuteness has the delicacy and

security of a fine work of the needle.
The accent is just without that seeking
for virile energy which too often spoils
the most charming qualities.' By
praising the femininity of Browne's
work, he relegated her to the lower
ranks of artists.

ELIZABETH SOUTHERDEN THOMPSON, LADY BUTLER
1846–1933

Elizabeth Southerden Thompson, Lady Butler
The Remnants of an Army, 1879
Oil on canvas
132.1 × 233.7 (52 × 92)
Presented by Sir Henry Tate 1897

Writing in the *Daily Telegraph* in May 1874, the critic George Sala described the stir caused by Elizabeth Thompson's painting *Calling the Roll after an Engagement, Crimea* at that year's Royal Academy exhibition: 'to the general public, Miss Thompson is as new as the Albert Memorial at Kensington; and it is for that reason that we hail her appearance with this honest, manly Crimean picture, as full of genius as it is of industry. We say that this sign is a wholesome one; because in every work of art executed by a woman, and commanding public acceptance and applause, we see a manacle knocked off a woman's wrist, and a shackle hacked off her ankle.'

Brought up in a wealthy and cultured family, Elizabeth Thompson and her sister Alice (who became a poet and essayist) were given early encouragement in their choice of work.

Nevertheless, outside their supportive circle Thompson faced the restrictions hindering women embarking on careers as artists during this period. Frustrated with the South Kensington Schools, she also left the Female School of Art, as working from the nude was forbidden, and enrolled in a private art school in order to draw from the model. She described her decision to become a military painter as owing to an early awareness that it was an area overlooked by English artists and she particularly admired contemporary French painters of military action such as Edouard Detaille.

In 1867 Thompson made her exhibiting debut at an exhibition of the Society of Female Artists with *Study of Horses in Sunshine* and *Fighting Bits*. She showed her work there regularly until she was in her seventies, and became an Honorary Member. In 1873

she showed at the Royal Academy for the first time (she was to exhibit there for the next fifty years), but it was the following year's exhibition that made her name. Her 1874 submission became one of the most talked about Academy pictures of the nineteenth century and proved extremely popular in reproduction. According to the *Art Journal* critic, the painting's power came from its refusal to shy away from 'the terrible havoc of war'. Thompson's refusal to glorify military action is likely to have resonated with the burgeoning social conscience of the 1870s, and with contemporary moves to reform the army. *The Remnants of an Army: Jellalabad, January 13th, 1842* represents one of the greatest disasters to have

befallen the military at that time, and can be interpreted as strongly critical of British strategy.

Thompson was also admired for her representation of landscape and light. In his *Academy Notes* of 1875 Ruskin remarked on the sky in her painting: 'I have not seen the like since Turner's death.' In her autobiography (London 1922), Thompson described working *en plein air* with her mother, preparing for her painting *The 28th Regiment at Quatre Bras* (1875, National Gallery of Victoria, Melbourne): 'We had a great difficulty in finding any rye at Henley, it having all been cut, except a little patch which we at length discovered . . . Mamma and I then went to work, but oh! horror, my oil brushes were missing. I had left them in the chaise . . . So mamma went frantically to work with two shiny water-colour brushes to get down tints whilst I drew down forms in pencil.'

Following her marriage to Major (afterwards Sir) William Butler in 1877, she combined her thriving career with roles as army wife and mother (of six children), moving between residences in England, including Dover Castle, and military business abroad in Egypt and South Africa. Despite her success Lady Butler was barred from election to the Royal Academy (she was nominated three times between 1879 and 1881). The members decreed that the Academy's constitution, defining suitable candidates as 'men of fair moral character', did not allow for the admittance of women.

Lady Butler continued to exhibit, and to write. In addition to her autobiography, she published *Letters from the Holy Land* (London 1903) and *From Sketchbook and Diary* (London 1909). But her art declined in popularity during the late nineteenth and early twentieth centuries, and the painting she submitted to the 1924 Royal Academy was rejected. There has been a critical re-evaluation of Lady Butler's art in recent years. An article by Krzysztof Cieszkowski on her life and work appeared in *History Today* in February 1982, and a major exhibition, *Lady Butler: Battle Artist*, toured from the National Army Museum in 1987–8. It has been argued that her work, although often patriotic, is not blindly so. She did not choose to celebrate the higher ranks of military life, but focused instead on the experiences of ordinary soldiers, and her politics were sometimes surprising. In common with her husband, who was an Irish Catholic and nicknamed 'the Radical General', she shared an ardent belief in home rule for Ireland. Butler's painting *Eviction* (1890, Department of Irish Folklore, University of Dublin) represents a scene she reportedly witnessed in County Wicklow: a woman standing among the ruins of her cottage as troops march away.

MILDRED ANNE BUTLER
1858–1941

In her book on Mildred Anne Butler (Dublin 1992), Anne Crookshank gives an account of a life spent, for the most part, at Kilmurry, County Kilkenny, Ireland. Butler painted her surroundings in the countryside, but her work was influenced by the art and artists she encountered on her travels.

Butler trained under Paul Naftel and Frank Calderon. She travelled on the continent, and also worked in Newlyn in Cornwall in the early 1890s. During this period Newlyn housed an artist's colony headed by Elizabeth Forbes and her husband Stanhope. Butler studied under Norman Garstin, who introduced her to modern French art. She began to paint natural light effects, sunlight and shadows, and to use unusual perspectives in her work. Her art can be understood in the

Mildred Anne Butler
Morning Bath, exh.1896
Watercolour on paper
71.1 × 52.1 (28 × 20½)
Presented by the Trustees of
the Chantrey Bequest 1896

context of the Newlyn group, which tapped into the taste for picturesque rural scenes in the increasingly urban and industrial society of the late nineteenth century.

However, like her contemporary Elizabeth Forbes, Butler did not paint the local fishing community, the subject for which their male colleagues at Newlyn became known. This may have been because, as middle-class women, they were not free to paint where and whom they chose. Instead, Butler's work increasingly focused on the natural world, birds and animals. Her *Morning Bath* was bought by the Chantrey Bequest for the large sum of fifty pounds, and discussion of Butler's art reached America, where the magazine *Hearth and Home* in 1897 described how the artist worked outside, as this gave her work 'an actuality and a freshness that can be acquired in no other way'. Butler exhibited at the Irish Fine Arts Society (later the Watercolour Society of Ireland), and the Dudley Gallery, London. She also exhibited at the Society of Lady Artists for nearly forty years, and was made an Associate Member.

MARIE CAZIN
1844–1924

Training first under Juliette Peyrol, sister of the animal painter Rosa Bonheur, Marie Guillet then studied with the painter Jean-Charles Cazin, whom she married. She spent most of her career working in her studio in the Latin Quarter of Paris. Exhibiting at the Paris Salons for the first time in the 1870s, she was elected onto the jury of the Société Nationale des Beaux-Arts, alongside Rodin. Cazin also won medals at the Expositions Universelles in 1889 and 1900, and showed her work at the Royal Academy, London.

Cazin had begun to work as a painter, but then moved to sculpture, making large-scale public monuments often featuring women. *The School* (1893, bronze relief, Musée de Tours) shows a woman teaching a child how to read, while *Helping the Sick* (1893, Musée de Tours) depicts a midwife with a newborn baby. These pieces are thrown into relief against the background of the French Republic and its creation of a free school system, and the work of French feminists of the time, who were arguing for acknowledgement of women's roles. But Cazin also sculpted male figures.

Marie Cazin
Evening, ?c.1884–8
Oil on canvas
32.7 × 46 (12⅞ × 18⅛)
Bequeathed by Mrs Mary James Mathews in memory of her husband Frank Claughton Mathews 1944

Her 1883 bronze bust of the biblical figure *David* is now in the Louvre, and her last major work, a memorial to her husband, was erected in Bormes, France in 1924.

In addition to tackling contemporary social issues, Cazin's work can be understood in the context of French Symbolist art. She painted atmospheric, melancholy sunsets, and sculpted works representing states of mind and emotions. Her bronze *Regret*, a female figure, her head in her hands, was admired by Odilon Redon in 1885. In his journal, published as *A Soi-Même* (Paris 1975), Redon wrote that Cazin's sculpture seemed to him to be 'the resurrection through bronze of the *interior dream*'.

ELIZABETH ADELA ARMSTRONG FORBES

1859–1912

Elizabeth Armstrong was born in Ottawa, Canada. She trained in London, New York and Munich, and visited Pont Aven in Brittany, and Holland. Early in her career she focused on etching, and through her use of this medium came to know Whistler and Sickert. She painted in London and in St Ives, where Marianne Stokes also worked. In 1885 she moved to Newlyn with her mother. Four years later she married the artist Stanhope Forbes, and the couple founded a painting school there in 1899.

Forbes's handling of paint is similar to that of the male artists at Newlyn, a subtle tonal technique developed from the work of French artists like Jules Bastien-Lepage. But rather than painting *en plein air*, as she had abroad, Forbes had a mobile studio built, and worked in her garden, so that she could paint without attracting comment. She also developed a particular interest in childhood, a subject considered suitable for women. Her painting *School is Out* (1889, Penlee House Gallery and Museum, Penzance) shows a woman teacher and her pupils. Forbes wrote and illustrated a book, *King Arthur's Wood*, for her son Alec, which was published in 1904. And in her painting *A Fairy Story*, exhibited at the Royal Academy in 1896, two girls are shown with a picture book. Forbes held two solo exhibitions on the theme of children, *Children and Child Lore* (1900, Fine Art Society), and *Model Children and Other People* (1904, Leicester Galleries). She also exhibited with, and was a member of, the New English Art Club.

After seeing Forbes's paintings in 1902, Frances Hodgkins wrote to her sister, 'Her work was magnificent – much better than her husband's – they were mostly Shakespearian, medieval things – but they simply sang with colour & light & brilliancy – no one could touch her.' The letter was published in *Singing from the Walls: The Life and Art of Elizabeth Forbes* (Bristol 2000) that accompanied an exhibition of her work at the Penlee House Gallery and Museum, Penzance, in 2000.

Elizabeth Adela Armstrong Forbes
Volendam, Holland, from the Zuidende, ?1895
Oil on wood
26.8 × 17.4 (10½ × 6⅞)
Presented by the Friends of the Tate Gallery 1986

JULIA EMILY GORDON
1810–1896

Julia Emily Gordon was probably taught
by her mother, Julia Bennet, Lady
Willoughby Gordon, and may also have
been influenced by other members of
her family with artistic interests, such
as Lady Elizabeth Susan Percy. Julia
Gordon sometimes made prints in
collaboration with her brother Henry,
including the etching *Calais* (1836, Tate).

A volume of Gordon's etchings was
published in London in 1848 containing
small, delicately drawn scenes in
Britain, France, Germany and Italy.
The first twenty-four prints are all
views of the Rhine, which she visited
a number of times. There are also
imaginary compositions of figures
in landscapes, as well as views of one
of the Gordon family's homes, The
Orchard, on the Isle of Wight. Gordon
also drew and painted in watercolour.
Her work was often romantic, with
castles and effects of moonlight, and

Julia Emily Gordon
Pere Lachaise
Watercolour, pencil and gum arabic on paper
9.9 × 17.5 (3⅞ × 6⅞)
Purchased as part of the Oppé Collection with assistance from
the National Lottery through the Heritage Lottery Fund 1996

had titles such as *Lord Byron's Dream*
and *Undine*.

An exhibition of Gordon's work was
held at the Brook Street Gallery, London
in 1939, and her art was also shown
with that of her mother and brother

at Southampton University in 1974.
The Tate Collection also houses a
number of portraits of Julia Emily
Gordon by Sir David Wilkie, in which
she is seen wearing a fez, and holding
what appears to be a sketchbook.

MARY GOW HALL
1851–1929

When she was only in her early twenties,
Mary Gow was included in Ellen
Clayton's survey *English Female Artists*.
She had trained at Heatherley's art
school. Study there included working
from the model, but the main thrust
was towards history painting and
illustration, and there was a large
collection of costumes and props. Gow's
training is likely to have been encouraged
by her family. Her father and brother
were genre and history painters.

In 1869 Gow made her exhibiting
debut at the Royal Society of British
Artists, becoming a member in 1875.
She also showed at the Royal Academy,
the Walker Art Gallery, Liverpool, the
Grosvenor Gallery and two watercolour
societies. Her oil paintings were in tune
with aesthetic tastes of the 1880s.

In *Fairy Tales* (1880), a girl sits with a
Walter Crane picture book open at the
story of *The Frog Prince*, while in *The
Story of the Willow Pattern* (1886) a
mother shows blue and white china
to her child. Gow also worked as an
illustrator. Developments in printing
technology and a parallel growth in
literacy meant that there were an
unprecedented number of illustrated
publications. Gow's work appeared in
the *Quiver, Cassell's Family Magazine*
and the *Graphic*. A commission from
the latter in 1895 resulted in *Your
Majesty*, a painting of the young
Queen Victoria being informed of
her accession. Sydney Prior Hall, a
fellow contributor to the *Graphic*,
and favourite artist of the Royal family,
became Gow's husband.

The models Gow used for *Marie
Antoinette* (1908), her watercolour in
the Tate Collection, appear in her work
over several years. *The Studio* carried
a reproduction of the watercolour
The Balloon of 1910, which had been
purchased by the Walker Art Gallery,
Liverpool. It shows the same woman
and children in late eighteenth-century
costume as the Tate work. Romantic
Victorian and Edwardian versions of
history focused on tales of tragic
queens (Mary Queen of Scots and
Lady Jane Grey were popular subjects).
Pictures of beautiful aristocratic women
and children contrasted sharply with
press images of the disruptive
campaigners for women's suffrage.

LUCY KEMP-WELCH
1869–1958

Lucy Kemp-Welch
Colt Hunting in the New Forest, 1897
Oil on canvas
153.7 × 306 (60½ × 120½)
Presented by the Trustees of the Chantrey Bequest 1897

Colt Hunting in the New Forest, shown at the Royal Academy in 1897, was a critical breakthrough for Lucy Kemp-Welch, and was purchased by the Chantrey Bequest. The critic for the *Daily News* wrote of it: 'It is so vigorous, and shows such a knowledge of the character and anatomy of these half-wild animals … the difficulties of foreshortening met and mastered, the landscape too, so broadly treated. We must go to Rosa Bonheur to find a parallel.'

Kemp-Welch trained at Professor Hubert von Herkomer's art school in the early 1890s. By 1907 she had taken over, becoming the first female principal of a co-educational art school in Britain, and she erected glass studios for studying animals in bad weather. In 1902 Kemp-Welch was elected to the Royal Society of British Artists. She also became the first president of The Society of Animal Painters, whose inaugural exhibition was held in 1914 (other members included Alfred Munnings and Herbert Dicksee). Solo exhibitions of her work were held at the Fine Art Society (1905), Dudley Galleries (1912), Leicester Galleries (1914) and Arlington Gallery (1934 and 1938).

As an illustrator Kemp-Welch brought to life Anna Sewell's *Black Beauty – the Autobiography of a Horse*. The version carrying her illustrations was published by J.M. Dent in 1915. In the same year she designed a Cavalry recruitment poster. Having been refused permission to work at the front, she made her painting *Forward the Guns* (1917, Tate) at a local army camp. Commissioned by the Women's Work Sub-Committee at the Imperial War Museum in 1919, she painted the women and horses at the Ladies Army Remount Depot in Wiltshire. She was also asked to paint a panel, eighteen feet high, on *Women's Work in the Great War* for the Royal Exchange, London, and depicted women picking up tools abandoned by men marching off to war. In her mid-fifties Kemp-Welch began to paint the circus, travelling with a caravan hitched to her Ford van, her attention drawn, as usual, to the animals.

EDITH MAUD RAWDON-HASTINGS, COUNTESS OF LOUDOUN
1833–1874

Edith Maud Rawdon-Hastings, Countess of Loudoun
Skeleton Ball, 1866
Pencil and pen and ink on paper
15.4 × 40 (6⅛ × 15¾)
Purchased as part of the Oppé Collection with assistance from
the National Lottery through the Heritage Lottery Fund 1996

An inscription on the mount of the Countess of Loudoun's drawing describes it as an 'impression of the ball (and the people at it) given when her brother the Marquis of Hastings came of age'. It seems likely that this was part of the celebration reported in the *London Illustrated News* on 5 July 1863: 'The Marquis of Hastings' "majority" has been celebrated with great festivities at Donington Park, Leicestershire, during the past week.' Unfortunately

the young Marquis lived for only five more years and died childless, leaving his sister to succeed him.

Looking at the drawing with hindsight, the skeletons seem to us a chilling presentiment of the fate of the young man in whose honour the ball was held. But there are two further possible layers of meaning. If the dancing skeletons were purely the product of the Countess's imagination, she could have been influenced by the Victorian taste for gothic literature, with its macabre and creepy effects. There is also the possibility that she was recording the type of fancy dress party that Victorian society loved. The Queen had held her first such ball in 1842. A painting by Landseer of Victoria and Albert in their costumes shows her wearing a fashionable crinoline, overlaid with supposedly fourteenth-century decorative touches. And the female skeletons are surrounded by the swirl of their mid-nineteenth-century skirts. In the year the drawing was made, the *London Illustrated News* reported that 'The modistes of the world of fashion have been so engaged of late in inventing new costumes for the numerous fancy dress balls that have been following one another over here in such rapid succession that they have hardly had time to bestow even a passing thought on toilets for ordinary occasions.'

GEORGIANA MACDONALD, LADY BURNE-JONES
1840–1920

Georgiana Macdonald's watercolour *Dead Bird* dates from her teens, when she trained at the South Kensington School of Design and had private art lessons with Ford Madox Brown. Her studies were curtailed first by family responsibilities, and then by her marriage in 1860 to Edward Burne-Jones.

Her biography *Memorials of Edward Burne-Jones* (London 1904) is a eulogy to her husband, but there is evidence of an incisive visual awareness in the descriptions of her friends Elizabeth Siddall and George Eliot: '[Eliot] was very like Burton's portrait-drawing of her, but with more keenness of expression; the eyes especially, clear and grey, were piercing: I used to think they looked as if they had been washed by many waters.' Her art was secondary to her husband's career, although, as Jan Marsh discussed in *Pre-Raphaelite Sisterhood* (London 1985), there were projects planned with other women of the circle. A pen-and-ink drawing of figures in medieval costume is all that has survived from a collaboration with Siddall to illustrate a book of fairy tales. And the *Memorials* mention working alongside Jane Morris, wife of William,

Georgiana Macdonald, Lady Burne-Jones
Dead Bird, 1857
Watercolour on paper
9.9 × 17.8 (3⅞ × 7)
Presented by Mrs J.W. Mackail 1938

at their home, Red House: 'how happy we were, Janey and I, busy in the morning with needlework or wood-engraving, and in the afternoon driving to explore the country round by the help of a map of Kent.'

Lady Burne-Jones became involved in politics. She was a Socialist and Anti-Imperialist, and took the side of the Boers during Britain's war in South Africa. She helped to found the South London Art Gallery, which opened in 1891, giving free exhibitions to the workers of the area. Her activities in local politics led to her election as a Parish councillor, a public office women could, by then, both vote for and hold. In *A Circle of Sisters* (London 2001), Judith Flanders describes the lives of Lady Burne-Jones and her siblings, including Agnes, who married Edward Poynter, later president of the Royal Academy.

ANNA LEA MERRITT
1844–1930

In her memoir, a version of which was finally published over fifty years after her death (Boston 1982), the American artist Anna Lea Merritt gave an account of her early training in Philadelphia: 'I received a modest allowance for dress and pocket money. Of this allowance I immediately appropriated enough to pay the fees for a course of dissection of the muscular system at the newly founded Women's Medical College. This use of my funds obliged me to make nearly all my dresses – but I determined to learn anatomy because Michelangelo had so done.'

The wealth of the aspiring artist's family also paid for private art tuition on her European travels in the late 1860s. Anna Lea was tutored in Dresden, Florence and Paris, and then in London by Alphonse Legros and the artist and critic Henry Merritt, whom she married in 1877. He died three months after their wedding, and two years later she published a biography, *Henry Merritt: Art Criticism and Romance* (London 1879), illustrated with her own etchings. She presented her husband as a paragon, but Merritt later drew attention to the problem of sexual inequality in marriage. In 'A letter to artists, especially women artists', published in *Lippincott's Monthly Magazine* in 1900, she argued that 'The chief obstacle to a woman's success is that she can never have a wife', and listed the tasks undertaken by women which men would be unable or unwilling to perform, including being 'personally suggestive of beautiful pictures'.

According to Merritt's autobiography, her husband's death also inspired *Love Locked Out*. Shown at the Royal Academy in 1890, it was the first painting by a woman to be acquired by the Chantrey Bequest. Merritt explained that she had originally intended the piece to be a

Anna Lea Merritt
Love Locked Out, 1889
Oil on canvas
115.6 × 64.1 (45½ × 25¼)
Presented by the Trustees of the Chantrey Bequest 1890

bronze sculpture, depicting death as a door dividing two lovers, the child, symbolising love, only able to enter when the door finally opened. Unable to afford to cast the work, Merritt eventually realised her conception in a painting, which drew upon her knowledge of contemporary British art, such as that of her friend the painter G.F. Watts.

Merritt never remarried, and built a successful career painting historical, classical and literary subjects and portraits. She continued to show her work in America, at the Pennsylvania Academy of the Fine Arts and the Avery Galleries, New York. The exhibition *Women Etchers of America* held at the Union League Club, New York, in 1888 included thirty-three of her prints. Her submission to the Exposition Universelle in Paris in 1889 received an honourable mention. In London she was elected a member of the Royal Society of Painters and Etchers, and exhibited at the Royal Academy, the New Gallery and the Grosvenor Gallery. Her painting *War* (Bury City Museum and Art Gallery), exhibited at the Royal Academy in 1883, was painted at the time of the Egyptian campaigns which led to the Siege of Khartoum and the death of General Gordon. Merritt's painting mixes classical and Renaissance costume and its combination of timely subject matter and historical dress located contemporary

British Imperialism within a glorious historical tradition. The depiction of women and children on a balcony, while men march below, also vividly represents the social division of the sexes in Victorian society.

Merritt also painted murals. Along with Annie Swynnerton, she was commissioned to make paintings for the vestibule of the Woman's Building at the World's Columbian Exposition, Chicago in 1893 (she also showed paintings in the British and the American sections). The work of hundreds of women was housed in the building, from crafts to work by established artists such as Merritt's fellow-American, Mary Cassatt. Merritt contributed panels showing women graduates and women sewing at embroidery frames. She also decorated the church of St Martin's, Chilworth, near Wonersh, Surrey, and published an article on the project. 'Mural painting by the aid of soluble silicates and metallic oxides, with examples chiefly from St Martin's, Wonersh' (co-authored with Professor Robert Austin) appeared in the *Journal of the Society of Arts* in 1895.

Established in the London art world, Merritt counted among her acquaintances William Holman Hunt, John Everett Millais, James McNeill Whistler, George Cruikshank and Frederick Leighton. Her portrait commissions included important figures such as Oliver Wendell Holmes

and Ellen Terry. In her memoir Merritt described painting a fellow celebrated expatriate, Henry James, in the late 1880s (the portrait is untraced): 'He had not that facility of language we expect from a famous author. Often he hesitated for the word he needed, which must be the right word exactly. If a foolish listener indiscreetly supplied one, which seemed too obviously right, he began the sentence again. He forgave my sins in that line and even, years later, on a motor tour with Miss Edith Wharton . . . came to see me.'

Having moved to the Hampshire village of Hurstbourne Tarrant in the early 1890s, Merritt painted her surroundings, and published two illustrated books, *A Hamlet in Old Hampshire* (London 1902) and *An Artist's Garden Tended, Painted, Described* (London 1908). The latter contains paintings and plans of her garden, with lists of flowers. It also allowed Merritt to air her views about the type of art she disliked: 'I have not acquired the latest impressionist style, which so ably represents things as seen from a motor-car at full speed. I have been obliged to sit out for many hours daily in freezing wind, and later in burning sun, looking carefully at flower and leaf . . . Art was exercised in planting; painting has been toil and trouble.'

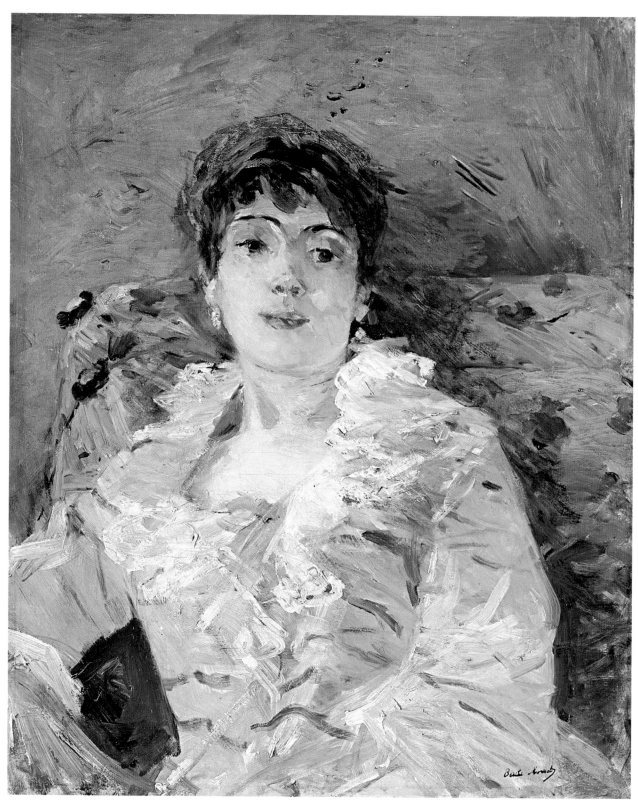

Berthe Morisot
Girl on a Divan, *c*.1885
Oil on canvas
61 × 50.2 (24 × 19¾)
Bequeathed by the Hon. Mrs A.E. Pleydell-Bouverie
through the Friends of the Tate Gallery 1968

BERTHE MORISOT
1841–1895

In 1864 Berthe Morisot made her exhibiting debut with her sister, Edma, at the Paris Salon. They showed two landscapes each. A critic for *Le Petit Journal* remarked that he was 'very surprised to learn from the catalogue entries that these paintings were by women'. The sisters were able to afford private tuition from artists such as Camille Corot and Achille-François Oudinot, and had copied works in the Louvre. For Berthe, Salon acceptance was the beginning of a career. She switched allegiance, however, from the Salon to the group who became known as the Impressionists, showing with them from their first exhibition in 1874. In the same year she married Eugène Manet, brother of her artist friend, Edouard Manet, an alliance in sympathy with her work. Edma gave up painting when she became a wife. Nevertheless, art continued to link the lives of the two women. Berthe painted Edma a number of times, reading in a field in *L'Ombrelle Verte* (1867, Cleveland Museum of Art, Cleveland, Ohio) and watching over the cradle of her baby daughter in *Le Berceau* (1872, Musée d'Orsay, Paris).

As Kathleen Adler and Tamar Garb discussed in their book on Morisot (Oxford and New York 1987) she has often been seen as a minor Impressionist. But some recent criticism has re-assessed her position. Morisot spent much of her life in the Parisian suburb of Passy, a space inhabited by women and children of their class during weekdays, while most men worked in the city. A woman of her social position did not have access to the cafe, the brothel or the backstage of the theatre, all significant subjects for her male artist contemporaries. Rather than seeing Morisot's art in terms of an absence of modern subject matter, Griselda Pollock

has argued in *Vision and Difference* (London and New York 1988) that her work invokes the particular presence of the female spectator in relation to the modern city. Morisot's paintings of women on balconies, terraces and verandas, separated from wider space but still in a relationship with it, such as the watercolour *On the balcony* (1872, The Art Institute of Chicago), represent, as Pollock puts it, the boundary 'between the spaces of masculinity and femininity'. Morisot herself saw women artists' work as innately different from men's: 'The truth is that our value lies in feeling, in intention, in our vision that is subtler than that of men, and we can accomplish a great deal providing that affectation, pedantry and sentimentalism do not come to spoil everything.'[3]

And it is important to realise that despite the restrictions, Morisot had the money, time and domestic help that enabled her to paint. Her subject matter was the lives of women of her circle, their servants, and the spaces they occupied, both domestic and *plein air*. Her only child, Julie, born in 1878, became one of her most important models. In the drypoint *Berthe Morisot Drawing with her Daughter* (1889, British Museum), the artist represented herself at work, the girl watching intently. A picture of a woman of ambition emerges from Morisot's correspondence. Writing to her sister in 1871 she complained: 'I hear that Fantin is making a fortune in London. Tissot is earning a lot of money . . . All these people are stealing my idea.'[4] Her work was exhibited in London (1883), New York (1886, 1887) and Brussels (1887, 1894), and she had a solo show at the Galerie Boussod et Valadon, Paris (1892). The year before Morisot's death was marked by the first purchase of her work by the French state, *Jeune femme*

au bal (1879, Musée d'Orsay, Paris).

A memorial retrospective of Morisot's art was held in 1896 at the Galerie Durand Ruel, Paris. The catalogue lists 363 works (more were received late), prefaced with an essay by Morisot's friend the poet Stéphane Mallarmé. Julie Manet wrote about the preparations for the exhibition in her diary: 'When I entered the Durand Ruel gallery, the paintings in rows along the floor suddenly made everything clear in my head. Monsieur Monet had already arrived and kissed me very tenderly; it was a great pleasure to see him again; it is so kind of him to drop everything and come, leaving his work. Monsieur Degas also helped with the hanging; then Monsieur Renoir arrived . . . Among his duties Monsieur Mallarmé was to see about the catalogue at the printers.'[5]

The exhibits included a portrait of Julie Manet with her greyhound, Laertes (the dog was a gift from Mallarmé). Painted in 1893, it shows the young woman in a dramatic dark dress against the background of a Japanese print; it was chosen by Monet as his bequest from Morisot, and is now in the Musée Marmottan, Paris. Mary Cassatt is named in the catalogue as the owner of the painting known as *Jeune femme de dos à sa toilette* (c.1880, Art Institute of Chicago). Painted with a technique which is at once light and fluid, and satisfyingly assured, the American artist is likely to have found in the representation of a moment in a woman's life, work in sympathy with her own. Mallarmé's catalogue essay described Morisot's art as 'an enchanted modern spectacle', and described the artist as a 'comrade in the struggle', part of a 'key moment in the history of painting this century'.

MARY SEVERN NEWTON
1832–1866

There is no biography of Mary Severn Newton, although she appears as a marginal figure in two books about her father, Joseph Severn, by Sheila Smith, Countess of Birkenhead (*Against Oblivion: The Life of Joseph Severn*, London 1943, and *Illustrious Friends: The Story of Joseph Severn and his son Arthur*, London 1965). Joseph Severn was a painter. He had been Keats's friend, and accompanied the poet on his final journey to Italy. Mary was taught by her father, and also by the portraitist George Richmond. She also read John Ruskin's works, and went to see his collection of art. In a caricature titled *Nat Gallery 15 Sep 1860*, she sketched herself copying after Titian, alongside Ruskin, who is also painting.

Mary Severn became a successful portraitist in watercolours in the 1850s, and helped to pay for the upkeep of her family, when her father's work began to lose favour, by undertaking commissions to paint wealthy clients, including the royal family. In a letter to her mother of December 1857 (published in *Illustrious Friends*), she wrote: 'I drew Monday and Tuesday in the Audience Room, a little room next to the Queen's own … This audience room is hung with heads of the Royal Family by Gainsborough, I never saw such painting, it was so luminous.' Severn also met Louisa, Marchioness of

Mary Severn Newton
View of Naples
Pencil, watercolour and gouache on paper
35 × 49.7 (13¾ × 19⅝)
Purchased as part of the Oppé Collection with assistance from the National Lottery through the Heritage Lottery Fund 1996

Waterford, and the pair went on several painting expeditions together.

In 1861 Severn married Charles Newton, a classical scholar who became Keeper of Antiquities at the British Museum. She began to work in oils, painting a self-portrait that was exhibited at the Royal Academy in 1863 (National Portrait Gallery, London) in which she portrayed herself holding her portfolio. According to the *Spectator* critic, there was 'no better lady's portrait than Mrs Newton's'. Other Academy submissions included a

painting after a Tennyson poem, and several portraits of women. After her marriage she illustrated her husband's work with drawings of antiquities. While drawing at the British Museum she was sometimes accompanied by her friend, the gardener Gertrude Jekyll, whom she sketched, and who went with the Newtons on archaeological visits to Greece and Turkey. It was while she was abroad, in Rhodes, that Mary Severn Newton died of measles.

ELIZABETH RIGBY, LADY EASTLAKE
1809–1893

Pupil of John Sell Cotman, artist, author and translator, Elizabeth Rigby, Lady Eastlake made her reputation as a critic for journals such as *Fraser's Magazine* and the *Quarterly Review*, writing on subjects including 'Lady Travellers' and the 'new and mysterious' art of

photography. In December 1848 she contributed a piece on *Jane Eyre* by 'Currer Bell' to the *Quarterly Review*. She found Brontë's novel full of 'ungodly discontent', but conceded that the author, likely to be a man, was possessed of 'great mental powers'.

Eastlake travelled widely from her youth. Having spent some time in Germany learning the language, she translated Passavant's *Tour of a German Artist in England* (London 1836). A stay in Russia led to her first major publication, *A Residence on the Shores of*

the Baltic (London 1841). This began her long association with the publisher John Murray, whom she visited in Albemarle Street, making portraits of two women of his family. While she was in Russia she made a series of watercolours, including portraits of the aristocracy and figure studies of peasants, architecture and landscapes. Eastlake described the rigours of her journey on her second visit: 'May 8 1844 – Rough water. The humours of the cabin are but few: meals your greatest incident . . . The Stewardess wanted to know where Petersburg was, and whether "Russia was a nice place". It is like Carlyle calling Luther a nice man.'[6]

A vivid painterly response to her surroundings infuses Eastlake's published journals and correspondence (London 1895), illustrated with reproductions of her drawings of places from Deal in Kent, to Turin. On a visit to Scotland in 1843 she noted: 'The Clyde is the spouse of the sky, and changes with his mood: nothing can be a greater contrast than the heavy dark hills and the dull opaque white Clyde, or the light glowing hill and the intense colour of the river. How difficult it is to draw from nature, how few the colours, how endless the modifications! It is hardly possible to give not only the right form and right colour, but the miles of ether that lie in between . . . My style of drawing gives a certain ideality, but no strength of expression.'[7]

Eastlake's work in the Tate Collection divides into two strands: there are imaginative, romantic, detailed drawings of castles, knights and ladies, in pencil and white chalk on coloured paper, and a number of sensitively drawn portraits from life of acquaintances, again in pencil, sometimes with watercolour. A drawing of Florence Nightingale, dated 1846, is in the collection of the National Portrait Gallery, London. Eastlake also etched, exhibiting with the Royal Society of Painters, Etchers and Engravers in 1881.

Moving in artistic circles in London in the 1840s, Eastlake knew J.M.W.

Elizabeth Rigby, Lady Eastlake
[title not known] 1839
Pencil and gouache on paper
26.6 × 19 (10½ × 7½)
Purchased as part of the Oppé Collection with assistance from the National Lottery through the Heritage Lottery Fund 1996

Turner, whose work she greatly admired, observing in her journal 'he does what he will – the others do what they can'. Among her acquaintances were Charles Landseer, the art critic Anna Jameson, and Charles Eastlake, later Director of the National Gallery and President of the Royal Academy, whom she married in 1849. Their home in Fitzroy Square became a centre for the Victorian art world. Lady Eastlake accompanied her husband on his annual European travels to buy works for the Gallery. The Eastlakes also built a private collection of art that included works by Holbein and Bellini. (In 1886 the young Beatrix Potter visited the elderly Lady Eastlake to view the collection.) Twenty-six works from their collection are now in the National Gallery. Lady Eastlake also continued to write, publishing numerous articles, a translation of Waagen's three-volume *Treasures of Art in Great Britain* (London 1854), biographies of her husband and of the sculptor John Gibson (both 1870), and *Five Great Painters*, on Leonardo da Vinci, Michelangelo, Titian, Dürer and Raphael (London 1883).

Lady Eastlake knew at first hand of the struggles of women to gain professional training and recognition as artists. Her close friend, Anna Jameson, was a trenchant advocate of women's access to the Royal Academy Schools, being one of the signatories of a petition sent to Academicians in 1859. The battle for the admission of women took place under Sir Charles Eastlake's presidency of the Royal Academy. According to Ellen C. Clayton's *English Female Artists* (London 1876), it was partly with Sir Charles Eastlake's support that the first woman student, Laura Herford, gained entrance to the Royal Academy Schools. She signed only her initials on her drawings for the entrance examination, thus giving no indication of her sex, and was accepted. Lady Eastlake wrote a biography of a friend who was a campaigner for women's suffrage, Harriet Grote (London 1880). Grote had been a founder of the Society of Female Artists in 1856, and Eastlake acted as a patron of the society for twenty-eight years.

VIOLET LINDSAY, DUCHESS OF RUTLAND
1856–1937

Violet Lindsay was a member of the family who founded and ran the Grosvenor Gallery, and she exhibited there between 1879 and 1890. The *Art Journal* remarked on 'the honourable place allotted to female artists' at the Grosvenor. Blanche Lindsay, co-owner of the Gallery, promoted the work of women she knew, and exhibitors included Elizabeth Forbes, Louisa Waterford and Anna Lea Merritt. This encouragement, combined with Violet Lindsay's status (she married Henry Manners, who became Duke of Rutland), shaped her art, most of which consists of portraits of society figures, drawings, and also sculpture, such as Tate's *Recumbent Figure of Lord Haddon.*

In 1899 her *Portraits of Men and Women* was published with reproductions of pencil drawings of Queen Victoria, the politicians Cecil Rhodes and H.H. Asquith, the writer Rudyard Kipling, and the actor Mrs Patrick Campbell. In 1925 a solo exhibition of her work in London was reported in *The Connoisseur*: 'The Duchess of Rutland exhibited upwards of fifty delicate silver-point and pencil portrait drawings at the Brook Street Galleries ... Her style is particularly suited to the interpretation of feminine beauty and elegance, but she usually achieves considerable success in her delineation of men ... several of the persons represented are, or were

formerly, much in the public eye. The early portraits included those of the late Lord Curzon, the late Lord Salisbury, Earl Balfour, the Countess of Oxford, Mr Churchill, and Nansen, the Explorer.'

A lithograph of about 1895, after the Duchess's drawing of the gardener Norah Lindsay, is in the collection of the National Portrait Gallery, London, as is a 1906 drawing of Diana, Viscountess Norwich, in fancy dress as Joan of Arc. The Duchess herself makes an appearance in a painting by another artist in the National Portrait Gallery's collection. In Henry Brooks's *Private View of the Old Masters Exhibition, Royal Academy, 1888* she can be seen in a small group which includes the portraitist George Richmond.

ELIZABETH ELEANOR SIDDALL
1834–1862

Unusually for a woman artist of this period, Elizabeth Siddall was working-class. She was making a living as a milliner when she began to model, and then resolved to be an artist and to write poetry (her work is included in *The New Oxford Book of Victorian Verse*, Oxford and New York 1987). Siddall was taught by Dante Gabriel Rossetti, whom she married, and she also trained at Sheffield School of Art.

The legend of Rossetti's melancholy muse has tended to eclipse the story of Siddall's existence as a creative woman. But as Deborah Cherry and Griselda Pollock argued in their essay 'Woman as a Sign in Pre-Raphaelite Literature: The Representation of Elizabeth Siddall' (*Art History*, 1984, revised and reprinted in Pollock's *Vision and Difference*, London and New York

Elizabeth Eleanor Sidda[
Sir Patrick Spens, 1856
Watercolour on paper
24.1 × 22.9 (9½ × 9)
Purchased 1919

1988), the gaps in the Siddall archive, the persistent mis-spelling of her name, and the similarity between Rossetti's pictures of other women and those for which Siddall supposedly modelled, mean that we should read his work as representation, rather than as the truth about Elizabeth Eleanor Siddall.

Although she was also struck by Siddall's appearance, Georgiana Macdonald's description of her friend in *Memorials of Edward Burne-Jones* creates a picture of an active figure, engaged in her work. 'I see her in the little upstairs bedroom with its lattice window, to which she carried me when we arrived, and the mass of her beautiful deep-red hair as she took off her bonnet ... Her eyes were of a kind of golden brown – agate-colour is the only word I can think of to describe them – and wonderfully luminous ... Whilst we were in her room she shewed me a design she had just made, called 'The Woeful Victory' – then the vision passes.' Siddall's art drew upon literature, including Shakespeare, Browning, Keats, Tennyson, Walter Scott and Arthurian tales. Her work was similar to that of the Pre-Raphaelites, in that she pictured somewhat stiff and stagey figures in medieval dress. But, unlike the brotherhood, Siddall represented women actively looking, rather than simply as a source of visual pleasure. She exhibited in London and New York during her lifetime, and an individual exhibition was held at the Ruskin Gallery, Sheffield, in 1991.

DOROTHY TENNANT, LADY STANLEY
1855–1926

Among the few works by women in the collection at the Tate Gallery's inauguration was Lady Stanley's *His First Offence*. The painting had been exhibited at the New Gallery, where it was bought by Henry Tate. Her *Street Arabs at Play* was acquired by another wealthy manufacturer, W.H. Lever, in order to advertise his company's Sunlight Soap.

Dorothy Tennant studied under Edward Poynter and Alphonse Legros at the Slade, and then at Henner's atelier in Paris. She exhibited at the Royal Academy, the Grosvenor Gallery and the New Gallery in London, and at the Paris Salon. Her first husband was the explorer Sir Henry Stanley. She painted his portrait and edited his autobiography (London 1909). But it was for her drawings and paintings of London life, particularly children, that Lady Stanley became known. These were reproduced in magazines, and in her book *London Street Arabs* (London 1890).

In the preface to *London Street Arabs* Lady Stanley gave advice on working from life in the city: 'You must first walk about little back streets and alleys towards sunset; stroll about the lake in St James's Park, or along the Embankment by the steps leading down to the water ... Then look, and look without worrying your mind to remember; take it all in – the movements, the

Dorothy Tennant, Lady Stanley
His First Offence, 1896
Oil on canvas
62.9 × 34.3 (24¾ × 13 ½)
Presented by Sir Henry Tate 1897

groups, the attitudes.' By the 1890s, the numbers of middle-class and upper-class women who, like Stanley, were entering higher education, were a visible presence in the city spaces, and were caricatured as 'New Women'. Lady Stanley's art was shaped by the class difference structuring society and the art world at the time. Models were often working-class, depicted by those of higher rank. But although some of her work seems to be a sentimental take on the life of the poor for wealthy audiences, there are also some images of the harshness of poverty. Stanley drew a mother slumped in a doorway with a child sprawled on her lap; another sells flowers in the rain with children clinging to her skirt. The very last etching in the book depicts a man in despair, his head in his hands, and is titled *Out of Work*.

MARIANNE PREINDLSBERGER STOKES
1855–1927

Born in Austria, Marianne Stokes trained in Munich and Paris. In 1884 she married the painter Adrian Stokes. The couple settled in St Ives, having befriended Stanhope Forbes. Stokes's early works were oil paintings influenced by the French realists Bastien-Lepage and Dagnan-Bouveret (the latter had taught her). They include *The Passing Train* (*c.*1890, Private Collection), in which a woman labourer, working in a field, stops to watch a locomotive steaming past, a representation of the collision of the ancient rhythms of rural life with the speeding machinery of modernity. From the 1880s, Stokes exhibited in Britain at the Royal Academy, the New Gallery, the New English Art Club and the Society of Lady Artists.

During the 1890s Stokes began to paint decorative biblical and medieval subjects, often with costumed female figures, and to work in gesso and tempera, becoming a member of the Society of Painters in Tempera alongside Mary Sargant Florence. According to the painter and critic Harriet Ford, writing in the *Studio* in 1900, two aspects of Stokes's childhood affected her work: being given an illustrated copy of Grimm's fairy tales, and experiencing the mysticism of Catholic ceremonies. Ford argued that although Stokes delighted 'in all

Marianne Preindlsberger Stokes
Candlemas Day, *c.*1901
Tempera on wood
41.6 × 34 (16⅜ × 13⅜)
Presented by the Trustees of the
Chantrey Bequest 1977

delicate and dainty means of expressing the thought, she yet never descends to triviality, to mere "prettiness"', and linked her to the Symbolist writer Maeterlinck. Stokes found another admirer in the writer Alice Meynell, sister of Lady Elizabeth Butler, who wrote about her for the *Magazine of Art* in 1901. More recently, her work was seen alongside that of Elizabeth Forbes in the exhibition *Women Artists in Cornwall 1880–1940*, held at Falmouth

Art Gallery in 1996.

Stokes did not confine herself to painting. She wrote *Hungary* (London 1909) with her husband, illustrated with her paintings of figures in traditional dress. And in 1912 William Morris's company made a tapestry to her design (Whitworth Art Gallery, Manchester). A text woven into the border in German reads (in translation), 'Honour to the women who braid and weave heavenly roses into earthly life'.

ANNIE SWYNNERTON
1844–1933

Although she had trained at the Académie Julian, Paris, Annie Swynnerton reportedly credited an acquaintance from her birthplace, Manchester, the writer Elizabeth Gaskell, with having had the greatest

influence upon her by introducing her to Edward Burne-Jones. And it was in Manchester that Swynnerton combined her art with her political convictions to powerful effect as a campaigner for women's suffrage.

Swynnerton painted from an early age. One of seven daughters, her watercolours augmented the family finances. She painted portraits (becoming a member of the Royal Society of Portrait Painters in 1891),

figure studies, often of women or children with some symbolical or allegorical meaning, and landscapes. Discrimination against women artists in her home city led Swynnerton and some colleagues to found the Manchester Society of Women Painters in 1879, offering unprecedented opportunities for women artists to draw from the life model, and to exhibit.

The president of the society, Susan Isabel Dacre, was painted by Swynnerton, who gave the portrait to the sitter. Exhibited at the Royal Academy in 1880, it is now in the collection of Manchester City Art Gallery. As Deborah Cherry discussed in *Painting Women: Victorian Women Artists* (London and New York 1993), Dacre is not represented as fashionable or conventionally beautiful in Swynnerton's painting. The artist rejected the function of many late nineteenth-century portraits of women. Instead the painting worked as a sign of friendship, and can be understood in the context of the groups of women forging careers as artists and forming networks during the period. The Manchester Society of Women Painters held three exhibitions in the early 1880s. Their presence in the city, and the fact that a member such as Swynnerton was showing work at London's Royal Academy, is likely to have influenced the decision of the Manchester Academy of Fine Art finally to admit women to full membership in 1884. Swynnerton was also a member of the Society of Lady Artists, and she and Dacre were among the artist signatories of the Declaration in Favour of Women's Suffrage in 1889. Four years later, Swynnerton painted Florence Nightingale at Scutari Hospital, and two other works depicting women in caring roles, as part of the decoration of the Women's Building at the World's Columbian Exposition in Chicago (a project shared with Anna Lea Merritt). Among the six Swynnertons in the Tate Collection is a portrait of Dame Millicent Fawcett in academic robes.

Annie Swynnerton
Oreads, exh.1907
Oil on canvas
177.8 × 177.8 (70 × 70)
Presented by John Singer Sargent 1922

Founder of one of the earliest university institutions for women, Newnham College, Cambridge, Fawcett became the first president of the National Union of Women's Suffrage Societies in 1897. She was a member of the Garrett family, whose female members were noted political activists, a number of whom were painted by Swynnerton and owned work by her.

Swynnerton's standing in the Manchester art world was recognised in a solo exhibition at the city's art gallery in 1923. It included *Mater Triumphalis* (1892), a female nude previously exhibited in Paris at the 1905 Salon des Beaux-Arts (now in the Musée d'Orsay). In common with Anna Lea Merritt, Swynnerton had painted Henry James. Although the location of the portrait is unknown, a photograph survives of a Swynnerton painting of the writer, which is likely to be that exhibited at Manchester in 1923, in which he is portrayed with a guarded, watchful expression. Portraits of Manchester sitters were also on show, including the Reverend William Gaskell, Unitarian Minister and husband of the novelist (1879, Manchester City Art Gallery). The first painting listed in the catalogue, *Evelyn, Daughter of Vernon Bellhouse* (1911, untraced), had been

praised by the critic of the *Observer* on its former exhibition at the Royal Academy in 1912: 'The picture is so original in conception, so firm in construction, so daring in treatment, so uncompromising in its rejection of easy expedients to obtain pretty effects, that it may be said to stand alone among the portraits in Burlington House.'

The portrait painter John Singer Sargent was among the private collectors who lent works to Swynnerton's Manchester City Art Gallery exhibition. His studio at Tite Street, Chelsea was hung with his collection of art, including paintings by Swynnerton. The painting of Capri he loaned was one of a number of landscapes shown at Manchester. Swynnerton had lived mainly in Italy for nearly three decades following her marriage to the sculptor, Joseph William Swynnerton in 1883, and she painted both her surroundings and subjects from classical mythology. Sargent presented another Swynnerton from his collection, *Oreads*, a painting of sea nymphs, to the Tate. His own double portrait of Swynnerton with their mutual patron, Mrs Charles Hunter (sister of the composer Ethel Smyth) was shown alongside Swynnerton's work in 1923.

A year earlier, Sargent supported Swynnerton's election as an Associate of the Royal Academy, the first woman to be admitted since the time of Angelica Kauffman and Mary Moser. Swynnerton exhibited there from 1879, and her work continued to be shown intermittently until 1934 (she also exhibited in London at the Grosvenor Gallery and the New Gallery). Laura Knight wrote about meeting the elderly artist on the Academy's Varnishing Day in her autobiography *Oil Paint and Grease Paint* (London 1936), and paid tribute to her: 'We women who have the good fortune to be born later than Mrs Swynnerton profit by her accomplishments. Any woman reaching the heights in the fine arts had been almost unknown until Mrs Swynnerton came and broke down the barriers of prejudice.'

LOUISA ANNE STUART, MARCHIONESS OF WATERFORD
1818–1891

Louisa Stuart lived in Ireland following her marriage to the Marquess of Waterford in 1842. On her husband's death she moved to Ford, Northumberland. Although she had little formal art training, she had seen European art while travelling with her diplomat father, made copies and studies after nature, corresponded with Ruskin and knew the Pre-Raphaelites. She exhibited at the Grosvenor and Dudley Galleries, and was a patron and then honorary member of the Society of Female Artists from 1865.

Watercolour was the Marchioness's main medium. She was influenced by Italian art, making copies after Mantegna, Tintoretto and Bellini, and literary sources, including works by Shakespeare and Elizabeth Barrett Browning. Her most ambitious project was the decoration of the village school she built at Ford with a series of 'frescoes' (in fact paintings on paper stretched over wooden frames and mounted on the wall) that are still in place today, showing biblical scenes on the theme of childhood. The Marchioness began the project in 1862, completing it twenty-one years later. She recorded the laborious process, writing in 1867: 'I have been working at my school frescoes, and, in despair at my failures in 'David', have begun a second time, and am doing the sheep from nature – a live creature having been (with difficulty) carried up into my room' (catalogue for *Lady Waterford Centenary Exhibition*, Ford,

Louisa Anne Stuart, Marchioness of Waterford
Christ Raising the Dead
Watercolour on paper
28.6 × 36.8 (11¼ × 14½)
Bequeathed by Adelaide, Lady Brownlow 1917

Northumberland 1983).

Ellen C. Clayton placed the Marchioness in the amateur section of *English Female Artists*, describing her work as 'marked by the breadth and fire of a man's genius, with a woman's graceful fancy'. According to Mrs Steuart Erskine, writing in the *Studio* in 1910, the Marchioness's lack of art education prevented her from developing her gifts. Waterford was unequivocal about her status, writing in 1879, 'I went to the Grosvenor yesterday . . . I was curious to see how my drawings looked. I can only say

these exhibitions are the best levellers I know; one has no more illusions about oneself and no flatterers are of avail. I see myself just as an amateur' (catalogue for *Lady Waterford Centenary Exhibition*, Ford, Northumberland 1983). She and her sister (also an amateur artist) were the subjects of Augustus Hare's *The Story of Two Noble Lives* (London and New York 1893). After her death three retrospectives of her work were held in London, and a solo exhibition at Ford in 1983.

THE TWENTIETH CENTURY

Photograph of Frances Hodgkins, Rosamund Marshall and Dorothy Kate Richmond in Holland, 1903 Auckland City Art Gallery, reproduced in Linda Gill (ed.), *The Letters of Frances Hodgkins*.

In her book *Women in the Fine Arts from the Seventh Century BC to the Twentieth Century AD* (Boston and New York 1904), Clara Erskine Clement acknowledged that there was still some prejudice against women, but believed that the days 'when in our country a young girl might almost as reasonably attempt to reach the moon as to become an artist' were over.

Clement was writing at a time when claiming a place in the art world was, for some women, part of a wider fight for equality. In Britain, the militant Women's Social and Political Union was formed in 1903. Three years later, the term 'suffragette' first appeared, in the pages of the *Daily Mail*. Visual culture, and particularly the representation of femininity, played a crucial role in the suffrage and anti-suffrage campaigns, as Lisa Tickner examined in *The Spectacle of Women: Imagery of the Suffrage Campaign 1907–1914* (London 1988). The Artists' Suffrage League was founded, with an atelier to produce propaganda, but activism did not only take place on the streets, a museum also became part of the battleground. Incensed by the Government's treatment of Emmeline Pankhurst, Mary Richardson visited London's National Gallery in 1914 and attacked the Velázquez painting *The Toilet of Venus*, better known as *The Rokeby Venus*.

With the advent of war, the campaigns for women's suffrage ended. Women's contributions to the war effort were in part responsible for the Act of 1918 that gave the vote to British women over the age of thirty. It was not until ten years later that suffrage was extended to women over the age of twenty-one. In the USA, the National American Woman Suffrage Association had won women the vote in various states during the late nineteenth century, but the Nineteenth Amendment to the Constitution, granting all women this right, was not passed until 1920. By the late 1920s women had been enfranchised in most of northern Europe. But although France had been the first European country to allow universal male suffrage in 1848, French women were not enfranchised until almost a century later.

The conflicts of 1914–18 and 1939–45 shaped women artists' work in particular ways. Following the first war, the Imperial War Museum was founded in London. During the early years of the museum's life it was decided that women artists' work should come under the aegis of a separate 'Women's Work Sub-Committee'. During the 1939–45 war male and female artists both came under the control of the War Artists' Advisory Committee, headed by Kenneth Clark. But inclusion did not mean an end to discrimination. Less than ten per cent of the work acquired by Clark's committee was by women. Women artists were excluded from working in proximity to the front during both wars, and no women received an Honorary Commission as a war artist with full rank in either conflict. At the first major exhibition of war works to be held by the Imperial War Museum in the winter of 1919–20 they made up only nine out of the 173 artists on show. In 1945, at the Royal Academy's exhibition *National War Pictures*, there were only fourteen women among the 151 artists. It was not merely a case of exclusion from exhibitions. The lack of official status as war artists prevented many women from working at all.

War art made by women focused on female contributions to the war effort. Clare Atwood and Anna Airy were among the small number of women employed to make art about the 1914–18 conflict. During the next war Evelyn Dunbar and Stella Schmolle were the only two women to win funded 'specially employed' status, and Laura Knight and Ethel Gabain were the only two to achieve the lower status of being commissioned to do a number of specific works (forty-one men were employed in the two categories). Mary Kessell and Evelyn Gibbs were among the slightly larger third group of women asked to submit a few pieces of their art for the committee to consider.

Helen Saunders
Abstract Composition in
Blue and Yellow, c.1915
Tate

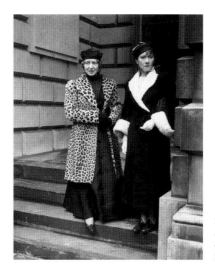

Photograph of Laura Knight
and Dod Procter on the steps
of the Royal Academy, 30 April 1937.
National Portrait Gallery Archive

Dunbar and Knight painted women's war work, but Knight, unusually, also painted a momentous historical event that was not a 'woman's subject', travelling to Nuremberg in 1946 to paint the war trials. Kessell visited Belsen and Berlin at the end of the war. Just under forty years later, Linda Kitson became the first woman artist commissioned to work near the centre of conflict, when she covered the Falklands war. The war made refugees of some Tate women artists. Jewish women who fled to Britain or America to escape the Nazi threat included Hilde Goldschmidt, Eva Hesse, Clara Klinghoffer, Else Meidner and Marie-Louise Von Motesiczky.

In Britain during the twentieth century access to art school was no longer the problem it had been (for those women who could afford it), although finding compatible work afterwards was much more difficult (for example, there were no women teachers at all at the Royal Academy until the 1960s).[1] In North America, the Arts Students League in New York remained a key centre for women's training until the 1940s, counting Lee Krasner and Georgia O'Keefe among its alumni, but the Museum of Modern Art did not hold a retrospective of a woman artist's work until O'Keefe's exhibition there in 1946. The Depression of the 1930s, and Roosevelt's institution of the Federal Art Project as part of the relief programme, which paid artists to create public works, gave both Krasner and Louise Nevelson their first major commissions. In Russia, the Academy of Arts in St Petersburg had admitted the first class of women candidates for the title of Artist (first class) in 1891, but there were no female academicians until 1916. Its rival, the Moscow School of Painting, Sculpture and Architecture, did not attract women students in large numbers, probably because the entrance exams required extensive previous training (although Natalia Goncharova won a place there). As a result, many women studied privately or travelled to Europe, as did

Sonia Delaunay. During the ferment of the first two decades of the twentieth century young Russian women artists were prominent in avant-garde groups, rejecting both artistic and social convention.

The different factions fragmenting the art world during the early twentieth century, and the proliferating exhibiting organisations and artist groups, did give women some opportunities to exhibit. In Britain, Jessica Dismorr and Helen Saunders were Vorticists, while Sylvia Gosse and Ethel Sands were among the founders of the London Group in 1913. 'Abstraction-Création' included Barbara Hepworth, Marlow Moss and Paule Vézelay among its members. Nevertheless, an overview of these groups indicates that women were still often unequally represented, both as members and exhibitors. The 7 & 5 Society, founded after the 1914–18 war, included only ten women among its fifty-six members, among them Jessica Dismorr, Evie Hone, Mary Potter and Winifred Nicholson. Women could still also be excluded altogether. At the foundation of the Camden Town Group in 1911, it was decided to forbid women membership. Modern art was defined as men's business. Separation was used tactically by some women as it had been in earlier times. The Women's International Art Club was founded in 1900. The organisation founded as the Society of Female Artists, which had entered its final incarnation as the Society of Women Artists in 1899 (it continues under this name today), exhibited the work of women whose work was to join the Tate Collection, including Sylvia Gosse, Dod Procter and Laura Knight, who became its first Honorary President.

Women were positioned differently from men in relation to themes and debates in modern art. The difficulty, for women, of coming to terms with the female body, objectified as the female nude in art, but also, for them, inhabited and

Sheila Fell
Catalogue cover of her 1969
exhibition at the Stone Gallery,
St Mary's Place, Newcastle.

experienced, had been evident in the suffrage campaigner's anger. Artists including Paula Modersohn-Becker, Suzanne Valadon and Gwen John all painted the female nude, the diversity of their work underlining the complexity of women's engagement with the subject. A number of women explored the idea of the 'decorative' in modern art, including Sonia Delaunay and Vanessa Bell. But, as 'decorative' has often been used pejoratively to signify trivial, pretty, feminine work in contrast to a modernism defined as serious, stripped-down and masculine, women artists' relationship with the decorative has been problematic. Even when male artists and critics have claimed the importance of the decorative, women working in the field have not necessarily been seen as equals. A group of eight male decorative painters, including Winifred Knights's husband, were chosen to work on a scheme of murals for the Palace of Westminster in 1925. She was not. Although the meaning of modernism has never been fixed, it has usually been configured in ways that operated against women.

The dilemma of the division between social constructions of femininity, and being a woman, was expressed by the writer Virginia Woolf, sister of Vanessa Bell. In her essay 'Professions for Women' (based on a speech given to the National Society for Women's Service in 1931), Woolf described:

> two of the adventures of my professional life. The first –
> killing the Angel in the House – I think I solved. She died.
> But the second, telling the truth about my own experiences
> as a body, I do not think I solved. I doubt that any woman
> has solved it yet. The obstacles against her are still
> immensely powerful . . . she still has many ghosts to fight,
> many prejudices to overcome. Indeed it will be a long time
> still, I think, before a woman can sit down to write a book

> without finding a phantom to be slain, a rock to be dashed
> against. And if this is so in literature, the freest of all
> professions for women, how is it in the new professions
> which you are now for the first time entering?[2]

Even a woman such as Woolf, childless with a private income, servants and a supportive husband, could experience 'immensely powerful' obstacles because of her sex. These were bolstered by the mid-century, when post-war attempts to re-stabilise led to many Western women being pushed back into the role of housewife. At the same time educational opportunities were opening up. In Britain, secondary schools now offered free and extended education to all children, even those from the working class. This new access, and the fact that women were now allowed to take degrees, meant that the daughter of a Cumbrian coal miner, Sheila Fell, was able to train as a painter in London at St Martin's School of Art.[3] But it also meant that the gap between young women's abilities and the opportunities they were offered became even more obvious; performing well alongside their male contemporaries at school and university did not guarantee them an equal chance to build a career. Women artists were rarely given large-scale retrospectives, and even large exhibitions of contemporary art discriminated against them. The Festival of Britain show *60 Paintings for 51* included only five women among its sixty artists. The inequalities women suffered were exposed in ground-breaking feminist writing. Simone de Beauvoir offered a powerful critique of femininity as learnt, rather than natural, and therefore alterable, in her landmark text of 1949 *Le Deuxième Sexe* (The Second Sex), writing, 'One is not born, but rather becomes, a woman'. Fourteen years later Betty Friedan published *The Feminine Mystique*, revealing the repressive ideology behind the image of the perfect housewife.

Helen Chadwick
Of Mutability:
The Oval Court and Carcass
Installation at the ICA,
London, 1986

The second wave of feminism was beginning to gather force.[4] Developments in contraception led to an unprecedented measure of control over reproduction for many Western women. Action towards other improvements in women's lives took place. In Britain in 1970 the first national Women's Liberation conference took place at Ruskin College, Oxford. Working-class women organised industrial action for equal pay, and in 1975 the Equal Pay Act and Sex Discrimination Act went into effect. Four years later the country had its first woman Prime Minister. The resurgence of feminism in North Amerca was inflected by the anti-war and civil rights movements, and by debates about the relationship between the aims of white feminist activists and black women who faced a double burden of discrimination. In France the Paris student revolt of 1968, and women students' disenchantment with their position in relation to their male colleagues, led to the formation of women's groups. Feminist activism in Europe and America was bolstered by radical writing. In 1970 Kate Millett published her *Sexual Politics*, and Germaine Greer *The Female Eunuch*.

The development of feminism in different places during the late twentieth century meant that it took on a variety of characteristics. It is more appropriate, perhaps, to write of feminisms, and these were played out in diverse forms of art practice and cultural criticism. In the United States there was a strong strand of celebratory work focusing on women's bodies and experiences, and attempts to construct a separate female iconography. It was within this environment that artist Judy Chicago's elaborate monument to great, often overlooked women from history *The Dinner Party* (1979) took shape, a piece whose emphasis on vaginal forms and collaborative 'craft' techniques led to some critical accusations of essentialism.[5] Reaction to the powers shaping specific societies could also

prompt women's work. Catholicism and critical response to church control over women's lives contextualise French-born Niki de Saint Phalle's creation of exuberant female fertility goddess figures in the 1970s. The same concerns characterise the work of Paula Rego, from Portugal, and Dorothy Cross, who was born in Ireland.

Feminists were not only making inroads into cultural production and its history. They were now working in many areas: sociology, economics, philosophy, law, psychoanalysis, linguistics and semiotics. And a dynamic feminist agenda bringing together different disciplines shaped some late twentieth-century art criticism and practice. Psychoanalytic theory and semiotics were being used to develop analyses of masculinity and femininity as constructed in representation, rather than essential and unchangeable, and this underpinned the work of a number of women artists. Mary Kelly explored the psychic terrain inhabited by mother and child in her *Post-Partum Document* (1973–9). For a number of women like Kelly, installation art (developed during the 1950s) proved fertile due to its potential to challenge the hierarchies and bridge the boundaries between different forms of art practice and sign-systems. Photography and mass-media techniques were brought into play. Cindy Sherman photographed herself in a variety of (dis)guises. Barbara Kruger's art mimicked and exposed the media through which we are addressed and defined.

Women also challenged the art-historical canon. Linda Nochlin's essay 'Why Have There Been No Great Women Artists?' of 1971 illuminated how 'the total situation of art making' had excluded women practitioners.[6] Nochlin collaborated with Ann Sutherland Harris on the landmark exhibition *Women Artists 1550–1950* held at Los Angeles County Museum of Art in 1976. Activist groups in the United States protested against the sexism and racism of the art

world. In 1989, The Guerilla Girls designed a poster which read, 'Do women have to be naked to get into the Met Museum? Less than 5 per cent of the artists in the Modern Art Sections are women, but 85 per cent of the nudes are female.' In 1982 the Women Artists' Slide Library was formed in London (now re-constituted as Make, the organisation for women in the arts), and began to publish a magazine focusing on art made by women, while in North America the collector Wilhelmina Cole Holliday founded the National Museum for Women in the Arts in Washington DC in 1987. Feminists reviewing the histories of twentieth-century culture, including Carol Duncan, Rozsika Parker, Griselda Pollock, Bridget Elliott and Jo-Ann Wallace, found that many accounts ignored women artists, and these writers worked to criticise and counteract their invisibility.

The representation of women's bodies was again at the forefront of critical debate towards the century's end. In her article 'The Body Politic', published in the journal *Art History* in 1978, Lisa Tickner called for the 'de-colonising of the female body; the challenging of its taboos; the celebration of its rhythms and pains, of fertility and childbirth. Narcissism and passivity must be replaced by active and authentic sexuality.' Lynda Nead's book *The Female Nude* (London 1992) explored recent feminist interventions and argued for desires other than those of heterosexual men to be addressed.[7] Performance artists, including Carolee Schneemann, had been using their own bodies in their work, erasing the comfortable dividing line between artist and model. Drawing on the French writer and critic Julia Kristeva's theory of the abject, Helen Chadwick celebrated the female body's capacity to break out of the constraints imposed upon it by patriarchal culture. In her book *Enfleshings* (London 1989) she wrote: 'Before I was bounded, now I've begun to leak.' Artist Jo Spence also worked with ideas of the abject and the grotesque.[8] In a series of compelling photographs, Spence showed herself naked, ageing and finally dying of cancer, a powerful contrast to the healthy, youthful ideal. Other women artists removed the image of the female body completely from their work (as Chadwick eventually did), or used only its traces in their art. Corporeal presence was signalled, but the pleasures of gazing at the spectacle of the female nude were refused.

There were also attempts to begin to address the almost blanket exclusion of women artists of colour from history. The exhibition *The Other Story* held at the Hayward Gallery, London, in 1989–90 purported to counter discrimination by showing the work of artists from African or Asian backgrounds living in post-war Britain. But there were only four women among the twenty-four artists. A year later, in 1990–1, artist Maud Sulter curated an exhibition of women's work from the Tate Collection at Tate Liverpool. *Echo: Works by Women Artists 1850–1940* ran parallel to, and in effect culminated with, her installation *Hysteria*, rewriting art history to include and conclude with the work of a black woman.

MARY ADSHEAD
1904–1995

The Times critic noticed Mary Adshead's work at the spring 1926 exhibition of the New English Art Club: 'This time the decorators undoubtedly have it … Miss Mary Adshead leads off with a Pompeian 'Spring'; a lady with a cornucopia, three doves and a kid framed in a border of fruit and foliage. With the figures relieved on a blue background it is a brilliant exercise.'

While Adshead was training at the Slade she met her husband, the artist Stephen Bone, and won her first commission, a mural for a boys' club. Her distinctive style, combining art deco's stylised shapes with a delicate lyricism, won her many further commissions, and she became secretary of the Society of Mural Painters. She painted murals in private houses, company buildings (including the restaurant at Selfridges), churches, and the British Pavilion at the Paris Exhibition of 1937. Adshead designed posters for London Transport, and murals of street scenes for Bank Underground Station (now destroyed). She also designed the first set of pictorial stamps to be issued by the

Mary Adshead
Morning after the Flood, 1928
Tempera on canvas
51.5 × 42.7 (20¼ × 16¾)
Purchased 1997

Post Office in 1949. Her publications included *Travelling with a Sketchbook: A Guide to Carry on a First Sketching Holiday* (1966), and a number of book illustrations. She also painted sets for the Elizabeth Taylor and Richard Burton film *Cleopatra* (1963).

Group exhibitions included the Women's International Art Club and the NEAC (she was elected a member in 1930). Solo shows were held at the Goupil Gallery (1930), and at Sally

Hunter Fine Art (1986, 1989). In the exhibition *Ten Decades: Careers of Ten Women Artists Born 1897–1906*, curated by Katy Deepwell (Norwich Gallery 1992), Adshead's work was seen alongside that of Eileen Agar, Evelyn Gibbs, Gertrude Hermes, Lilian Holt, Barbara Hepworth and Sylvia Melland. The Mappin Art Gallery, Sheffield owns a self-portrait of 1931, in which a confident and fashionable figure poses, brush poised to begin painting.

EILEEN AGAR
1899–1991

Interviewed at the age of ninety, Eileen Agar recalled a visit to her studio by the art critics Roland Penrose and Herbert Read in 1936: 'they looked around and they said "Oh but you're a Surrealist" and I said "am I?"'[9] As Agar's remembrance of an event of over fifty earlier suggests, this meeting was significant. It led to her inclusion in the International Surrealist Exhibition at the New Burlington Galleries, London

in 1936, and to membership of the British Surrealist Group.

Agar was born into a wealthy family in Argentina. Having moved to England, she was encouraged by her art teacher, Lucy Kemp-Welch. Agar trained at Leon Underwood's studio, where she met Henry Moore and Gertrude Hermes. She also studied at the Slade. On a visit to Paris she encountered works that developed her

sense of abstract composition, training under the Czech Cubist painter Frantisek Foltyn, and meeting Brancusi. In 1926 Agar met the Hungarian writer and poet Joseph Bard, whom she lived with for the rest of her life and married in 1940. With him she edited a short-lived journal, *The Island*, which included work by Moore, Hermes and the writer Naomi Mitchison. Agar's contribution included a woodcut and an essay on

Eileen Agar
The Autobiography of an Embryo, 1933–4
Oil on board
91.4 × 213 (36 × 83⅞)
Purchased 1987

religion and artistic imagination. Bard and Agar spent time in Italy where they met Margaret Mellis and the poets W.B. Yeats and Ezra Pound.

At the centre of Agar's art was a fusion of the rational and ordered with the intuitive and automatic. Her interest in the natural world and sexuality is evident from the beginning of her career, in the important early painting *Autobiography of an Embryo* (1933–4). Agar's attitude towards her own feminine identity was shaped by her knowledge of the ambivalence of many of her male Surrealist colleagues towards women's creativity and sexuality. In her autobiography *A Look at My Life* (London 1988), she recalled that Jacqueline Lamba, Andre Breton's wife, 'was expected to behave as the great man's muse, not to have an active creative existence of her own. In fact, she was a painter of considerable ability, but Breton never mentioned her work. The men were expected to be very free sexually, but when a woman like Lee Miller adopted the same attitude whilst living with Man Ray, the hypocritical upset was tremendous.' Agar spoke of her decision to remain childless as linked to her artistic vocation: 'It was very difficult because most men thought oh well the women will get married and have children and . . . forget about art . . . that's why

I decided I'd never have children I thought you can't do both.'

Agar always continued to paint, creating works in which strong structure and rhythm underly the often organic, lushly coloured forms. But she also used disparate materials and methods, including collage and found or 'interpreted' objects, in an inventive, witty manner. For Agar, the element of chance the found object introduced made it the ultimate Surrealist art form. Pieces such as *Marine Object* (1939, Tate), created from flotsam and jetsam she found by the sea, show a typically imaginative juxtaposition and allusiveness. Picasso is documented as having had a keen interest in this aspect of Agar's work, having met her in 1937 in the South of France in a party including the photographer Lee Miller. Agar's work with objects sometimes plays with ideas of sexual identity. The sculpture *Angel of Anarchy* (1936–40, Tate) is the second version of a work exhibited at the International Surrealist Exhibition held in Amsterdam in 1938, and subsequently lost. Although this piece could be described as 'feminine', wrapped in feathers that had adorned Agar's mother's hair, along with embroidered fabric, beads and shells, underneath all of the decoration is a portrait head of Joseph Bard. Agar also made wearable pieces, and was

photographed in her elaborate *Ceremonial Hat for Eating Bouillabaisse* (1936, artist's estate), decorated with starfish, shells, fishnet and a lobster tail.

Photography also became an important medium for Agar. Her striking photographs of rocks in Brittany taken in the late 1930s inspired a series of her own paintings years later. Agar was photographed by Lee Miller in 1937, a portrait that shows her shadow silhouetted against one of the ornate pillars of Brighton Pavilion. There is a protrusion at Agar's waist in the picture – the camera she carried everywhere, which reportedly prompted Picasso to comment that she appeared to be pregnant with a camera. It is a striking image for a woman artist who had decided to put work before having children to be pregnant, instead, with undeveloped pictures.

As late as 1965 Agar was exploring new ways of working, abandoning oil paint for the new medium of acrylic. She had eighteen solo shows during her lifetime, including a retrospective at the Commonwealth Art Gallery, London in 1971. In 2000 an exhibition of her work was held at the Scottish National Gallery of Modern Art in Edinburgh.

EVA DOROTHY ALLAN, known as JULIAN PHELPS ALLAN
1892–1996

In 1929 Eva Dorothy Allan became Julian Phelps Allan. Her new name is likely to have signified a lesbian identity. Female homosexuality had recently come to the fore of public debate. Radclyffe Hall's novel *The Well of Loneliness*, whose central character is a woman named Stephen Gordon, had been banned for obscenity when it was published in Britain in 1928. For those women who wanted to declare their difference from the heterosexual norm, using men's names became an effective strategy.

Allan trained at the Westminster School of Art, the Royal Academy Schools, and in Florence. She travelled in Europe to study Byzantine and Romanesque sculpture. Allan exhibited at the Grosvenor Gallery and the Royal Society of British Artists. During the 1930s she showed portraits of women and religious works at the Society of Women Artists. At the Royal Academy, where she won a gold medal in 1925, she exhibited a number of bronze busts, including *Marjorie*, which was bought by the Chantrey Bequest in 1929, and given to the Tate. But she did not work exclusively in this medium. Her *Mother and Child design for a memorial to the late Head Mistress of Peckham Secondary School*, carved in Caen stone, was shown at the Academy in 1931.

Allan was also given a number of church commissions, and created bas-reliefs for London's Lambeth and Maudsley hospitals.

During the 1939–45 war Allan served in the Auxiliary Territorial Service, becoming a colonel and first president of its War Office Selection Board (she had also served in the First World War). She portrayed the director of the ATS, the botanist and teacher Dame Helen Gwynne-Vaughan, in a bronze bust, exhibited at the Royal Academy in 1937. Ten years later Allan was elected a fellow of the Royal Society of British Sculptors.

ANTHEA ALLEY
1927–1993

Writing in the catalogue for Anthea Alley's 1964 exhibition at the Hamilton Galleries, London, Alan Bowness located her as part of a modern movement that blurred the distinction between painting and sculpture, writing that Alley's work was 'dynamic, implying thrust and movement within a defined space'.

She had trained as a painter at the Regent Street Polytechnic, Chelsea School of Art, and the Royal College of Art (winning a painting prize at the John Moore's exhibition in 1961). In 1955 she married Ronald Alley, later Keeper of the Modern Collection at the Tate Gallery, and became a self-taught sculptor. Working with welded steel, brass, aluminium, sand and cement, as well as light and water, Alley made abstract, sometimes kinetic, sculptures. She incorporated themes of modern industry and technology in her work,

Anthea Alley
Spatial Form, 1962–3
Welded brass
33.7 × 27.9 × 29.8
(13¼ × 11 × 11¾)
Purchased 1964

as in the mixed-media-on-board piece *These men invented Television* of 1962, and the steel sculpture *Clustered pipes* of 1964. In common with Elisabeth Frink, Alley made sculptures of birds and horses. She also taught at several art schools.

Alley's first solo exhibition of sculpture was held alongside a show of Gillian Ayres's paintings at the Molton Gallery, London in 1960. Four years later she shared a show at the Arnolfini Gallery, Bristol with Ayres (the Arnolfini Gallery held a second exhibition of

Alley's work in 1969). Group shows included the Women's International Art Club, the London Group, and the Artists International Association.

CLARE ATWOOD
1866–1962

An article 'The Woman Painter at Work', in the *Daily Graphic* in July 1923, reported on Clare Atwood's portrait of the actor Ellen Terry. The same paper in November 1924 featured a photograph of Atwood, in tie and tailored jacket, standing by her painting of another actor, Sybil Thorndike. Atwood was a friend of Terry, of her daughter Edith Craig, the campaigner for women's suffrage, actor and producer, and of Craig's partner, a woman writer known as Christopher St John. Known as 'Tony' by this circle, Atwood went to live with Craig and St John in Kent during the First World War. She was still close to Terry's family in her late seventies, and painted Craig in bed in 1943 with a book and a cat for company. John Gielgud, whose room is shown in the Tate painting, was Ellen Terry's great nephew.

Atwood trained at the Westminster School of Art and the Slade, showing her work at the Society of Women Artists, the Royal Academy, and internationally. Atwood exhibited most frequently at the New English Art Club, and became a member in 1912. Her *Interior of the Coach-Wheelwright's Shop at 41 Marshall Street, Soho*, exhibited at the NEAC in 1897, is now in the Museum of London. Her solo exhibition at the Carfax Gallery in 1911 included the London scenes *Billingsgate Market* and *Costers, Covent Garden*, and paintings

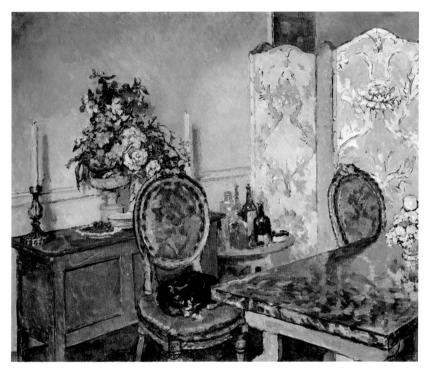

Clare Atwood
John Gielgud's Room, 1933
Oil on canvas
82.9 × 76.2 (24¾ × 30)
Presented by Mrs E.L. Shute 1937

of theatrical life such as *Rehearsal, Drury Lane: The Rose-coloured Box*.

Her choice of subject matter and technique suggests that Atwood should be at home in the company of the Camden Town Group, and Sickert, who may have taught her at Westminster School of Art. But as women were forbidden membership, painters such as Atwood remain relatively unknown in comparison with their Camden Town contemporaries. The different position

of women also shaped her war work. Atwood was commissioned by the Women's Work Sub-Committee to paint service women for the Imperial War Museum. She completed three works, and donated a further painting to the museum, *Christmas Day in the London Bridge YMCA Canteen* (1920), in which Ellen Terry hands out food in a dining-hall crowded with Belgian refugees.

MARGARET DOROTHY BARKER
born 1907

In 1925 Margaret Barker won a scholarship to the Royal College of Art. Four years later, while still a student, she exhibited *Any Morning* at the New English Art Club. The painting was a critical success. Bought by the Chantrey Bequest from the exhibition, it was given to the Tate Gallery in the same year.

Barker's tutor at the Royal College of Art, Randolph Schwabe, may have influenced the precisely executed descriptions of space in his student's work (he was known for his architectural draughtsmanship). It also appears that Barker had followed an important aspect of art school training of the period, the practice of copying at the National Gallery. The painting hanging above the bed in *Any Morning* is Peter de Hooch's *Courtyard of a House in Delft*, painted in the seventeenth century and housed in the National Gallery's collections.

By painting de Hooch's work into her picture, Barker was taking the bold step of allying herself with a type of art much admired by a number of early twentieth-century artists. But rather than just following de Hooch's pattern, Barker played a clever spatial game.

Margaret Dorothy Barker
Any Morning, exh.1929
Oil on canvas
62.2 × 91.4 (24½ × 36)
Presented by the Trustees of the Chantrey Bequest 1929

In Barker's painting, we see the relationship between interior and exterior reversed from their arrangement in de Hooch's picture. We look through an interior outwards, rather than looking in from outside. Barker also included mundane modern furnishings, such as the striped blanket, which are likely to have appealed to the vogue for representations of 'ordinary life' among some British artists and critics of her time. She painted landscapes, portraits and figures, combining her practice with her teaching in girls' schools, until her marriage in 1938 ended the most productive part of her career.

LAURA ANNING BELL
1867–1950

Laura Richard studied with Alphonse Legros at the Slade. She married twice, exhibiting as Laure Richard-Troncy, and then under the name of her second husband, the artist Robert Anning Bell. She was a portraitist, specialising in subtle pencil drawings and exquisitely modulated pastels. Her work was exhibited in Paris at the Salon de la Société des Artistes Français, and in London at the Society of Women Artists and the Royal Academy.

Annie Horniman, the pioneer of repertory theatre and backer of first performances of plays by George Bernard Shaw and William Butler Yeats, had also trained at the Slade, and the two women are likely to have met there. At the time that this portrait was made, Horniman was at the height of her career. She owned the Abbey Theatre in Dublin from 1904–10, and also at different times the Midland Theatre in Manchester and the Gaiety in London. Horniman was known for her sumptuous clothes, and was portrayed splendidly dressed in

paintings by both John Butler Yeats and Emma Magnus. Bell chose instead to focus on her face, which appears delicate yet worn and not idealised, against a plain, dark collar. The portrait was shown at the Paris salon, and is likely to be the work listed as *Miss Horniman* exhibited at the Society of Women Artists in 1925.

In 1919 Anning Bell held an exhibition with Mary Davis and Constance Rea at the Fine Art Society. Among her works were portraits of Robert Anning Bell and of Annie Horniman (likely to be the pastel now owned by Tate which was presented by the artist). There was also a portrait of Charles Ricketts, which may well be the drawing now housed in the National Portrait Gallery, a profile of the artist, collector, designer and founder of the Vale Press.

Laura Anning Bell
Miss Annie Horniman, ?*c*.1910
Pastel on paper
50.2 × 40 (19¾ × 15¾)
Presented by the artist 1931

VANESSA BELL
1879–1961

Virginia Woolf wrote the catalogue foreword for her sister Vanessa Bell's exhibition at the Cooling Gallery, London in 1930. She began, 'That a woman should hold a show of pictures in Bond Street ... is not usual ... it was held, until sixty years ago that for a woman to look upon nakedness with the eye of an artist ... was corruptive of her innocency and destructive of her domesticity ... Hence ... the fact that every Victorian family has in its cupboard the skeleton of an aunt that was driven to convert the native [work as a missionary] because her father would have died rather than let her look upon a naked man ... and so there drop out of the cupboard with her bones half a dozen flower pieces done under the shade of a white umbrella in a Surrey garden.'

Reacting against the expectation, even in their highly cultured family,

Vanessa Bell
Abstract Painting, *c*.1914
Oil on canvas
44.1 × 38.7 (17⅜ × 15¼)
Purchased 1974

that they would be content with domestic familial roles, the sisters decided on respective careers as artist and writer. Vanessa trained with Sir Arthur Cope in the late 1890s, at the Royal Academy Schools under John Singer Sargent, and for a short time at the Slade. In 1905 she founded an exhibiting organisation, the Friday Club, which included Clare Atwood, Edna Clarke-Hall, Mark Gertler, J.D. Innes, Derwent Lees and Henry Lamb. The lives and work of Bell and Woolf remained closely interlinked. Woolf discussed the position of women artists in her book *A Room of One's Own* (London 1929). In turn, Bell created book jackets and illustrations for her sister, and painted portraits of Woolf, showing her as if about to speak (1912, Monks House, the National Trust), and sewing (1912, National Portrait Gallery, London).

Among Bell's other images of women are her stylish portrait *Mrs St John Hutchinson* (1915, Tate), in which the writer sits against a geometric background. Her face appears almost to dissolve against its setting, suggesting an uncertainly about identity characteristic of a number of Bell's portraits of women of the same period. In *Women Artists and Writers: Modernist (im)positionings* (London 1994), Bridget Elliott and Jo-Ann Wallace argued that this uncertainty could be understood in relation to the battles over the role of women during the suffrage campaign and the First World War, that made the fixing of femininity in representation difficult.

Some critics have read class distinctions inscribed in Bell's work, and this can be inferred in the difference between the elegant, clean-limbed figure in *The Tub* (1917, Tate), again modelled by Mrs St John Hutchinson, and the ungainly *Nude* (c.1922–3, Tate), whom the poet Wendy Cope described as having been portrayed as 'Depressed and disagreeable and fat' by the 'well-bred, artistic Mrs Bell'.[10] Bell also painted domestic scenes peopled by the women servants who made her life as an artist possible. Her portraits of men include the writers Aldous Huxley (c.1929, Private Collection) and E.M. Forster (c.1940, Private Collection).

Bell's abstract works in paint and cut paper developed alongside her design work for the Omega Workshops that she set up with Roger Fry and Duncan Grant in 1913. Bell's watercolour design for an Omega fabric on graph paper was included in the exhibition *Vorticism and its Allies* at the Hayward Gallery in 1974. The important exhibitions of Post-Impressionist works organised by Fry in 1910 and 1912 influenced Bell's love of French art. It is telling that, writing to Fry of visiting an exhibition in 1911, Bell's preferred painter worked in Paris: 'We went to the New English yesterday. My word, what a show! Of course Steer is quite done for, and the John seemed to me to be some rather sentimental drawings badly put together ... As for Henry Lamb ... It's simply too deadly – academic drawing ... Miss John seemed to me much more interesting than anyone.'[11] Bell revered Cézanne, and the solidity and structure of some of her still life and landscape paintings show her knowledge of his work. Matisse's influence is noticeable in works such as *Studland Beach* (c.1912, Tate) and the folding screen *Bathers in a Landscape* (1913–14, Victoria and Albert Museum), with their simplified forms, striking colour and heavy outlines.

Following her move to Charleston, Sussex, with Grant in 1916, Bell's work became increasingly naturalistic in style, and she painted her surroundings, as in *The Open Door, Charleston* (1926, Bolton Museum and Art Gallery), domestic life with her children and members of her circle. The hand-painted decor she created for her home has been preserved and has had a lasting influence on interior design. Bell created sets for ballets by Frederick Ashton and Ethel Smyth in the 1930s, and designed a dinner service, commissioned by Kenneth Clark, featuring portraits of famous women (Bell among them). The Arts Council held a retrospective of her work in 1964.

ELINOR BELLINGHAM-SMITH
1906–1988

In 1951, Elinor Bellingham-Smith's painting *The Island* was awarded one of only five purchase prizes at the Festival of Britain. It had been commissioned as part of the *60 Paintings for 51* exhibition. Selected artists had been invited to make large works for display in the schools, hospitals and libraries that formed the new Welfare State. Among Bellingham-Smith's fellow exhibitors were Vanessa Bell, Prunella Clough and Karin Jonzen.

Bellingham-Smith is likely to have been influenced in her choice of vocation by her family. Her father, a surgeon, was also an art collector, and her uncle was a painter. She studied at the Slade in the late 1920s at the same time as Ithell Colquhoun, Elsie Few, Helen Lessore, Mary Potter and Rodrigo Moynihan, whom she married.

Bellingham-Smith's first solo exhibition was held at the Leicester Galleries in 1948 (the galleries remained her main exhibiting venue). Most of her paintings were English landscapes, such as *St Margaret's Bay* and *Boats at*

Cookham. Sometimes these included children, as in *Girls by the River*, and *Dragon-flies* (1947–8), a painting of a blue-green idyll of girls and boys watching insects hovering above the water, which was bought by the Tate. The fluid, sketchy style of these paintings characterised her practice throughout her life. She also worked as an illustrator for Shell and *Harper's Bazaar* magazine. Bellingham-Smith exhibited with the London Group from 1931, becoming a member in 1952. Her work was also shown at the Royal Academy, the New Art Centre, and the New Grafton Gallery, where a memorial exhibition was held in 1989. In the same year, her paintings were shown at the Aldeburgh Festival.

NADIA BENOIS
1896–1975

A 1936 edition of the *Studio* carries a feature by Sybil Vincent, 'In the Studio of Nadia Benois', describing the artist's family background in Russia (vol.112, July–December 1936). Benois's father had been court architect to the Tsar, and her uncle, Alexandre Benois, established the Ballets Russes with Diaghilev. The wing of the Peterhof Palace near St Petersburg where the family lived is now a museum of their work. Benois trained at a private art school in St Petersburg. But she left the Soviet Union in 1920 to live in Britain with her husband Jona Ustinov (their son is the actor and author Peter Ustinov).

Her surroundings in London gave Benois some of the subject matter for her still life and city scenes, as in her painting of Kensington Gardens (1937, Manchester City Art Gallery). Benois also painted on her regular travels in France, and was described by Sybil Vincent as 'a leading landscape painter of the modern school'. Her first solo exhibition was held in 1924 at the Little Gallery in the Adelphi Theatre. She exhibited at the Matthiesen Gallery (1953) and shared the exhibition *Three Women Painters* with Clare Crossley and Nancy Tennant at the Michael Parkin Gallery in 1975. From 1929

Nadia Benois
Near La Garde Freinet, 1935
Oil on canvas
63.5 × 76.2 (25 × 30)
Presented by the Contemporary Art Society 1936

onwards she exhibited regularly at the New English Art Club.

Benois also designed costumes and decor for the ballet. Her work was shown alongside that of her uncle and Vanessa Bell in the exhibition *Designs for the Ballet* held at University College, Leicester in 1951. She designed for several productions by Marie Rambert's ballet, including *Dark Elegies* (1937), with music by Mahler, and she also worked for Ninette de Valois at Sadler's Wells, creating sets and costumes for *The Sleeping Princess* (1939). Benois later collaborated with her son, designing for his plays and screenplays.

EMILY BEATRICE BLAND
1864–1951

Emily Beatrice Bland had several exhibitions at the Leicester Galleries during the 1920s. In 1928 her *Paintings of Flowers and Landscapes* were exhibited there alongside work by Paul Nash. *The Times* critic reviewed the exhibitions, describing Bland as 'a decorative impressionist, interested primarily in light, air, and colour, but with an eye to pattern'. The critic cautioned that Bland sometimes 'lapsed too easily into decoration' but concluded that, at her best 'Miss Bland is a captivating artist, lyrical in feeling and lively in execution'.

Bland trained at the Slade in the early 1890s and exhibited at the New English Art Club, eventually becoming a member. She lived in Chelsea, part of a circle of Slade-trained women artists that included Ethel Walker and Louise Pickard, who were labelled by Philip Wilson Steer the 'Cheyne Walkers'. Bland also showed her work at the Royal Academy (between 1906 and 1950), at the Redfern and Goupil Galleries and the Fine Art Society.

Although she had a long professional career (her *Printemps à Londres* was bought by the French State in 1927, and given to the Musée d'Orsay), Bland has slipped into obscurity. This may be because her preferred subject matter, flower painting, has been perceived as feminine and facile. But the reviewer of the 1928 exhibition for the *Morning Post* commented, 'she courts rather than shirks difficulties'. *Striped Camellias* is a refusal of simplistic demarcations between the man-made and the natural

Emily Beatrice Bland
Striped Camellias, 1927
Oil on canvas
45.7 × 34.9 (18 × 13¾)
Presented by the Trustees of the Chantrey Bequest 1929

world, public and domestic space, and the division of masculinity and femininity between these oppositional pairings. Nature appears in the form of flowers, but they are cut and arranged, enclosed under a bell-jar or window-box, and the space of the interior is opened out onto the world outside the window, suggesting the subtleties of Bland's position as a modern woman.

PAULINE BOTY
1938–1966

At the age of twenty-three, Pauline Boty had her first group exhibition with Peter Blake, Geoffrey Reeve and Christine Porter at the Artists International Association in London. An *Observer* review titled 'The New Satire' commented, 'Ernst has known best how to impart a wayward poetry to photographic and printed fragments. By similar means his disciple at the AIA, Pauline Boty, alludes to the enigma of the space age with mock titles. Pungent comment in image and caption is the whole idea.'

After Boty's early death she was written out of the history of British Pop Art. A recent exhibition and catalogue (Whitford Fine Art/The Mayor Gallery 1998) has uncovered her role. Boty trained at the Royal College of Art. Her paintings and collages juxtaposed images from women's and pornographic magazines, sometimes with vivid, sensual painted flowers, and she also drew upon literary sources (Gertrude Stein is invoked in the early work *a rose is a rose is a rose*).

In common with other pop artists Boty was fascinated by film (she also worked as an actress), and what she termed 'present day mythology'. Film stars appear in *With Love to Jean Paul Belmondo* (1962) and *The Only Blonde in*

Pauline Boty
The Only Blonde in the World, 1963
Oil on canvas
121.9 × 152.4 (48 × 60)
Purchased 1999

the World (1963), a painting of Marilyn Monroe in a still from *Some Like it Hot* (1959), a film in which femininity is seductive but also sent up as a comic, camp masquerade. Boty portrayed a confident female sexuality in the work *5-4-3-2-1* (1963), used on the catalogue cover for the only solo exhibition during her lifetime, at the Grabowski Gallery in 1963. A beautiful young woman is pictured laughing beneath a text that

reads 'OH FOR A FU . . .' Political comment remained at the centre of Boty's work. She layered collage, text and paint to simulate and critique the mass-media modern world and the representation of femininity within it. In the painting *Cuba Si* (1963), a young woman ponders the Cuban revolution unfolding behind her. She is at the centre of the picture; she is not on the sidelines.

MAUDE 'GRILDA' BOUGHTON LEIGH
*c.*1881–1945

The series of letters sent by the Boughton Leigh sisters to their friend Gwen John in Paris are now housed in the National Library of Wales, Aberystwyth. Maude Boughton Leigh, who changed her name to the more unusual 'Grilda', studied at the Slade at

the same time as John. She also trained at the Atelier Cormon, Paris, and made several further working visits to the French capital in the 1900s and 1910s in the company of her sister Ellen, who adopted the name 'Chloë'. The sisters helped John, employing her as a model

and sending useful presents, and they also admired her gifts as an artist. Chloë sat for paintings, including a work now in the Tate Collection, and a portrait commissioned by the sisters and now in the collection of Leeds City Art Galleries. When they returned to

Britain, John kept them informed of Parisian events, such as the exhibition in 1920 of the work of another ex-Slade artist, Madge Oliver.

Like John, Chloë Boughton Leigh converted to Catholicism, and the pair visited a convent near Brussels together in the early 1930s. Following Grilda Boughton Leigh's death, her paintings and drawings (including the portrait of her sister) along with John's painting of Chloë (now in Leeds) were found in her Canvey Island home. Comparing the portraits, it is noticeable that both Gwen John and Grilda Boughton Leigh painted Chloë with large, capable hands, and in a pensive, melancholy mood. The two portraits represent Chloë absorbed by the inner life made possible by the time and freedom that unmarried independent life offered some early twentieth-century women.

Maude 'Grilda' Boughton Leigh
Chloë Boughton-Leigh
Oil on canvas
71.1 × 50.8 (28 × 20)
Purchased 1947

E. BOX
1919–1988

When she first exhibited her work, at the Hanover Gallery, London in 1949, Eden Fleming adopted the pseudonym E. Box. She had studied at the Regent Street Polytechnic in the late 1930s, and then married Professor Marston Fleming. Box accompanied her husband on his research visits to North America, Africa, Russia, Asia and Europe, gathering material for her own work.

Box painted highly coloured, stylised animals and figures, sometimes with Christian significance, in exotic landscapes. The catalogue for her 1981 retrospective at David Carritt Ltd in London was prefaced by Howard Hodgkin, who wrote that Box's work was 'painted with the direct one to one representation that we find in Persian and Indian miniature painting'. Roy Strong, in a 1978 article for *Vogue* magazine, identified the influence of icons and the work of the Douanier Rousseau in her paintings. *The Expulsion* (1951, Tate) shows animals inside the Garden of Eden, the gate shut against the two small figures in the distance. Above the couple hangs a flaming sword, flanked by two angels. Box also used literature as a source for her art: one painting was titled *To Pushkin – A Leningrad Memory April 1957*, while later works referred to poems by William Morris, Andrew Marvell, William Blake and John Clare.

Robert Melville gave an account of Box's career in his book *Gentle Friends: the Paintings of E. Box* (London 1956). Box had fifteen solo shows, including two at the Betty Parsons Gallery, New York (1953 and 1958).

THE HON. DOROTHY EUGENIE BRETT
1883–1977

In her memoir, which is unpublished (although excerpts appear in Sean Hignett's *Brett from Bloomsbury to New Mexico*, London 1984), Brett described the writer Katherine Mansfield asking to see her work while they were both at Garsington, home of the society hostess Ottoline Morrell: 'I was then painting a group of Ottoline's weekenders ... Ottoline, Strachey, Murry, Katherine, Gertler, Aldous Huxley, Julian ... She gave me encouragement I needed badly. Katherine really started me doing some serious painting in England.' Mansfield's letters to Brett discuss their own work and that of writers and artists they admired, including Anton Chekhov, Edouard Manet and Wyndham Lewis (see C.K. Stead (ed.), *The Letters and Journals of Katherine Mansfield*, Harmondsworth 1977).

Brett trained at the Slade where she met Mark Gertler and Carrington. It was with a portrait of Dora Carrington that she made her exhibiting debut at the New English Art Club in 1914, and in common with her friend she chose to be known just by her last name. Living in Hampstead, Brett sometimes worked alongside the artists of the Carline family, joining them when they had a life model posing. Her work sometimes reflected the troubling times: she exhibited two paintings about the First World War at the NEAC, *Blind Soldiers* (1915) and *Widows* (1916).

In 1924 Brett travelled to New Mexico to join her friends the writer D.H. Lawrence and his wife Frieda. She painted a portrait of Lawrence (1925, National Portrait Gallery, London),

The Hon. Dorothy Eugénie Brett
Ceremonial Indian Dance:
The Matachinas, 1948
Oil on canvas
127 × 101.6 (50 × 40)
Presented by the artist 1959

and published an account of their relationship (*Lawrence and Brett: A Friendship*, New York 1933). The Lawrences returned to Europe, but Brett remained in New Mexico for the rest of her life. She painted the Pueblo Indians and their myths and rituals, and met Georgia O'Keefe. A retrospective of Brett's work was held at the Taos Gallery of Contemporary Art, New Mexico in 1980.

KATHERINE CAMERON
1874–1965

The *Art Journal* in 1900 praised
the work of Katherine Cameron:
'nothing more delicate in colour and
draughtsmanship was ever produced
outside of Japan'. The reviewer identified
her Scottish background as a key
influence on her work: 'She has the
true race feeling of the Celt for love
and legend ... old ballads and fairy
mysteries furnish most of her themes.'

Cameron trained at the Glasgow
School of Art from 1890 to 1893, and
then at the Atelier Colarossi in Paris.
She was part of the progressive group
of young women artists discussed in
Jude Burkhauser's *Glasgow Girls:
Women in Art and Design 1880–1920*
(Edinburgh 1990). A photograph
survives showing Cameron in the
studio with these women, who dubbed
themselves 'The Immortals', perhaps
signalling their ambition to become
'immortal' in the same way as male
artists. Discrimination against women
in the Scottish art world had spurred
the formation of the Glasgow Society of
Lady Artists in the 1880s, and Cameron
became an active member.

Cameron showed her watercolour
and gouache paintings and etchings in
Britain and America. Her main venue
remained the Royal Scottish Academy,
where she exhibited from 1894 to 1965.
She also worked as an illustrator of
romantic and fairy stories, often for the
Edinburgh publisher T.C. and E.C. Jack,
including titles such as *In Fairyland*
(1904) and *Stories of King Arthur's
Knights* (1905). Early in her career
Cameron had contributed to *The Yellow
Book*. Volume X (1896) featured her
Babies and Brambles, in which flowers
twine around fairy children, while *The
Black Cockade* in Volume XIII (1897)
shows a young woman in a dramatic
plumed hat.

Katherine Cameron
The Mountain Fern, *c.*1923
Intaglio print on paper, print
42.9 × 19.1 (16⅞ × 7½)
Presented by the artist 1960 and accessioned 1987

HILDA CARLINE
1889–1950

Hilda Carline looks out of her self-portrait with the concentrated gaze of an artist. But the painting is puzzling. Carline wears a hat and necklace, suggesting that she is dressed to go out, rather than for work, and although we see her paint-box and brushes, her hands are folded at her waist and the bed behind her seems to signify that she is not in a studio. It is as if her identity as an artist could not be fully realised, either in art or in life.

Daughter of one painter, Carline was the sister of two others, Sydney and Richard. The Carline family lived in Hampstead. Her brothers had studios there, but Hilda was relegated to using the passage between them. This spatial marginalisation ran parallel with the critical marginalisation of her art, in favour, first of her brothers', and then that of her husband of twelve years, Stanley Spencer. A solo exhibition, which toured from the Usher Gallery, Lincoln, in 1999, has attempted to redress the balance.

Carline trained first at the Tudor-Hart School of Art in Hampstead. During the 1914–18 war she served in the Women's Land Army. Entering the Slade in 1919, she won several prizes, and a painting submitted for an award shows herself and an art student friend, Cora Stoop, returning from their Land Army work on horseback. Carline exhibited with the London Group and at the Royal Academy. Although her work was often interrupted by the demands of her family after her marriage in 1925, her landscapes, often with great depth of perspective, and her portraits, notably those of her daughters and her mother, give a sense

Hilda Carline
Self-Portrait, 1923
Oil on canvas
74.9 × 57.8 (19½ × 22¾)
Presented by Miss Shirin Spencer and Miss Unity Spencer,
the artist's daughters, and Richard Carline the artist's brother 1975

of her gifts. Her magnificent painting of her maid, Elsie (1929, The Brighton and Hove Collections) shows the figure full length, in her best clothes, the kitchen range behind her. The setting, combined with the geometry of the carpet design and the maid's modish dress, skilfully weaves together modernity, domesticity and femininity.

NANCY CARLINE
born 1909

After training at the Slade from 1929 to 1932, Nancy Higgins worked for Sadler's Wells Ballet. She met Vladimir Polunin who was designing sets there, and subsequently returned to the Slade to enrol on his stage design course. She attended the Euston Road School, and exhibited with the London Group, the New English Art Club and the Royal Academy. Her paintings of portraits, figures in domestic settings and biblical and classical subjects, are characterised by subtle, natural colours and a sensuous but restrained use of media.

During the Second World War she painted the city and took part in Artists International Association exhibitions. *Soho in War-time* (1940) shows women hurrying through the narrow sombre streets, while *VE Night* (1946) depicts the celebrations marking the end of the conflict. After the war she married Hilda Carline's artist brother, Richard. The Carlines' home in Hampstead, and their family, became the chief subject of her painting. In *Supper on the Terrace* (1946, Tate) she sits with her husband, his mother and sister Hilda Carline, who had returned to live with her family following her divorce from Stanley Spencer.

Nancy Carline took part in family group exhibitions: *The Carline Family* at the Leicester Galleries, London in 1971 and *The Spencers and the Carlines* at the Morley Gallery, London (and touring) in 1980. In 1985 she had an individual exhibition at Camden Arts Centre.

DORA CARRINGTON
1893–1932

Writing in 1921, Carrington estimated her position as an artist: 'I have more feeling really for Sign Boards & very simple 18th cent English painting than for modern French ... Matisse is exquisite ... But he's not quite rich enough or tight enough for me. A little too – how shall I say it, water-coloury & pale-muslin dresses for me ... I hope to see some more Ingres soon in Paris. I saw some at the British Museum about 3 weeks ago. They are astonishing ... Piero di Cosimo is my saint at the moment, I burn all my candles to him.'[12]

At the Slade, where she began her studies in 1910, Carrington won prizes including the Slade Scholarship. (Her work is still in the collection of University College London.) Fellow students who became her friends included Dorothy Brett, Alix Sargent Florence (daughter of the artist, Mary), Paul Nash and Mark Gertler. During her studentship Carrington developed her distinctive personal style, transforming herself from an Edwardian lady to a figure with bobbed hair, sometimes dressed in breeches. She dropped her first name to signal her new identity.

Carrington has been the subject of a feature film and a biography focusing on her relationships with Bloomsbury Group figures such as Lytton Strachey (whom she lived with from 1917) and Virginia Woolf. But, as Jane Hill argues in her monograph on the artist (London 1994), Carrington's artistic allegiance lay not with the Bloomsbury painters but with the artists of Chelsea, and her own collection contained works by Augustus John, Mark Gertler and John Nash, that she had exchanged with them. Like theirs, Carrington's art is figurative, polished and precise, but also suggests an intensely personal vision. This was partly because she painted the people and places she knew, and was also a result of her manipulation of scale and space. She exhibited in London at the New English Art Club, the London Group and the Grosvenor Galleries.

Among Carrington's portraits, the best known are perhaps the images of Lytton Strachey, such as the painting in which he peers through his spectacles at a book (1916, private collection). To quote Jane Hill, aside from her paintings of her companion, 'Carrington's finest portraits are of women of character.' Her painting of Lady Strachey (1920, Scottish National Portrait Gallery) pictures the old lady as a formidable figure. The artist wrote of it: 'She looks like the Queen of China, or one of El Greco's Inquisitors.'[13] *Mrs Box*, a Cornish farmer in her seventies, is so solid and weather beaten as to appear carved out of wood (1919, private collection).

Carrington was also a painter of places. Her earliest landscapes were painted at Hurstbourne Tarrant, where her family lived. Later she portrayed her surroundings at her homes in Tidmarsh

Mill, Berkshire, and then at Hamspray, Wiltshire, and painted on her travels in France and Spain in the 1920s. Her work was included in the exhibition *Landscape in Britain 1850–1950* (Hayward Gallery 1983), and can be understood as part of the wider cultural celebration of traditional rural life that took place in response to the First World War. Painting in Watendlath, Cumberland, she wrote: 'The more I live here the more exquisite I find everything! It has the beauty of that poem Hero & Leander by Marlow ... I have never seen so many rare objects gathered together in one valley before. The little hillocks, with the grey rocks protruding from under the worn green plush carpet reminds me every day of that lovely picture by Bellini in the National Gallery of the Disciples on the Mount.'[14]

The decorative art that had been an important part of her work from her student days continued to occupy Carrington. In 1913 she painted a fresco in the library of Ashridge House, Hertfordshire, with another woman student, perhaps inspired by the teaching of Mary Sargent Florence, who had lectured on fresco and tempera painting at the Slade. Carrington designed for the Omega Workshops and created decorative schemes for interiors, tiles and furniture, including, in 1927, a gramophone cabinet (Portsmouth City Museum and Art

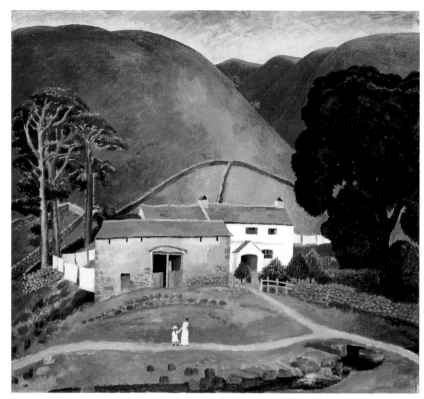

Dora Carrington
Farm at Watendlath, 1921
Oil on canvas
61.1 × 66.9 (24 × 26⅜)
Presented by Noel Carrington, the artist's brother 1987

Gallery). She painted pub signs, and works on glass and silver paper, and made woodcuts and drawings to illustrate books published by the Omega Workshops, the Hogarth Press, and for an edition of *Don Quixote* published by Oxford University Press in 1922. Carrington's last completed

work, made in 1931, was a *trompe-l'oeil* window at Biddesden House (home of the writer Nancy Mitford's sister, Diana Guinness) from which a cook in eighteenth-century dress gazes out at the passer-by.

HELEN CHADWICK
1953–1996

Roses, engine oil, liver, snow, Germolene, earthworms, fur, chocolate, blackberries and urine: these are some of the materials Helen Chadwick used in her art, making installations, or photographic pieces. Working with such diverse media, and dealing with the human body, its pleasures and

its mortality, Chadwick has had a significant influence on some major contemporary artists.

From her student days (at Brighton Polytechnic and Chelsea School of Art), Chadwick re-imagined the body, often the female body. She chose a quotation from Angela Carter's *The Sadeian*

Woman (London 1979) to preface the catalogue for her exhibition *De light* at the Institute of Contemporary Arts, University of Pennsylvania in 1991. Carter had argued against 'All the mythic versions of women', which she saw as attempts to console them 'for their culturally determined lack of

access to the modes of intellectual debate'. This critique is likely to have chimed with Chadwick's desire to create images in which the female body is at once moving and beautiful and a riot of flesh and fluids, rather than the pristine spectacle that fills culture and the media.

Chadwick used her own body in her exhibition *Of Mutability* held at the ICA, London in 1986. It was made up of two installations, *The Oval Court* and *Carcass*. A lyrical composition of repeated images of her naked figure, which she represented entwined with food, flora and fauna, tumbled and spread across the floor, metal spheres resting upon the images. Looking up at the walls, the viewer saw the artist's weeping face mounted on twisting columns, mourning the passing of pleasure. In an adjoining room stood a glass tower filled with layers of decaying detritus, a pungent *memento mori*. This work, with its dazzling use of mixed media (including photocopies used to create the floor piece), led to Chadwick's nomination for the Turner Prize in 1987.

Self-representation in Chadwick's work had been given a harder edge in *Ego Geometria Sum* (1982–4), an installation of plywood objects symbolising different stages in her development, including an incubator and a wigwam, on which the artist printed photographs of her body. Around the walls of the room hung photographs of the naked artist holding the objects, relating her present self to memories of her past. *Lofos Nymphon* (1987) projected photographs that showed Chadwick and her mother, both naked, against the backdrop of the city of Athens, where their family originated. In *Vanity* (1989), Chadwick, half-draped in fabric and feathers, holds a mirror reflecting *The Oval Court* behind her. By contrast, *Self-Portrait*, made two years later, does not represent her face or body at all, only the hands

Helen Chadwick
Enfleshings I, 1989
Photographic transparency
and light-box
106.6 × 91.5 × 18 (42 × 36 × 7⅛)
Purchased 1994

with which she made her art, worn fingers adorned with gold rings, cradling a brain: woman represented as hard work and intellect. Included in the gang of *Bad Girls* at the ICA exhibition in 1993, Chadwick's work was seen alongside that of Dorothy Cross and Nan Goldin (among others). While at the exhibition *Féminin-Masculin: Le Sexe de l'Art*, held at the Pompidou Centre, Paris in 1995, Louise Bourgeois was among Chadwick's fellow exhibitors.

Chadwick's work prompts the viewer to contemplate our bodily existence. Describing meat as 'a red

mirror', she produced two series of transparencies mounted in light-boxes, *The Meat Abstracts* (1989) and *The Meat Lamps* (1989–91). The light bulbs and wires protruding from flesh in these works vividly depict the mystery of mind housed within body, and the rich textures of the meat make us feel almost as if we are touching rather than looking. The appeal to senses other than sight was developed in *Piss Flowers* (1991–2) and *Cacao* (1994). The flowers evoke the memory of basic bodily functions. The smell and sound of bubbling chocolate in *Cacao* was as compelling as its appearance.

Chadwick's exhibition *Effluvia*, at the Serpentine Gallery, London, in 1994, featured *Bad Blooms*, in which sticky cleaning and cosmetic fluids were arranged into lurid displays.

In works made just before her death, Chadwick's theme was the origin of life. During a residency at the Assisted Conception Unit of King's College London, she photographed pre-embryonic cells from IVF treatment, transforming them into jewel-like constellations titled *Unnatural Selection*, suggested by the process of value grading shared by jewellers and the new technologies of fertility. In her book *Enfleshings* (London 1989) the artist described her awareness of the brevity of life as a catalyst for creativity: 'Duration makes moments of coupling all too finite. To compensate all we have is exchange, the heat of our physicality an impulse to activity.' A memorial show, *Stilled Lives*, toured from the Portfolio Gallery, Edinburgh in 1996, and an exhibition was held at the Ferens Art Gallery, Hull, in 1999.

EVELYN CHESTON
1875–1929

Evelyn Davy trained at the Slade. During her studentship she won a joint award for figure painting with Augustus John and her prize-winning work, *A Negress, Seated, Seen from Behind* is still in the collection of University College London. She then joined Walter Russell's landscape painting class in Richmond, Yorkshire, where she met the artist Charles Cheston, who became her husband.

Cheston's landscapes are full of light and vitality, reflecting both the teaching of Philip Wilson Steer at the Slade and her interest in the Impressionist paintings she had seen on a visit to Paris in 1912. Cheston remained friends with her old tutors, Steer, Henry Tonks and Frederick Brown, and they visited the Chestons' home in Studland, Dorset. In common with Vanessa Bell, Cheston painted the sweeping bay there. She exhibited regularly at the New English Art Club, and in 1908 became one of the few women to be elected a member.

Two years after Cheston's death a retrospective was held at the Mappin Art Gallery, Sheffield, and her husband published a book on her life and work,

Evelyn Cheston
Betchworth Lane, October, 1917
Watercolour on paper
25 × 37 (9⅞ × 14⅝)
Purchased 1924

Evelyn Cheston (London 1931). He described the discrimination she had faced as a woman artist. She had entered a painting of Studland Bay for the *Nameless* exhibition at Colnaghi's Gallery in 1920 (where artists exhibited anonymously), which was admired by a prospective client. On finding out that the artist was a woman, the client withdrew from the purchase. Charles Cheston commented: 'the general conception of women's abilities at that date was wholly inadequate. The Parliamentary vote, it is true, had been fought for and at last won . . . but their flights across continents or supremacy as marksmen were unimagined, and one suspects that art collectors had not foreseen their future.'

EMMA CIARDI
1879–1933

The Fine Art Society held a memorial exhibition of Emma Ciardi's paintings in the summer of 1934. She was born in Venice, where her grandfather, father and brother were all artists, and learnt to paint under their instruction. Ciardi attempted to emulate the Italian artists she admired, Guardi and Canaletto. Her work was acclaimed during her lifetime, she was made an Honorary Academician at the Royal Academies of Art in Venice and Milan, and won medals at international exhibitions.

Over twenty years earlier, Ciardi had shown eighty paintings at the Leicester Galleries in London. Her exhibition there featured London cityscapes, including *Oxford Street, From Waterloo Bridge* and *Nelson's Column*. Also on show were her paintings of Venice. *La Regatta Vicino al Rialto, Venezia*, a sweeping view of gondolas crowding the waterway, was bought by Mary Davis and her husband. The Davises were also the first owners of *Diaphanous Day* (1924), a painting of Venice, which they donated to the Tate.

Diaphanous Day had been exhibited at Ciardi's 1928 exhibition at the Fine Art Society, *Paintings (Fantastic and Venetian Subjects)*. 'Fantastic' subjects referred to the genre paintings Ciardi also became known for, with titles such as *Le Jardin d'amour* and *Le Rendez-Vous*. They depicted Italian ornamental gardens, including the Villa d'Este and the Villa Borghese, inhabited by elegant figures in eighteenth-century costume. Ciardi's paintings are likely to have tapped into a desire to re-invent the past as an idyllic, untroubled age, an escape from the modern world. Several were owned by the Italian royal family.

EDNA CLARKE HALL
1879–1979

In her unpublished memoir (Slade Archive), Edna Waugh recalled her first day at the Slade and an encounter with the tutor, Henry Tonks: 'I was standing shyly by the Venus de Milo, sketchbook in hand, when a very tall man came up to me. He asked for my book, glanced through it, and remarked: "So you are going to be a second Burne Jones?" "No," I replied promptly, "A first Edna Waugh".' Waugh took painting lessons from Gwen John, although she made drawing the focus of her work (Waugh's sister Rosa, also a Slade student, founded a teaching studio for women in London, and among her students was Helen Saunders). An early portrait by Waugh of herself with fellow Slade student Grace Westray (location unknown) commemorated these circles of women training together.

At the age of nineteen Waugh became Mrs Clarke Hall, wife of a barrister. Alison Thomas gives an account of Clarke Hall's struggle to reconcile her artistic vocation with

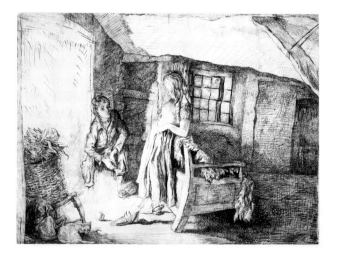

Edna Clarke Hall
Catherine Earnshaw and Heathcliffe at Wuthering Heights, c.1910–11
Pen and ink on paper
55.9 × 74.9 (22 × 29½)
Purchased 1941

marriage in *Portraits of Women: Gwen John and her Forgotten Contemporaries* (London 1994). She began to exhibit at the New English Art Club, participating in the shift towards the appreciation of drawing as an art form in its own right. Her work, in which figurative, sometimes romantic, subject matter is rendered in vigorous line, was also exhibited at Vanessa Bell's Friday Club. A series of illustrations made for Emily Brontë's *Wuthering Heights*, but never published, are now in the Tate Collection.

Clarke Hall was the first woman to have a solo exhibition at London's Chenil Gallery, in 1914, the *Saturday Review* describing her as a 'sensitive and expressive draughtswoman who can reach a masterly plane'. She exhibited regularly at the Redfern Gallery. Her work was seen alongside that of Alexandre Benois and the Camden Town Group at Manchester City Art Gallery in 1939, and a retrospective held in London (Milne and Moller, Max Rutherston) in the year of her death.

PRUNELLA CLOUGH
1919–1999

Prunella Clough began her career making figurative paintings of working people and their environments, including *Building Site* (1956, Sheffield Galleries and Museums Trust) and paintings of printers, fishermen, factory workers and lorry drivers. She then rejected the depiction of human presence in a literal form, and instead painted 'urban still-life', small areas of lived-in and worked-in sites, and objects bearing the scars of hard use. Clough described this process of editing down: 'The problem is finding a form for the urban chaos, because visually any scene in a fully urbanised context is overloaded. It is a problem of reduction, and simultaneously finding a form for the subject.'[15]

The modernist designer Eileen Gray was Clough's aunt, and is cited as a strong influence upon her, if not in her field of work, in her commitment to it. Clough began training in 1938 at the Chelsea School of Art, initially as a sculptor, changing soon after to painting. The war put an end to her studentship, and she worked for the Office of War Information, drawing maps and charts. In addition to developing a precision that she retained, this may also have spurred Clough into her lasting involvement in the abstraction and distillation of signs from the everyday environment.

Clough's choice of subject matter was in tune with her times. In the foreword for her retrospective at the Whitechapel Art Gallery in 1960, Michael Middleton placed her in the company of Robert Colquhoun, Keith Vaughan and John Minton. Middleton argued that, having experienced the war and its aftermath, these artists developed a romanticism that 'sprang from the mean streets of the great cities, the casual yet significant

Prunella Clough
Wire and Demolition, 1982
Oil on canvas
152 × 167 (59⅞ × 65¾)
Purchased 1982

gestures of labourers, the bizarre quirks of the human condition in the twentieth century. Revelation, not escape was its aim.' Some recent critical attention has related Clough more to French Post-Impressionism in her insistence upon the decorative, poetic possibilities of the commonplace. And, in her foreword to Clough's retrospective at Kettle's Yard, Cambridge in 1999, Emma Hill detected a wide range of precursors at work: 'Magpie-like, she has collected from the influences of Cubism, Surrealism, social realism, Abstract Expressionism, and has left from every decade of her work, paintings which are entirely contemporary to their time, yet which exist, in subtle ways poised between what preceded and followed them.'

Critics have also taken different stances with regard to the question of Clough's identity as a woman artist, and the interpretation of her work in this light. For Patrick Heron, Clough was not a 'feminine' artist, but was to be counted among the great painters, because her work was characterised by 'an enormous spatial originality and subtlety'.[16] By contrast, Sue Hubbard contended that there was 'a 'female' sensibility about her work', which Hubbard defined as 'modest', 'domestic' in scale, and 'gentle' and 'subdued' in colour.[17]

What is generally agreed, however, is that Clough's art compels the viewer to marvel at detritus transformed into art. Rubbish lying on a battered surface is the focus of the painting *Plastic Bag* (1988, Annely Juda Fine Art, London). A bundle of wire is flattened into a series of marks on a canvas but retains its scratchy knotted physicality in *Wire and Demolition* (Tate). Clough

sometimes found her finished pieces too elegant, divorced from their origins, and she struggled to retain the awkward edginess of reality. Her search led to a use of diverse media and methods. In addition to paper, board and canvas, she worked on sandpaper and formica. She was also a renowned printmaker, winning a prize for lithography at the Sao Paolo Biennial Exhibition in 1950 (the Tate Collection houses a number of her prints). But Clough's preference was for oil paint, which allowed her to create what she described as her 'beat up look'.

Clough's first solo exhibition was held at the Leger Gallery in London in 1947. In the 1960s she showed at the Grosvenor Gallery, during the following two decades at the New Art Centre, and then at Annely Juda Fine Art. In the year of her death Clough was awarded the Jerwood Painting Prize. At her funeral, at St James's Church, Piccadilly, her friend Bridget Riley read from the work of Emily Dickinson, a poet who found in the details of her everyday surroundings the material for her art.

ELISABETH COLLINS
1904–2000

In her catalogue essay for an exhibition of her husband Cecil Collins's work at the Anthony d'Offay Gallery, London in 1991, Elisabeth Collins described how she had initiated the subject matter for which he became known. 'I had made a drawing of a Fool, [Hein] Heckroth saw it and was enchanted. He eagerly talked about the Fool and its implications, about the need for magic in our time, and from that day Cecil's Fool work started.'

Elisabeth Ramsden trained as a sculptor at the Royal College of Art under Henry Moore in the late 1920s, where she met Cecil Collins. She had begun to exhibit, but following their marriage in 1931, his career took precedence. The couple lived in London, and also in Buckinghamshire, where they met Eric Gill and David Jones. During the late 1930s they became part of the community of artists at Dartington Hall. It was there, in March 1939, that Elisabeth Collins made her pencil and ink wash drawing of a fool.

The Dartington period, which lasted until 1945, was the most prolific of Elisabeth Collins's career. Her paintings of figures, in gouache, ink and watercolour, were sometimes mystical or folkloric (fools, angels, magicians and princes). The dream-like distortions of scale and strange juxtapositions recall the work of the Surrealists she met in the 1930s.

Elisabeth Collins
Another World, c.1939–40
Ink on paper
50.8 × 38.1 (20 × 15)
Purchased 1996

The Collinses collaborated on a public commission in 1973, the decoration of a chapel in Chichester Cathedral. Following her husband's death in 1989, Collins moved into his studio and had two solo exhibitions in London, at the Albemarle Gallery (1989) and at England & Co (1996).

ITHELL COLQUHOUN
1906–1988

In *Metamorphoses* Ovid told the story of Scylla, the water nymph turned to stone by a jealous rival. Painted by Ithell Colquhoun, Scylla's legs are twin outcrops of rock. The boat whose prow pushes between them and is dwarfed by them signifies a phallus. Colquhoun depicts Scylla as a symbol of dangerous female sexuality.

Although she is often described as a Surrealist, Colquhoun only took part in one Surrealist exhibition, and split from the British Surrealist group in 1940. Nevertheless, she continued to share aspects of art practice with the Surrealists, namely her interest in automatism, dreams and the occult. Colquhoun had trained at the Slade, and developed a highly finished painting technique that she attributed to the way in which drawing was taught there. But she also introduced elements of chance into her work. Her influential essay 'The Mantic Stain' (published in the journal *Enquiry* in 1949) described the different techniques by which chance effects could be created, a way, she wrote, of tapping into 'a treasury of symbolic scenes or "mind-pictures"'.

Colquhoun's paintings are sometimes macabre and sinister. *The Pine Family* (1941, Museum Collection, Arturo Schwarz, Milan) depicts brutally castrated, dismembered figures. She also made work with a political agenda. At her solo exhibition at the Mayor Gallery in 1939 she showed *Tepid Waters (Rivières Tièdes)* (1939, Southampton City Art Gallery), a commentary on the Spanish Civil War, in which sinister rivulets seep from the closed doors of a church. Colquhoun was also an incisive portraitist. A drawing of the archaeologist and classicist Humphry Payne is in the collection of the National Portrait Gallery, London, as are two self-portraits. Colquhoun also published criticism and experimental Surrealist novels, and her own library (Tate Archive) includes an 1890 edition of the journal of a woman painter from an earlier generation, Marie Bashkirtseff.

Ithell Colquhoun
Scylla, 1938
Oil on board
91.4 × 61 (36 × 24)
Purchased 1977

MAGDA CORDELL
born 1921

In the catalogue for Magda Cordell's
1956 exhibition at the Hanover Gallery,
London, the critic Laurence Alloway
described her as a successor to Jackson
Pollock and Willem de Kooning,
combining vigorous action painting
with imagery: 'a cast of women and
long-necked figures (androids with a
patina of pathos)'. The word-list he
compiled in response to Cordell's work
mixes space age terminology with
fashionable slang: 'solar, delta, galactic,
ulterior, fused, far out'.

Cordell and her husband, a musical
director at EMI, were members of the
Independent Group, which centred on
London's Institute of Contemporary
Arts in the 1950s. Cordell had a solo
exhibition of collage and monotypes
there in 1955. The group was formed by
the design historian Reyner Banham,
and then was reconfigured by Alloway
and the painter John McHale in 1954–5
in order to explore, through lectures
and exhibitions, art's relationship with
popular culture and the mass media.
The group pre-empted the British Pop
Art scene, and its influence was
recently examined by an ICA exhibition
in 1990 and in Anne Massey's *The
Independent Group: Modernism and
Mass Culture in Britain 1945–59*
(Manchester 1995).

In the exhibition of abstract art,
Statements, held at the ICA in 1957,
seventeen male artists were joined by
only four women, Cordell, Sandra Blow,
Barbara Hepworth and Mary Martin.
During Cordell's working process a
female figure often emerged from
layers of paint. She positioned the
representation of femininity by a
woman artist at the heart of an art
world in which women were
outnumbered. And the appearance of

Magda Cordell
Figure (Woman), 1956–7
Oil on board
231.2 × 152.2 (91 × 59⁷/₈)
Presented by the artist 1996

Figure (Woman), reminiscent of ancient
goddess figures, is an interesting play
on the close relationship between
modern art and archaic images
of woman.

JANET CREE
1910–1992

The Oriental Portrait was exhibited
with Janet Cree's painting *Miss Doreen
Gaskin* at the Royal Academy in 1933.
Cree was in her final year at the Byam
Shaw School of Art, studying under
Ernest Jackson, when this work was
bought by the Chantrey Bequest and
given to the Tate Gallery. She was only
in her early twenties, but had already
forged a distinctive practice. All her
Academy exhibits were small, figurative
tempera paintings.

Cree's portrait can be located as
part of the early twentieth-century
revival of tempera, a challenge to the
dominance of oil painting. The Society
of Painters in Tempera, which had
numbered Mary Sargant Florence
among its founder members, had
increased in size, and in 1930 Maxwell
Armfield published his *Manual of
Tempera Painting*. For artists working
in this medium, who included Margaret
Gere and Winifred Knights, early Italian
painting was the inspiration. This ran
counter to the narrow definition of
modern art as following a French
legacy. Cree may well have seen the
major exhibition *Italian Art*, held at
the Royal Academy in 1930.

Cree took up the conventions of
Italian quattrocento portrait painting,
with its composition of head and
shoulders set against a plain background
and the scroll declaring her identity as
artist. The contemporary vogue for all
things 'oriental' is combined here with
a style of portraiture that had been
used historically to represent wealthy,
powerful Italian sitters, but is deployed
here by Cree to depict a woman who is
not white, and who earned her living
as a professional model.

Janet Cree
The Oriental Portrait, 1932
Tempera on canvas
30.5 × 22.5 (12 × 8⅞)
Presented by the Trustees of the Chantrey Bequest 1933

NORA LUCY MOWBRAY CUNDALL
1889–1948

In her book *Unsentimental Journey* (London 1940) Nora Cundall described driving across America alone in the late 1930s, stopping along the way to hunt on horseback or go to a rodeo. Her excitement infuses the writing: 'Three thousand miles of road ahead, and God's in his Heaven.' And she had the following advice for a younger generation: 'Don't try to fill that nice opening in Uncle William's office. To hell with Uncle William. Be the black sheep of the family. Be a rolling stone.'

Cundall's book is illustrated with her oil paintings and line drawings. These include portraits of American Indians and landscapes. *Madonna of the Painted Desert*, a painting of mother and child, and *Badger Creek Rapids*, a painting of a stretch of the Colorado River between Marble Canyon and the Grand Canyon, were both exhibited at the Royal Academy in 1936. Cundall wrote that the American landscape gave her a 'feeling of having "been there before", due of course to having seen so many western films'. But her journey did not only take her out into the wilds. She visited Hollywood night clubs, and was disapproving of the fact that few Americans, in her opinion, 'know how to drink'.

After training at the Westminster school under Sickert, and at the Slade, Cundall exhibited at the New English Art Club and Paris Salon, and became a founder member of the National Society of Painters, Sculptors, Engravers and Potters. Her first solo show was held at the Redfern Gallery in 1925, and a memorial exhibition was held at the Royal Society of British Artists in 1949. In Cundall's portrait *Smiling Woman* (1922 Tate) the figure's shoulders are draped with an Indian blanket, perhaps brought back from America by the artist as a souvenir of her adventures.

MARY HALFORD, LADY DAVIS
1866–1941

Mary Davis shared an exhibition at the Fine Art Society of 'Pictures, Portraits, Fans and Frivolities' with Laura Anning Bell and Constance Rea in 1919. The fans were Davis's contribution; their titles included *A la Japonaise* and *Pierrot's Courtship*. Although it may seem a particularly trivial, feminine occupation, Maurice Denis and Paul Gauguin were among the modern artists who had designed fans in France, and, in Britain, Charles Conder. Davis knew Conder, and like him, she often painted on silk. In 1914, five years after his death, a joint exhibition of their work was held at the Colnaghi and Obach Gallery in New York.

Davis's husband made his fortune mining in South Africa. The couple settled in Britain, where they assembled an art collection including work by Canaletto, Rembrandt and Van Dyck. They also patronised contemporary artists, owning work by Whistler, and

Mary Halford, Lady Davis
Fan: Masques and Bergamasques
Watercolour on fabric
19 × 41.3 (7½ × 16¼)
Presented by Francis Howard through the National Loan Exhibitions Committee 1914

by Charles Ricketts and his partner Charles Shannon. Conder was commissioned to create silk panels for the Davises' London home in Holland Park.

Davis exhibited her work at the Grosvenor Gallery, the Leicester Galleries, the Ridley Art Club, the Royal Institute of Oil Painters and the International Society of Sculptors,

Painters and Gravers. She and her husband gave some of their collection of work by contemporary British artists to the Musée du Luxembourg, Paris (now housed in the Musée d'Orsay), feeling that British art was under-represented in France, and they also made donations to the South African National Gallery.

STANISLAWA DE KARLOWSKA
1876–1952

In the monograph on the painter
Robert Bevan, Stanislawa de Karlowska's
husband, written by their son (London
1965), de Karlowska appears as a
footnote to his story. It is asserted that
she was beautiful but 'far from being
an intellectual'. In fact, de Karlowska
had a long, dedicated career as an artist.
She trained in Cracow, Poland, and then
at the Académie Julian, Paris. After her
marriage to Bevan in 1897, the couple
moved to London, the city which
became their most important subject.
Both exhibited at the Allied Artists
Association in 1908, but while Bevan
was recruited to join first the Fitzroy
Street Group, and then the Camden
Town Group, De Karlowska was
not invited.

De Karlowska's painting combined
a modernist style (the structures of the
city streets were summarised in areas
of strong colour) with knowledge of
the vivid patterns of Polish folk art,
a characteristic that distinguished her
work from that of many of her British
contemporaries. She exhibited with the
Women's International Art Club from
the 1900s. De Karlowska was also a
founder member of the London Group,
showing with them throughout her life,

Stanislawa de Karlowska
Swiss Cottage, exh.1914
Oil on canvas
61 × 76.2 (24 × 30)
Presented by the artist's family 1954

and her painting *At Chalk Farm* (1923)
was included in the 1964 Tate exhibition
Fifty years of the London Group.

The Adams Gallery held two solo
exhibitions of de Karlowska's work,
in 1935 and 1954. At the latter, her
memorial exhibition, there were a
number of paintings of Soho Square,
including *The Square in Wartime*
(1939–40). She and Bevan were
given a joint exhibition at the Polish
Library in 1968.

CATHERINE DEAN
1905–1983

Catherine Dean had her first individual
exhibition at the age of seventy-six, at
London's Mercury Gallery. She trained
at Liverpool School of Art, and then at
the Royal College of Art during the
1920s, where she met the painter Albert
Houthuesen, whom she married in
1931. Until her husband's death in 1979,
her time was devoted to supporting his
career as an artist. She also worked as a
teacher at art colleges.

During the 1930s and 1940s, Dean
and her husband divided their time
between London and her family's
holiday home in North Wales, where
he had a studio, and she painted and
drew studies from nature. At her
Mercury Gallery show there were
paintings in oil, gouache and
watercolour of plants and domestic
subjects. There were also a city scene
near her South London home –

Fish Shop, Monday, Brixton – and two
works indicating her literary tastes,
Du Côte de Chez Swann and *Cherry Tree
and Pushkin*. Dean painted the oil
Sheep's Skull and Ferns (1935, Tate) in
Wales, while Albert Houthuesen was
portraying the miners at a nearby
colliery. It is her only painting in the
Tate Collection, which houses thirty-five
works by her husband.

SONIA DELAUNAY
1885–1979

In 1905 Sonia Terk travelled to Paris from St Petersburg to train as an artist. Five years later she married the painter Robert Delaunay there, and, in collaboration with him, created Simultanéisme, an art based on the harmonies and dissonances of colour relations, developed in response to life in the modern city.

One of Delaunay's most important works is also one of her earliest, a quilt she designed and made for her baby son in 1911 (Musée d'Art Moderne, Paris). Delaunay emphasised the fact that the quilt was home-made, using uneven fabric patches and leaving the sewing visible. She stitched together modern art, signalled by the strongly coloured abstract design, and the decorative and domestic (often marginalised as feminine). In doing so she pre-empted the practice of a number of important women artists who would work at the century's end. Delaunay recalled that her sewing led to a breakthrough in both her own and her husband's art: 'When it was finished, the arrangement of the pieces of material had a Cubist look to them, and we then tried to apply the process to other objects and to paintings.'[18]

The couple visited the Bal Bullier, the Montparnasse dance hall frequented by artists, wearing 'simultaneous' clothes made from irregular pieces of a variety of fabrics. Writing in 1914, the poet and critic Guillaume Apollinaire described one of Delaunay's dresses as 'areas of bright, delicate or faded colours, combining old rose, tangerine, 'nattier' blue, scarlet, etc., appearing in juxtaposition on different materials such as woollen cloth, taffeta, tulle, flanelette, moiré and matt silk.'[19] Delaunay made a series of paintings evoking the bustle of the boulevards,

including *Étude de lumiere, boulevard St Michel* (1912, Musée Nationale d'Art Moderne, Paris). *Prismes électriques* of 1914 (Musée Nationale d'Art Moderne, Paris) was exhibited in that year's Salon des Indépendants, and re-creates the dazzle of the new electric lamps illuminating Parisian public space. The use of rhythm and colour developed in these early works was still shaping her painting decades later, as in *Triptych* (1963, Tate).

Almost hidden in the composition of *Prismes électriques* is a block of text in which the name of a poet friend, Blaise Cendrars, is visible. Delaunay designed books for the writers of her circle, Cendrars, Apollinaire and Arthur Rimbaud. For Cendrars's poem *La Prose du Transsibérien et de la petite Jehanne de France*, which tells the story of a train journey from Moscow to Paris, she created a volume whose pages unfolded to two metres in length, a visual metaphor for the rail track stretching out before the passengers. Delaunay dressed her poet friends in embroidered waistcoats, and created a new stitch suitable for her designs based upon her knowledge of the traditional embroidery of the Ukraine. Her work tied in with the vogue in Paris for all things Russian stimulated by the Ballets Russes, and among her clients were the film star Gloria Swanson and the socialite Nancy Cunard. Delaunay also designed for the stage and cinema, working on Diaghilev's production of *Cleopatra* in London in 1918. Having become friendly with the Dada circle in Paris, she created designs for Tristan Tzara's *Le Coeur à Gaz* in 1924, and, with her husband, designed for the films *Vertige* and *Le P'tit Parigot*, made two years later.

Sonia Delaunay
Prose on the Trans-Siberian Railway and of Little Jehanne of France, 1913
Watercolour and relief print on paper
195.6 × 35.6 (77 × 14)
Purchased 1980

By 1920 Delaunay had begun to produce her decorative art on a commercial scale. She was careful to continue to weave together her work as a fine and a decorative artist, and to make clear that she took both equally seriously, exhibiting her paintings and fashion designs together. The shapes Delaunay used in her art and her textiles are similar in their simplicity and in their vibrant colours. Printed onto fabric, her circles, spirals, waves and lozenges are not clean-edged. A slightly blurry irregularity signals the hand of the painter.

At the *Exposition des Arts Décoratifs* in Paris in 1925 Delaunay exhibited with the designer Jacques Heim, her partner in her new fashion atelier. The same year the artist and theorist André Lhôte edited a book on Delaunay, combining reproductions of her work with poems by writers of her circle. He wrote of 'the agreeable way in which she covered the sweet undulations of the human body with a geometrical architecture'.[20] Delaunay was concerned with emphasising and 'liberating', rather than hiding or altering, the natural shape of the female body. Two years later she lectured at the Sorbonne on 'The Influence of Painting on the Art of Clothing'. Delaunay's designs diversified to include a Citroen B.12 car, covered in her signature blocks of colour, and beachwear. She also created simple cut-out dress patterns for working women to make.

Delaunay's many exhibitions included two retrospectives at the Musée Nationale d'Art Moderne, Paris (1967 and 1975). She joined the group Abstraction-Création in 1932, and was a founder member of the Groupe Espace in 1953. Working into her old age, she was awarded the Grand Prix de l'Art Féminin in 1969, and, six years later, designed a UNESCO poster for the International Year of Women.

JESSICA DISMORR
1885–1939

Jessica Dismorr trained at the Slade from 1902–3, under the American painter Max Bohm in Etaples in 1904, and in Paris in the early 1910s at the Académie de la Palette, where the teachers included Metzinger, de Segonzac and J.D. Fergusson. During her career she exhibited with the London Group, the 7 & 5 Society and Abstraction-Création. But it is for her involvement in Vorticism, alongside the only other woman member of the group, Helen Saunders, that she is now remembered, even though few of her works from this period have been traced. She joined the Rebel Art Centre in 1914, was a signatory of the manifesto in the Vorticist publication *Blast* in that year and contributed to the group's exhibitions. Later, in 1920, she showed her work as part of Wyndham Lewis's Group X.

Urban space is often the subject of Dismorr's Vorticist art and writings, such as the prose and poetry published in *Blast II* (1915). As Jane Beckett and Deborah Cherry have argued in 'Women under the Banner of Vorticism'

Jessica Dismorr
Abstract Composition, *c.*1915
Oil on wood
41.3 × 50.8 (16¼ × 20)
Purchased 1968

(*ICSAC Cahiers 8/9*, Brussels 1988), Dismorr's images of the city are characterised by a 'multiplicity of view', a destabilising of boundaries that particularly resonates with women's experience. From the late nineteenth century onwards numbers of middle-class and upper-class women had begun to carve out careers and live independently in London, as Dismorr did. For Dismorr and Saunders, the Vorticist rejection of the status quo and embrace of the modern age chimed with their desire to radically rework women's role. Indeed, the first edition of *Blast* had asserted that suffragettes and artists were 'the only things . . . left in England with a little life in them'.

In 1925 Dismorr had her first solo exhibition at the Mayor Gallery, London. During the late 1920s and 1930s she made portraits. She painted the artist Katherina Dawson Giles, whom she had met in Etaples in 1904 and whose family home in London she shared for a number of years in the 1930s, and also made a series of drawings of young poets, including Dylan Thomas and Cecil Day Lewis. Her later paintings, such as *Related Forms* (1937, Tate), moved again towards abstraction: cool arrangements of soft green-grey and putty colours. The work of Dismorr and Giles was seen together at a joint exhibition at the Fine Art Society, London, in 2000. The accompanying catalogue by Quentin Stevenson gives an overview of their lives and careers.

EVELYN MARY DUNBAR
1906–1960

Combined in Evelyn Dunbar's work is a preference for working on a large scale and picturing sweeping perspectives (she was a member of the Society of Mural Painters), with a botanist's eye for minute detail. Dunbar trained at Rochester and Chelsea Schools of Art, and then at the Royal College of Art from 1929 to 1933. In her final year as a student she began a series of murals at Brockley County School for Boys (now the Prendergast School). The paintings, which are still in place, show the school in the far distance, boys clambering down steps towards it. Foliage and flowers in the foreground are painted with delicate precision.

In 1939 Dunbar was about to open an art gallery when the outbreak of war put a stop to her plans. The following year she became one of only two women to be 'specially employed' as a war artist over a prolonged period. Dunbar travelled the country painting women's activities, particularly those of the Women's Land Army. She described

Evelyn Mary Dunbar
A Land Girl and the Bail Bull, 1945
Oil on canvas
91.5 × 182.9 (36 × 72)
Presented by the War Artists Advisory Committee 1946

working on *A Land Girl and the Bail Bull*, which she painted in just four months, in a letter of 1945 (Imperial War Museum Archive): 'All the observation had to be done before 5am and once we did an all night journey of about 100 miles to the farm where the idea came into being, arriving at 4 o'clock in the morning, and came back the next day!' In *Landgirls Going to Bed* of 1943, one of her paintings in the Imperial War Museum, the viewer looks down from the top of a bunk bed on women absorbed in their preparations.

After the war Dunbar joined the New English Art Club, and from 1950 taught at the Ruskin School of Drawing. During the last two years of her life she painted murals at Bletchley Training College. An exhibition of her work is being planned by the Imperial War Museum.

JOAN EARDLEY
1921–1963

As a student at Glasgow School of Art, Joan Eardley's promise was noted, and she was awarded the James Guthrie Prize for portraiture. On a travelling scholarship to Italy and France for six months in 1948–9, she admired the work of Massacio, Fra Angelico and Giotto. Her own paintings and drawings focused on peasants, and the weight of their presence and the expressive, almost clumsy line with which they are described recalls van Gogh. The life of the poor runs as a constant theme through her art as she travelled back from Italy to the streets and tenements of Glasgow. She shared her interest in such subjects with the wider cultural mood of her time, and with Scottish compatriots such as James Cowie, who taught at an art summer school she attended in 1947.

Eardley worked in the most deprived areas of Glasgow – Townhead, Greenock and Port Glasgow – and described her motivation: 'The character of Glasgow lies with its back streets where the people are, something that's real.'[21] (She also taught at Glasgow School of Art.) From this period a body of work emerged in which the lives of the neighbourhood children took centre stage. Eardley captured the painful awkwardness, and the exuberance, of childhood. These are not sentimental, simplistic images. In contrast to the gawky, boisterous cheek of her street children at play there are portraits of a daughter of the Sampson family of Townhead, who appears in *Little Girl with a Squint* (c.1962, Dumfriesshire Educational Trust) and other works as a fragile, introspective figure.

Eardley's art absorbs the viewer in its physical characteristics, the textures of pastel or layered and worked paint, sometimes mixed with sand or grass, and the bold use of graffiti and collage.

The newspaper stuck onto some paintings performs the dual role of having a strong formal function within the structure of the work, while forcefully reminding us of the stuff of everyday life. Graffiti also has a compositional role, while also evoking the milieu of the young urban poor.

Eardley bought a house and studio in the fishing village of Catterline, on the north-east coast of Scotland, in 1956, and shifted her artistic focus to the landscape (she also retained her Glasgow studio). Her series of paintings of salmon nets staked out against the wind record the working reality of village life. They also convey the artist's delight in the abstract division of net posts across the picture surface, and the painterly loop, swing and tangle of the nets. There are clear parallels between the works of this period and the art of the American Abstract Expressionists,

Joan Eardley
Salmon Net Posts, c.1961–2
Oil on board
118.5 × 217.5 (46⅝ × 85⅝)
Presented by the Friends of the Tate Gallery 1986

particularly de Kooning, and Pollock, whom Eardley admitted to an interest in.[22] As she had previously done in Glasgow, Eardley observed her often bleak surroundings with an eye to their translation into art: 'Certainly the coldest and worst day of the year – a most exciting day too with every variation of colour – black sea, bright green sea, yellow sea and no sea.'[23] The gestural, expressive paint that characterises her Catterline work creates a vivid sense of the commotion of wind and sea. In *The Wave* (1960–1, Scottish National Gallery of Modern Art, Edinburgh) what appears almost to be a solid wall of water is about to crash onto the shore.

The force and vitality of Eardley's work, and the uncompromising practicality of her appearance – cropped hair and dressed in fisherman's jumpers and trousers in an era when the fashion was for a feminine, full-skirted silhouette – led to some confusion among the critics of her day, as Elizabeth Foster uncovered in her thesis on Eardley's art and its critical reception.[24] For several of the writers on the artist, painting and personal appearance were to read as signs of masculine or feminine identity, and both Eardley and her work were troubling. Nevertheless, she received the accolade of election to the Royal Scottish Academy.

Eardley's first solo exhibition was held at the Gaumont Cinema, Aberdeen (1950); her London shows included the St George's Gallery (1955) and Roland Browse and Delbanco (1963). The critic for the *Glasgow Herald*, reviewing the Arts Council exhibition *Four Scottish Painters* held in Edinburgh, in which Eardley participated just before her death, was unequivocal in its praise: 'Eardley has forged her own hard language (never elegant, although within it can be found tenderness and delicacy as well as sheer strength and power), which she uses not to charm the senses out of the body, so to speak, but to communicate relentlessly at times almost in a manner possessed, her over mastering concern, her concern in fact with sheer existence.' An Arts Council memorial exhibition of Eardley's work toured from Glasgow and Edinburgh in 1964.

CELINE EMILIAN
born 1902

Celine Emilian was born in Paris of Romanian parents. She trained in the atelier of the sculptor Antoine Bourdelle in the early 1920s, and worked as his assistant. Bourdelle's influence can clearly be seen in Emilian's work, such as in the bronze bust *Angela* (1930, Tate), which has a classical calm and solidity, but also a stylised, summarised, modern character. She made a bronze bust of her teacher, as a tribute to him.

Although she returned to Romania, Emilian travelled back to Paris every year to work for Bourdelle. She made bas-reliefs for the Eglise St Remy at Rheims, France, and showed her work at the Paris Salon. She also made regular visits to her studio in Rome, and her work was exhibited at the Venice Biennale in 1934 and 1936.

Emilian made two relief sculptures for the Romanian Pavilion at the Paris International Exhibition in 1937 and was commissioned to carve twenty marble statues of past queens of Romania for a Bucharest park during the early 1970s. Major retrospectives of her work were held in the city, at the Stalin Park in 1957, and at the Sala Dalles in 1979, where 132 sculptures were shown. These reflected her travels. There were busts of the French pianist Alfred Cortot, and the Italian dramatist Luigi Pirandello. Emilian's exhibition was also shaped by the political situation in Romania at the time. First on the catalogue list was a bust of the Communist president, Nicolai Ceasuescu, and a full-length sculpture of his wife Elena, portrayed as an imposing, implacable figure.

FLORENCE ENGELBACH
1872–1951

Following her marriage in 1902,
Florence Engelbach stopped painting
for many years. As Florence Neumegen,
she had trained at the Westminster
School of Art and the Slade during the
1890s. She painted figure studies with
titles such as *Breton Woman Knitting*
and *French Peasant*, and had begun
to exhibit at the Royal Academy.
The catalogue essay of her memorial
exhibition, held at the Leicester
Galleries, London in 1951, described her
as 'a fine example, to those numerous
women who, starting on an artistic
career, marry and allow domestic life
to crush all their early ideals and so be
buried in a hum-drum existence …
she restarted painting in 1931 – and
from then, until the time of her …
death she painted as one inspired.'

Engelbach's work changed from her
student days. The sombre, close-toned
subjects gave way to sensuous paintings,
with strong colours and effects of light.
These were mainly of flowers, but she
also painted landscapes, nudes and
portraits. In his catalogue foreword for
an exhibition of her flower paintings at
the Lefevre Galleries in 1934, the then
Tate director J.B. Manson praised her
work, but in such a way that the
difficulty women faced trying to be
taken seriously when painting such

Florence Engelbach
*Roses, c.*1934–8
Oil on canvas
35.6 × 40.6 (14 × 16)
Presented anonymously 1939

subjects is apparent: 'Mrs Engelbach's
pictures are simple works of art;
expressions of feeling and delicate
perception. They are not intellectual
contrivances.'

Engelbach's paintings were
exhibited at the Beaux-Arts Gallery,
run by Major and Helen Lessore,

the Society of Women Artists and
elsewhere. She was elected a member
of the Royal Institute of Oil Painters
and the National Society of Painters,
Sculptors, Engravers and Potters.

CLAIRE FALKENSTEIN
1909–1997

Interviewed by *Vogue* in June 1959
(with Gillian Ayres), Claire Falkenstein
listed what she used to make her
sculptures: 'Iron, brass, glass, silver,
stainless steel … Oxy-acetylene
lamps and goggles.'

After training with Alexander
Archipenko at Mills College, Oakland,

USA and then at Stanley Hayter's
Atelier 17, Falkenstein stayed in Paris
from 1950 to 1962. She was included
along with Germaine Richier and Maria
Vieira da Silva in the exhibition *L'Ecole
de Paris? 1945–64* in 1998–9 at the
Fondation Musée d'Art Moderne,
Musée National d'Histoire et d'Art

de Luxembourg. Influenced by
developments in science, cosmology
and philosophy, Falkenstein made
sculptures exploring notions of space
as endlessly extending, rather than
enclosed, with titles such as *Nuclear,
E=MC², Gravity, Sun, Planet Mars*, and
Element. She made individual units

or 'signs' which were then arranged in spatial relationships as 'sets' or 'ensembles', emulating scientific structures. These include the sculpture in metal, *Century Point as a Set No.26* (1970–1), in the Tate Collection.

Falkenstein also designed jewellery, and the decor for a dance performance in New York in 1958 in which the set projected out from the stage into the audience. During 1968–9 she made doors, and windows (reaching up to nearly forty metres high), for St Basil's Cathedral, Wiltshire Boulevard, Los Angeles. The traditional leaded armature of stained glass was replaced by steel, and given a much weightier presence, the glass jutting out in fractured layers, so that they appear almost to be sculptures rather than windows. In 1961 the American art patron Peggy Guggenheim commissioned a pair of gates for the Venetian palazzo housing her collection. Falkenstein enmeshed lumps of coloured Murano glass in a web of iron, a metaphor for human existence within the infinite connections that form the universe. Guggenheim loved the finished piece, and was amazed that Falkenstein had welded the gates herself, writing in *Art of the Century* (New York 1979) that it was 'a tremendous job for a woman'.

HILDA FEARON
1878–1917

Hilda Fearon was part of a circle of artists in St Ives in the 1900s. She had studied in Dresden, and at the Slade, before travelling to Cornwall to train under the painter Algernon Talmage. Talmage, whose wife was also a painter, taught students to work *en plein air*, observing light effects on the figure and the landscape. Fearon portrayed her teacher smoking and reading. His estimation of her work is evident in that he presented the painting of hers that he owned to the Tate Gallery.

Fearon's sister, Annie, was also an artist. She painted biblical subjects, and married the Vicar of St Hilary Church, near Marazion, Cornwall. Through Hilda and Annie's contacts, the church was decorated with paintings of the saints by contemporary Newlyn artists. Annie Fearon also painted the altarpiece triptych for Truro Cathedral, among other church commissions.

Hilda Fearon exhibited at the Royal Institute of Oil Painters (becoming a member in 1910), the Walker Art Gallery, Liverpool, the Paris Salon and the Carnegie Institute, Pittsburgh. She showed her work most regularly at the

Hilda Fearon
The Tea Party, 1916
Oil on canvas
54.6 × 66 (21½ × 26)
Presented by Algernon Talmage 1936

Royal Academy. The eighteen works she exhibited there are mainly domestic scenes, such as *The Breakfast Table* and *Nannie Bessie and John*, both exhibited in 1916, and landscapes, including *The Road Across the Downs*, shown in the year of her death. Sunlight plays across figures in Fearon's work, often mothers and children. The peaceful, domestic subject matter of her paintings, and their academic polish, are likely to have given their viewers at the Royal Academy a comforting sense of continuing tradition in the midst of the 1914–18 war.

SHEILA FELL
1931–1979

Writing in the *Studio* in 1958, John
Dalton observed of Sheila Fell, 'It is
her constructing power, her designing
which is strong, recalling at times
Sutherland in Pembrokeshire or Keith
Vaughan: a question of drawing. The
shapes are rammed home, drawing
and designing together. There are even
hints of Permeke and Chagall, not only
in her subject – simple duties of the
land, weddings, processions, mysteries.
And further back, in her boldness and
concentration of a universe within a
village – gleams of Samuel Palmer.'
Dalton concluded, 'Sheila Fell has
discovered, like Paul Nash and Ivon
Hitchens, the secret of place.'[25]

Fell was the daughter of a miner,
and born and brought up in the small
mining town of Aspatria, Cumbria.
Her working-class background made
her an unusual art student. She recalled
the difficulties she faced at St Martin's
School of Art in the catalogue for
her South Bank Centre (and tour)
retrospective of 1990–1: 'My room cost
thirty shillings a week, which left only
ten shillings for food, soap, stamps and
materials. The teacher at the art school,
sick of seeing me wearily drawing,
week in week out, borrowed paints
and brushes from the other students
one day in order to help, which made
me feel terribly ashamed and slightly
like a charity.' Fell wrote about her
experience in an essay for
*Breakthrough Autobiographical
Accounts of the Education of Some
Socially Disadvantaged Children.*[26]

Fell's art focused on the relationship
between workers and their environment,
a choice of subject matter shaped by
her background, and by art history.
Her paintings of toiling labourers, such
as *Potato Pickers 1* (1960, Arts Council
Collection) clearly draw upon her
admiration for van Gogh. She can also

Sheila Fell
Maryport, Cumbria, 1965
Oil on canvas
101.9 × 127 (40⅛ × 50)
Presented by the Trustees of the Chantrey Bequest 1980

be located firmly within her time, in
tune with the taste for harshly realist
subjects in mid-twentieth-century
British culture, and her work was
included in the exhibition *The Forgotten
Fifties* that toured from the Graves Art
Gallery, Sheffield, in 1984. Communities
in Fell's art centre on work, and she
painted those she knew from her
immediate surroundings, as in *Houses
Near No. 5 Pit* (1957, Walker Art Gallery,
Liverpool). The furrowed paint in *Silage
Heaps near Drumburgh II* (1964,
Swindon Art Collection) vividly
represents churned earth. Fell stated
emphatically, 'I have no interest in any
painting which does not have its roots
in reality – or tap root at least, in fact,
primarily. The closeness of my
relationship with Cumberland enables
me to use it as a cross section of life. All
the landscape is lived in, modulated,
worked on and used by man.'[27]

In her feel for the dour, melancholy
beauty to be found in the resolutely
unpicturesque, Fell also shares an
approach with L.S. Lowry. They met
in 1956 after he bought two of her
paintings – he was to own a total of
fifteen of her works – and became
friends. They visited Yorkshire together
and the town of Maryport in Cumbria,
where Fell made a series of paintings.
In Lowry's *An Island of 1942* (Manchester
City Art Galleries), a derelict house is
marooned in the centre of an industrial
wasteland (one of a series of paintings
he made of solitary buildings). Fell's
Deserted House on the Yorkshire Moors 1
transposes a similar subject matter and
mood, an abandoned home with dark
windows, onto the purplish-brown hills,
under an oppressive sky.

Fell painted few portraits, but
they are notable for their strength of
construction and lack of sentimentality.

A painting of her mother of 1958 (Private Collection) owes a debt to Cézanne in the arrangement of the stolid figure, sitting with her hands in her lap. Six years later Fell was commissioned by Somerville College, Oxford, to paint Dorothy Hodgkin, the Nobel Prize-winning scientist.

The development of Fell's work was described by Helen Lessore in her catalogue essay for the South Bank Centre retrospective. Lessore observed that the heavy lines and sombre earth colours Fell used in her early paintings 'have the mysterious force of legends and old ballads'. Lessore identified a shift towards the end of the 1950s to a concern with the abstract elements of the work, and a parallel lightening of palette. Fell's later paintings are sometimes characterised by a rich expressionist impasto and the use of orange and yellow.

Lessore was particularly qualified to write about Fell, having given the artist her first solo exhibition at the Beaux-Arts Gallery in 1955. Fell had graduated from St Martin's School of Art only four years previously. The show was an immediate critical success, and Lessore subsequently organised four more individual exhibitions. Fell's association with the Beaux-Arts Gallery meant that she was in the company of the other artists who exhibited there, Frank Auerbach, Leon Kossoff, Francis Bacon, Michael Andrews and Lucian Freud. In 1957 Fell was awarded a prize at the John Moore's Liverpool exhibition, and was elected Royal Academician in 1974.

ELSIE FEW
1909–1980

Elsie Few was born in Jamaica and moved to London, where she studied at the Slade in the late 1920s, at the same time as William Coldstream. She painted subtle, tonal landscapes, figures and still lifes, worked with the Euston Road School, and married one of its founder members, Claude Rogers. The organisation of the early exhibitions of this group is a telling example of how women have been edited out of art history. Few had shared an exhibition with Rogers and Victor Pasmore at the Burnett Webster Gallery, Kingston, Jamaica, in 1936 (she had her first individual exhibition there in the same year). In 1948 her work was included in the survey show of Euston Road artists and students held at Wakefield City Art Gallery. But when, in the same year, the Arts Council created what they called 'a concentrated version' of the Wakefield exhibition, no women artists were included. Few's paintings, and those of Sylvia Melland, who had been a Euston Road student, were not shown. Few's portrait *Thelma Painting at the Euston Road School* (1938) is likely to be a painting of Thelma Hulbert, another woman who had worked at Euston Road, but was also conspicuously absent from the Arts Council exhibition.

Elsie Few
Bradfields, 1947
Oil on wood
30.5 × 35.6 (12 × 14)
Purchased 1981

From 1934 onwards Few exhibited with the London Group. Her career as an artist was combined with work as an art teacher. During the late 1960s Few's practice changed from figurative painting to abstract collage, which was the focus of a solo exhibition at the Whitechapel Art Gallery in 1973. She used a variety of papers, from fine Japanese paper to scraps found on the street. Some of the pieces of paper had personal associations for her, creating an interplay between subjective memories and the paper's purely formal properties. A year after Few's death a memorial exhibition of her work was held at the Bury St Edmunds Art Gallery.

ELSA FRAENKEL
1892–1975

Following the rise of the Nazis in Germany, Elsa Fraenkel and her husband travelled to Paris. She took a studio there, studied the Louvre collections, and met Brancusi and Mondrian. The bronze head *A Young Frenchman* (1935, Tate) is a portrait of a friend's husband, the painter Marcel Derulle. Fraenkel portrayed him with his eyes closed, a thoughtful stillness settling across his features. This invokes the tradition of taking masks of a sitter's face, either from life or posthumously, creating a feeling of both immediacy and suspense. The sense of the sitter having turned away from the world towards his interior life recalls the work of the Symbolists, and also suggests a strategy adopted in defence against the troubling times. In the year that she made this portrait Fraenkel and her husband moved again, settling in England.

Fraenkel trained at the Karlsruhe Academy and in Paris, and travelled through Italy, Spain, Portugal, Africa and India studying the cultures of these countries, before the political situation forced her into exile. In England she became an art teacher, in addition to working as a sculptor of portrait busts. Her sculpture was shown at the Anglo-Jewish exhibition held at the Ben Uri Gallery, London, as part of the Festival of Britain in 1951. Jewish artists, many of whom had left their home countries as part of successive waves of refugees, were exhibited together, and Fraenkel's work was shown with that of David Bomberg, Mark Gertler, Jacob Kramer, Isaac Rosenberg, Lily Delissa Joseph and Clara Klinghoffer.

ELISABETH FRINK
1930–1993

Elisabeth Frink is among the best-represented women artists in the Tate Collection. One of her most important works is a recent acquisition, *Dying King* (1963). As is typical of Frink, the roughly worked surface signals the hand of the artist. Although the subject might seem classic, it was also contemporary. Death and suffering was a major theme in post-war European sculpture, and Frink was influenced by Laurence Olivier's film of Shakespeare's *Richard III* (1955), in which the final battle scene climaxes with the dramatic killing of the king.

Helen Lessore gave Frink her first break, inviting her to show in a group exhibition at the Beaux-Arts Gallery in 1952. The young sculptor was still a student at Chelsea School of Art, and cited Alberto Giacometti, Henry Moore and Germaine Richier as her favourite artists. Among the work she exhibited was a bronze, *Bird*, which was bought by the Tate Gallery. *Bird* was a predator, spiky and aggressive, cast in cold metal and symbolic, perhaps, of the danger that had filled the skies during the recent war. A significant strand of Frink's work was made in response to current events and politics. She was one of the British winners of the international competition for a monument to the Unknown Political Prisoner in 1953, entering a plaster maquette of a man with a raven on his wrist. Living in France during the 1960s, the time of the Algerian war, she worked on a series of sinister sculptures, the *Goggle Heads*, which she described as 'a political comment' on the atrocities there.[28] Frink became involved in Amnesty International, designing posters for them and donating work for sale on their behalf. She depicted martyrs and victims in her *Tribute Heads* (1975–7). Even works that seemed to have no overt political symbolism, such as the running man sculptures of the late 1970s and 1980s, grew out of her preoccupation with human rights: the men represented fugitives.

Frink focused on male figures, rarely portraying women. Her men can be menacing, but are often vulnerable, unheroic and contemplative. Her *Horizontal Birdman* of 1962 at Manchester Airport is falling helplessly. And there is an intriguing mystery at the centre of her art, in that many of her sculptures bear a striking resemblance to the artist herself. This could be read as a form of self-portraiture, overlaid onto the male figure, although Frink refused any suggestion of androgyny in her work. She often spoke of her love for her father, and the distinctive bone structure of her figures possibly arose from her memory of him. Frink made portraits of the composer Sir William Walton, whose bust (1976) is now in the Royal Festival Hall, and the conductor Sir George Solti, whose portrait (1983) was commissioned for the Royal Opera House. She was also a prolific printmaker, and illustrated *Aesop's Fables* (London 1968), Chaucer's

Elisabeth Frink
Dying King, 1963
Bronze
Purchased with assistance from the National Art Collections Fund 1998

Canterbury Tales (London 1972), and the *Iliad* and *Odyssey* (London 1978). Her last prints, made in 1992, depicted the folkloric figure the Green Man.

Among Frink's many exhibitions were a series of solo shows at the Waddington Galleries, London, and exhibitions at the Kettle's Yard Gallery, Cambridge (1973), the Yorkshire Sculpture Park, Bretton Hall (1983, 1994) and the Royal Academy, London (1985). The National Museum of Women in the Arts, Washington DC held a major retrospective in 1990. There are now *catalogues raisonnés* of Frink's sculpture (London 1984) and her prints (London 1998).

Frink was elected a Royal Academician in 1977, and was invited to be the first woman president of the Academy, but declined, feeling that it would distract her from her work. Her affiliation with the Academy, figurative use of the traditional materials plaster and bronze, and the strong religious and symbolic current in her art, have meant that she fell out of critical favour. She has, however, been discussed in a feminist context, and her work was included in the touring exhibition *Women's Images of Men* that opened at the Institute of Contemporary Arts in 1980. The recent resurgence of the figurative and

spiritual in sculpture suggests that she may now be reassessed. An exhibition of her sculpture opened the new Jerwood Sculpture Park at Witley Court, Worcestershire, in 2000. Public works include *Walking Madonna* (1981) on the green outside Salisbury Cathedral, and a cast of the eagle she designed for the lectern of Coventry Cathedral in 1962 was chosen as the memorial for President John F. Kennedy in Dallas, Texas. Frink's last work, a powerful sculpture of the Risen Christ for Liverpool's Anglican Cathedral, was installed in the year of her death.

SUE FULLER
born 1914

Sue Fuller was born in Pittsburgh, USA. She trained under Hans Hofman, Joseph Albers, and, in common with Claire Falkenstein, with Stanley Hayter. Hayter had moved his printmaking studio, Atelier 17, to New York from Paris in 1940. There, Fuller made etchings experimenting with fabrics and textures, which led in the 1940s to a series of prints and abstract sculptural constructions made with string.

In the catalogue foreword for her 1966 solo exhibition at the Storm King Art Center, New York, Fuller wrote about working with modern materials in response to modern times: 'The latest plastic embedments contribute further dimension to the concept of drawing. The path of a trajectory to the moon or in orbit around Mars is a line drawing. Transparency, translucency, balance, precision is the aesthetic associated with such graphics. In terms of linear geometric progressions my work is visual poetry of infinity in the space age.'

Fuller combined teaching with her practice. She had a number of individual exhibitions, and along with Agnes Martin and Bridget Riley, she was one of the few women to be included in the landmark exhibition *The Responsive Eye* held at the Museum of Modern Art, New York in 1965, which

Sue Fuller
String Composition 128, 1964
Mixed media
91.4 × 91.4 × 3.8 (36 × 36 × 1½)
Presented by Enerson Crocker through the Friends of the Tate Gallery 1965

showcased artists making optical and kinetic art. Although Fuller's art was abstract and made use of new media, she sometimes incorporated conventional materials and figuration. At her Storm King Art Center show she exhibited her *String Compositions and Plastic embedments* (a process for which she was given a patent) alongside watercolours, prints and collages with titles such as *Queen Anne's Lace* and *Lancelot and Guinevere.*

MARGARET GERE
1878–1965

In 1912, Margaret Gere shared an exhibition at the Carfax Gallery with her half-brother, Charles Gere. He showed fifty-five works, to her ten. Among Margaret's Exhibits was *Noah's Ark*, which was bought by the Contemporary Art Society from the exhibition, and given to the Tate Gallery. The following year the Ashedene Press published the Geres's *Morte d'Arthur*, with three illustrations by Gere and twenty-six by her brother.

Gere studied at the Birmingham School of Art during the 1890s. She also trained at the Slade, and counted among her London friends Ethel Walker and Virginia Woolf. Gere was one of the original members of the Birmingham Group of Artist-Craftsmen, and was included in the 1975 exhibition *The Earthly Paradise: F. Cayley Robinson and the Painters of the Birmingham Group* held at the Fine Art Society, London. The Birmingham Group were involved

in the revival of tempera painting. Gere
travelled to Florence in 1900 to study
Italian painting with her half-brother
and her sister Edith, also an artist.
Participating in the first exhibition of
the Society of Painters in Tempera held
at the Carfax Gallery in 1905, she was
noticed by the *Athenaeum* critic, but the
praise was double-edged: 'It is for the
delicacy and freshness of its fancy, the
real delight in free and appropriate
invention which it discovers, that we
think it so attractive … Miss Gere's is
not a great or ambitious talent, but it
has the inexplicable quality of perfect
sincerity and ease.' Gere also exhibited
at the New English Art Club (becoming
a member), and her solo shows included
the Cotswold Gallery (1922) and the
Beaux-Arts Gallery (1929). She exhibited
regularly with the Cheltenham Group
of Artists, and a retrospective was held
at Cheltenham Art Gallery in 1984.

Gere's relationship with her
sister may have motivated her early
watercolour of two girls clinging
together, its title taken from Christina
Rossetti's poem, *The Goblin Market:
'There's No Friend Like a Sister in Calm
or Stormy Weather'*. Among her
numerous paintings of women is the
tempera portrait *Mrs Alfred Thornton*
(1916, Manchester City Art Gallery).

Margaret Gere
Noah's Ark, *c*.1909
Tempera on silk mounted on board
26.4 × 26.4 (10⅜ × 10⅜)
Presented by the Contemporary Art Society 1917

KAFF GERRARD
1894–1970

During her long, dedicated career as an
artist and potter, Kaff Gerrard had only
one significant exhibition, a joint show
at Colnaghi's in 1931, shared with her
sculptor husband (a Slade professor),
at which she showed her ceramics.

While she was at the Slade during
the early 1920s Gerrard was a star pupil,
winning a number of awards, including
prizes for painting from the cast and for
portraiture. Although she had focused
on city scenes and still life when she
was a student, Gerrard began to paint
landscape. Her work was in tune with

that of Paul Nash and her Slade
contemporary Graham Sutherland,
and she was strongly influenced by
the revival of interest in Samuel Palmer
during the late 1920s.

Gerrard painted Sussex and the
South Downs. She portrayed the impact
of the 1939–45 war, the countryside
punctuated by twisted metal and
scarred by bomb craters. Gerrard's
husband was a war artist, but her own
work was not acquired by the Imperial
War Museum until the 1990s (the
museum now owns three of her

paintings). Her work became
increasingly symbolic. The landscape
and the natural forms she found on her
regular painting excursions, such as the
strange, sculptural fungi pictured in
Tate's oil painting *Still-life with Yellow
Fungus* (*c*.1936–9), were used as a
starting point for her compositions,
which sometimes had Christian meaning.
Towards the end of her life she made a
series of intensely coloured abstract
paintings. Twenty-one years after her
death a retrospective was held at the
Royal Museum and Art Gallery, Canterbury.

EVELYN GIBBS
1905–1991

At her joint exhibition with Sylvia Melland at Zwemmer's Gallery, London in 1957, Evelyn Gibbs showed oil paintings and drawings of Italy. The catalogue described her career, beginning as a 'brilliant student' at the Royal College of Art who was awarded a Rome Scholarship in Engraving from 1929–31. To earn her living, Gibbs became a schoolteacher. Although this was easier work for women to find than art college teaching, which remained almost exclusively male, women still faced discrimination. Between the wars women had to leave teaching if they married, and were paid less than men doing the same job. Despite this, Gibbs made a success of her career. She published a book advocating the reform of her profession, *The Teaching of Art in Schools* (London 1934), in which she suggested using imaginative materials and working in response to exhibition visits, rather than just copying, which, she wrote, 'stifled the child's natural creative impulse'. This pioneering work earned her a lectureship at Goldsmiths College in the year the book was published.

Gibbs continued painting, drawing and print-making, and had a number of solo exhibitions. In the Riverside Studios' show *Six Hammersmith Artists* of 1981 her work was seen alongside that of Edna Ginesi and Mary Fedden,

Evelyn Gibbs
Low Tide, Hammersmith, 1977
Lithograph on paper, print
48.9 × 62.5 (19¼ × 24⅝)
Presented by Curwen Studio 1978

and she also exhibited at the New English Art Club, the Royal Academy, the Artists International Association and the Women's International Art Club. Evacuated out of London in 1939, Gibbs moved to Nottingham, where she founded the Midland Group in 1943, to bring regular exhibitions of contemporary art to the region. She also undertook commissions for the Imperial War Museum who own five of her works, including the oil painting *Women's Voluntary Service Clothing Exchange*, which shows women and children sorting and trying on clothes. There are drawings of women factory workers making munitions, and nurses busy with blood transfusions. An exhibition of Gibbs's work toured Britain in 2002 (including her home, Liverpool, where it was shown at the University Art Gallery), and she was the subject of a book by Pauline Lucas.

EDNA GINESI
1902–2000

Edna Ginesi was a painter of landscapes, still-lifes and flowers, and a stage designer. She trained at Leeds College of Art, where she met Barbara Hepworth, Henry Moore and Raymond Coxon, whom she was later to marry, and at the Royal College of Art from 1920–4. The award of a travel scholarship in 1924 allowed her to study in Europe. In her landscape paintings from this period, the emphatic brushstrokes which construct forms suggest that she had admired Cézanne's work on her travels, while in later work, such as *Everglades* (Tate 1964), her technique is more fluid and allusive.

From 1929 onwards Ginesi showed with the London Group, becoming a

member in 1933. Her painting *Thames-side* (1962) was included in the exhibition celebrating fifty years of the London Group at the Tate Gallery in 1964. At her first individual exhibition, at Zwemmer's Gallery, London, in 1932, Ginesi showed a London scene, a view of Hammersmith Bridge, and among the works there were also landscapes in Yorkshire and the Lake District. At this time Ginesi was also designing decor for the Camargo Ballet. The turbulent events of the 1930s and 1940s interrupted her work. She went to Spain during the Civil War, and served as an ambulance driver during the Blitz.

Late in their careers, Ginesi and Coxon shared joint exhibitions at the Linton Court Gallery, Settle in 1982, and the Michael Parkin Gallery, London, in 1985. A retrospective of Ginesi's work was held at the Cartright Memorial Hall, Bradford, in 1956.

Edna Ginesi
Landscape, North Wales, 1937
Oil on canvas
63.9 × 81.2 (25⅛ × 32)
Presented by Mrs Hazel McKinley 1938

FEODORA GLEICHEN
1861–1922

The sculptor, painter and etcher Lady Feodora Gleichen was the daughter of Prince Victor of Hohenlohe-Langenburg. Her younger sister, Helena, also became an artist. In her memoir, *Contacts and Contrasts* (London 1940), Helena Gleichen recalled: 'In those days it was a terrible thing for one's daughters to insist on having professions, but my father encouraged us each to go ahead as if we had been boys.'

After training at the Slade, Gleichen became known for portrait busts of the aristocracy, memorials and decorative architectural pieces. These included statues of Queen Victoria (a relative by marriage), Edward VII, Florence Nightingale and Lord Kitchener. Tate houses her *Head of a Girl* (c.1921). Gleichen

exhibited at the Grosvenor Gallery, the Royal Academy and the 1900 Exposition Universelle in Paris. She was elected a Fellow of the Royal Society of Painter Printmakers in 1884. An exhibition of her watercolours was held at the Cotswold Gallery, London in 1922.

Gleichen was particularly interested in women's art. She exhibited with the Society of Women Artists and left a bequest to the Royal Society of British Sculptors to fund an annual award for women. During the First World War her sister Helena Gleichen served as an ambulance driver and radiographer. She and her friend Nina Hollings (sister of the composer Ethel Smyth) constructed a portable X-ray machine. The Women's Work Sub-Committee

of the Imperial War Museum commissioned Feodora Gleichen to create models illustrating her sister's work, and *Taking a Radioscope of a Wounded Soldier on the Italian Front* and *Taking a Radiograph with the Dynamo Driven by the Motor Car* are still in the museum's collection. *The Englishwoman* magazine commented in 1918 that the first piece portrayed 'the devoted work which is being done under primitive conditions by women in medical and hospital units abroad'. Feodora Gleichen's son had commanded the 37th Division at Monchy-les-Preux, and she created a memorial to them in the year of her death.

GRACE GOLDEN
1904–1993

Grace Golden pictured London.
She studied at Chelsea School of Art,
the Royal College of Art and the Regent
Street Polytechnic, painting in oil
and watercolour, and making wood
engravings, illustrations and posters.
Golden exhibited at the Royal Academy,
the Fine Art Society and the Leicester
Galleries.

In 1951 Golden's book *Old Bankside*
was published with fifty-one illustrations
depicting the history of the area. She
described sketching the city during her
childhood, from her family home. She
wrote that she 'could see the River
Thames curving between London and
Blackfriars Bridges. The bank that joins
them on the Surrey side is known as
Bankside and towards it I feel the pride
of personal possession.' Golden drew
the riverside wharfs and alleyways, and
the new Bankside Power Station (now
Tate Modern). Her work so impressed
the actor and director Sam Wanamaker
that he asked her to be the archivist of
his project to rebuild Shakespeare's
Globe Theatre.

Free Speech (Tate), exhibited at the
Royal Academy in 1940, depicts the
crowds at Hyde Park's Speaker's Corner.

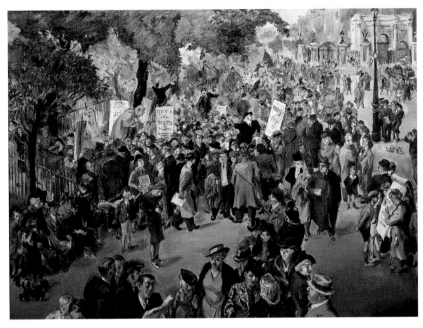

Grace Golden
Free Speech, 1940
Oil on canvas
40.6 × 55.9 (16 × 22)
Presented by the Trustees of the Chantrey Bequest 1940

The subject is likely to have seemed
timely during the war against a regime
that persecuted dissent. The War
Artists' Advisory Committee gave
Golden a sketching permit so that she
could continue to draw the city, and
bought her oil painting *An Emergency
Food Office*, in which people queuing
for ration books are observed with

humorous scrutiny (Imperial War
Museum). A retrospective of Golden's
work, *A Londoner's London*, was held at
the South London Art Gallery in 1979.
In the exhibition *Artists' London*, held
at the Museum of London in 1993,
Golden and the women's suffrage
campaigner Sylvia Pankhurst were the
only women included.

HILDE GOLDSCHMIDT
1897–1980

During her youth spent in Leipzig and
Munich, Hilde Goldschmidt's wealthy
family moved in cultural circles, and
she knew the painter Marianne
Werefkin and her partner Alexei
Jawlensky, and the writers Rainer
Maria Rilke and Thomas Mann. Training
initially in book design, her admiration
for Der Blaue Reiter prompted her to
begin painting, and when the Dresden
Academy opened its doors to women

for the first time, Goldschmidt enrolled,
studying there from 1920 for three years.

Taught by Oskar Kokoschka, her
work became expressionist, uniting
strong colour and simplified form. She
travelled, working and exhibiting in
New York in 1923, and visiting Paris in
1926, where she took a studio in
Montparnasse. Her interest in Van
Gogh led her to visit the son of Dr Gachet,
where she saw his collection of the

artist's works. She had her first solo
exhibition at the Gallery Caspari,
Munich in 1932.

Following the rise of the Nazis,
Goldschmidt moved to Britain. She
settled in the Lake District where she
befriended fellow refugee Kurt Schwitters.
According to Joseph Paul Hodin in his
book on Goldschmidt, *Way of Life*
(Portland, Oregon 1976), *The Sphinx*
is set in the Langdale landscape.

Throughout her career she continued to experiment. In the 1960s she made a series of abstract works, and her first visit to Israel in 1968 prompted a group of coloured monotypes. Goldschmidt had exhibitions at the Künstlerhaus, Vienna in 1975, and at Camden Arts Centre, London in 1976. Hodin quoted from a letter written by the artist at the age of seventy-five: 'I am a late flower. The experience of painting and the creative urge is stronger now than it was when I was thirty or forty.'

Hilde Goldschmidt
The Sphinx, 1948
Oil on canvas
88.9 × 61 (35 × 24)
Bequeathed by the artist 1982

NATALIA SERGEYEVNA GONCHAROVA
1881–1962

In her 'Thoughts on Art' written in 1912, Natalia Goncharova declared: 'Cubism is a positive phenomenon, but it is not altogether a new one, especially as far as Russia is concerned. The Scythians made their stone maidens in this hallowed style. Wonderful painted wooden dolls are sold at our fairs . . . in France, too, it was the Gothic and African figure sculptures that served as the springboard for Cubist painting. Over the last decade, Picasso has been the most important, most talented artist working in the Cubist manner, whereas in Russia it has been yours truly.'[29] The following year Goncharova exhibited over 760 works at the Moscow Art Salon. This was the first large-scale retrospective in the city given to a woman artist's – or an avant-garde artist's – work, and proved a great success. It was sponsored by the woman dealer Klavdiia Mikhailova.

One of an extraordinary group of women artists in early twentieth-century Russia, Goncharova featured alongside Alexandra Exter, Liubov Popova, Olga Rozanova, Varvara Stepanova and Nadezhda Udaltsova in the touring exhibition *Amazons of the Avant-Garde*, organised by the Guggenheim Museum, New York, in 1999–2000. Goncharova entered the Moscow School of Painting, Sculpture and Architecture in 1898. A fellow student, Mikhail Larionov, became her close collaborator. For women in the avant-garde, forging a new art could mean trying to live in new ways. Goncharova and Larionov cohabited but remained unmarried until 1955. Addressing women in an open letter of around 1913, she exhorted: 'Believe in yourself more, in your strengths and rights before mankind and God, believe that everybody, including women, has an intellect in the form and image of God.'[30]

Goncharova's early work was influenced by Gauguin and Matisse. Modern French art was being imported and exhibited in Russia by wealthy collectors. Goncharova used her knowledge of the new art as a filter through which to pass the forms and conventions of Russian popular and religious culture, peasant embroidery, hand-coloured prints (lubki), shop signs and icons. The marriage of European modernism with Russian culture is evident in *Gardening* (1908, Tate), in which barefoot women carry pots of white tulips. Goncharova defined her neo-primitive style as 'Eastern' in contrast to the rationalism of the Western renaissance, and she and Larionov organised two artist groups in Moscow, Bubnovy Valet (Jack/Knave of Diamonds) and Osliny Khvost (The Donkey's Tail), including Malevich, Shevchenko and Tatlin. The obvious influence of peasant artefacts is likely to have offended cultivated society, which tended to regard them as primitive and ugly. Goncharova's exhibition of several figure paintings at the Society of Free Aesthetics in 1910 led to her trial in court on a charge of

Natalia Sergeyevna Goncharova
Linen, 1913
Oil on canvas
95.6 × 83.8 (37⅝ × 33)
Presented by Eugène Mollo and the artist 1953

indecency. The furore was heightened because she was a woman; the male art establishment reacted against such work being made by a female.[31]

Goncharova began to picture modernity, and, influenced by Cubism and Futurism, painted fractured compositions capturing movement. In *The Weaver (Loom + Woman)* (1913, National Museum of Wales, Cardiff), the figure is an extension of the loom, her arm like a lever. *Linen* had a personal resonance for Goncharova. Her family had owned linen factories, and she explored the relationship between femininity and the fabric of everyday life in the painting. We are not shown the person working on the crisp lace and piles of shirts, collars and cuffs, but it would, conventionally, have been a woman, and the iron evokes her presence. Goncharova also performed

in Futurist theatre and film. And, with Larionov, she developed a mystical representation of light and space, 'Rayism', in a series of paintings titled *Rayist Forest* of 1912–14 (Staatsgalerie Stuttgart and elsewhere), which, again, drew upon Cubism and Futurism, but also the work of Sonia Delaunay and her husband.

In 1913 Diaghilev commissioned Goncharova to design the ballet *Le Coq d'Or* (The Golden Cockerel) for the Ballets Russes (Rimsky-Korsakov composed the music after a poem by Alexander Pushkin). She travelled to Paris to see the production in 1914. Three years later she and Larionov moved to the French capital, and in 1918 he organised the exhibition *L'Art Décoratif Théâtral Moderne* at the Galerie Sauvage. Several of Goncharova's designs were for ballets

with music by Stravinsky, including *L'Oiseau de Feu* (The Firebird) (1926). She was also a printmaker and graphic artist. During the First World War she made a series of lithographs, *Misticheskiye obrazy voyny* (Mystical Images of War). Having illustrated Pushkin's *Tale of Tsar Saltan* in 1921, she designed for the ballet performed eleven years later in Lithuania.

Goncharova was critically neglected for a long period, but she continued to work. A series of late paintings, including *Outer Space* of 1957–8 (National Art Gallery, Wellington, New Zealand), celebrate the launch of the first sputnik from the Soviet Union. In 1961 an exhibition was organised by the Arts Council of Great Britain, and in 1963 a Goncharova and Larionov retrospective was held at the Musée d'Art Moderne de la Ville de Paris.

DORA GORDINE
1906–1991

Writing in *The Spectator* in 1938, the poet and critic Arthur Symons reviewed Dora Gordine's exhibition at the Leicester Galleries: 'Her profound sense of pure form in sculpture, heedless alike of realism and of exaggerated abstraction, is united with the subtlest delicacy of modelling, and these qualities combine to endow her bronzes with an abnormal power, an almost uncanny life, which only the sculpture of the greatest civilisations of the past has been able to produce.' Symons and his wife bequeathed Gordine's *A Malay Sultana* to the Tate Collection.

Gordine was born in St Petersburg, Russia. She travelled to Paris in 1925, studied under Aristide Maillol and exhibited at the Salons. Over the next decade she travelled, making busts of people she encountered on her journeys, and a series of bronze sculptures for a government building

Dora Gordine
Guadaloupe Head, c.1925–7
Bronze
36 × 23 × 23 (14⅛ × 9 × 9)
Transferred from the Victoria
and Albert Museum 1983

in Singapore, before moving to England in 1936. In that year she married the diplomat the Hon. Richard Hare, and designed their London home and studio, Dorich House. Gordine's portrait sitters included the actor Edith Evans. In 1947 she travelled to Hollywood, designing film sets and lecturing on art.

The Leicester Galleries held a number of solo shows of Gordine's work. She also exhibited at the Society of Women Artists, and at the Royal Society of British Sculptors, where she was elected a member. Her sculptures are in the collection of the Royal Institute of British Architects,

and, in the late 1940s, *Happy Baby* was donated by its owner to the maternity ward of Holloway Prison. Dorich House now holds a collection of Gordine's work, her archive, and the couple's collection of Russian fine and decorative art.

LAURA SYLVIA GOSSE
1881–1968

Sylvia Gosse's mother and aunts had trained as painters, and Gosse was sent to the St John's Wood School of Art, the Royal Academy, and Sickert's Rowlandson House school, where she was co-principal from 1909 to 1914. Gosse focused on the subject matter for which Sickert's Camden Town Group became famous, female figures in interiors, sometimes nude, music halls, circus performers, Coster girls, and street scenes in London and Dieppe. But their ban on women artists barred her from membership.

Despite this discrimination, Gosse had a long and prolific career. At her first solo exhibition, at the Carfax Gallery in 1913, her drawings and etchings included *A Window in Camden Town*, and *The Garden, Rowlandson House*, which shows a group of women students drawing. Gosse exhibited with the Society of Women Artists and was elected a member. She had numerous individual exhibitions at London galleries, and also showed with the Allied Artists Association, the New English Art Club, and the Royal Academy. With Ethel Sands she was one of the founder members of the London Group.

Kathleen Fisher, Gosse's friend, described her life and work in *Conversations with Sylvia* (London 1975). Her significant role in this period of English art lies in her reworking of Camden Town themes to focus on

Laura Sylvia Gosse
Walter Richard Sickert, 1923–5
Oil on canvas
50.8 × 30.5 (20 × 12)
Presented anonymously 1927

female protagonists. The painting *The Printer* (Borough of Thamesdown, 1915) depicts a woman busy over a press, while in the etching *Two Women* (British Museum) a female figure on a bed is scrutinised by a second, fully

clothed woman who perhaps represents the artist herself. Exhibitions of Gosse's work were held at Hastings Museum and Art Gallery (1978) and the Michael Parkin Gallery, London (1989).

MERAUD GUEVARA
1904–1993

After studying at the Slade in the mid-1920s, Méraud Guinness trained in New York under Alexander Archipenko, and then with Francis Picabia in France. Picabia wrote the catalogue foreword for her first solo show, in Paris at the Galerie van Leer in 1928. Among the works exhibited were three portraits of him, along with paintings of fish and flowers, and of Liverpool Cathedral.

The following year, Guinness married Chilean artist Alvaro Guevara. Her work developed in two directions. She made paintings of women in the South of France, combining a smooth finished surface (likened by critics to the French primitives and Clouet) with a solidity of form learnt from Cubism, and a strange space and atmosphere influenced by Surrealism. On her American debut at the Valentine Gallery in 1939, the *New York Sun* commented: 'First there was Balthus, now there is Meraud Guevara.' Guevara also worked non-figuratively. As Waldemar Georges described in the catalogue for her 1956 exhibition at the Galerie Guénégaud, Paris, her abstract works evoked 'the structures of the natural world', suggestive of forests, undersea life and fantastic flowers. Among Guevara's group exhibitions was *31 Women*, organised by Peggy Guggenheim at her gallery Art of this Century in 1943, where her work was seen with that of Dora Carrington, Frida Kahlo, Louise Nevelson and Dorothea Tanning among others.

Guevara's friend Gertrude Stein wrote of her: 'Paint is she.' But she was experimental with her media and methods, and also used collage and cellophane. Her 1959 exhibition at the O'Hana Gallery, London, was titled 'Early work and present research in new materials'. She is the subject of a book currently in preparation by Monica Cena Elie-Joseph.

Méraud Guevara
Seated Woman with Small Dog, *c.*1939
Oil and pencil on canvas
89 × 65 (35 × 25⅝)
Presented by Salander Galleries, New York 1979

ELSIE MARIAN HENDERSON
1880–1967

In 1924 Elsie Henderson had her first solo exhibition at the Leicester Galleries. She exhibited drawings, lithographs and bronze sculptures of wild animals. The titles suggest that Henderson emphasised the savage aspect of nature: the drawings include *Jaguar Tearing its Prey* and *Leopard Killing a Parrot*.

Henderson's mother was an amateur painter and encouraged her daughter's ambitions, sending her to the Slade during the early 1900s, where she developed her fluid, fluent drawing style, and then to Paris. Henderson worked in various Parisian ateliers, among them Colarossi's. In the catalogue for a joint show with her close friend the animal painter Orovida Pissarro (held at the Michael Parkin Gallery, London, in 1985) she is quoted as describing the city as 'feverish – emotional . . . its colour and warmth and freedom develops me like a hot-house plant – it is dangerous!' She also trained with Othon Friesz, and, back in London, with Ernest Jackson, who taught her lithography. It was around 1916 that Henderson began to focus exclusively on animals, drawing at Regent's Park Zoo. Tate owns two of her drawings, *Three Studies of Leopards* and *A Tiger* (both 1916). In 1917 she designed a much-admired poster advertising the Zoo for London Underground.

Henderson exhibited with the Women's International Art Club, the Royal Academy, and the Society of Women Artists. In the late 1920s she moved to Guernsey following her marriage to the French consul there, and kept detailed journals of the German occupation of the 1939–45 war, during which her husband died. She returned alone to England, painting into her old age. Her work was seen in two solo exhibitions at Sally Hunter Fine Art, in 1997 and 1999.

BARBARA HEPWORTH
1903–1975

Walking through the garden of Barbara Hepworth's St Ives studio (now her museum) you pass her sculptures, and can look into the room where she worked. The hammers and chisels are laid out as if she had just set them down. It is a rare example of a woman artist's work-place being preserved.

Hepworth was born in Wakefield, Yorkshire. In her autobiography she noted that her childhood had been unusually liberal for the period: 'my father . . . fulfilled his idea that his three daughters and one son should have equal opportunities.'[32] After winning a scholarship to Leeds School of Art, where she met Henry Moore and Edna Ginesi, Hepworth trained at the Royal College of Art. A travel scholarship in 1924 took her to Italy, and a photograph survives of her there, with her first husband, the sculptor John Skeaping, and Winifred Knights. Like Skeaping and Moore, Hepworth rediscovered the art of direct carving into stone, as practised by medieval craftsmen and sculptors outside the Western tradition. Their aim was to create work in which the finished piece was suggested by the character of the stone, revealed during the working process. Hepworth, who had her first solo exhibition in London at the Beaux-Arts Gallery in 1928, shared an exhibition with Skeaping at Arthur Tooth's Gallery in 1930.

Hepworth's next joint exhibition there, in 1932, was held with Ben Nicholson, who became her second husband, and by whom she had triplets two years later. During the 1930s she made a group of Mother and Child sculptures that allowed her to experiment with undulating organic shapes, and with the holes and inter-relationships between grouped pieces that became a marked feature of her work. She also began to introduce drawing onto the surface of her sculpture, sometimes adding an eye, a mouth or the outline of a profile. At the outbreak of war, Hepworth moved to Cornwall, first staying with Margaret Mellis and her husband, and eventually buying a studio there. Her work became increasingly austere, in common with the Constructivist work of the artists she knew, Naum Gabo and Piet Mondrian. The sculptures she produced into the 1940s were mainly in wood, and a number of pieces, pierced and threaded with taut strings, and with coloured interiors drawing attention to their internal spaces, had a huge impact on the visual culture of the time.

By the late 1940s and 1950s Hepworth's standing was assured, although some contemporary critics, including Herbert Read, tended to represent her as the feminine (lesser) counterpart to Moore's masculine genius. A retrospective of Hepworth's work was shown at the 1950 Venice

Barbara Hepworth
Pelagos, 1946
Part painted wood and strings
36.8 × 38.7 × 33 (14½ × 15¼ × 13)
Presented by the artist 1964

Biennale, and the two sculptures she made for the Festival of Britain the following year were among a number of prestigious public commissions, culminating in the monumental *Single Form* sited in front of the United Nations building in 1964. She had introduced a new element into her practice, metal, often bronze, but sometimes copper or brass. The use of metal had been re-invigorated by the younger generation of post-war sculptors. Importantly, it also allowed Hepworth to produce large-scale pieces more rapidly than carving, and the finished sculptures were less easily damaged. Speed and durability were significant factors for an artist who was keen to preserve and promote her reputation with a steady stream of public commissions and exhibitions.

Among the many shows of Hepworth's work have been retrospectives at the Whitechapel Art Gallery (1954, 1962), the Walker Art Center, Minneapolis (touring 1955–6), the Tate Gallery, London (1968), and Tate Liverpool (1994). She also had a series of exhibitions at Reid and Lefevre and Gimpel Fils galleries in London during her lifetime. Hepworth was a member of the 7 & 5 Society and Abstraction-Création, and was the only woman member of Unit One. In Cornwall she helped to form the Penwith Society of Arts in 1949. Her achievements were acknowledged with prizes in the Unknown Political Prisoner Competition in 1953, the Sao Paulo Bienal of 1959 and the Salon International de la Femme, Nice, in 1970.

Tate houses a large collection of Hepworth's art (listed in a catalogue published in 1999). In London, her bronze *Winged Figure* (1957–62), commissioned by the John Lewis department store, hovers high above Oxford Street. And the National Portrait Gallery owns a small, stunning self-portrait of 1950, in oil and pencil on board. The artist showed herself at work, and her penetrating gaze and her hand are the focus of the picture.

Towards the end of her life, Hepworth wrote in her autobiography: 'the dictates of work are as compelling for a woman as a man ... and this is only just being realised.' She asserted that she had a physical relationship with her sculpture, rather than an optical one. This suggests that the importance of Hepworth's contribution to modernism, in addition to her dazzling formal inventiveness, might include her privileging of her body's own experience over the visual world in which femininity was often objectified. Her work and its significance were explored in *Barbara Hepworth Reconsidered* (Liverpool 1996), and, more recently, in exhibitions at Tate St Ives and Yorkshire Sculpture Park (2003).

GERTRUDE HERMES
1901–1983

At Leon Underwood's School of Painting and Sculpture during the mid-1920s, Gertrude Hermes gravitated towards wood engraving and carving, and worked alongside Henry Moore, Blair Hughes Stanton (her husband for five years) and Eileen Agar. In her old age Agar spoke of her great affection for Hermes, and of the fine quality of her art, an example of which she had been given by the artist.[33]

From 1924 to the 1930s most of Hermes's work was as a wood engraver. She participated in the revival of this art form in Britain between the wars as one of a group of artists who founded the English Wood Engraving Society in 1925. Although engraving had largely been supplanted by photography as a means of illustration, Hermes and a number of her contemporaries saw in it the opportunity of combining the discipline of design and the challenging restrictions of working with wood and ink, with the freedom and imaginative inventiveness of artistic expression. Writing in the *Studio* in 1930, the critic Maximilien Vox described how English wood engraving was now of 'the highest rank'. His article was illustrated with work by Hermes, and included a number of women artists considered to be at the forefront of new developments in the medium.

Many of Hermes's wood engravings were made as book illustrations, and she produced designs for the Penguin Illustrated Classics, although she preferred to refer to her work in this field as 'decorations'. Hermes often drew upon the natural world for her subject matter, particularly plants and animals. She illustrated T.S. Eliot's *Animula* (London 1929), Izaak Walton's *The Compleat Angler* (London 1939) and Gilbert White's *The Natural History of Selborne* (unpublished), among other titles. She shared her predilection for nature with other engravers of the period, such as Agnes Parker Miller, who was one of her fellow exhibitors at an important early exhibition at St George's Gallery in 1928. But she also engaged with the modern world. In *Through the Windscreen*, a wood engraving of 1926 (Towner Art Gallery, Eastbourne), the headlamps of a car illuminate a country road at night, picking out trees and telegraph poles. And her art could also represent violence with vigour. In *High Explosive* of c.1926, made to illustrate a privately printed edition of T.E. Lawrence's *Seven Pillars of*

Wisdom, the contrast of hard geometric lines and billowing curves forcefully evoke an explosion ripping a train apart.

Hermes's sculptures also drew upon her love of nature. She made carvings in wood and stone, and works in bronze, creating horses, rabbits and other animals, and insects such as *Moth* of 1926, which was included in the exhibition *British Sculpture in the Twentieth Century* at the Whitechapel Art Gallery in 1981. Hermes was among a number of sculptors working in the 1920s who followed a method close to abstraction, developed from animal forms. Some of her smaller animal pieces also had functions, as doorknockers, letterboxes, handbells, weather vanes and car mascots. Hermes also became an acclaimed portrait sculptor. She made over fifty such works including portraits of writers, musicians, politicians and children. Among them are sculptures of the poet Kathleen Raine (1954, Tate), and the painter Prunella Clough (1962) with one arm extended as if she were about to start work.

Hermes did not restrict her practice to fine art and illustration. In 1938 she was admitted to the National Register of Industrial Designers. The architectural features she created included a mosaic floor and carved stone fountain for the foyer of the Shakespeare Memorial Theatre at Stratford-upon-Avon. In 1925 she collaborated with Blair Hughes-Stanton on a mural for the British Pavilion at the World Fair in Paris, and, twelve years later, she designed a thirty-foot sculptured glass window for the International Exhibition of Arts and Industry held there. She made three glass panels for the British Pavilion of the World Fair in New York in 1939. Hermes's work as an engraver had been selected for the Venice Biennale in 1940, but the advent of war meant that it was never sent. During the conflict she moved to Canada, where she worked as a precision draughtsman for a shipbuilders, and to New York, producing

Gertrude Hermes
Fathomless Sounding, 1932
Relief print on paper
38.1 × 25.1 (15 × 9⅞)
Purchased 1984

commissions as a designer and engraver, and painting six panels for the British Booth of the Women's Exhibition at Grand Central Palace. Hermes also taught at a number of British art schools.

A regular contributor to group exhibitions including the London Group, the Royal Academy, and the Women's International Art Club, Hermes also had a number of solo shows.

Retrospectives were held at the Whitechapel Art Gallery in 1967 and at the Royal Academy in 1981. Elected an Associate of the Royal Academy in 1963, Hermes was aware that she was the first woman engraver whose work had been recognised in this way, and is reported to have remarked, 'Shame on them.'[34]

EVA HESSE
1936–1970

In her book on Eva Hesse (New York 1976), critic Lucy Lippard argued that the story of Hesse's life, from her flight from Nazi Germany as a child, to her early death, had taken precedence over serious appraisal of her work. Hesse's tragic history, and her diaries (Archives of American Art, Washington DC), have prompted such biographical readings. But Hesse saw herself as part of an artistic and intellectual trajectory; one of the authors she admired was Samuel Beckett. And, as Lippard points out, biographical interpretation often has a political function when applied to women's work, preventing exploration of its wider cultural significance. Hesse's diary certainly suggests that she found negotiating her role as a woman and artist difficult. She read Simone de Beauvoir's *The Second Sex*, and posed the question, 'Do I have a right . . . to womanliness? Can I achieve an artistic endeavour and can they coincide?'[35]

Hesse trained as a painter at art schools in New York, and then at the Yale School of Art and Architecture under Josef Albers. Her early gestural abstract works showed her admiration for Willem de Kooning and Jackson Pollock. Hesse made a series of paintings in which her face is a warped mask, including *Untitled* (1960, Museum of Modern Art, New York). These can be understood as encapsulating the artist's struggle with her medium (in her diaries she wrote about 'fighting to paint'), and also as in tune with the existentialism of the Abstract Expressionists. But Hesse's distortion of her features can also be read as picturing the collapse of fixed, essential identity that was to be explored in some feminist thought.

Although Hesse moved from painting to working in three dimensions, drawing remained a constant presence

Eva Hesse
Untitled, 1965
Drawing and gouache on paper
49.6 × 64.7 (19½ × 25½)
Purchased 1986

in her practice, as Ellen H. Johnson examined in the catalogue for the 1982 retrospective of graphic work held at Allen Memorial Art Museum, Oberlin College. Hesse had her first one-woman exhibition of drawings at the Allan Stone Gallery, New York, when she was twenty-seven. She spent 1964–5 in Germany with the sculptor Tom Doyle, her husband for five years. This period proved a watershed in her graphic art. Drawings such as *And He Sat in a Box* (1964, Barbara Gross Galerie, Munich) take a square as a central motif, a shape with a multiplicity of associations. Hesse sometimes referred to it as a 'box' or 'window', and it could be interpreted as a vessel (suggestive of the female body) or as a frame for feelings and events. Her tutor, Josef Albers, had made the square the template for his experiments with colour. And in the context of the art of her time, the freehand imperfection of Hesse's drawings was a departure

from Minimalist work with the box. Within Minimalism the box could signify simple mass-produced objects, whose multiplicity subverted the monumentality and preciousness of sculpture, invoking instead the material and industrial world.

Hesse was mining the interface between hard-edged, abstract restraint and the organic, emotional, and irrational, drawing upon two different strands in art practice, the work of de Kooning, Pollock and Lee Bontecou on the one hand, and that of Donald Judd, Carl Andre, Agnes Martin and Sol LeWitt on the other. Writing to LeWitt in 1965, she described 'drawings – clean, clear, but crazy like machines, forms larger, bolder, articulately described so it is weird – they become real nonsense'.[36] In her later graphic work Hesse focused on repetitious circles, as in the drawing *Untitled* (1967, Tate), a rectangle of tiny ink circles hovering in the centre of graph paper.

Sculpture occupied Hesse from the mid 1960s. She tried out her ideas in 'test pieces', referring to her finished works as 'objects'. Her sculptures are ambitious and unhesitant, but their lines are not clean; they often hang, lean, or huddle together, and they can be unstable pieces with hanging cords change their configuration with each new installation. Lippard wrote of the piece *Repetition Nineteen 1* (1967, Museum of Modern Art, New York), made up of nineteen separate cylindrical vessels, that '[they] sit on the floor in aimless but congenial disorder'. The sculptures are constructed from an inventive mess of mixed (sometimes impermanent) materials. *Tomorrow's Apples (5 in white)* (1965, Tate) is painted concretion, enamel, gouache, varnish, cord-wrapped wire, and papier-mâché on masonite. Hesse wrote about the contradictory characteristics of her sculpture in catalogue notes for a 1969 group exhibition *Art in Process IV* at Finch College Museum of Art, New York:

> textures coarse, rough, changing.
> see through, non see through,
> consistent, inconsistent.
> enclosed tightly by glass like
> encasement just hanging there.
> then more, others. will they hang
> there in the same way?
> try a continuous flowing one.
> try some random closely spaced.
> try some distant far spaced.
> they are tight and formal but very
> ethereal. sensitive. fragile.[37]

The marriage of opposites In Hesse's art can be understood as a critical swathe cut through simplistic binary definitions; a move towards a fertile, but delicate freedom. Major retrospectives were held at the Solomon R. Guggenheim Museum, New York in 1972, Yale University Art Gallery in 1992, and Tate Modern in winter 2002–3. Writing in 1994, in the catalogue for the exhibition *Sense and Sensibility: Women Artists and Minimalism in the Nineties* at the Museum of Modern Art, New York, Lynn Zelevansky described Hesse as 'one of the first to offer an alternative to orthodox Minimalism', arguing that her 'emphatically hand made work', which explored 'disquieting psychological realms' and was preoccupied also with the body, 'prefigured certain concerns of the Women's Movement as they would be manifested in the art world'. Mona Hatoum and Andrea Zittel were included in the exhibition among the artists considered to have built upon Hesse's legacy.

FRANCES HODGKINS
1869–1947

Writing to her sister in the summer of 1925 Frances Hodgkins enthused, 'I am just back from 3 weeks in Paris – Paris under new conditions – none of the old 'Me' none of the old Paris – I lived like a real lady for once – taxis everywhere … I was sent over on purpose to see the wonderful Exposition Arts Decoratif, an ultra modern show of European and British industrial art – all marvellously well done and displayed.'[38]

Hodgkins's visit had been arranged by the Calico Printers' Association of Manchester where she worked as a designer during the mid 1920s. Her interest in modern fashion can be seen in the drawing *Seated Woman* of *c.*1925–30 (Tate), with its detailed depiction of patterned fabrics, stylish jewellery and cloche hat. On its exhibition at the Lefevre Galleries in 1945, her dealer Duncan Macdonald wrote, 'It looks truly magnificent on the wall, and Matthew Smith when he called yesterday, thought it was just as good as a Matisse drawing; only stronger, he added.'[39]

By the 1920s Hodgkins knew Paris well. She had travelled to Europe from her New Zealand birthplace for the first time in 1901, and spent two years visiting England, France, Italy, Morocco, Belgium and the Netherlands. Returning to France, she became the first woman instructor at the Académie Colarossi in 1910, eventually setting up her own art class in Montparnasse that proved so successful that she also held a summer school. Hodgkins's teaching was described by a pupil who became a friend and patron. Interviewed in the late 1960s, Jane Saunders remembered, 'I was trying to produce, for her criticism, a watercolour based on what I thought I saw before me and I felt fairly pleased with it. The drawing I felt was neat and the colour not too bad. How mistaken I was, I soon found out. A few slashes of the brush across my effort and all was transformed … here was someone who could teach me something – new and real.'[40]

Hodgkins's journeys across continents have led to speculation about the influence of different countries and cultures in her work. Pamela Gerrish Nunn, writing in *Woman's Art Journal* (Winter 1994–5) argued that rather than identifying with one particular school or place, Hodgkins was alive to her surroundings in all their variety, so cannot be slotted into the convenient categories created in art history which divide artists up by location and affiliation. Hodgkins began her career making watercolours of Maori subjects, yet her later work, lyrical and full of colour, was seen by some as part of the tradition of British

art (her friend the artist John Piper included her in his 1942 publication *British Romantic Artists*), and, along with Gertrude Hermes she was asked to represent Britain at the Venice Biennale of 1940.

The representation of femininity is central to Hodgkins's art. Her vivid still-life paintings of the mid-1930s are sometimes a form of self-portraiture, depicting collections of objects that Hodgkins chose as representative of herself. These include *Self-Portrait: Still Life* (Auckland City Art Gallery, New Zealand), an arrangement of high-heeled shoes, patterned materials, hats, handbags and flowers. *In Loveday and Ann: Two Women with a Basket of Flowers* (1915), the artist has paid attention to the elaborate hairstyle of one sitter, juxtaposed with the simple black hat of the other. The painting *Double Portrait* (c.1922–5, Hocken Library, Dunedin, New Zealand), portrays Jane Saunders and her friend Hannah Ritchie (and was owned by the sitters), with emphasis again on the pleasures of colour and pattern.

There could be perceived to be a contradiction between Hodgkins's refusal of the conventional roles allotted to women throughout her uncompromising, rigorous life (she was unmarried and childless, and pursued her career through periods of poverty and illness), and the importance given to decorative ephemera, fashion and dress in her work. Hodgkins's motivation may well have lain, to some degree, simply in her enjoyment of such things. But we should also be wary of reading such subject matter as unsuitable for the serious woman artist, when, for a male artist like Matisse, it was accepted and celebrated. Both Sonia Delaunay and Marie Laurencin exhibited at the *Exposition des Arts Décoratifs* that Hodgkins attended in 1925. And aspects

Frances Hodgkins
Loveday and Ann: Two Women with a Basket of Flowers, 1915
Oil on canvas
67.3 × 67.3 (26½ × 26½)
Purchased 1944

of Hodgkins's work make us look again at the relationship between femininity and decoration. In her catalogue for the exhibition *Echo* (Tate Liverpool, 1991), Maud Sulter identified a particular significance in the contrasting appearances of Loveday and Ann (underlined by their different facial expressions) as a representation of 'the seldom pictured everyday reality of women taking simple pleasure in each other's company', 'who can agree to disagree and still remain friends'.

Hodgkins showed with exhibiting societies in New Zealand at the start of her career, and in Paris at the Salon d'Automne. In Britain her exhibiting venues included the New English Art Club, the London Group, the National Portrait Society, the Women's International Art Club, the Leicester Galleries, and the Lefevre Galleries (where a retrospective was held in the year before her death). At the 7 & 5 Society her work hung alongside that of Jessica Dismorr, Evie Hone, Winifred Nicholson, Ben Nicholson, David Jones and Ivon Hitchens. Hodgkins also exhibited in the London Gallery's Surrealist exhibition *Living Art in England* in 1939. Her correspondence, edited by Linda Gill, has been published (Auckland, New Zealand 1993).

LILIAN HOLT
1898–1983

Lilian Holt did not have her first solo exhibition until she was in her early seventies (at the Woodstock Gallery, London). Her work as a painter had often been interrupted, either by financial necessity (when she took office jobs) or by her support for her second husband, David Bomberg, whose career took precedence over her own.

Holt trained at Putney Art School and the Regent Street Polytechnic. Her first husband was a London art dealer. Living with him in the 1920s, she had no time to paint, but was able to study work by Sickert, Epstein, Kramer and Bomberg at first hand. She became close to Bomberg in the late 1920s, but did not start painting properly again until 1945. Holt worked in the life room at the Borough Polytechnic. She was a founder member of the Borough Group (other woman members included her daughter Dinora Mendelson, from her first marriage, and Dorothy Mead), and the later artists'

Lilian Holt
Tajo, Ronda, 1956
Oil on canvas
71.1 × 91.1 (28 × 35⅞)
Purchased 1980

group, the Borough Bottega. She painted London, landscapes and portraits with expressive force and a striking use of colour, similar to Bomberg's. Like him, some of her later works were abstract, such as *Elemental Force* and *Star Flight*.

After Bomberg's death Holt went on painting expeditions to Mexico, Basutoland, Andalucia, Yugoslavia, Morocco, Turkey and Iceland. Her energies were

divided between her own art and securing her husband's reputation. An exhibition of her work, along with that of her family – Bomberg, Dinora, and Dinora's former husband, Leslie Marr – took place at the Ben Uri Gallery in 1981. A retrospective had been held there the year before, and a memorial exhibition was held at the Gillian Jason Gallery, London, in 1983.

EVIE HONE
1894–1955

Two women are credited with introducing Cubism to Ireland, Evie Hone and her friend Mainie Jellett, and their work has been explored in Bruce Arnold's *Mainie Jellett and the Modern Movement in Ireland* (London and New Haven 1991). Having trained at Byam Shaw School of Art and Westminster School of Art with Sickert, in the early 1920s Hone travelled to Paris where she studied under Lhôte and Gleizes with Jellett. There they met the designer Eileen Gray, whose use of developments in modern abstract art had an impact upon them. Hone and Jellett exhibited

Evie Hone
The Crucifixion, 1948
Leaded glass
39.4 × 50.8 (15½ × 20)
Presented by Derek Hill 1948 and accessioned 1981

in Ireland and France, and were elected to the group Abstraction-Création. A review in the September 1924 edition of the *Studio* of their joint exhibition in Dublin was scathing, reporting on the 'vehement controversy' it had excited. By September 1938 the same magazine was praising their work in a group exhibition 'marked by accomplishment and taste' where art of the 'Irish old school tie or more precisely "my beautiful shawl" kind' were thankfully few.

It was art such as Hone's *Composition* (*c*.1924–5, National Gallery of Ireland, Dublin), constructed from geometric shapes, that caused the furore. By 1933 she changed her medium to stained glass, producing her first major work, *My Four Green Fields*, in 1939 for the Irish Pavilion at the New York World Fair, where it was awarded first prize. Hone made glass for numerous churches, and her window *The Crucifixion* (1948), based on an ancient Irish stone carving, was placed over a door in the Tate Gallery's sculpture hall. In 1949 she began a commission for a window at Eton College Chapel (a gouache for this is in the Tate Collection). The simplicity and strength of her designs, the lead used as a form of drawing, creating bold outlines, is evidence of her admiration for Rouault.

Hone's and Jellett's careers continued to interlink. In 1943 both were founder members of the Irish Exhibition of Living Art. A memorial exhibition was mounted there following Hone's death, and in 1958–9 a retrospective was held at University College, Dublin, and in London at the Arts Council and Tate Galleries. Hone left her own collection, including work by Picasso, Gris and Gleizes, to the National Gallery of Ireland.

JULIA BEATRICE HOW
1867–1932

L'Infirmière resonates when it is looked at against the backdrop of the First World War. Women were working as nurses in unprecedented numbers and Julia Beatrice How herself served with the Red Cross. Moreover, the representation of women and children, for which How became known, had a new significance. Some French artists had returned to figuration, taking the mother and child as their subject matter, rejecting modernist experiment in favour of a reassuring celebration of fertility and nurture in the midst of destruction, a move which was later labelled by the writer Jean Cocteau the *rappel à l'ordre* (the call to order).

How trained at Professor Herkomer's art school, and then in Paris at the Académie Delacluse, Montparnasse. She lived in the Rue Notre-Dame-des-Champs, a street with one of the highest concentrations of artists in the city. During regular visits to Holland and Brittany (she set up a studio in Etaples), How drew and painted simple interiors and their inhabitants, in sympathy with a contemporary predilection for Dutch painting. Her palette was soft, but also confident; vivid hues were juxtaposed with tonal

Julia Beatrice How
L'Infirmière, *c*.1914–18
Oil on canvas
65.4 × 47 (25¾ × 18½)
Presented by the Trustees of
the Chantrey Bequest 1935

passages. The subtle atmosphere of her work led to comparisons with Eugène Carrière and Whistler, while her domestic subject matter had similarities with the *intimistes*. Her art was highly regarded in France. She was elected a Sociétaire of the Salon des Beaux-Arts, had solo exhibitions, and her work was bought by the French state (it is now in the Musée d'Orsay).

At a retrospective held at the City of Manchester Art Gallery in 1936, How's painting *Mother and Child* was shown, lent by a Mrs F. Engelbach, probably the artist Florence Engelbach. Other solo shows during the 1930s included the New Burlington Galleries, Northampton Art Gallery, and the Glyn Vivian Art Gallery, Swansea. An exhibition *Beatrice How: A Scottish Painter in Paris* was held by the Fine Art Society in the winter of 1979–80.

THELMA HULBERT
1913–1995

From the mid-1930s to late 1930s Thelma Hulbert worked with the group of artists who formed the Euston Road School, William Coldstream, Victor Pasmore and Claude Rogers. She had trained at the Bath School of Art, and in London at the Central School of Arts and Crafts. At Euston Road she was the organising secretary, as well as continuing her own practice. Hulbert also taught.

Hulbert's painting was tonal and figurative, in common with that of her colleagues. But her emphasis was not on the figure or portraiture, but still life – often with plants and flowers – and landscape. And her use of colour was sometimes inventive rather than strictly realistic, contrasting soft, delicate pinks and ochres with striking blacks. In addition to exhibiting in group shows, including those of the London Group in the late 1930s, Hulbert had individual exhibitions at galleries including Heffers Gallery, Cambridge (1950), and in London at the Leicester Galleries (1958). A retrospective organised by Bryan Robertson at the Whitechapel Art Gallery in 1962 showed her paintings, watercolours and pastels.

Although her work was included in the survey *Modern British Painting*,

Thelma Hulbert
Black Screen: Dried Leaves, 1983
Oil on canvas on board
151.8 × 101 (59¾ × 39¾)
Presented by the Administrators of the
Thelma Hulbert Memorial Fund 1996

curated by Tate director John Rothenstein in 1949 at Heffers Gallery, which included figurative painters such as Stanley Spencer, Winifred Nicholson and Matthew Smith in addition to the Euston Road artists. More recently Hulbert has been edited out of art history. In a *Manchester Guardian* review of 1958, Frederick Laws cautioned against dismissing her:

'Because her themes are apt to be domestic and her colours pale there is a danger that her pictures may be graciously labelled "feminine". They are as ladylike as Bonnard and Turner.' The poet Frances Cornford (quoted in the Leicester Galleries catalogue) described Hulbert's art as 'almost Proustian in elaboration of space and light and emotional atmospherics'.

LOUISE HUTCHINSON
1882–1968

When Louise Hutchinson decided to become a sculptor she was in her early sixties, and had already made her name as a photographer. She was born in France, but settled in England, where she taught herself to sculpt. Hutchinson soon established a reputation as one of

a group of sculptors that included Reg Butler and Kenneth Armitage, who had returned to figuration and subjective expressiveness after the Second World War. A number of them had had no art school training in sculpture, and their work, often in metal, carried the traces

of the artist's hand, contrasting with the immaculate, serene abstraction that had dominated pre-war work.

The critic and art historian Herbert Read wrote about the development in his catalogue introduction for the British Pavilion at the 1952 Venice

Biennale: 'These new images belong to the iconography of despair, or of defiance ... Here are the images of flight, or ragged claws "scuttling across the floors of silent seas", of excoriated flesh, frustrated sex, the geometry of fear.' The new sculpture, which seemed a response to the recent momentous events, was given a public presence. Hutchinson was one of the twelve British finalists in the international competition to create a monument to the Unknown Political Prisoner in 1953, the only other women being Elisabeth Frink and Barbara Hepworth. The works were all exhibited at the Tate in 1954.

Hutchinson had a solo exhibition at the Beaux-Arts Gallery in 1953, and a second in 1956. Among the works, which were either bronze or terracotta, were numerous portraits. Hutchinson had portrayed the gallery's director, Helen Lessore, and the artists Patrick Heron and Mary Fedden. She also made bronze heads of the art critics J.P. Hodin, Herbert Read and David Sylvester.

Louise Hutchinson
Three-fold Head, c.1953
Cast material
33 × 32 × 18 (13 × 12⅝ × 7⅛)
Transferred from the Victoria & Albert Museum 1983

EVELYN GRACE INCE
c.1886–1941

In 1934 Evelyn Ince's tempera painting on wood, *Flower Piece*, was bought by the Chantrey Bequest and given to the Tate Collection. It is typical of her detailed, polished work, much of which was exhibited at the Royal Society of British Artists, where she became a member in 1926, and at the Royal Academy, where she showed from 1917 until the year of her death.

As flower painting had long been considered an appropriate field for the female artist, Ince's attractive treatment of the subject is likely to have contributed to her success at these more conservative and conventional exhibiting societies. She also painted landscapes, portraits and classical subjects, such as *Echo and Narcissus* (exhibited at the Royal Academy in 1921) and *Bacchus and Ariadne* (shown at the Royal Society of British Artists in 1926). Among her other exhibiting venues were the New English Art Club, and the Society of Women Artists.

Ince had trained at the Byam Shaw and Vicat Cole School of Art, where she won a scholarship. Her studies had been interrupted by the war, and she worked on the land between 1916 and 1918. Among her exhibited works, *Girl in a Landscape* shown in 1926 and *Building the Stack* exhibited in 1933 may have represented aspects of her wartime experience.

GWEN JOHN
1876–1939

Training at the Slade from 1895 to 1898, Gwen John was part of a large group of women students that included Edna Clarke Hall and Ursula Tyrwhitt. It was with two other women that she made her first visit to Paris in the winter of 1898, to study at Whistler's Académie Carmen. John made her exhibiting debut at the New English Art Club in 1900 with *Portrait of the Artist*, which attracted critical attention for its 'notable qualities'. Three years later she embarked on a walking tour of France with a friend, Dorelia McNeill. Her painting *Dorelia in a Black Dress*, made during this period, surely owes something to Ingres in the pose and costume of the figure. Other paintings of the same sitter show her as a student with books, representing the experience of John and her female friends who entered higher education in the era of the New Woman.

John returned to Paris in 1904 and spent the rest of her life there. She painted interiors, sometimes empty, such as *A Corner of the Artist's Room in Paris* (c.1907–9, Sheffield City Art Galleries), or occupied by a solitary female figure, as in *Chloë Boughton-Leigh* (c.1907, Tate), and constructed in a subtle palette of close tones. Critical writing has sometimes pictured John as an unworldly religious recluse (she converted to Catholicism in the early 1910s), reading the style and subject matter of her work as a reflection of this identity. However some of John's letters create a very different vision of the artist, dressing up for social and studio life in the French capital. She gained an influential patron in the American collector of modern art John Quinn, and her work in his collection

was included in the Armory Show, New York in 1913. John wrote about her enjoyment of art-world events, enthusing about exhibiting at the Salon in the early 1920s: 'It is amusing to have things in them and go and see them at the vernissage and to give vernissage cards to friends and to make rendez-vous!'[41] Such letters suggest that readings of her images of women and rooms can be opened up and located as part of her time.

During her early years in Paris, John worked as a life model, notably for Auguste Rodin. She also continued to work as an artist, making a series of drawings of the female nude, and two paintings of the model Fenella Lovell in 1909–10, *Girl with Bare Shoulders* (Museum of Modern Art, New York), in which she wears a downmarket version of a Parisian haute couture empire-line dress, and *Nude Girl* (the Tate Collection), in which she is semi-naked, her clothes pulled down to her thighs. The guarded expressions of the women in these drawings and paintings, and their poses, which are self-conscious rather than seductive or natural, suggest that John was aware of the history of representation of the female nude (from Goya's *Majas* to Manet's *Nana*), and was attempting to unsettle the viewer's relationship with such images.

John's paintings of rooms can also be seen as part of wider developments in contemporary art. French painters of interiors including Vuillard were exhibiting in Paris, and there are clear correspondences between a painting such as John's *Interior (Rue Terre Neuve)* (c.1920–4, Manchester City Art Galleries), with its light filtering into a room picked out in minute variations of grey

and white, and Vuillard's tonal images of his family apartment. John's representation of rooms which are ordinary rather than expensively decorated also link her to the Camden Town group, and painters such as Sickert. But the group specifically excluded women, and John's depiction of similar subject matter can be interpreted as a strategic response to this discrimination. John's simple rooms can be read as the site of a woman artist's work, a point made clear in *The Teapot (Interior: Second Version)* (c.1915–16, Yale University Art Gallery), with its pot of paintbrushes.

The ordinary modern interior is also a setting for religious events in John's art, as in *A Lady Reading* (c.1910–11, Tate), which draws upon fifteenth-century paintings of the Annunciation. John made a series of paintings of the founder of an order of nuns, including *Mère Poussepin Seated at a Table* (c.1915, National Museum of Wales, Cardiff). Again this locates her firmly within the culture of her period. The influential artist and theorist Maurice Denis was arguing for just such a representation of religious subjects as part of the everyday world, using modern representational techniques, and John quoted one of his thoughts on art as a foreword to her solo exhibition at the New Chenil Galleries in 1926.

The Denis pensée used by John referred to Cézanne, and his influence can be discerned in the paintings of impassive seated women and girls, painted in rhythmic touches of colour chosen with mathematical precision, that occupied her from the 1910s onwards, such as *Girl in Mulberry Dress* (c.1923–4, Southampton City Art

Gwen John
Dorelia in a Black Dress, c.1903–4
Oil on canvas
73 × 48.9 (28¾ × 19¼)
Presented by the Trustees of the Duveen Paintings Fund 1949

Gallery). They indicate John's affiliation with the French 'call to order', a return to classicism in response to the chaos of the First World War, as do her series of portrait drawings of plainly dressed children posing out of doors, which are likely to have appealed to a post-war taste for rural simplicity. John's work is fascinating partly because of its thoughtful and varied inter-relation with the art of her time. Retrospectives were held by the Arts Council of Great Britain in 1946, and the Barbican Art Gallery, London in 1985. Among the artist's surviving papers is a note of a quotation, in French, from Oscar Wilde's *The Picture of Dorian Gray*: translated, it reads 'there is only one thing in the world worse than being talked about, and that is not being talked about',[42] suggesting that she may have enjoyed the continuing debates about her work.

LILY DELISSA JOSEPH
1863–1940

Lily Solomon was born in London, sister of the painter Solomon J. Solomon. She trained at the Ridley School of Art and the Royal Academy, and married the architect Delissa Joseph, exhibiting her paintings alongside his drawings at the Suffolk Street Galleries in 1924. A joint exhibition of work by Joseph and her brother was held at the Ben Uri Gallery in 1946. More recently, her paintings were seen as part of the survey *Jewish Artists of Great Britain 1845–1945* held at the Belgrave Gallery, London in 1978. Along with Clara Klinghoffer she was one of only five women to be included in the exhibition of forty artists.

In addition to her work as a painter of interiors, portraits and landscapes, Joseph was a political and religious activist. Her exhibition *Some London and Country Interiors*, held at the Baillie Gallery in 1912, was reported in the *Jewish Chronicle*. Next to the review appeared an announcement: 'We are requested by Mr Delissa Joseph to state that Mrs Joseph was unable to receive her friends at the Private View of her pictures, as she was detained at Holloway Gaol, on a charge in connection with the Women's Suffrage Movement.' Joseph was one of the founders of the Hammersmith Synagogue and ran reading rooms in Whitechapel. Having met the impoverished young artist Isaac

Lily Delissa Joseph
Roofs, High Holborn, c.1937
Oil on canvas
134.6 × 147.3 (53 × 58)
Presented by the Trustees of the Chantrey Bequest 1937

Rosenberg while both were copying at the National Gallery in 1911, Joseph enlisted the help of two women friends and funded his Slade training.

According to Joseph's niece, *Roofs, High Holborn* was a view from the window of her studio in Bedford Row, looking out towards the Old Bailey. She exhibited in London at the Society of Women Artists, the New English Art Club, and the Royal Academy, among other venues. In her self-portraits Delissa Joseph emphasised her modernity, vigour and beliefs. *Verve* (present location unknown), exhibited at the NEAC in 1889, shows her wearing a fashionable dress and an animated expression, while in *Self-Portrait with Candles* (Ben Uri collection) she practises Jewish ritual.

KATHLEEN, LADY KENNET
1878–1947

In her autobiography, *Self-Portrait of an Artist* (London 1945), which drew upon her diaries, Kathleen Kennet described how she had studied at the Slade before travelling to Paris in 1901, where she trained at the Académie Colrossi, was taught by Rodin, and became friends with Isadora Duncan, Alice B. Toklas and Gertrude Stein.

She forged a career as a sculptor of male nudes and portraits of the eminent men of her age, including George Bernard Shaw (1918, private collection), William Butler Yeats (1907, National Portrait Gallery), a number of politicians and her first husband, the Antarctic explorer Captain Scott, whom she commemorated in a full-length statue, dressed in his expedition clothes (1915, Waterloo Place, London). Kennet's own political stance was complex. She had become a success in the male-dominated profession of sculpture, was the first woman member of the council of the Royal Society of British Sculptors, and, in photographs, appears dressed in a man's overalls. But despite her ground-breaking career, Kennet was, like her friend the politician H.H. Asquith, firmly against women's suffrage. Her diary records how, after a day arranging an exhibition of her work, she took part in an anti-suffrage demonstration at the Albert Hall, where, she noted, 'Several people were carried out kicking'.

During the 1914–18 war Kennet worked in a French hospital and in armaments factories. She modelled the faces of injured soldiers for plastic surgeons. Among the solo exhibitions of her work in London were those held at the Greatorex Gallery (1929), the Fine Art Society (1934) and Heal's Mansard Gallery (1948). Her work was seen in 1999 at an exhibition at Dorich House

(former home of Dora Gordine), and she was the subject of a biography written by her granddaughter, Louisa Young (London 1995).

Kathleen, Lady Kennet
The Rt Hon. H.H. Asquith, *c.*1912–13
Bronze
31.1 × 25.4 × 24.9 (12¼ × 10 × 9¾)
Presented by Lord Duveen 1929

MARY KESSELL
1914–1977

Mary Kessell trained at Clapham School of Art and the Central School of Art and Design. She painted and also worked as an illustrator, graphic designer, printmaker and jewellery designer. In the catalogue foreword for her retrospective at the Camden Arts Centre in 1980, Barbara Dorf traced the influences upon her work: 'Rouault, Turner and Chinese artists . . . the Bible was regular reading. As well as the Scriptures, there were the epic poets who affected her so intensely: Dante, Milton and Virgil.'

In 1945 Kessell travelled through Germany, visiting Belsen and Berlin. Her sombre, subtle depictions of the scenes she encountered, in a mixture of sanguine and charcoal, include drawings of refugees, and a series entitled *Notes from Belsen Camp*, and are in the collection of the Imperial War Museum, London. Excerpts from Kessell's German Diary were published in the *Cornhill Magazine* in 1946. She wrote: 'Berlin smells of death. Incredibly, like a million year old ruin, so silent that crickets sing and one can hear them, with pale figures creeping around trees hidden in the dark. Pools of water, pale in the moonlight, and white ruins like great white teeth bared.' And drawings of refugees were shown at the Leicester Galleries' first solo exhibition of her art in 1950 (she had three further exhibitions there). Her sympathetic but unsentimental representations of stricken people led Oxfam to send her on a drawing assignment to India in the late 1960s.

Kessell also made imaginative paintings, such as *Still Life under the Sea* (1960, Tate), a haze of blue with forms suggestive of seaweed, coral and under-sea creatures. Her religious works include *A Saint* (1942, Ashmoleon Museum, Oxford) and the mural *Judith and Holofernes*, painted at the Old Westminster Hospital, London, during the war. Late in her career she adopted collage as her main medium.

EVE KIRK
1900–1969

Eve Kirk's paintings were shown alongside those of Paul Nash at Arthur Tooth's gallery in 1939. Like Nash, she had studied at the Slade, and she was primarily a landscape painter. Tate's oil painting *Avignon* (1939) shows evidence of her training in the skilled, detailed delineation of the city across a sweep of fields and river. Kirk's work was included in the centenary exhibition *The Slade Tradition*, held at the Fine Art Society in 1971, with a number of other women artists who had been Slade students, including Carrington, Margaret Fisher Prout and Edna Clarke Hall.

Augustus John lent two paintings by Kirk that he owned to her solo exhibition held at the W.B. Paterson Gallery, London in 1930. Both were of the south of France. He also supplied the catalogue preface, writing: 'With a curious swiftness and certainty she has captured a method, a technique which seems to provide a perfect means for the interpretation of the subjects of her choice, the streets, the quays and the market-places of Provence, Italy or London.' The London scenes included two paintings of an area strongly associated with modern British art, *Fitzroy Street* and *Fitzroy Square*. Two years later, an exhibition at Arthur Tooth's included her painting *The Thames at Wapping*, owned by the Contemporary Art Society. Kirk worked as part of the civil defence from the outbreak of the war, and her exhibition at the Leicester Galleries in 1943 was, for the most part, made up of paintings of London, including *From Waterloo Bridge, Old Compton Street* and *Charlotte Street*. Her *Bomb Damage in the City* was shown as part of the exhibition *National War Pictures* at the Royal Academy in 1945.

Kirk also worked as a designer, creating posters for Shell during the 1930s. She also decorated the Catholic Church in Newtown, Montgomery in the mid 1940s. When she moved to Italy, a decade later, Kirk stopped painting.

CLARA ESTHER KLINGHOFFER

1900–1970

Born in Austria, Clara Klinghoffer moved to Britain where she trained at the John Cass Institute, the Central School of Art and Design, and the Slade from 1919 to 1921. She travelled to Paris in the late 1920s, and lived for a while in Holland. With the turmoil of 1939, Klinghoffer emigrated to America. From that time on she divided her time between New York and London.

Klinghoffer was admired for her highly polished, academic drawing and portraiture. Tate Director J.B. Manson praised her work in the *Studio* in December 1927, because she had not, he wrote, fallen into the trap of trying to be modern and following French artists, such as Cézanne, while art historian and Tate curator Mary Chamot compared her drawings to 'the great Italian masters' in *Modern Painting in England* (London 1937). *The Old Troubadour* (exhibited at the Women's International Art club in 1928) was singled out by the *Apollo* critic in April 1928 as 'an outstanding achievement, both as a bit of character delineation and as sheer painting'. Among Klinghoffer's portrait sitters

Clara Esther Klinghoffer
The Old Troubadour, 1926
Oil on canvas
53.3 × 64.8 (21 × 25½)
Presented by the Trustees of
the Chantrey Bequest 1933

were the actor Vivien Leigh in costume as Shakespeare's Cleopatra, the writer Isaac Bashevis Singer, and her friends the artists Lucien and Orovida Pissarro. The National Portrait Gallery owns her paintings of the pianist Harriet Cohen (1925), who was known for her interpretation of Bach.

Her first solo show took place in 1920 at the Hampstead Art Gallery, while Klinghoffer was still in her teens. Later exhibitions included shows of her

drawings at the Leicester Galleries (1923), and at the Redfern Gallery (1926, 1929 and 1938). She also exhibited with the New English Art Club, the Royal Academy and the London Group. Her work was exhibited at the Nationale Kunsthandel Amsterdam (1928), a number of American Galleries, and the Venice Biennale. More recently, in 1976, a solo exhibition was held at the Belgrave Gallery, London.

LAURA KNIGHT

1877–1970

In her autobiography *Oil Paint and Grease Paint* (London and New York 1936), Laura Knight attributed her later success to a formative influence: 'One of the greatest moments of Mother's life came when she found that I, a mere baby, was never so content as with pencil and paper; even before I could speak or walk I drew. There was no question of my purpose in life. I remember her saying when I was only a few years

old, "You will be elected to the Royal Academy one day".'

At Nottingham School of Art, where she trained from 1891–7 she met her husband, Harold Knight. Knight wrote about the restrictions placed upon women students and described having to work in the Antique Room while the men studied from the life, and being criticised for producing work that was 'strong, like a man's'.[43] With Harold

Knight, she went first to Staithes, in North Yorkshire, and then, in 1907, to Newlyn, Cornwall, where the group of artists centred on the school of Stanhope Forbes included Dod Shaw, and her future husband Ernest Procter.

Staithes had inspired muted, realist works, but in Cornwall Knight produced landscapes full of shimmering light. She began to paint *Spring* during the First World War, when, for reasons of

security, representing the landscape near the coast was forbidden, and so she had to memorise small parts of what she saw outside – a bunch of twigs, the colour of a field – and to build her painting from these mental notes in the studio. During a time of darkness and death, Knight depicted the English countryside as bright and burgeoning, full of the promise of future life. The artist Ella Naper, who stands at the centre of *Spring*, appears as the model Knight is painting in a self-portrait of 1913 now in the National Portrait Gallery. Ella stands naked, while Knight looks on, in her bohemian hat and neck-scarf. Knight's self image was important to her. In a series of photographs by the celebrity photographer Bassano she adopts a variety of guises, smoking a cigarette in an embroidered 'peasant' blouse, and resplendent in a sequinned evening gown.[44] Knight appears in her neck-scarf and hat in a photograph illustrating a *Tatler* article of 1927, 'The Latest Woman A.R.A. and her Work', reporting her election as an Associate of the Royal Academy. She was only the second woman to be given this accolade since the eighteenth century (Annie Swynnerton being the first). And when Knight was made a full Academician nine years later, she was the first woman to achieve this status since Mary Moser and Angelica Kauffmann. In 1932 Knight became president of the Society of Women Artists, remaining in office for the next thirty-five years.

Knight began to make images of the ballet, theatre and circus during the 1920s and 1930s. In *The Modernity of English Art 1914–30* (Manchester 1997), David Peters Corbett pointed out that Knight's interest centred on the women performers' preparations, subject matter which she may have chosen as a response to masculine viewpoints of modern experience, and that these images make visible the relationship 'between public and private experience

Laura Knight
Spring, 1916–20
Oil on canvas
152.4 × 182.9 (60 × 72)
Presented by the Trustees of the Chantrey Bequest 1935

and public and private languages and understandings'. The difference between reality, with all its rough edges, and the spectacle of femininity, is also alluded to in the contrast between Knight's subject matter and her chosen technique. She depicted women involved in the elaborate process of creating an appearance, yet her paintings are polished rather than sketchy, giving her 'unfinished' women performers a weighty presence. The solidity of form in Knight's work is likely to owe something to her knowledge of Procter's art.

At the invitation of Lydia Lopokova, star of the Russian Ballet, Knight pursued her fascination with backstage life. She recalled her arrangement with the ballerina: 'Her room should be my studio, she should never stay in any position on my account, she should go on with her make-up and dressing, stand in front of the long glass and go

through positions and steps. We were both workers. There was to be no conversation.'[45] She also portrayed Anna Pavlova and Tamara Karsavina. In 1923 Knight began to make prints. The aquatint *Three Graces of the Ballet* (1926) reinterprets the classical composition, with one dancer adjusting her wrinkled tights, another applying her powder and a third half-clad in a ballet skirt. Knight toured with Carmo's circus and worked at Olympia with Bertram Mills's circus in the 1920s and 1930s. In her painting of three jugglers, *The Balagher Girls*, women take the three graces' pose again, wearing cheap blond wigs and heavy stage make-up and standing in front of the big top. Knight's interest in the travelling life developed into a series of paintings of Romany people, including *The Gypsy* (Tate).

Knight's paintings of women often appear strikingly modern. *Irene and*

Pearl, a portrait of two black American women, reproduced in the *Graphic* in 1928, has a backdrop of skyscrapers. A painting of a female saxophone player was shown at the National Gallery of Art, Washington DC in 1928, and *Miss Ealand*, exhibited at the Royal Academy in the same year, depicts the sitter in a jacket and tie, with cropped hair, holding a gun. Commissioned to paint women involved in the war effort by the War Artists' Advisory Committee, Knight painted *Ruby Loftus Screwing a Breech Ring* (1943), showing the young woman who had mastered one of the most complex machining jobs at the Royal Ordnance factory. Knight also made portraits of military medallists, including Corporal Pearson of the WAAF, winner of the George Cross, whom she portrayed in 1940 against a tangle of barbed wire. In 1946 she went to Nuremberg to paint the trial of Nazi war criminals. For Knight, absorbing work was a woman's right, and the subject of much of her art.

WINIFRED MARGARET KNIGHTS
1899–1947

Winifred Knights had a critical triumph at the age of twenty-one when *The Deluge* won her the first Rome Scholarship for Decorative Painting to be awarded to a woman. The *Daily Graphic* featured the work on its cover in February 1921 and enthused about the 'remarkable' painting, in which the ark was reminiscent of 'modern concrete buildings' and the figures were 'those of present day men and women', concluding that 'critics declare the painter a genius'. Knights portrayed her mother as the figure carrying a baby, while the woman at the front of the painting, escaping the rising water with an expression of fear, is a portrait of the artist herself.

Knights won a number of prizes and a scholarship while she was at the Slade in the late 1910s. One of her award-winning works, the tempera painting *Composition: Mill Hands on Strike* (1919, University College London) shows a stoic group of men and women against an eerily lifeless industrial landscape. Knights used her meticulous technique to depict contemporary events, in line with some current definitions of decorative painting, as an engagement with real life filtered through knowledge of Renaissance perspective and colour theory. *The Deluge* can be understood in the context of Knights's experience of the recent war, while the painting of

Winifred Margaret Knights
The Deluge, 1920
Oil on canvas
152.9 × 183.5 (60¼ × 72¼)
Purchased with assistance from the Friends of the Tate Gallery 1989

striking workers portrays industrial unrest. She also undertook religious subjects, working from 1928 to 1933 on a commission to paint *Scenes from the life of St Martin of Tours* for the Milner Memorial Chapel, Canterbury Cathedral.

During her lifetime Knights rarely exhibited. Her work has been shown recently in *The Last Romantics: The Romantic Tradition in British Art* at the Barbican Art Gallery in 1989, and alongside that of her husband the painter W.T. Monnington in *Two Way Traffic, British and Italian Art 1880–1980* at the Royal Albert Memorial Exhibition, Exeter in 1996. A retrospective was held at the Fine Art Society and the British School at Rome in 1995.

GHISHA KOENIG
1921–1993

In an interview (in the catalogue for her 1974 exhibition 'Ghisha Koenig Sculpture 1968–74' at the Bedford House Gallery, London) the sculptor recalled being told by a tutor at Hornsey School of Art, 'There are no women sculptors'. Despite this discouragement, and the interruption of her training by the Second World War, Koenig began to study again in 1946 at Chelsea School of Art under Henry Moore and then at the Slade. Koenig's father was an art critic and writer and her mother an actor, and they numbered among their Jewish artist friends David Bomberg, Mark Gertler, Jankel Adler and Josef Herman.

Koenig's sculptures were usually high relief, in bronze or terracotta, and often represented the factory workers she observed in Kent. Her work was realist, and also expressionist. She wanted to capture the psychological atmosphere of the workplace, and the small differences between the workers, whom she did not see as anonymous cogs in the machine. Politics lay behind her choice of subject matter, a modern reworking of the peasant themes of Courbet, Millet and van Gogh, fuelled by her belief that, as she put it in the 1974 interview, 'Most human beings have very little choice in our society'. Koenig showed with the left-wing anti-fascist Artists International Association, where art on industrial themes was exhibited in the early 1940s. She won a

Ghisha Koenig
The Machine Minders, 1956
Artificial stone, metal and wood
130 × 106 × 60 (51⅛ × 41¾ × 23⅝)
Purchased 1986

commission for the Festival of Britain, and for a new housing scheme in Poplar, East London. She was one of the group of artists tackling similar themes during this post-war period who were exhibited in *The Forgotten Fifties* at the Graves Art Gallery, Sheffield in 1984.

Koenig's work was shown at the Whitechapel Art Gallery's *Jewish Artists in England – 1656–1956* in 1956. She was singled out by the *The Times* critic, along with fellow exhibitor Lily Delissa Joseph, as little-known artists whose work compared well with that of their more celebrated contemporaries. Koenig also showed with the Society of Portrait Sculptors and had solo exhibitions at the Grosvenor Gallery (1966) and the Serpentine Gallery (1986). A memorial exhibition was held at the Boundary Gallery in 1994. Koenig's drawings were shown with those of Henry Moore and Hamo Thorneycroft at the exhibition *Work and the Image*, held at the Henry Moore Institute, Leeds in 1998.

LEE KRASNER
1908–1984

Histories of the first generation of Abstract Expressionists often include Lee Krasner as the sole woman artist. She had major exhibitions during her lifetime, from her first retrospective at the Whitechapel Art Gallery, London in 1965–6, to an exhibition that toured from the Museum of Fine Arts, Houston in the year before her death. A recent show organised by Independent Curators International toured from the Los Angeles County Museum of Art, California from 1999 to 2001. But despite Krasner's stature, discussion of her work has often concentrated on her relationship with her husband of eleven years, Jackson Pollock. Although she undoubtedly drew stimulus from his art, recent criticism has begun to address issues specific to Krasner, notably her identity as a Jewish woman artist.

Although she lived in Brooklyn, New York, Krasner chose to go to a school in Manhattan, Washington Irving High School as, unusually for a public school, it allowed girls to major in art. She went on to train at the Women's Art School of the Cooper Union, and the Art Students League. Her early work embraced Realism and Surrealism, as in the painting *Gansevoort I*, (1934, Pollock-Krasner Foundation). She also studied under Hans Hofmann at his School of Fine Arts from 1937 to 1940, working from the model in a style that drew upon her knowledge of Cubism, Picasso and Matisse. Krasner became politically

Lee Krasner
Gothic Landscape, 1961
Oil on canvas
176.8 × 237.8 (69⅝ × 93¼)
Purchased 1981

active, working as a muralist for the Works Progress Administration Federal Art Project and then joining the American Abstract Artists group in 1939. This internationalist left-wing organisation contrasted with the regionalism and isolationism of some American art, and Krasner is likely to have been partially motivated by her position as a Jew during the rise of the Nazis.

In 1942 Krasner was invited to show her work in the exhibition *French and American Painting* at the McMillen Gallery, New York. Fellow exhibitors included Matisse, Picasso, de Kooning and Pollock. Three years later she and Pollock married and moved out of the city to The Springs, East Hampton. There, having turned their living room into a studio, Krasner made her abstract *Little Image* paintings. Her self-professed aim to 'absorb Pollock' is evident in the all-over compositions, but Krasner developed her own pictorial vocabulary. As Robert Hobbs elaborates in his book accompanying her 1999–2001 retrospective, other Abstract Expressionists also made use of sign systems. However, Krasner's method of painting from right to left, and her mark-making, which sometimes seems to draw upon her knowledge of Hebrew, could be linked to archaeological finds of ancient texts at the time, suggesting that she may have been making 'efforts to keep the faith of Jewish solidarity while still remaining resolutely modern and avant-garde in a post-Holocaust world. Krasner also made two mosaic tables in 1948. Contemporary in style, low and round, with triangular feet, their surfaces were made into abstract works of art, using tile, pieces of Krasner's jewellery and everyday objects such as keys and coins. Rather than being purely modernist, they can be interpreted as crystallising the combination of domesticity and artistic practice in her own life.

In the early 1950s Krasner created her 'personage paintings', and collages such as *Desert Moon* (1955, Robert Miller Gallery, New York), with its contrasting black, hot pink and orange. The collages made use of a mixture of media, sometimes incorporating fragments from both her and Pollock's works, and she exhibited them in a critically successful solo show at the Stable Gallery, New York in 1955. The following year Pollock died, and Krasner was able to move into his spacious studio. With the freedom to work on a much larger scale, she produced paintings known as the *Earth Green* series, including *The Seasons* (1957, Whitney Museum of American Art, New York), with its massive curving rhythms, pinks and greens and organic, sexually suggestive forms. By contrast, the more than thirty paintings known as the *Umber and White* series of the early 1960s are characterised by sombre, heavy colour, and slashing brushwork, and have sometimes been interpreted biographically as expressions of unresolved anger and the pain of loss. In the 1970s Krasner created the series of collages *Eleven Ways to Use the Words to See*, titled after verb tenses and moods, as in *Imperative* (1976, National Gallery of Art, Washington DC). Again she re-used past works, slicing up drawings from her time as a Hofmann student and adding flashes of painted colour. Her bold juxtaposition of parts of different pieces, disrupting their original significance, has been critically linked to postmodern concerns with the instability of meaning in language.

The changes in Krasner's art throughout her career can be seen as driven by an energetic drive towards formal development. But it is also possible to read them in the light of Krasner's life, without interpreting them as simplistically autobiographical. Some of their characteristics, their scale and the media she used were shaped by her shifting work arrangements. The changes in her practice also suggest that she was applying her knowledge of psychoanalytic models of subjectivity as fluid and fractured rather than fixed (she underwent psychoanalysis in the mid-1950s) and perhaps offer a critique of the dominant cultural image of artistic genius as a male producing one signature style, that she had experienced at such close quarters. At the age of sixty-four, Krasner joined the group Women in the Arts to protest at the discrimination against women artists by the Museum of Modern Art, New York.

As the wife of a famous painter, Krasner has sometimes served as Pollock's foil in critical writing. Her awareness of her distance from representations of herself, and her understanding of identity as a shifting construct, is evident as far back as *Self-Portrait* (1930, Pollock-Krasner Foundation). She pictured herself as an artist, wearing practical overalls and in the act of painting, but also as a transient reflection in a mirror. Other strategies involved changing her name to Lee from her feminine birth name of Lena, and signing canvases with the ambiguous 'LK'. Images of her vary from informal 'family' photographs taken with Pollock and their dog in the 1950s to late portrait photographs by Irving Penn and Robert Mapplethorpe, in which she is an imperious grande dame.

MARIE LAURENCIN
1885–1956

Marie Laurencin is one of the few women artists to have a museum dedicated to her, in Tateshima, Japan. She was born in Paris, the illegitimate daughter of a Creole seamstress. After training as a porcelain painter, Laurencin studied fine art at the Académie Humbert, where she met Georges Braque, who introduced her to Picasso's Bateau Lavoir circle of Cubists.

Laurencin pictured her central role in this group, both as an artist and the muse of the poet Guillaume Apollinaire, in two paintings of 1908, one a portrait group of eight figures, *Apollinaire and his Friends* or *Country Reunion* (Centre Georges Pompidou, Paris), the other, *Group of Artists Les Invités* (The Cone Collection, Baltimore Museum of Art). The latter portrays Picasso, Laurencin, Apollinaire and Picasso's mistress, Fernande Olivier. It encapsulates the style which made Laurencin famous. Unlike her detailed, dark, richly coloured early paintings (a fine example, *Portrait of the Artist's Mother* of c.1906, is in the Ashmolean Museum, Oxford) *Les Invités* is a pared-down arrangement of curving lines, simplified forms and flat, mask-like faces. It was bought by the influential collector Gertrude Stein. In the same year Laurencin was given a solo exhibition at the Galerie Berthe Weill, Paris and many others followed.

There has been controversy over Laurencin's role in this important epoch in modern art. She asserted that her work, mainly portraits of women

Marie Laurencin
The Fan, 1919
Oil on canvas
30.5 × 30 (12 × 11¾)
Bequeathed by Elly Kahnweiler 1991 and accessioned 1994

painted in a restricted palette of rose pink, pale blue and soft grey, as in the Tate Collection *Portraits* (1915), was an expression of her femininity. She designed for Diaghilev's Ballets Russes and for the couturier Paul Poiret, and her work was shown at the *Exposition des Arts Décoratifs* in Paris in 1925. But, as Bridget Elliott and Jo-Ann Wallace have discussed in their survey of women in modernism (London and New York 1994), the 'feminine' decorative qualities of Laurencin's work have meant her relegation to the lower ranks of twentieth-century artists. In fact, both her work, and her persistent claim to be both a woman and a leading modern, were ground-breaking.

FELICIA LEIRNER
born 1904

Felicia Leirner only began to study sculpture when she was in her mid-forties. She was born in Warsaw, Poland, but emigrated to São Paolo, Brazil in 1927. There she trained with the sculptor Victor Brecheret.

For the first decade of her career, Leirner made figurative sculpture, somewhat similar to Henry Moore's work. There are single figures, and mothers with children. The torsos and interlocking limbs in some of these sculptures began to be honed down to such an extent that they became almost abstract arrangements, and by 1958 Leirner had abandoned figuration. Nevertheless, she retained an organic sense of form that can be seen in the flowing, curved lines of some of her pieces, while others developed from her knowledge of church architecture and symbolism, the forms of arches and crosses. Leirner also began to work on a much larger scale, creating pieces that the viewer could walk through.

Although she is little known in Britain, the Tate Collection houses Leirner's bronze sculpture *Composition* (1962); her art has been much admired and exhibited in her adopted country. She is represented internationally in collections including the Hermitage, St Petersburg and the Stedelijk Museum, Amsterdam. She was awarded the Rio de Janeiro Museum of Modern Art's prize at the 1955 São Paolo Biennal, and the award for best Brazilian sculptor in the Biennal eight years later. There is now a museum devoted to her in São Paolo, where her work can be seen lining the walkways of a sculpture garden, and silhouetted against the sky.

HELEN LESSORE
1907–1994

Interviewed as she reached her eightieth birthday for the Royal Academy Magazine (Autumn 1987) the painter and gallery director Helen Lessore recalled her childhood: 'I had a great aunt who used to give me books of Titian, Raphael, Rembrandt, Rubens, Van Dyck and Murillo … I had been brought up to the idea that I would be a painter as a matter of course because my mother thought I had talent.'

During the 1920s the young Helen Brook had been a prize-winning Slade student. She wanted to teach, but found 'it was not possible in those days for a woman to teach in an art school', and instead became a secretary at the Beaux-Arts Gallery, London. She married the gallery's owner, Frederick Lessore, taking over following his death in 1951. Helen Lessore slept in a bed in the centre of the gallery surrounded by the figurative art she loved, by artists including Frank Auerbach, Sheila Fell, Lucian Freud and R.B. Kitaj.

Helen Lessore
Symposium 1, 1974–7
Oil on canvas
168 × 213.7 (66⅛ × 84⅛)
Purchased 1981

Lessore was one of only four women among the forty-five artists included in Kitaj's seminal show of contemporary figurative art, *The Human Clay*, held at the Hayward Gallery in 1976. She exhibited a pencil *Study of Frank Auerbach* (1974), which is now owned by the Arts Council, as is her *Self-Portrait II* (1966), a painting of her strong profile. In *Symposium I* some of the artists she worked with are seen conversing on the island of Patmos, a reference to Lessore's belief in the enduring legacy of classical Mediterranean culture, which she explored further in her book *A Partial Testament: Essays on some Moderns in the Great Tradition* (London 1986). Her influence was celebrated in the 1984 Tate exhibition, *The Hard Won Image*, and a retrospective was held at the Fine Arts Society in 1987.

KIM LIM
1936–1997

The sculptor and printmaker Kim Lim travelled from Singapore to London in 1954 to train at St Martin's School of Art and the Slade. She described the early influences on her work in an interview in *Studio International* in 1968: 'I prefer an art that has quietude and containment. This describes classical Western art, the art of the Greek orders and of Brancusi and Matisse, as much as it does the art of the East.'

Lim rejected the figurative expressionism in dark metal that had dominated post-war sculpture, preferring a contemplative, abstract exploration of her chief concerns, 'space, rhythm and light'. But her work was also different from that of the major abstract sculptors of her generation with its overbearing scale and weighty presence. She can be seen as part of the revival of constructivism by a group of artists working in post-war Britain, among them Mary Martin. The strong female presence among this second wave of constructivists could be due to its utopian, international ideology,

Kim Lim
Intervals II, 1973
Wood
Purchased 1975

a belief in the potential for progress that may have seemed in tune with political moves towards equality for women.

Working on a small scale (determined by her desire to make her sculptures without assistance), Lim used a variety of materials. From the late 1970s she carved, often in Portland stone and Rose Aurora marble. She had already worked inventively with wood and steel, adding another layer to her sculptures by painting

them, and also with fibreglass, whose translucency she liked. Lim introduced a poetic naturalism to her later works by exploring the effects of light playing across incisions in their surfaces, and choosing titles such as *Wind-stone*, *Sea-stone*, *Stem* and *Source*. A solo exhibition at the Axiom Gallery in 1966 was the first of a number of shows. Her prints, often used to develop ideas for sculpture, were exhibited at the Tate in 1977, and the Camden Arts Centre held a retrospective in 1999.

RITA LING
born 1922

In 1955 Rita Ling exhibited the green limestone sculpture *Galway Cow* (now in the Tate Collection) at the Royal Academy. She also showed a terracotta bust of John Skeaping (the sculptor and first husband of Barbara Hepworth). After graduating from Wolverhampton College of Art, Ling had trained under Frank Dobson and Skeaping at the Royal College of Art. Her choice of an animal subject and the summarised solidity of her style show the latter's influence. Animals were an important subject for those British sculptors

working in the early twentieth century who took part in the renaissance of direct carving (who included Gertrude Hermes). The Irish reference in the title reflected Ling's own family roots.

Ling went on to combine her practice as a figurative sculptor of portrait busts in bronze with teaching. She was the first woman tutor to work in the sculpture department at the Royal College of Art (from 1955 to 1960). Ling's work decorates the imposing Dutch Church at Austin Friars in the City of London. She and Skeaping

collaborated on the carvings there. Again, this locates her firmly in the context of her times. The resurgence of commissions for church decorations in the twentieth century led to a number of modern sculptors and painters contributing to the decoration of Britain's churches. Progressive ideas about the modernisation and reform of Christianity were to be reflected in art by ground-breaking artists, including Barbara Hepworth, Jacob Epstein and Henry Moore, that was housed in new Church buildings.

FLORA LION
1876–1958

There are nine portraits by Flora Lion in London's National Portrait Gallery. Among her sitters were the theatrical pioneer Annie Horniman, and the author and patron Lady Isabella Augusta Gregory. The two women had a common friend in the poet and dramatist W.B. Yeats and had worked together on the publication of his collected works in the 1900s.

Lion trained in London at the St John's Wood School of Art, the Royal Academy (where her tutors included Solomon J. Solomon and John Singer Sargent) and the Académie Julian in Paris. She portrayed society figures, painted landscapes and flower pieces, and made lithographs. Lion had solo exhibitions at the Alpine Club (1923), Barbizon House (1929), the Fine Arts Society (1937) and Knoedler's Gallery (1940). Her group exhibitions included the Society of Women Artists and the Royal Academy. She also served on the council of the Royal Society of Portrait Painters.

Aspects of her life and work suggest that Lion was a forceful figure. After their marriage in 1911, her husband, also a painter, changed his second name to

Flora Lion
My Mother, 1909
Oil on canvas
127.6 × 115 (50¼ × 45¼)
Presented by Francis Howard through the National Loan Exhibitions Committee 1915

hers. Among her paintings of women is a portrait of two girls, exhibited at the Royal Society of Portrait Painters in 1928. *Yvonne and Esmé* are shown in boots, breeches and ties, with bobbed hair. The elder's stance, unsmiling, with her hand on her hip, is an unusual portrayal of a girl as an authoritative figure. Lion also represented herself as an imposing presence brandishing a sheaf of brushes, in a painting shown

at the exhibition *Self-Portraits by Living Artists*, held at the Russell-Cotes Art Gallery and Museum, Bournemouth in 1947 (present location unknown). The Imperial War Museum own two of her paintings from 1918, *Building Flying Boats* and *Women's Canteen at Phoenix Works, Bradford,* in which a queue of women in overalls wait for food.

LUCY
born c.1918

At the exhibition *Contemporary Canadian Eskimo Art* held at London's Gimpel Fils Gallery in 1961, *The Green Bear* was one of two stone-cuts designed by an artist listed as 'Lucy' who lived on Baffin Island in the Arctic Circle (*The Green Bear* was intended to make lithographs, and carved by another artist, Eegyudluk). The exhibition had been prompted by a 'revival' of Inuit art,

and the formation of the 'West Baffin Eskimo Co-operative', an organisation formed to make and sell Inuit art in Cape Dorset, the town where Lucy worked.

But there is another side to this story. The 'revival' occurred at a time of increasing encroachment on what had been Inuit territory. The Hudson Bay Company were working in the area and

the Canadian Government had built a military airport and radar stations there. The catalogue for the Gimpel Fils exhibition states, without irony, that through the twin interests of commerce and defence 'twentieth-century technology was brought to the very door of the Eskimo, increasing his contact with our civilisation'.

The catalogue glosses over what

was, in effect, a colonial enterprise, and represents the Inuit artists in a manner reminiscent of the nineteenth-century language of British Empire. In the preface, gallery owner Charles Gimpel summarised the characteristics of 'The Eskimo'. He wrote about a 'mongoloid type, dark skinned with the slanted eyes associated with Asian races … They are capable of great kindness and yet frightening cruelty; improvident, they seem indifferent to the future and the passing of time.' The Canadian government's avowed aim, 'to bring the Eskimo into the pattern of Canadian life', and make them 'accept our sense of values', was based on a perception of these indigenous people as a barbarous, unsophisticated, 'other'. Nothing is known of Lucy; she and her work are in the strange position of being outsiders within the history of art constructed in the Tate Collection.

Lucy
The Green Bear, 1961
Stone
47 × 87.6 × 16.8 (18½ × 34½ × 6⅝)
Presented by Charles Gimpel 1961

FRANCES MACDONALD
born 1914

Frances MacDonald was one of the few women artists to be included in the exhibition *National War Pictures* held at the Royal Academy in 1945. She had been commissioned to contribute work by the War Artists Advisory Committee (who presented *Building the Mulberry Harbour, London Docks* to the Tate Collection). Like the great majority of women artists who worked for the committee, and unlike their male colleagues, MacDonald was not given an official salaried post as a war artist, but was paid to work on a few pieces over a short term. She painted one of the harbours used in the invasion of France in June 1944, and exhibited the painting now in the Tate Collection, along with studies of the London docks, at the Royal Academy exhibition, in addition to works titled *Chelsea Old Church* and *Salvaging a Crashed German Aircraft*.

Frances Macdonald
Building the Mulberry Harbour, London Docks, 1944
Oil on canvas
55.9 × 121.9 (22 × 48)
Presented by the War Artists Advisory Committee 1946

MacDonald had studied at Wallasey School of Art, and at the Royal College of Art under William Rothenstein during the late 1930s. She painted landscapes, city scenes and portraits. She also taught at a number of art schools, focusing on disseminating the skills of good draughtsmanship. Her exhibitions included a solo show at Wildenstein's in 1947 and at the Alfred Brod Gallery in 1961, at which she exhibited paintings in oil and watercolour of London and a portrait of her husband, the painter Leonard Appelbee.

MARY SPENCER MCEVOY
1870–1941

There was a long hiatus in Mary Spencer McEvoy's career. She had studied at the Slade, where she met the painter Ambrose McEvoy, whom she married in 1901. Between 1899 and 1910 she exhibited regularly at the New English Art Club. The work she showed there suggests that she shared the predilection of some of her Slade contemporaries, such as Gwen John, for portraiture and interior painting after the Dutch masters. There are works titled *The Student, The Blue Dress* and *An Old Letter. Interior: Girl Reading* clearly refers to Dutch painting, with its stilled atmosphere, but it can also be understood in the context of the young women of her circle who were entering the new century having been able to study seriously. Maud Sulter noted in her catalogue for the exhibition *Echo* (Tate Liverpool 1991) that the painting of a female figure reading did not only signify the sitter's gentility, but also 'a quest for knowledge and new ideas.'

Then McEvoy disappears from the lists of exhibitors. It is assumed that her time was devoted to her children and to helping her husband, who built a hugely successful career as a society portrait painter. It seems that this help included painting for him. Soon after they

Mary Spencer McEvoy
Interior: Girl Reading, 1901
Oil on canvas
53.3 × 43.8 (21 × 17¼)
Purchased 1927

were married, Ambrose McEvoy was commissioned to paint a series of works for Long Tower Church, Londonderry. They were to be a mixture of three original paintings and twenty-two copies of old masters depicting the life of Christ. While Ambrose painted the originals Mary worked on the copies, finding suitable works and making cartoons, which she then laboriously squared up and painted onto copper panels. The year after Ambrose McEvoy's death in 1927, she began to exhibit again, showing a series of portraits of women at the Royal Academy, and at Knoedler's Gallery, London, in the 1930s.

SINE MACKINNON
1901–1996

Sine MacKinnon was born in County Down, Northern Ireland. She studied at the Slade in the late 1910s and early 1920s where she won prizes for painting, drawing and anatomy, and a scholarship. She then went to Paris, reportedly encouraged by her mother, where she had some further training at the Ecole des Beaux-Arts. Her 1928 submission to the Society of Women Artists, a painting of a wharf near London Bridge, was sent from her address on the boulevard Raspail, Montparnasse.

MacKinnon exhibited at the Paris Salons and in London. Her first solo exhibition was held at the Goupil Gallery in 1928, and she showed at the Redfern and Lefevre galleries, and with the New English Art Club and the London Group. At a joint exhibition with Stephen Bone, husband of her friend Mary Adshead, at the Fine Art Society in 1929, she showed paintings of Connemara in Ireland.

For the most part, MacKinnon painted scenic views, landscapes and townscapes seen during her travels in Greece, Portugal and in France, where she spent most of her life. But there was another side to her work. A painting reproduced in the *Studio* in 1945, then on show at the Lefevre galleries, shows a blasted landscape, with a crater full of water, tangles of barbed wire and tree stumps. It clearly refers to the war, and also has a strange, dream-like Surrealist atmosphere. The Tate Collection's oil *Farm Buildings in Provence* (1934), with its parched uninhabited landscape, blank windows, leafless trees with twisted branches and intense blue sky, has a similar unsettling edge.

MARY MARTIN
1907–1969

It was not until she was in her forties that Mary Martin worked as a full-time artist. She had studied at Goldsmiths and the Royal College of Art, painting still life and landscape. An early copy of a painting by Watteau in oil survives (*c.*1929, private collection), incongruous next to the geometric abstraction for which she became known.

By 1950 Martin had moved completely away from figuration, first painting, then making reliefs in metal, perspex, plaster and wood. Along with her husband, the sculptor Kenneth Martin, she became a leading member of the constructivist revival in Britain, creating work concerned with nature but which sought to explore natural laws of space and light rather than make figurative representations. A limited repertoire of forms, often a dissected cube, were arranged in permutations suggested by mathematical ideas, and sometimes coloured. Martin won the John Moore's art prize (1969, joint winner with Richard Hamilton), had a number of solo exhibitions, (including the Institute of Contemporary Art in 1960 and a tour from the Ashmolean Museum, Oxford, in 1970, both with her husband), and showed with the Artists International Association and the London Group. A retrospective was held at the Tate in 1984.

Some of Martin's most important work was made with architects, part of her project to give art a social function. With Kenneth Martin and the architect John Weeks she constructed a pavilion for the exhibition *This Is Tomorrow* at the Whitechapel Art Gallery in 1956. Her reliefs spread over the panels dividing up the space, an integral part of the environment rather than a surface decoration. Her commissioned works included *Tidal Movements* of 1960, made for the P & O ship the SS Oriana. And she also made multiples, participating in the group project 'Unlimited Multiples' in 1969 (along with Liliane Lijn, among other artists), an attempt to mass-produce mail order art from a workshop in Bath, making it accessible to all. Martin was quoted in the catalogue arguing that works of art were 'physical, material presences meant to be handled, gazed upon and lived with. To possess them, both privately and publicly, is a primitive human urge: food for the mind and the spirit.'

Mary Martin
Black Relief, 1957–*c.*1966
Painted wood, board and plastic
76.4 × 114 × 14.8 (30⅛ × 44⅞ × 5⅞)
Presented by the Friends of the Tate Gallery 1987

DOROTHY MEAD
1928–1975

Tate Archive has a letter sent by Dorothy Mead to her friends David Bomberg and Lilian Holt in 1952 during her travels. She had admired Rembrandt's work in Amsterdam, and then went on to Paris, where she was less impressed: 'I got the feeling that . . . imperfect though some of our paintings are we at least have higher aims than many of the painters here.'

Mead trained at South-East Essex Technical College, Dagenham with David Bomberg. She followed him to the Borough Polytechnic, where she studied from 1945 to 1951, and then went to the Slade. Mead helped to form the Borough Group, organised to promote the work of Bomberg and his students. The strong structures and dynamism of her work shows his influence. The group's first exhibition was held in 1947 at the Archer Gallery and, unusually, included more women than men. Mead showed six works, among them a nude and a cityscape, *Snow in South London*. She exhibited at other key Borough Group exhibitions and in 1964 her work was shown at the Arts Council exhibition *6 Young*

Dorothy Mead
Chessboard, 1958
Oil on canvas
76 × 64 (29⅞ × 25¼)
Presented by Andrew Forge
1971

Painters, along with Peter Blake, William Cozier, David Hockney, Euan Uglow and Bridget Riley.

Although Mead was highly respected among her contemporaries and became the first woman president of the London Group she was largely overlooked by commercial galleries and was never given a solo exhibition. Two of her paintings, one a self-portrait, were included in the exhibition *Bomberg and his Students* held at the South Bank University in 1992.

ELSE MEIDNER
1901–1987

In an article 'The Art of Else Meidner' published in the *Studio* in 1960 (vol.159, January–June 1960), art historian J.P. Hodin located her as part of a group of artists who, 'owing to . . . political circumstances . . . have made the British isles their second home'. (Hodin later presented Meidner's *Death and the Maiden* to the Tate Collection). Meidner had studied in Berlin where she won a scholarship on the recommendation of Kathe Kollwitz as well as prizes for her drawings and engravings, and had her first solo exhibition of oil paintings and drawings in 1932.

A year later new anti-semitic legislation forbade Meidner from exhibiting. She and her husband, also an artist, moved to England. Although he returned to Germany after the conflict, she did not. Her work took up the graphic expressionism of Kollwitz and used it to represent aspects of the Jewish experience in modern Europe. In the drawing *Diaspora* (artist's estate, Kibbutz Shluchot), a grief-stricken woman covers her eyes and clings to her child. A comparison of two self-portraits reveals a changing self-representation evoking the artist's

traumatic experience. The Meidner of the 1927 charcoal drawing *Self-Portrait, Laughing* is very different from the haunted, pallid woman in the oil *Self-Portrait* of 1947. And she made a series of works depicting an encounter between a female figure and death.

Hodin was writing in response to Meidner's solo exhibition at Helen Lessore's Beaux-Arts Gallery in 1959. Meidner also showed in London at the Matthiesen Gallery (1956) and at the Ben Uri Gallery; an exhibition with her husband in 1949 was followed by individual exhibitions in 1964 and 1972. A retrospective was held at the Mishkan Le'Omanut Museum of Art, Ein Harod, Israel in 1992.

Else Meidner
Death and the Maiden, c.1918–25
Drawing on paper
55 × 49.7 (21⅝ × 19⅝)
Presented by Professor J.P. Hodin 1983

SYLVIA MELLAND
1906–1993

At her retrospective at the Boundary Gallery, London in 1997, Sylvia Melland's paintings and prints included interiors and still-life. There were also scenes in France, in Arles and Aix-en-Provence, and at the Parisian studio on the rue Daguerre where she had worked in the 1930s. The choice of subject matter, drawn with a sinuous line and often brilliantly coloured, indicates the influences that shaped Melland's works, including van Gogh and Matisse. The two are referred to in the oil *Estaminet Wimille* of the early 1930s, in which a Matisse-like interior with table, chairs and windows is decorated with a painting of a billiard room, reminiscent of van Gogh's *The All-Night Café* (1888, private collection). There were also images of architectural space that suggested other influences, such as contemporary design and film. In the painting *Ladbroke Square* of 1931, the viewer looks out through a distinctive modern curved railing, while in the aquatint *Staircase at Stresa* of 1963 a sinister, snaking balustrade shadows a red wall.

Sylvia Melland
Still Life with an Open Window, 1931
Oil on canvas
76.3 × 68.5 (30 × 27)
Presented by David Melland 1997

Melland had trained at Manchester School of Art, the Byam Shaw School, and for a short time at Euston Road, where she became friends with Margaret Mellis. Among Melland's exhibitions was a show with Thelma Hulbert at Basil Jonzen's Weekend Gallery in 1948, and with Evelyn Gibbs at Zwemmer's Gallery in 1957. She also exhibited with the Artists International Association, the Women's International Art Club and the Royal Society of Painter Etchers. Melland briefly abandoned her strong palette during her Euston Road period, but her artistic mentors and her love of travel put the colour back into her work. She travelled through Europe, stayed in South Africa with her sister in the 1920s, and the two also went to Sweden together. In a self-portrait painted in Stockholm in 1934, the young Melland wears a modish nautical striped top, and behind her is the sea.

MARLOW MOSS
1890–1958

Like her friend Paule Vézelay, Marjorie Jewell Moss adopted a more sexually ambiguous name. She trained at the St John's Wood School of Art and then at the Slade, before moving to Paris in 1927. Her new environment suited her new identity. It was the era of *La Garçonne*, the short-haired 'bachelor' girl, subject of Victor Marguerite's best-selling novel of 1922. Paris also nurtured Moss's abstract painting in which she explored space and form with a palette of red, blue, yellow, black, white and grey. Moss entered the Académie Moderne, where she was taught by Fernand Léger and Amadée Ozenfant.

There has been some debate about the close relationship between Moss's work and that of Piet Mondrian, whom she met in 1929. Both developed compositions using double lines to divide space. But Moss's interest in precise calculation and structure (carried out with compass and ruler) pre-dated her knowledge of Mondrian's methods. She had studied mathematics and architecture intensively at the British Library. There are also similarities between her work and that of Vézelay (their correspondence is in the Tate Archive). Both women used curved lines made out of cord or, in Moss's case, rope. Moss was a founder member of Abstraction-Création in 1931, which Vézelay later joined. In turn Moss joined the British branch of an organisation co-ordinated by Vézelay, the Groupe Espace.

Moss's reputation as a pioneer of abstraction may have been harmed by the loss of much of her pre-war work when her French home was bombed in 1944. Settling in Cornwall, she became part of the community of artists including Barbara Hepworth and Ithell Colquhoun. Moss had two exhibitions at Erica Bransen's Hanover Gallery in London (1953 and 1958), and in 1962 her retrospective followed Mondrian's at the Stedelijk Museum, Amsterdam.

Marlow Moss
Composition in Yellow, Black and White, 1949
Oil on wood and canvas
50.8 × 35.6 × 0.6 (20 × 14 × ¼)
Presented by Miss Erica Brausen 1969

MARIE-LOUISE VON MOTESICZKY
1906–1996

Marie-Louise Von Motesiczky was Austrian. Her *View from the Window, Vienna* (1925, Tate) is a vista of rooftops seen from her family's flat in the city. She trained in Paris, and then from 1927–8 under Max Beckmann in Frankfurt. Her painting is figurative, expressionist and sometimes allegorical. The weighty presence of her figures, her energetic drawing and intense colour are similar to Beckmann's, and these characteristics, allied to her subject matter, often self-portraiture and images of women, also link her to Paula Modersohn-Becker.

In 1938 Von Motesiczky and her mother (who was Jewish) fled to the Netherlands to escape the Nazis, and then to England. Her *Self-Portrait with a Red Hat* (1938), made during this upheaval, is a remarkable assertion of her presence, both as a vibrant, elegant young woman and an artist with a questioning gaze, although the shadowy second figure in the painting seems to hint at the dangers surrounding her. It was during their stay in Holland, in early 1939, that Von Motesiczky had her first solo exhibition. Her brother who had stayed behind was killed in Auschwitz, and she commemorated him in a painting made several years after his death. Among her British works is a portrait of the writer Elias Canetti (1992, National Portrait Gallery). Her most significant late paintings are the series of portraits of her mother, including *From the Night into Day* (1975, Tate) which are moving in their unflinching scrutiny of the old woman who is portrayed nearly bald, smoking a pipe, walking with sticks, or bundled up in bed.

Helen Lessore gave Von Motesiczky a retrospective at her Beaux-Arts Gallery in 1960, and paid tribute to her in the introduction to *A Partial Testament* (London 1986). The Goethe Institute held a major exhibition in 1985, with a catalogue essay by Ernst Gombrich, and two years before her death an exhibition was organised jointly by the Österreichische Galerie, Vienna, and the City Art Gallery, Manchester.

Marie-Louise Von Motesiczky
View from the Window, Vienna, 1925
Oil on canvas
62.5 × 31 (24⅝ × 12¼)
Presented by the artist 1986

LOUISE NEVELSON
1899–1988

In 1905 Leah Berliawsky and her family emigrated from her birthplace in Kiev, Russia to the USA. They settled in Maine, where they encountered anti-Semitism. By the time she moved to New York in 1920, Leah had changed both her first and second names. She studied at the Art Students League and with Hans Hofmann. Nevelson also worked with Diego Rivera on a mural project, and met his wife Frida Kahlo.

At first Nevelson painted but then started to sculpt, in bronze, terracotta and marble. Her subject matter included birds, as in *Bird Form* (*c*.1945, Museum of Fine Arts, Houston, Texas), and figures, reminiscent of those of Louise Bourgeois. In the mid-1950s Nevelson began to make the work for which she is known: constructions, sometimes entire environments, made from junk, mainly wood, found on the city streets. Nevelson's art can be understood as developing from the work of Marcel Duchamp and Kurt Schwitters. Like Duchamp, her work embraced readymades and collage, and her large scale constructions can be related to Schwitters's *Merzbau*. Nevelson was placed in the wider history of such work in the exhibition *The Art of Assemblage* at the Museum of Modern Art in 1961. Like Duchamp and Schwitters, she used found objects, but Nevelson's work was often specifically urban. She foraged in areas of New York that were being redeveloped, picking up 'old wood that had a life, that cars have gone over and the nails have been crushed'.[46] Also unlike her predecessors, Nevelson always completely transformed her material, removing previous associations that the objects may have had through the act of assemblage and painting

Louise Nevelson
An American Tribute to the British People, 1960–4
Painted wood
309.9 × 434.3 × 116.8 (122 × 171 × 46)
Presented by the artist 1965

them monochrome, 'retranslating' them. Nevelson can also been seen as part of an American tradition: her focus on modest materials, imbuing them with spiritual significance, has been linked to Walt Whitman's writings, while her assemblage of the everyday has parallels with the work of Pop artists such as Jasper Johns and Robert Rauschenberg. According to the American critic Hilton Kramer, writing in 1958, Nevelson's work, and its architectural scale, extended the boundaries of sculpture, opening up possibilities.[47]

Nevelson believed that her art had a mysterious spiritual dimension. In *Sky Cathedral* (1958, Museum of Modern Art, New York) boxes pile upon each other, their interiors filled with things which could be familiar objects, but whose identities, veiled in black paint, elude us. Working in white, Nevelson

created environments, including *Dawn's Wedding Feast*, made for the exhibition *Sixteen Americans* at the Museum of Modern Art, New York in 1959–60, some of the pieces being re-used for her submission to the Venice Biennale in 1962. The *Royal Tides* series, all painted gold, such as *Royal Tide IV* (1960, Wallraf-Richartz-Museum, Cologne), first shown at the Martha Jackson Gallery, New York in 1961, evoke the elaborate ancient altarpieces and tombs uncovered by archaeologists. In 1977 Nevelson designed an installation and vestments for a Manhattan church. She made many permanent public works, sometimes in industrial materials, including, in the late 1970s, the Louise Nevelson Plaza in Manhattan.

Looking at writing on Nevelson, such as the book *Dawns + Dusks* (New York 1976), on which she collaborated with Diana McKown, the prominence

given to images of the artist is striking. Photographed in front of her work at her 1980 retrospective at the Whitney Museum of American Art (she had her first major museum retrospective there in 1967, and a further exhibition in 1998), she wore a flamboyant dress and her trademark thick false eyelashes. On Nevelson's worn and lined face the lashes do not look pretty; they draw attention to their own artificiality, making her gaze theatrically compelling. Aside from the pleasure dressing up gave her, Nevelson's elaborate

image suggests a manipulation of self-representation to make a powerful statement of feminine presence in the art world. She is quoted as saying: 'If I looked too refined and said "fuck it" they wouldn't quite understand. Looking as I do I can say it.'[48]

Nevelson claimed that her sex made her work essentially different, writing that her use of wood, with its domestic associations, was perhaps 'closer to the feminine'. She argued: 'A man simply couldn't use the means of, say, fingerwork to produce my small pieces.

They are like needlework . . . My work is delicate; it may look strong, but it is delicate. True strength is delicate. My whole life is in it, and my whole life is feminine, and I work from an entirely different point of view. My work is the creation of a feminine mind – there is no doubt.'[49] The interweaving of identity and work was explicit in the black installation *Mrs N's Palace* (1964–7); the mirrored floor in this piece reflected the inhabitant, making them part of the space.

E.Q. NICHOLSON
1908–1992

At the exhibition *The Nicholsons: A Story of Four People and their Designs* held at York City Art Gallery in 1988, E.Q. Nicholson's work as a textile designer was seen alongside that of her husband, the architect Kit Nicholson, and his siblings Ben and Nancy, all three children of Mabel Pryde Nicholson.

Elsie Myers had been born in London. She worked as a batik printer for the designer Marion Dorn before her marriage to Kit Nicholson in 1931. She collaborated with her husband, designing interiors for his modernist buildings, including the London Gliding Club, built in 1936. She also worked with Nancy Nicholson, printing textiles and working at her graphic design company, Poulk Press. E.Q. also continued with her own textile designs, taking natural forms, plants and animals and transforming them into striking repeat patterns, often using lino blocks. In *Black Goose* of 1938 the shape of the bird is set off by a subtle slate-blue ground, whereas the silkscreen *Runner Beans* of c.1950 is

E.Q. Nicholson
Still Life with Mirror, *c.*1949
Pencil, watercolour and gouache on paper
45.5 × 60.3 (17⅞ × 23¾)
Presented by Timothy Nicholson 1989

a delicate pattern of twining stems and leaves interrupted by hot red flowers. It was used on the Royal Yacht *Britannia*.

During the Second World War Nicholson began to paint still-life and

plant studies. An exhibition of her work at the Hanover Gallery, London in 1950 was shared with Peter Rose Pulham and Keith Vaughan.

MABEL PRYDE NICHOLSON
1871–1918

The Harlequin is one of four portraits Mabel Pryde Nicholson painted of her daughter Nancy in harlequin costume. The harlequin had famously appeared in his diamond-patterned clothes in Picasso's blue-period paintings; a romantic figure, his costume also offered a fascinating formal problem for the painter. But there is further significance in that the figure Nicholson painted was a young girl. Nancy is masquerading as masculine, a point underlined in another painting from the series in which she leans against a large sword.

Nicholson, who had trained at Hubert von Herkomer's art school, reduced her practice after her marriage to the artist William Nicholson and the birth of their children. Her husband and her brother James Pryde formed the influential graphic design team The Beggarstaff Brothers. But Nicholson had her own success. Having sold a large painting for £200, she commissioned Lutyens to design a studio in 1912. The Tate Collection also houses her *Family Group* of *c*.1911, showing three of her children and a maid. Like her paintings of Nancy, this is not a sentimental picture. A sense of foreboding hangs over the small, alienated figures, dwarfed by a huge toy sailing ship. The Nicholson children continued their parents' involvement in culture. Nancy married the poet Robert Graves; their artist son Ben married Winifred Nicholson and then Barbara Hepworth; and Kit, who became an architect, was the husband of designer and painter E.Q. Nicholson.

Two years after Nicholson's death, the first solo show of her work was held by the Goupil Gallery. The *Country Life* critic picked out the Harlequin portraits as the best in the exhibition, and compared Nicholson's 'native, rugged melancholy' to the work of Emily Brontë. In his review for the *Woman's Leader*, Robert Graves took issue with readings of Nicholson's art as a pale imitation of her husband's work. He argued that her career, like that of many other women, had been circumscribed by her family duties, but that she had 'painted certainly more than one masterpiece'.

Mabel Pryde Nicholson
The Harlequin, *c*.1910
Oil on canvas
101.8 × 64.3 (40⅛ × 25⅜)
Presented by Timothy Nicholson 1982

WINIFRED NICHOLSON
1893–1981

Winifred Nicholson is known as a painter of flowers. In *Flower Table* (Tate, 1928–9) plants in pots crowd together, and she wrote of them: 'You can never circumscribe within the prison of a square bed even the tamest of flowers. They struggle, they sprawl ... They know more geometry than Pythagoras – and all sunflowers practise mathematical law in the spiral arrangement of their seeds ... they will show how to turn light into rainbows. They know even better than Bridget Reilly [*sic*].'[50]

While flower paintings by van Gogh are among the most expensive works of art in the world, the same subject painted by women has often been seen as an insignificant part of the history of modernism. This double standard was in evidence from the early days of Nicholson's career. In 1930 the *Observer* published a joint review of Nicholson and Berthe Morisot, as the Leicester Galleries in London were exhibiting both artists. Although the article praised Nicholson, the critic scanned both women's work for its 'feminine qualities'. But as Nicholson's writing on flowers suggests, her art was not just a simple expression of her femininity. And, although by taking up flower painting Nicholson was positioning herself within what had been an important field of practice for women from the eighteenth century onwards, she was also part of a modern move towards using flowers as a vehicle for formal experiment. Nicholson was a member of the 7 & 5 Society from the mid-1920s, a number of whose male and female members painted similar subject matter. In the catalogue for Nicholson's exhibition of 1987–8 that toured from the Tate Gallery, Judith Collins argues that although artists of the period such as Vanessa Bell, Duncan

Grant and Frances Hodgkins also featured window sills and plants in their compositions, 'Winifred's work appears to be unique in presenting foreground flowers and distant background held together formally and tonally, but primarily by colour harmonies.'

It is also important to acknowledge the breadth of Nicholson's art. She painted landscapes, such as *Sea and Sand* (c.1926–7, Kettle's Yard, Cambridge). Among her portraits is *Jake and Kate on the Isle of Wight* (1931–2, City of Bristol Museum and Art Gallery), a painting of two of the children she had with Ben Nicholson (her husband from 1920 until 1931). The style of these works developed from her awareness of the work of Alfred Wallis. Nicholson's move to Paris in 1932 (where she stayed for six years) led her onto a new, abstract path. Outlining the trajectory her art had taken, she later wrote, 'I had discarded all my pre-raphaelite romance – copying the visual world of appearances – and with fond delight traced with a compass and set square proportions that leapt out of the canvas unexpected to my thought and to my eye.'[51] In Paris Nicholson met Evie Hone (an old friend from her days as a student at the Byam Shaw School of Art), Jean Arp, Sophie Tauber Arp, and Piet Mondrian, with whom she formed a close friendship (copies of Mondrian's letters to Nicholson are in the Tate Archive). Nicholson's paintings of this period include *Quarante-huit, Quai d'Auteuil* (1935, Tate), named after the address of her apartment, which was reproduced in the book *Circle: International Survey of Constructive Art* (London 1937) alongside work by Mondrian, Gabo and Barbara Hepworth. Jean Arp is reported to have said that Nicholson's art 'opened

up a new direction in abstract work'.[52] Looking at it in the context of the leading British abstract artists of the period, her work is distinguished by its refusal to reject or subdue colour in favour of compositional concerns. During her time in the French capital Nicholson also built up her own art collection, including work by Mondrian and Giacometti.

Infusing both Nicholson's figurative and abstract work was her fascination with light and colour. She published her theories, including, in *Circle*, a piece titled 'Unknown Colour', arguing for a modern art in which it was 'no longer necessary to set about seeking some form into which the colour may be tagged to give it meaning', and for the exploration of what she believed to be a new dimension, beyond the traditional colour spectrum. Nicholson was still experimenting with colour late in her career, painting light passing through glass objects and prisms, as in *Sunroom* (1980, private collection). But while her researches into what she termed 'the mathematics of colour' were precisely calculated, she saw her work as rich in emotional and mystical meaning, rather than purely intellectual.

Nicholson exhibited several times at the Lefevre Gallery (showing with Ben Nicholson and William Staite Murray in 1928), at the Leicester Galleries (including, in 1954, an exhibition at the same time as Paule Vézelay), and at the Crane Kalman Gallery. In addition to the Tate exhibition, retrospectives were held at the Third Eye Centre, Glasgow in 1979–80 (and touring), Abbot Hall Art Gallery, Kendal (1982), and at Kettle's Yard, Cambridge (2001). Nicholson's art, theories and correspondence were brought together in *Unknown Colour: Paintings, Letters and Writings by Winifred Nicholson* (London 1987).

Winifred Nicholson
Moonlight and Lamplight, 1937
Oil on canvas
76.2 × 88.9 (30 × 35)
Purchased 1975

MADGE OLIVER
1874–1924

In her catalogue foreword for Madge
Oliver's 1935 memorial exhibition at
J. Leger & Son's Gallery, London, Ethel
Walker considered her 'a great painter'
and described what she had admired
in Oliver's work: a 'free handling of
paint, and a breadth of design in
her compositions'.

The memorial exhibition gathered
together interiors, still lifes and
landscapes painted in France, where
Oliver had settled. She had trained at
the Slade, where she was awarded a
Slade scholarship in 1896–7, her fellow
winner in that year being the young
Augustus John. A glimpse of a Miss
Oliver, who may well be Madge Oliver,
joining in a student debate at University
College in the late 1890s, survives.
The student *Gazette* reported that,
countering a motion that 'the world
was degenerating', Miss Oliver had
argued that, on the contrary, progress
was being made, because women could
now become students and travel around
London. If this was indeed Madge Oliver,
her later journeys around Europe and
eventual choice of Cassis in the South
of France as her home suggest that she
was making the most of the recently
won freedoms for New Women at the
beginning of the twentieth century.

Oliver's painting of the corner of her
studio links her work to that of another
ex-Slade student working in France at
the time, Gwen John. Oliver's other
painting in the Tate Collection, *Interior,
Pierrefroide* (1920–4), shows a window
with an empty chair beside it (again

Madge Oliver
Le Coin de l'Atelier, c.1920–4
Oil on canvas
42.5 × 36.8 (16¾ × 14½)
Presented by Miss Ida Brown and Charles Oliver,
the artist's brother 1936

subject matter for which John is
known). The two women also portrayed
nuns. Both women share the common
influence of a branch of contemporary
French painting, the *Intimiste* work of
Bonnard and Vuillard. Oliver, unlike
John, had a solo exhibition in Paris, at
the Galerie Druet in 1920. She died four
years later while visiting Corsica.

LOUISE PICKARD
1865–1928

In January 1924 the Goupil Gallery held an exhibition of work by Charles Ginner, Louise Pickard and Ethel Walker. The catalogue note on Pickard was written by her old Slade tutor, Henry Tonks. He had taught many brilliant women students, but made it clear that their art was to be looked at indulgently and categorised separately: 'There are charming signs of growth in the work of women artists today, something peculiar to them, faint indication of romance differing from that of man, that makes one look upon their work expectantly.'

Pickard painted landscapes, portraits and still-life in oils. Like her fellow 'Cheyne Walker' Ethel Walker, she divided her time between London and North Yorkshire. Many of her works were interiors with still-life arrangements and windows, sometimes with a female figure, echoing the concern of other contemporary artists – such as her friend Beatrice Bland, and Gwen John – with the representation of femininity in relation to interior and exterior space. In her painting *The Green Balcony* (*c*.1927, Tate), shadows cut across a riverside balcony, on which stands an empty wicker chair. Pickard exhibited at the New English Art Club

Louise Pickard
Still Life by a Window, *c*.1916
Oil on canvas
81.3 × 101.6 (32 × 40)
Presented by the Trustees of the Chantrey Bequest 1941

(becoming a member in 1923), at the International Society of Painters, Sculptors and Gravers, and at the Royal Academy.

Among Pickard's paintings at her memorial exhibition held at the Alpine Gallery, London in 1928, was *Mrs Fisher Prout by Lamplight*, which is likely to have been a portrait of Millicent Margaret Fisher Prout. In the catalogue, the artist and critic D.S. MacColl located Pickard in the tradition of Monet and Pissarro, concluding, 'I think no one will deny that . . . the painter of Mrs. Fisher-Prout could reach at times a masculine force.'

BEATRIX POTTER
1866–1943

From her teenage years until the age of thirty, Beatrix Potter kept a journal, written in a code deciphered by Leslie Linder (London and New York 1966). The picture of Potter that emerges is of an acerbic and humorous young woman with a keen critical eye. Writing of a visit to the Royal Academy in June 1882 she complained: 'I think on the whole that the Academy is very poor. There are few pictures which are at all striking, and the majority are bad. The worst are by members. It seems a shame that they can't be kept out.'

Although her family had connections with the art world (Millais was a friend), Potter had scant training. She drew with governesses, received an Art Student's Certificate, and had lessons with a female tutor recommended by Lady Eastlake. Potter shared her early fascination with the natural world with her brother. A list of packing she made in 1889 in her journal includes, in

addition to the normal requirements of a lady of the period (slippers, white petticoat), '2 bird's skeletons'. Potter drew and made watercolour paintings of flora and fauna, fungi, fossils and archaeological finds. Her attempt in 1896 to be accepted as a naturalist artist by the scientific community was unsuccessful, probably owing to her sex, and an awareness of the discrimination faced by women in the arts is likely to have informed the interest in their achievements which runs through her journal. She wrote about reading Lady Eastlake's *Five Great Painters* in the year of its publication, commenting, 'most interesting book I have seen for this long time'. The work of other animal painters attracted her attention: 'I naturally fell to comparing this and the other Landseer with the great stag picture by Rosa Bonheur, charitably placed in another room. I think the Landseers come out badly.' In awe at an exhibition of old masters held at the Royal Academy in 1883 she wrote: 'I was rather disheartened at first, but I have got over it. That picture by Angelica Kauffmann [*sic*] is something, it shows what a woman has done.'

According to Margaret Lane in *The Magic Years of Beatrix Potter* (London and New York 1978), the artist may have been inspired by the work of another woman, Anna Lea Merritt, while working on her first published book, *The Tale of Peter Rabbit*. Lane points out the similarity between the composition of Potter's *Peter by the Locked Door*, and Merritt's *Love Locked Out*. As Potter had an incisive knowledge of the art world it seems likely, especially given Merritt's high profile following the purchase of her work by the Chantrey Bequest. Peter Rabbit developed from a 'picture letter' Potter had made for the child of her ex-governess. Initially Potter had the book printed privately in 1901, before Frederick Warne and Co. accepted and published it in 1902.

Beatrix Potter
The Mice at Work:
Threading the Needle, *c*.1902
Pen and ink and watercolour on paper
11.1 × 9.2 (4⅜ × 3⅝)
Presented by Capt. K.W.G. Duke RN 1946

Over the next decade Potter created books featuring a variety of animal characters such as *The Tale of Mrs. Tiggy Winkle* (1905), *The Tale of Mr. Jeremy Fisher* (1906), and *The Tale of Little Pig Robinson* (1930). The Tate Collection has a complete group of her illustrations for *The Tailor of Gloucester* (1903). Potter's development into an artist-author of children's books may have been motivated by the fact that such work, perceived as relatively insignificant, offered opportunities to

women who had no formal art training. Her images, in pen and ink and watercolour, are playful, delicate and animated. But the stories can also be attractively sinister and even violent. We remember the fox's sly seduction of the naive Jemima Puddle-Duck, and the frustrated Hunca Munca and Tom Thumb smashing up the doll's food and burgling their house in *The Tale of Two Bad Mice* (1904). Potter was aware of the commercial aspects of her work, and its educational potential. In *Peter*

Rabbit's Painting Book (1911) children were given a list of essential paint colours, 'Antwerp blue, Crimson lake, Gamboge, Sap green, and Burnt sienna' (she later published two further such titles). Potter insisted that her books be small – a scale suitable for children to hold – and affordable. She became concerned that the British market was being flooded by cheap foreign goods, making it difficult to produce a Peter Rabbit doll she had designed and obliging her to have American editions of her work printed in the United States. Deciding to speak out, she

designed a poster protesting at the demise of the Camberwell Doll Trade, and wrote and printed leaflets in the period up to the election of 1910.

Potter's period of campaigning was also spurred by her position as a landowner. The enormous success of her books had enabled her to buy a farm in 1905, Hill Top at Sawrey, Westmorland, in the Lake District. In a pamphlet written five years later she bemoaned the rising land taxes and her own lack of power to register her dissatisfaction: 'I have no vote!' In 1913 Potter married and, although she

published several later books, her interests turned increasingly to farming and conservation. Potter's legacy did not only include the work for which she is famous. Her studies of fungi were used to illustrate a book on the subject in 1967. She also left more than 4,000 acres of the Lake District to the National Trust. The exhibition *Beatrix Potter and her World*, held at the Tate Gallery, London in 1987–8 recognised her work as art, rather than labelling it illustration. And a book by Eileen Jay, Mary Noble and Anne Stevenson Hobbs examined her work as a naturalist (London 1992).

MARY POTTER
1900–1981

There is a portrait by Mary Potter of an ATS Sergeant in the collection of the Imperial War Museum, London. Painted in 1941, it sets up a dialogue between the war-time reality of life in the forces and a femininity predicated on the decorative. The young woman is pictured in uniform, but her hair is in a fashionable high roll above her brow, and she has plucked her eyebrows and painted her lips scarlet. As Mavis Nicholson's collection of memoirs of women during the Second World War *What did you do in the war, mummy?* (London 1995) reveals, women of the period sometimes took great pride in being able to wear a uniform.

Potter trained at the Slade from 1918 to 1920, and lived in London and Aldeburgh. She was briefly a member of the 7 & 5 Society in the early 1920s, where her subject matter, small-scale, domestic still-life and interior paintings, land and seascapes, in quiet orchestrations of pale colour, was in tune with fellow exhibitors Winifred Nicholson and Christopher Wood. She showed at the New English Art Club from 1920, and the London Group from 1927. Two of her paintings were exhibited in the Tate's survey show

Mary Potter
Golden Kipper, 1939
Oil on canvas
50.8 × 40.6 (20 × 16)
Purchased 1940

Fifty Years of London Group Exhibitions, held in 1964, including her *Early morning, Regent's Park* of 1946, owned by her close friend the composer Benjamin Britten.

Potter had her first solo exhibition at the Bloomsbury Gallery in 1931. A joint

show was held with Edna Clarke Hall at the Redfern Gallery three years later. She had retrospectives at the Whitechapel Gallery in 1964 and at the Serpentine Gallery in the year of her death.

DOD PROCTER
1892–1972

The *Daily Mail* of 20 October 1928 carried the story of Dod Procter's success: 'Mrs Dod Procter's famous picture "Morning", shown at the 1927 Royal Academy was bought for the nation by the *Daily Mail*. The painting was exhibited in the United States and is making a tour of British art galleries before being finally lodged in the Tate Gallery.' The paper reported that, in Sheffield, the painting 'was inspected by 17,817 people during the four weeks it was on view'.[53]

Procter's mother, herself Slade-trained, shaped her daughter's career, moving the young Dod and her brother to Newlyn to study at Stanhope Forbes's school. While at Newlyn the young artist met other painters including Laura Knight and her husband Harold, Gluck, and Ernest Procter, whom she later married and settled with in the town. In 1910 mother and daughter went to the French capital in order that

Dod could study at the atelier Colarossi and see modern French art, and some of her earliest exhibited works were paintings of Paris and Versailles.

The art that made Procter's name during the 1920s is typified by *Morning*, with its simplified sculptural forms, cool colours and realistic, even austere depiction of a young woman. Her work has obvious parallels with contemporaries such as Meredith Frampton and Glyn Philpot, and also with Picasso's classical figuration. Cissie Barnes, the fish merchant's daughter from Newlyn who modelled for *Morning*, also posed for a number of other works including *Girl in Blue* of 1925 (Laing Art Gallery, Newcastle upon Tyne). Procter's incisively drawn and subtle tonal paintings of female nudes include several of Eileen Mayo, who was also an artist, and who is seen in *Model Resting* of 1924 (Pyms Gallery, London). In a self-portrait (date unknown, private

collection on loan to Penlee House, Penzance Museum and Art Gallery), Procter portrayed herself with modish bobbed hair, and wearing a scarf around her neck reminiscent of those worn by her friend Laura Knight in her self-portraits. The composition of the painting, with her face in sharp profile and strikingly lit, draws the viewer's attention to her intent and serious gaze.

Procter was sometimes criticised for what was perceived as an unfeminine, clinical hardness in her work. Following her great success at the 1927 Royal Academy exhibition, her 1929 submission *Virginal*, a painting of a young female nude holding a dove, was rejected, an event which was reported in the national press. Writing on 'Women as Artists' in May 1929, the critic of the *Sheffield Telegraph* complained, 'there is at times something positively brutal in pictures by women, as if they were determined to prove that they can be

Dod Procter
Morning, 1926
Oil on canvas
76.2 × 152.4 (30 × 60)
Presented by the *Daily Mail* 1927

as mannish as any man. This was so much the case with Mrs Procter's nude.' He described another of her works as having 'almost a Robot strength in it'. A number of paintings of nudes accompanying the tour of *Morning* had also caused a controversy, and were deemed unsuitable for exhibition.

By contrast, critics who admired Procter's work saw in it a successful fusion of two conflicting forms of art, as Anthony Bertram argued in the *Studio* in 1929: 'Although Mrs. Procter represents accurately, conforming to the foot-rule in which the academic mind takes so great a delight, she is essentially a modern painter. Without Cubism Mrs. Procter could never have existed, or at least she could never have been the Mrs. Procter whom we know.'[54] Reviewing Procter's first solo show at the Leicester Galleries which opened in May 1932, the critic of the *Nottingham Journal* praised her 'versatility', and continued, 'Seen in a room by themselves the impression of cold severity that they usually convey disappears altogether'.

Procter had a series of solo shows in London at the Leicester Galleries. In America her work was seen at the Carnegie Institute's International Exhibition, Pittsburgh in 1928 and at the Carl Fischer Gallery, New York in 1935 and 1936. Her exhibiting record at the Royal Academy led to her being made an Associate in 1934 and Academician in 1942. She also had a number of joint shows with Ernest Procter, despite the difference between her work and his mythological and religious paintings. Their work was seen together in a joint exhibition which toured from Manchester City Art Gallery to venues including the New York liners *Aquitania* and *Berengaria* from 1927–9, and, more recently, in a show which was toured from the Walker Art Gallery, Liverpool, in 1990.

Procter did not limit her subject matter to Newlyn. In 1920 she had undertaken a commission with her husband to decorate the Kokine Palace in Rangoon, Burma, where working with Burmese, Indian and Chinese craftsmen introduced them to new forms of visual culture. Writing about the Procters' art in *Apollo* in 1927, Mary Chamot identified a possible effect of this visit in Dod Procter's predilection for rounded forms.[55] In the 1940s and 1950s Procter visited Jamaica and Africa, and produced many portraits, such as *African Head* (Plymouth Museum and Art Gallery), a sensitive painting of a Masai child. On her travels Procter also undertook lucrative commissions to paint portraits of the British colonial establishment.

Two of Procter's flower paintings, made at different stages of her career, show her later development to a softly natural style. *Bella Donna Lilies* (MacConnell Mason Gallery, London), exhibited at the Royal Academy in 1924, is hard-edged, stylish and modern, the clean, sculptural lines of the pink lilies set off by a background starkly divided into cream and dark ultramarine. By contrast, in *Flowers on the Dresser*, exhibited there twenty-four years later, soft blue paint describes a simple domestic arrangement, with a background of china cups. In the long series of letters which she wrote to her husband (Tate Archive), Procter's observation of the smallest details of the colour and light of her surroundings in Newlyn is often the subject: 'The sun has opened out all the red and white anemonies [*sic*]; they stand up very straight and open themselves so wide that they look quite flat on the top … this white paper is beautifully bright, with the purple shadow of my hand across it.'[56]

MILLICENT MARGARET FISHER PROUT
1875–1963

Millicent Margaret Fisher Prout's father was the American Impressionist painter Mark Fisher, who had trained with Sisley in Paris. In a letter to the art historian and curator Mary Chamot, who was researching for her book *Modern Painting in England* (London 1937), his daughter recalled: 'I studied under my father … in fact I may say I was apprenticed as from the earliest date I worked with him in the fields making studies of cattle or attendant holding a lantern on one occasion while he painted a sheep fold by moonlight.'

After training at the Slade in the 1890s, she taught art and then married a farmer. Fisher Prout spent much of her time painting *en plein air*, and working on portraits and still life. Women artists were an important subject for her. *Breakfast in a Country Studio* (1939, location unknown) shows a woman by a window with a large pot of paintbrushes, while the female figure in *An Artist at her Easel* (1948, location unknown) works in the middle of a field. Tate owns her oil *Home Grown* (1952), a profusion of fruit and flowers arranged in front of a window, painted in light, fresh colours.

Fisher Prout exhibited with a number of London Galleries, at the NEAC from 1906 (becoming a member in 1925), and the Royal Academy (where she was made an Associate) between 1921 and 1964. In 1935 she was elected a member of the Society of Women Artists and showed there for nearly forty years. A memorial exhibition was held at the Royal Society of Painters in Watercolours in 1966, accompanied by a catalogue, *Mark Fisher and Margaret Fisher Prout, Father and Daughter*.

ISABEL RAWSTHORNE

1912–1992

The stamps filling the pages of Isabel Rawsthorne's passports (Tate Archive) are witness to a colourful life. She trained at Liverpool School of Art and the Royal Academy. In 1934 she went to Paris, living in Montparnasse, and life drawing at the Académie de la Grande Chaumière. She modelled for Derain and Giacometti, and Picasso painted her portrait. With her first husband, a foreign correspondent, she travelled to Spain at the outbreak of civil war, and met the journalist Martha Gellhorn.

In 1939 Rawsthorne returned to England. Her contribution to the war effort was as a designer of black propaganda – leaflets to undermine the enemy – at Bletchley Park. Rawsthorne described the work in her unpublished memoir: 'They must be eye-catching so that people would be curious and pick them up; also quickly legible . . . What were humorously called "greeting cards" were leaflets of a highly sexual nature. This was great fun. Fancy being employed by the government to create pornography!'

After the war she returned to painting, working in a semi-abstract style that may well have been influenced by her friend Francis Bacon (who also painted her). She had her first solo exhibition in 1949 at the Hanover Gallery. During the 1950s and 1960s she designed ballet sets and costumes (both her second and third husbands were composers) for Sadler's Wells and Covent Garden, and painted and drew dancers, including Margot Fonteyn and Rudolf Nureyev. Exhibitions of Rawsthorne's work have recently been held at the Mercer Gallery, Harrogate and the October Gallery, London (1997–8, catalogue by Suzanne Doyle) and the Michael Parkin Gallery, London (1998).

Isabel Rawsthorne
View through a Window II, 1967
Oil on canvas
94 × 175.2 (37 × 69)
Purchased 1997

ANNE REDPATH
1895–1965

Along with Elizabeth Blackadder and Joan Eardley, Anne Redpath is among the most significant twentieth-century Scottish painters. Redpath trained at Edinburgh College of Art. She was awarded a travelling scholarship to Belgium, France and Italy in 1919. In the same year her paintings were noticed by the critic for the *Scotsman* who wrote that they were 'marked by a pleasing purity of strength and colour'. Following her marriage and move to France in 1920, she stopped painting for a number of years to bring up her three sons.

In 1934 Redpath returned to Scotland without her husband and began to work again, painting landscapes and the vibrant still lifes for which she became known. These show the influence of modern French artists (she admired Braque and Matisse), and of an earlier generation of Scottish colourists, such as Samuel Peploe and J. D. Fergusson. Books often appear in Redpath's still life, including Penguin paperbacks with their distinctive covers, as do flowers or flower patterns, as in *Indian Rug (Red Slippers)* (*c*.1942, Scottish National Gallery of Modern Art). Redpath also worked as a decorative artist, designing tapestry and painting furniture.

Being a woman artist affected Redpath's critical reception, and her work was dismissed as 'sugary', showing 'naivete' and with a 'feminine' sense

Anne Redpath
The Poppy Field, *c*.1963
Oil on canvas
76.2 × 76.2 (30 × 30)
Presented by the Trustees of the Chantrey Bequest 1965

of colour. Redpath was aware of the difficulties faced by women artists. She joined the Scottish Society of Women Artists, which had been founded as a result of discrimination against women at the Royal Scottish Academy, becoming president in 1944. And Redpath spearheaded a breakthrough when she became the first woman to be made a full member of the Academy in 1952. She had numerous solo exhibitions, including a touring show organised by the Arts Council in 1965. A retrospective was held at the Scottish National Gallery of Modern Art, Edinburgh, in 1996–7.

FRANCES RICHARDS
1903–1985

At an exhibition of over fifty years of her work held at Campbell and Franks Gallery, London in 1980, Frances Richards showed paintings, drawings, lithographs, engravings and embroideries. Included were her early tempera paintings on religious subjects, such as *Seven Angels of the Apocalypse* of 1926, her war-time drawings, including *The Dead Child* of 1943, and her illustrations, among them a group of nine prints inspired by Rimbaud's *Les Illuminations*, published by the Curwen Press in 1975. The Tate Collection houses a number of her lithographs and intaglio prints, in addition to the tempera painting *Left and Right of the Long Path* (1957).

Richards trained at the Royal College of Art in the mid-1920s, where she began to make her imaginative and symbolic figurative work, and learned tempera and fresco painting. She was an avid reader of poetry, and William Blake's work, combining text and image, was a great influence upon her. Catalogues of Richards's exhibitions sometimes carry lines of verse, either her own or those of poets she admired. Some of her titles also have literary references. She painted Shakespeare's Ophelia in 1963, and the title of the tempera *Mourners To and Fro* of the same year suggests that she had been reading Emily Dickinson.

A long career as an artist stretching from her first exhibition at the Redfern Gallery in 1945 right up to her late seventies was combined with teaching at art colleges, and commissions, including decorations for the Orient liner *Orcades*, in 1937. She shared her love of working with poetry with her husband, the painter Ceri Richards.

GERMAINE RICHIER
1904–1959

Germaine Richier trained in the 1920s under two artists who had worked for Rodin, Louis Guigues and Antoine Bourdelle. She became one of the most powerful sculptors of her time, showing at international exhibitions including the Venice Biennale (1950, 1952 and 1954) and the São Paulo Bienal (1951). There were major retrospectives of her work at the Musée Nationale d'Art Moderne (1956), the Musée Picasso, Antibes (1959), and the Musée Rodin (1968).

Before the Second World War Richier was a sculptor of conventional portrait busts and nudes. But after the conflict she began to make figures in bronze, whose pitted, scarred surfaces carried the marks of their making and at the same time evoked the terrible destruction. A Crucifix commissioned in 1950 for a Catholic church designed by Le Corbusier caused an outcry when it was unveiled, and had to be removed. The etiolated, tortured body of Christ appeared to be collapsing into the rough surface of the sculpture. But in Britain her work was well received by a young generation of artists. The catalogue of her first London exhibition, at the Anglo-French Art Centre in 1947, called for 'a new epoch' in art, 'the result of a meeting between plastic expression and lacerated expression'. Elisabeth Frink remembered the great impression Richier's work made upon her as a young woman visiting an exhibition at the Hanover Gallery in 1955.[57] In the catalogue essay for that show, David Sylvester wrote, 'For Richier the assertion of the human image does not depend on creating – in the old humanist tradition . . . fine, noble effigies of unadulterated man . . . Hers is a human image challenged, battered, ruined, and still obstinately human.'

Richier was one of the few women to be included in the 1982 Barbican Exhibition *Aftermath: France 1945–54, New Images of Man*, along with her friend Maria Helena Vieira da Silva. They collaborated on the painted sculpture *La Ville* (1952, private collection), in which Richier's skinny figure stands in front of a fractured cityscape painted by da Silva, an individual alone in a world with no coherent meaning. Both women also made work about chess, a game in which pieces are manipulated in a power play that is, in reality, a pointless exercise. Richier's *L'Echiquier (Grand)* is a group of colourfully painted plaster figures on plinths. They look like chess pieces, but magnified, and seem to be hybrids – spindly, sinister mixtures of animal, insect and human. Their large scale suggests that, standing near them, you could become part of the game. The work of both da Silva and Richier embodies the existentialist philosophy being developed in Paris, a belief in the absurdity and anguish of existence. Richier was the only woman among the ten artists in the exhibition *Paris Post-War: Art and Existentialism 1945–55*, held at the Tate Gallery, Millbank in 1993. The merging together of animal and human forms in so much

of Richier's work suggests another reading in the context of her age. Her work can be seen as a representation of the latent bestiality of humans.

Some of Richier's sculpture seems in sympathy with the images of women made by her male contemporaries. *La Mante, grande* (1946, editions in several European public collections) was perhaps influenced by Picasso's monstrous mantis-woman, and the work of the Surrealists, for whom the insect symbolised female erotic power. Other female figures follow the well-trodden ground of turning women into objects. In *L'Eau* (1953–4, Tate), the head of a seated woman curves to form the top of a jug, with looped handles/ears.

But other works pointedly subvert the representation of the sexes. In these, Richier seems to turn the division of power structured in Picasso's many pairings of the brutal, potent male artist/bull/minotaur and the soft, vulnerable model/woman, on its head. There are a series of bronzes from the early 1950s titled *La femme-coq* and *L'homme-oiseau*. The woman is a cockerel, ruler of the roost, the man merely a bird. *Hurricane Woman* (1948–9, Tate) is a dark figure whose heavy body appears about to lurch into motion. She is companion to a male nude, titled *L'Orage*, meaning 'the storm' (1947/8, Tate), whose title indicates that he symbolises a less powerful force (the name of the female figure in French, 'L'ouragane', is a masculine word, adding another layer to Richier's gender games). *L'Araignée 1* (1946, Goulandris Foundation, Greece) is not a spider, but a flailing female figure, pulling on a taut wire thread, straining for release (Richier made a series of works in a similar vein, but with a woman/ant). The piece has a strong feminist resonance, and an interesting parallel in the arachnids made by Louise Bourgeois.

Richier's work in the male-dominated arena of bronze sculpture (even the word 'sculpteur' is masculine in French) caused consternation among some critics of her time. And her own image (hair scraped back under a scarf, dressed in workers' overalls) jarred with the hyper-polished femininity of post-war French culture, eptomised in Dior's New Look. More recent exhibitions of Richier's sculpture, at the Fondation Maeght Saint Paul de Vence (1996) and the Akademie der Künste, Berlin (1997) have allowed contemporary audiences to reassess her importance.

Germaine Richier
Chess Board (Large Version), 1959
Painted plaster
Dimensions variable
Presented by the artist's estate 2000

ADOLFINE MARY RYLAND
1903–1983

Adolfine Ryland worked as a printmaker, sculptor, painter and designer. Her practice across these different media was united by her keen-edged, modern style and inventive graphics. She had studied at Heatherley's and at the Grosvenor School of Modern Art under the influential printmaker Claude Flight. Flight believed in making linocuts as a social project, giving everyone the opportunity to have art in their home.

Ryland's main exhibiting venue was the Women's International Art Club, where she showed from 1927 onwards, becoming a member from 1936 to 1954. She also undertook public commissions, and worked for London County Council designing low reliefs for a number of buildings, among them the School of Butchers and St Martin's School of Art. Her reliefs for the art school, which she worked on from 1937 to 1939 and which still decorate the entrance, show students at work. One woman sits at a sewing-machine, while another unfurls a bolt of fabric. But Ryland's work is not always easy to identify as she sometimes signed herself 'Koncelik', her mother's maiden name.

In 1987 the Michael Parkin Gallery in London held an exhibition *Printmakers of the 20s and 30s and Adolfine Ryland*. On show were Ryland's paintings, drawings, prints, sculptures and designs for book jackets and posters. Amongst them were two designs advertising London Underground, which speak of an optimistic age of efficient, modern public transport to the new suburbs. They read 'Home from the office' and 'Out of the fog, into the sunshine'.

Adolfine Mary Ryland
Isaac Blesses Jacob, 1933
Stone
91.4 × 53.3 × 10.2 (36 × 21 × 4)
Presented by the Trustees of
the Chantrey Bequest 1940

ANNE SAID
1914–1995

At her first solo exhibition, held at Helen Lessore's Beaux-Arts Gallery in 1957, Anne Said showed drawings. They depicted natural forms, sometimes in realistic compositions, as in her drawing of a gnarled root, *Jo's Wild Wood* (1961, Tate), or arranged all over the surface of the picture, as in *The Dried Sea*, in which dead leaves, curling ivy and the spiky cases of nuts lie in front of a desert, bones protruding from the sand. Said found some of her subject matter in Britain, while other works reflected her stay in Egypt from 1941 to 1955, including *Camel Bone by a Stream* and *Aswan from Sirdar Siraar Island*.

Said studied at Queen's College London in the late 1920s, and then briefly in Paris under Amédée Ozenfant, working as a textile designer to pay her way. After moving to Egypt she taught alongside her husband, the artist Hamed Said. They both exhibited with a group of their students in Cairo in 1948 and 1955, in London at the Arts Council in 1949 and in 1952 at the Islamic Cultural Centre. Said's work was also seen in the English/ Egyptian publication *The word and the image*.

Said returned to England, exhibiting in the New Art Centre and elsewhere. The Langton Gallery, London, held a show of her drawings in 1973. Her daughter Safaya also became an artist, having trained under her mother, and developed a career as a painter, illustrator and textile designer.

NIKI DE SAINT PHALLE
1930–2002

In 1998 Niki de Saint Phalle opened her Giardino del Tarocchi (Tarot Garden) in Garavicchio, Tuscany. She had been given land on which to build a sculpture park in the 1970s. Working with her second husband, the Swiss artist Jean Tinguely, she constructed twenty-two sculptures out of metal, concrete, ceramic and glass, based upon the major Arcana of the Tarot (there is also a permanent collection of her work at the Niki Museum, Nasu, Japan).

Saint Phalle wrote of the project: 'At last, my lifelong wish to live inside a sculpture was going to be granted: a space entirely made out of undulating curves ... I wanted to invent a new mother, a mother goddess, and be reborn within its form ... I would sleep in one breast. In the other I would put my kitchen' (in a letter published in *World of Interiors*, December 2000). This was a bold response to a particular problem for women artists – the negotiation of the female body, inhabited by them, but often objectified in art. It was the culmination of a career

Niki de Saint Phalle
Shooting Picture, 1961
Plaster, paint, string, polythene and wire on wood
143 × 78 × 8.1 (56¼ × 30¾ × 3¼)
Purchased 1984

in which different media – including film, oil-paint, graphic art and writing – were brought to bear on the representation of femininity.

Saint Phalle's best-known works are her exuberant *Nana* sculptures (the word is Parisian slang, meaning 'chick') such as *Black Venus (Miss Black Power)* of 1965–7 (Whitney Museum of American Art, New York). But she also exposed the dark side of female fantasy and experience. During the early 1960s she made assemblages about monstrous births. A series of bride sculptures have the dusty, dessicated appearance of Miss Haversham, the character in Charles Dickens's *Great Expectations* (London 1860–1). In Saint Phalle's book *Mon Secret* (Paris 1994), childish handwriting describes sexual abuse and breakdown. Violence was at the heart of Saint Phalle's earliest work. Influenced by Neo-Dada, she extended Marcel Duchamp's work with the readymade to include guns, knives and scissors. Her series of 'tirs' (shooting paintings) are relief compositions, filled with paint and food, which Saint Phalle shot, causing them to spew out their contents. She was invited to join the Parisian *Nouveaux Réalistes* group in 1961, but her focus on the social and political position of women set her apart from her male colleagues.

ETHEL SANDS
1873–1962

In her book *Miss Ethel Sands and her Circle* (London 1977), Wendy Baron described the life and work of this painter of interiors, figures, flowers and still life. Sands was born in America, and her wealthy family moved to England while she was a child. She trained at Eugène Carrière's Parisian atelier, and lived in France and England.

Sands is known for her association with Walter Sickert. Although she was invited to join his Fitzroy Street Group, she and other women were excluded from the Camden Town Group. This exclusion has been reflected in critical perception of her work as a pretty copy of Camden Town painting, overlooking Sands's significance. Responding to her first solo exhibition (in Paris in 1911) a critic wrote: 'Vuillard has not done better in this respect. Miss Ethel Sands is an intimiste of the most subtle kind.' In 1912 a joint show was held at the Carfax Gallery with her life-long partner, Nan (Anna Hope) Hudson, and a solo exhibition at the Goupil Gallery in 1922 was reviewed in most of the national newspapers. She also showed with the Allied Artists Association and was a founder member of the London Group. In Sands's work, interior spaces are painted in subtle colour. Rather than picturing Sickert's gloomy poverty, she painted exquisitely arranged interiors, often at the homes she created with

Ethel Sands
The Chintz Couch, c.1910
Oil on millboard
46.4 × 38.4 (18¼ × 15⅛)
Presented by the Contemporary
Art Society 1924

Hudson. Hudson's painting of their house, the Château d'Auppegard, has recently been given to the Tate Collection.

A brief history of the critical reception of Sands's painting now known as *Tea with Sickert* (c.1912) reveals the politics of interpretation at work. Sands titled the painting *A Tea Table* and exhibited it at her 1912 Carfax show. The *Westminster Gazette* admired it as a 'daring picture', but the influential critic Roger Fry, writing in the *Nation*, dismissed the whole exhibition as 'frankly feminine'. By 1988 Sands's painting had been retitled to include the name of the famous male painter, making it marketable at a Christie's auction. But the picture portrays two people, a man and a woman, and despite the new title identifying the male figure as an important artist, the female figure dominates. The viewer's perspective echoes her sightline, sweeping across the table and up into the corner, into which the small male figure is pushed.

MARY SARGANT FLORENCE
1857–1954

Campaigner for women's suffrage and founder member of the Society of Painters in Tempera in 1901, Mary Sargant Florence rejected academic oil painting. In 1912 she returned to the Slade where she had trained and taught tempera and fresco painting to a generation of students including her daughter Alix and Carrington.

Sargant Florence explained the importance of fresco in a lecture given to the Society of Painters in Tempera in 1906. She argued that the combination of careful craftsmanship with artistic invention meant that it was 'a nobler and fuller expression of thought' than other art forms. Neither was it retrogressive, for 'Fresco is so essentially "plein air" in its effects that it should be the medium in which modern thought in Art should express itself best'. Tate owns two cartoons for her frescos at Bourneville Junior School, Birmingham of *c.*1913 (the frescoes themselves are still in place). They show biblical scenes, and are titled *Suffer Little Children to Come unto Me* and *Pentecost. Children at Chess*, a portrait of her son and daughter, is an example of her work in tempera. She showed this painting at the New English Art Club, where she became a member. She also exhibited at the Royal Academy and the Society of Women Artists.

Much of Sargant Florence's work has been destroyed. Lost works include the mural she painted at the home she built in 1899–1900, Lord's Wood in Marlow, Buckinghamshire, depicting a scene after a story by the Symbolist writer Maeterlinck. Her frescos at Oakham School illustrating Thomas Malory's *Le Morte d'Arthur* were covered over in 1994. But the mural she painted in 1912 at Chelsea Town Hall has survived. Sargant Florence also

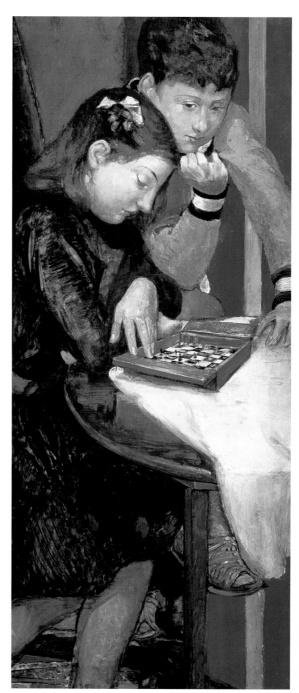

Mary Sargant Florence
Children at Chess, *c.*1903
Tempera on wood support
90.2 × 40 (35½ × 15¾)
Presented by the Trustees of the Chantrey Bequest 1949

published work. Her series of woodcuts for the children's book *The Crystal Ball* (1894) are peopled with characters in medieval costumes, described in sinuous line. *Colour Co-Ordination*, her book on colour theory, was published in 1940. Her role in the fresco revival was examined in the exhibition *The Last Romantics: The Romantic Tradition in British Art: Burne-Jones to Stanley Spencer* at the Barbican Art Gallery, London in 1989.

HELEN SAUNDERS
1885–1963

The three abstract compositions by
Helen Saunders in the Tate Collection
were all donated by her sister, Ethel
Saunders, in 1963 and are among the
few works to have survived the
bombing of her London flat during the
Blitz. They date from around 1915, the
high-point of Saunders's work as a
Vorticist, when she published two
designs in the second edition of
the Vorticist journal *Blast*, and
collaborated with Wyndham Lewis on
the decor of the Restaurant de la Tour
Eiffel in London. Two years later, she
took part in the Vorticist exhibition in
New York.

Saunders had studied at the art
studio run by Edna Clarke Hall's sister
Rosa Waugh in the mid-1900s,
then briefly at the Slade, and the
Central School of Arts and Crafts.
She exhibited at Vanessa Bell's Friday
Club, and with the Allied Artists'
Association in the 1910s, and later
with the London Group and the Artists
International Association.

Her early works can be seen as part
of English Post-Impressionism. As a
Vorticist she developed a hard-edged
geometric style, combined with
symbolic and figurative references.
The jagged fragmentation of her work
can be understood as an artistic
response to the violent upheavals of her
time, informed by the circle she moved
in, which included women pacifists and
campaigners for suffrage.

Saunders also wrote poetry, and
was part of the avant-garde group of
Imagists (and Vorticists) who met
regularly in Soho in 1915, including
Ezra Pound, T.S. Eliot and Hilda Doolittle.
Her poem *Vision of Mud*, published in
the second edition of *Blast*, gives voice

Helen Saunders
Abstract Multicoloured Design, c.1915
Gouache, watercolour and pencil on paper
35.9 × 25.7 (14⅛ × 10⅛)
Presented by Miss Ethel M. Saunders in memory of her sister 1963

to an individual swamped by the
battlefield.

Although she carried on working
throughout her life, Saunders's later
still-life and landscape painting went
unnoticed. Much of her art is now lost,
but an exhibition was held at the
Ashmolean Museum, Oxford, and the
Graves Art Gallery, Sheffield, in 1996.

RENEE SINTENIS
1888–1965

In 1915, the sculptor and graphic artist Renée Sintenis had a major breakthrough when her work was exhibited at the Berlin Secession and bought by the poet Rainer Maria Rilke. She had trained at the Stuttgart Art School, and then in Berlin. Her work was noticed by the influential gallery owner Alfred Flechtheim, with whom she had annual exhibitions, including a joint show with Marie Laurencin in 1925.

Sintenis specialised in sculptures of animals and figures and in portraiture. She often worked on a small scale, which contributed to her success, as her art could be accommodated by private collectors. She modelled her sculptures in clay, black wax, and terracotta, and cast them in bronze or silver. Her full-length bronze portrait of the Finnish runner *Nurmi* (1926, Nationalgaleries, Berlin) vividly captures his speed and grace, and her work was well-received in an age in which sport had become mass entertainment, and the sportsman celebrated as the highest form of humanity.

Transformation is the subject of one of Sintenis's most important works, *Daphne* (1930, Wallraf-Richartz-Museum, Cologne). The bronze sculpture shows the nymph, whose story is told in Ovid's *Metamorphoses*, at the moment in which she turns into a tree to escape her pursuer, Apollo. Transformations also take place across Sintenis's self-representations. Her Tate *Self-Portrait* (1931), an austere terracotta mask etched with lines, is very different from more softly attractive earlier self-portraits. Sintenis forged her identity as a phenomenally successful artist – whose masculine clothes and hairstyle signalled her lesbianism, and who had changed her name from the more feminine 'Renate Alice' – against the backdrop of the emergence of the new woman in German inter-war culture. She is discussed in this context in *Visions of the neue frau* (edited by Marsha Meskimmon and Shearer West, Aldershot 1995). Sintenis was the first woman sculptor to become a member of the Prussian Academy, in 1931. Although the rise of the Nazis stalled her career (she resigned from the Academy and her studio was bombed), after the war she was made Professor at the Berlin Academy.

ELIZABETH SORRELL
1916–1991

Elizabeth Tanner studied at Eastbourne College of Art in the 1930s, and in the design department of the Royal College of Art, where she trained in mural painting under Professor Ernest Tristram, an expert in medieval art, and won a travel scholarship. Following her graduation she taught in art colleges and worked as a designer of fabrics and wallpapers. She exhibited at the Royal Academy from the late 1940s, the New English Art Club, and with the Royal Society of Painters in Watercolours, becoming a member in 1966.

During the Second World War she spent some time in the Lake District. Her watercolour *Troops in Ambleside* (1941) is in the collection of the Wordsworth Trust Museum, Grasmere. It shows in vivid detail a bird's-eye view of a line of troops snaking through the small town, accompanied by a truck full of waving nurses. The Tate Collection's watercolour *Ferns in the Conservatory* was made in the year the war ended.

Marriage to the historical illustrator Alan Sorrell in 1947 rekindled her interest in medieval art, and the decorative intricacy of her figurative drawings and watercolours reflected her knowledge of this field. She often drew and painted dolls, landscapes, flowers and natural forms. Her spiky, tangled *Basket of Seed Pods* is in the collection of the Harris Museum and Art Gallery, Preston. The Sorrells held a joint retrospective at Chelmsford Art Gallery in 1975.

VALERIE THORNTON
1931–1991

Interviewed in *Arts Review* in March 1982, Valerie Thornton described how she found the direction for her art: 'There was a moment when I was still floundering around at the Regent St Poly. I arrived early at Charing Cross Underground to meet a friend, and there I saw an exhibition of enormous photographs of old churches. It was like a religious conversion for me, the crumbling ruins seemed so powerful. Next morning, I think it was in 1951, I was up at 7 drawing a bombed church, till 9.30 when I had to go off to the Poly. Now, the subjects which turn me on still come in great waves – sometimes its vernacular, sometimes, as now, its Romanesque sculpture.'

Thornton painted, drew and made prints. Studying in 1954 at Stanley Hayter's Atelier 17 in Paris awoke in her an awareness of the potential of printmaking to evoke the weathered, textured stones of buildings. She described how on first arriving to work with Hayter 'I found bubbling acid, black hands, and it was all very liberating'. She travelled in Italy, Spain and France, making studies of buildings. The Tate Collection houses a series of five prints of architecture, from the French town of Amboise (1973) to a Norfolk farm (1977) and also the oil painting *Bominarco (The Abruzzi)* (1988), in which the effect of time and wear on a wall painting is subtly rendered.

Thornton admired Stanley Spencer, Graham Sutherland and Winifred Nicholson. She owned some of Nicholson's work and the two women formed a close friendship. Thornton had solo exhibitions at the Philadelphia Print Club (1960), the Redfern Gallery (1992) and the Ashmolean Museum, Oxford (1994–5). She was a founder member of the Printmakers Council.

WINIFRED TURNER
1903–1983

In 1988 the Ashmolean Museum, Oxford, held a joint exhibition of the work of Winifred Turner and her father, Alfred (also a sculptor). She had trained at the Central School of Art and Design, along with her sister Jessica, and Winifred then went on to the Royal Academy Schools in the late 1920s.

Turner and her father worked in the style known at the time as 'New Sculpture', of which Jacob Epstein is the best-known practitioner. This was a move away from Edwardian academicism towards a vital modernity expressed in clean, stylised lines. Turner added her own specific touch. Unlike her father's, her work is never narrative. Neither is it sexually explicit, as Epstein's and Eric Gill's often is, although it is seductively sensual. There are references to other cultures in her work, often in the arrangement of the figure, which is sometimes reminiscent of goddesses from some Asian religions, as in Tate's bronze sculpture of a seated woman, *Thought* (exhibited 1933). According to her sister, Turner often arranged a large mirror in her studio and posed for herself. This double role as artist and model may account for the subtlety of her representation of the female form, which was admired by the actor Vivien Leigh, one of her patrons. Turner also showed women in their modern incarnation. Her *Land Girl*, exhibited at the Royal Academy in 1945, wears contemporary clothes, even down to her wellington boots.

The *Studio* in the following year (vol.132 July–December 1946) carried a reproduction of one of Turner's sculptures, an elegant composition of a seated nude girl, to illustrate the type of work produced by the Royal Society of British Sculptors. The society was receptive to women's work. Kathleen Lady Kennet served on its council and Feodora Gleichen had instituted an annual award for women sculptors. By 1930 Turner had been elected both a Fellow and then an Associate, and was teaching at the Central School, where she had studied.

URSULA TYRWHITT
1872–1966

Ursula Tyrwhitt's watercolour *Flowers* (1912) was given to the Tate Collection by Mary McEvoy, who had trained with her at the Slade. While she was a student, Tyrwhitt became a close friend of Gwen John, and John painted an early portrait of her, now lost. She travelled to Paris to work in the Atelier Colarossi and visit John, and later studied at the British School in Rome and again at the Slade.

In 1974 the Ashmolean Museum, in Tyrwhitt's home city of Oxford, held an exhibition *Ursula Tyrwhitt: Oxford Painter and Collector*. On show were her portraits, landscapes and a number of flower compositions, mainly in watercolour. There was also one sculpture, a terracotta bust of Gwen John, which Tyrwhitt had taken to Rodin to ask his advice. In addition, there was Tyrwhitt's own collection, works by Gwen and Augustus John, Walter Sickert, Stanley Spencer, Philip Wilson Steer, Margaret Fisher Prout and Ethel Walker, many of which were bequeathed to the Ashmolean.

Tyrwhitt exhibited at the New English Art Club, becoming a member in 1913. The fact that women artists were in the minority at its exhibitions is reflected in a letter from Gwen John to her in 1908 (National Library of Wales): 'I hope our pictures will hang together!! I feel so lonely in the New English!' At the Special Retrospective Exhibition of the organisation in 1924, the two Tyrwhitt flower pieces on show were lent by their owner, her old tutor at the Slade, Philip Wilson Steer.

PAULE VEZELAY
1892–1984

Although she worked across media, as a printmaker, painter, sculptor and textile designer, all of Paule Vézelay's art is united in its exploration of line and balance. Early works represent this theme figuratively: a curvaceous woman teeters across the tightrope in the print *La Danseuse à la Corde* of 1923 (Tate). In later abstract paintings, soft rounded forms are balanced by sharp shadows. The series of sculptures *Lines in Space* of the 1950s are made from threads stretched across a frame. Vézelay also used wire, which allowed her to contrast curves and straight lines. Light falling across the pieces added another dimension, as she acknowledged in the title of her 1954 exhibition at the Leicester Galleries, *Lines in Space and their Shadows.*

Vézelay was also a curator and writer, organising an exhibition of contemporary British art in 1925 which showcased Paul Nash and Ben Nicholson, among others. Thirty years later she curated a show at the Royal

Paule Vézelay
Forms on Grey, 1935
Oil on canvas
129.9 × 97.1 (51⅛ × 28¼)
Bequeathed by the artist
1985

Festival Hall of members of the Groupe Espace, including Jean Arp, Sonia Delaunay, Walter Gropius, Ithel Colquhoun, Marlow Moss and herself. Her writings include a series of articles on aspects of London life.

Vézelay's image was important to her. In her self-portrait of the late 1920s, *Harmony* (National Portrait Gallery, London), the artist painted herself in gentle greys and pinks, arms languorously raised over her head, but this softness contrasts with the sharpness of the lines, echoing her incisive gaze. Born Marjorie Watson Williams, she had changed her name on moving to Paris in 1926, signalling her allegiance to the French art world. She was sure of her own stature as the first English abstract artist to achieve an international reputation, although she commented in an interview with the *Observer* in 1983 (the year of her Tate retrospective): 'You have to be twice as good as men to get recognition.'

MARIA HELENA VIEIRA DA SILVA
1908–1992

Having decided on a career as an artist as a young girl (she took lessons from tutors at the Lisbon School of Fine Arts at the age of fourteen), Maria Helena Vieira da Silva moved to Paris to study sculpture under Antoine Bourdelle. She then decided to be a painter, studying under Othon Friesz and Fernand Léger, and having her first solo exhibition at the Galerie Jeanne Bucher in 1933. She continued to show there for over fifty years.

Vieira da Silva's work is characterised by kaleidoscopic compositions and sweeping perspectives. Her paintings of patterns include works that appear abstract, such as *Les Lozanges* (1938, Museum of Modern Art, New York), although there are hints at the presence of figures and architectural structures. She painted games in which pattern is central, as in *La Partie d'échecs* (1943, Musée Nationale d'Art Moderne, Paris), which could have been shaped by her admiration for Bonnard, whose interiors were sometimes decorated with checked material. Her shattered spaces were used to great effect in paintings reflecting the war, such as *Le Désastre* (1942, Musée Nationale d'Art Moderne, Paris), and their sense of doom on a grand scale evokes the work of an earlier painter of cataclysms, John Martin. Vieira da Silva also painted the vistas of the modern French capital, as in

Maria Helena Vieira da Silva
Paris, 1951
Oil on canvas
32.7 × 45.7 (12⅞ × 18)
Purchased 1959

La Gare Montparnasse (1957, Walker Art Centre, Minneapolis).

During the war Vieira da Silva lived in Lisbon and Brazil, returning to Paris for good in 1947. Wilhelmina Barns-Graham recalled visiting her there in the early 1950s, having shared an exhibition with her at the Redfern Gallery, London. Among Vieira da Silva's international exhibitions were a show alongside Germaine Richier at the Stedelijk Museum, Amsterdam in 1955, and touring retrospectives. Included in the exhibition *L'Ecole de Paris 1945–64* of 1998–9 (Fondation Musée d'Art Moderne, Musée National d'Histoire et d'Art de Luxembourg), Vieira da Silva was described as 'unclassifiable', but a significant artist in the post-war context in that her work represented modern alienation, 'the ungraspable reality of a labyrinth to which we can never give order with our perspectives, to which we are forever "strangers"'.

ETHEL WALKER
1861–1951

Although there is to date no biography
of Ethel Walker or *catalogue raisonné* of
her art, Tate Archives house a collection
of notes on her life and career compiled
by the painter Grace English, who met
Walker in 1931 and became her friend
and patron. English wrote about her
first visit to the artist: 'I was invited
to see her work at her Chelsea studio,
127 Cheyne Walk . . . The studio was
just a first floor double room in an
old Victorian house on Chelsea
Embankment, overlooking the river . . .
In this studio she lived, slept, worked
and received her friends and models,
surrounded by her paintings, and
her dogs, always rough haired terriers,
in succeeding generations, for company.'

According to English, Walker did
not decide on her vocation until the
age of twenty. She trained at the
Westminster School under Frederick
Brown. With her close friend Claire
Christian (with whom she lived for
fifteen years) she travelled, visiting
Spain and copying works at the Prado.
They saw Impressionist pictures in
Paris and particularly admired Manet.
The two women had a friend in the
writer and critic George Moore, and
they appear in his trilogy *Hail and
Farewell* (London 1911–14). Walker's
exposure to modern European art had
a profound influence on her technique,
characterised by a light, loose handling
of paint, an approach which was also
in sympathy with the work of British
artists such as Walter Sickert (whose
evening classes she attended) and
Philip Wilson Steer.

Portraits were a key part of Walker's
work. These range from the masterly
early painting *The Artist's Stepmother,
Mrs Arthur Walker* of c.1899 (Tate),
whose dark tonality and introspective
mood are strongly reminiscent of

Ethel Walker
Self-Portrait, ?exh.1930
Oil on canvas
63.5 × 76.5 (25 × 30⅛)
Presented by
Major E.O. Kay 1951

Whistler, to paintings of the ballerina
Anna Pavlova and the actors Flora
Robson and Elsa Lanchester. She painted
the latter several times, including a
portrait of the actress in costume as
Prue in Congreve's *Love for Love* in the
early 1930s. According to Grace English,
the painting was commissioned by
Lanchester's husband, the actor Charles
Laughton. Walker also portrayed fellow
artists Lucien Pissarro, Ithell Colquhoun
and Vanessa Bell (1937, Tate). Representing
herself, she created an image of a
stylish woman artist full of confidence.

Walker did not work exclusively
in London. She made regular visits to
Robin Hood's Bay, North Yorkshire, to
paint the land and sea. In a letter from
there to Grace English she wrote:
'The snow came the day after I left for
RH's bay, a fog with it . . . The sun
melted the snow on Monday, the sun
was shining when I painted a rough
sea. I stood out painting happily in
the ice cold wind 3 snow pictures.'[58]
Her *Seascape: Autumn Morning* (c.1935)
is in the Tate Collection.

In the large imaginative
compositions that also form a major
part of her work, Walker painted

themes from classical mythology and
the Bible. Her interest often lay in the
representation of female characters,
such as Lilith, and also Nausicaa, the
Tate version of which was exhibited in
representation of Britain at the 1939
World Trade Fair in Chicago. The
rhythm and decorative arrangement of
these works also reflect her interest in
traditional Chinese painting.

Walker did not begin to exhibit her
work until the age of thirty-seven. She
showed at the New English Art Club,
where she was one of very few women
to be elected a member, and then at the
Royal Academy (becoming an Associate
in 1940). Walker joined the Friday Club
organised by Vanessa Bell, and the
London Group, and in 1932 was made
Honorary president of the Women's
International Art Club. In 1930 and 1932
she represented Britain at the Venice
Biennale. Having her first individual
exhibition at the Redfern Gallery in
1927, Walker also exhibited at the
Leicester Galleries and had many
shows at the Lefevre galleries. Her
correspondence with Grace English in
Tate Archives discusses the hanging of
her work at various exhibitions,

arrangements for English to sit for her, and for a meeting of the two women with Nadia Benois. Walker wrote to English about her 1939 Lefevre exhibition: 'Thank you for your beautiful letter about my show, which filled my soul with completest happiness and contentment, & made me able to dispense so easily with the limited survey of all the obtuse press opinions, & made them non-existent . . . Because I am a woman I have to be patronised it seems with a sea of futilities and adjectives.'[59]

Following Walker's death, an exhibition was organised by the Arts Council and the Tate as a memorial for her and two contemporaries, Gwen John and Frances Hodgkins. The catalogue foreword argued that although the three artists shared 'no similarity of style, outlook or intention; each . . . in her own sphere has made a decisive contribution to the history of British painting in the first half of this century.' T.W. Earp, in his catalogue essay on Walker, defined her particular contribution: 'although in technique

her impressionism was less doctrinaire and scientific than that of the French masters – nearer to Whistler than to Monet, with less use of divided colour and for the most part content with a broad daylight effect, she gained the same result of vibrance and spontaneity. This shows particularly in her portraits of women, usually painted in one dominant key of radiant colour, which, without effort at deliberate likeness, net the sense of personality in their rapid grasp of a moment's mood.'

EDITH GRACE WHEATLEY
1888–1970

Edith Wolf trained at the Slade from 1906–8, and then in Paris at the Atelier Colarossi. She painted briefly in Newlyn, Cornwall, before returning to London, where she had a long career as a painter of figures, flowers, animals and birds. She showed mainly at the Royal Academy (1914–64), the Royal Society of Miniature Painters, and the NEAC where she was elected a member.

In 1912 she married a painter, John Wheatley, and her portrait of him was her first submission to the NEAC the following year. Wheatley had already had some success, as her delicate watercolour on ivory *The Lady Clarissa* was bought by the Walker Art Gallery, Liverpool, from the 1910 autumn exhibition there. It shows a woman wearing a full-skirted dress, which appears to be of the same mid-Victorian period as the wide ruffled skirts of the lady resting in the Tate drawing. The artist may have been taking part in the vogue among NEAC artists for what some critics in the early 1900s labelled 'the modern antique'.

But, as happened to many women artists of Wheatley's generation who

Edith Grace Wheatley
Seated Woman, 1913
Drawing and watercolour on paper
35.6 × 25.4 (14 × 10)
Purchased 1922

married artists, she saw her husband become much more successful than she was. He was made an Official War Artist during the 1914–18 conflict, and appointed Director of the National Gallery of South Africa, and Professor of Fine Art at the University of Cape Town. Grace Wheatley was Senior Lecturer in Fine Art at the University from 1925–37, and she painted the ceiling of

the new art gallery. In 1937 the couple returned to England, settling in Sheffield. Contrasting completely with her usual subject matter, Wheatley represented the war's effect on the local steel industry. In 1945 her *Forging six-pounder shell bodies, Kilnhurst steel works* was shown at the Royal Academy, and the following year she exhibited *The tyre mill Kilnhurst steel works*.

WOMEN WORKING NOW

Mona Hatoum
Homebound, 2000
installed the Duveen
Galleries, Tate Britain

Looking at the diversity and visibility of women artists working now, it seems as if the potential Clara Erskine Clement saw around a century ago may have been fulfilled. The claim that we live in a post-feminist age, the idea that, to quote Virginia Woolf, there are no more 'ghosts to fight', is comforting. But is it the real picture?

In Britain today, women still face discrimination. Julie Mellor, chair of the Equal Opportunities Commission, cautioned: 'although women have made great strides towards equality in education and in the workplace, there are still real inequalities. There's still an 18 per cent difference between the hourly rate that men and women receive for full-time work.'[1] Even within education, among the earliest of all professions to admit women to its ranks, discrimination is rife. The pay gap between male and female academics has actually widened over the past five years.[2] The British election of 2001 seemed to be a reversal of women's earlier progress in the world of politics. The number of women elected to the House of Commons actually dropped for the first time in twenty years; they account for only 18 per cent of MPs. Westminster now lags thirty-third in the league table of women in parliament, behind North Korea, Croatia and Tanzania.[3] Across Europe and the United States of America the battle over women's rights continues – and this is in the privileged West, where most of the women artists in the Tate Collection and visitors to Tate galleries originate. Women living in countries outside the prosperous 'First World' often experience far greater hardship and danger. According to a World Health Organisation report of 2000, 70 per cent of those living in poverty across the globe are women.

In the field of contemporary culture the position of women has been considered serious enough for UNESCO to commission a paper on 'Women and Cultural Policies'.[4] The paper argued that the marginalisation of women artists could no longer be attributed to lack of training, but that there is evidence to suggest that aesthetics in society remain almost exclusively controlled by male 'gatekeepers', the most prestigious awards are still being given mainly to men, and women face an 'absence of support by their mentors, professors and other available role models (which continue to be predominately male)'. The authors of 'Women and Cultural Policies' later compiled a paper on women in the arts and media, examining eight European countries (including Britain) and revealed that although women make up between 30 and 60 per cent of all art students, and 38 to 45 per cent of artists, they only account for between 3 and 20 per cent of lecturers and professors.[5]

Women's marginal presence in the Tate Collection only echoes wider prejudice against them. Sexual discrimination perpetuates a situation in which women achieve less in the arts than men, while making it seem that this is an impartial matter of artistic 'value'. Among the art critics and historians who refuse to paper over the cracks in the name of post-feminism are Amelia Jones and Katy Deepwell. Jones has taken issue with the dismissal of feminist work of the 1970s in much mainstream art history, and argued for its continued importance.[6] Deepwell combines historical research with attention to the situation of women working in today's art world. *New Feminist Art Criticism*, edited by Deepwell, includes an essay 'On women dealers in the art world' by the dealer Maureen Paley, founder of Interim Art. Paley states: 'All the battles that were fought in the 1970s and early 1980s led many people to feel that there is no longer a barrier to women being shown . . . There is still an enormous amount of ground to cover. What we are really experiencing is the first stage of tokenism.'[7]

The necessity of continuing the feminist project means that some women today see themselves as part of a 'third wave' of feminism. The 'third wave' is informed by both a

Cindy Sherman
Untitled Film Still #48, 1979, reprinted 1998 (detail)

Sarah Lucas
The Old In Out, 1998
Tate

desire to counter the dangerous backlash against feminism that underlies 'post-feminism', and the need to critique, refine and develop the feminist project. In terms of women's work and history as artists, it implies a move beyond the polarities of a rigidly defined 'feminist art' versus a refusal of any reading of art in feminist terms. It should be the case today that the potential feminist resonance of an art work can be discussed, and its relationship to the history of women's practice, without confining the work solely within those interpretations.

But the need for a 'third wave' in relation to art can appear to be negated by the media attention given to the work of a few female figures, in Britain the most notable being Tracey Emin. It is important to make the distinction here that media attention does not necessarily mean serious critical attention, with the status, respect and financial rewards that implies. The column inches devoted to Emin have a down-side. While they have helped to build her a lucrative career, Emin's media image as 'art's bad girl' (*Guardian*)[8] and 'A Tart for her Art' (*Independent*),[9] means that her work tends to be read in tabloid terms as titillating confession, its art-historical and political significance overlooked.[10] And critic Sarah Kent has pointed out the 'astounding' difference in price paid by the collector Charles Saatchi for work by Emin and by a male artist of her generation and circle during the same period. Emin's *My bed* (1999) sold for £150,000, while the collector paid £1,000,000 for Damien Hirst's *Hymn* (1999).[11]

Women artists continue, as they did historically, to adopt a variety of approaches to the relationship between their identities as women, feminism, and their work. Some, including the British abstract painter Bridget Riley, do not see their work as influenced at all by the fact that they are women. For others, the belief that second-wave feminists made all the progress that is necessary means that they claim to feel liberated from what they see as an onerous obligation to make art dealing with 'female issues'. There are also artists who see their practice as influenced either by the fact that they are women or by their feminist politics. Gillian Wearing has suggested that women artists are perhaps more willing to explore emotions in their work. Other women have worked or continue to work with a feminist agenda, including Mary Kelly, Cathy de Monchaux, Lubaina Himid and Sarah Lucas, who has said: 'Feminism helped me mobilise myself for a while … and it gave me a lot of ammunition.'[12]

Despite this divergence of opinion between women artists, surveying those in the Tate Collection it seems that there are strands in contemporary art that some women have in common, that have developed from the work of second-wave feminists. Germaine Greer, writing in *The Whole Woman* in 1999, nearly thirty years after her seminal second-wave book was published, argues that the female body is still a battleground. 'The millennial feminist has to be aware that oppression exerts itself in and through her most intimate relationships, beginning with the most intimate, her relationship with her body. More and more of her waking hours are to be spent in disciplining the recalcitrant body, fending off the diseases that it is heir to and making up for its inadequacies in shape, size, weight, colouring, hair distribution, muscle tone and orgiastic deficiency, and its incorrigible propensity for ageing.'[13] A number of women artists continue the work of destabilising the idealised female form and representing the lived, experiencing body, with all of its abject mess, notably Kiki Smith and Tracey Emin – whose blanket piece *Psycho Slut* (1999) was appliquéd with the words 'Yea I know nothing stays in my body'.

The desire to represent women's experience also shapes the work of a number of women artists who make autobiography an important part of their practice, including Louise Bourgeois, Nan Goldin and Georgina Starr. The domestic domain has been

Rachel Whiteread
Untitled (Floor), 1994–5
Tate

made menacing and haunting in the work of Mona Hatoum, Abigail Lane and Rachel Whiteread. Psychoanalytic theory has infused the work of Sarah Lucas, Sam Taylor Wood and Gillian Wearing. Images and ideas of masculinity are being explored in the art of Mary Kelly, Ana Maria Pacheco and Paula Rego. And some women artists build on earlier feminists' use of role-reversal, parody and irony, in order to subvert the status quo. They make jokes, rather than being the butt of them. Sarah Lucas's dead-pan demeanour masks a darkly humorous edge. She has managed to insert herself into the distinguished avant-garde trajectory of Marcel Duchamp and his descendants by responding to his famous masculine in-joke, the ready-made fountain/urinal of 1917, with a series of works incorporating unisex toilets.

Women artists' choice of media can be influenced by the history and politics of women's work as artists. There is a strong current of work today that blurs conventional divisions between fine art and what have been categorised as 'feminine' crafts and decorative arts. The use of sewing runs through the history of women's art like a thread linking women artists from the early twentieth century to the second wave of feminists to a number of later women artists. Rosemarie Trockel has made knitted pieces. Representing flowers was traditionally seen as a minor form of fine art practice that women were encouraged to take up, and in which they established themselves as far back as the Regency painter Clara Maria Pope. Contemporary artists such as Anya Gallaccio, who work with flowers, are part of this long history of women's work. Minimalist art of the 1960s and 1970s such as that of Eva Hesse, which offered a critique of the conventions of practice, has left a fertile legacy for women artists today, amongst them Roni Horn and Andrea Zittel (whose work was included in the 1994 exhibition *Sense and Sensibility: Women Artists and Minimalism in the Nineties* at New York's Museum of Modern Art, along with that of Mona Hatoum and Rachel

Whiteread). And, as we enter the twenty-first century, video has become a key medium for fine art with a critical agenda, as the fragmentary, temporal nature of video work and its relationship with the material world undermine the idea of the precious fine art object. The exhibition *Whistling Women*, curated by critic Sarah Kent for the Royal Festival Hall, London in 1995, included video pieces by Lucy Gunning, Susan Hiller, Gillian Wearing and Catherine Yass.

As so many women now are making exciting, important work, what can be done to ensure that they do not, like so many of their predecessors, disappear into obscurity when the history of today's art is constructed in the museums and art history books of tomorrow? While the complexities of the debates around positive discrimination and the difficulty of collecting are evident, it is also clear that the under-representation of women artists in the institutions of the art world continues, and needs to be addressed. It is worth reiterating here that, at the time of writing, only 316 women are represented in the Tate Collection, while as early as 1859 the art historian Elizabeth Fries Ellett complained in her book *Women Artists in all Ages and Countries* that she only had space to include around 550 of the important women artists she knew of.[14] If the work of historical women artists is brought into the museum, and that of contemporary women is supported, our understanding of the art of the past, and the terms in which we conceive of the art of the future, will be transformed. *Tate Women Artists* written in 2100 could tell another story.

The last word should go to a woman artist. Anya Gallaccio was commissioned to create a work for Tate Britain's Duveen Galleries just over a century after the first Tate Gallery opened. *Beat* (2002) included an installation of seven oak tree trunks for visitors to walk through. Gallaccio said that she chose oak as it was a symbol of male mythology, and that by felling the trees she was 'evoking different histories'.[15]

GILLIAN AYRES
born 1930

In March 1958 a *Vogue* feature pictured women wearing monochrome suits thrown into stark relief by a background of spatters and stains of paint. The models were standing in front of four panels by Gillian Ayres commissioned to decorate South Hampstead High School for Girls in 1957 (the paintings are now in the staff room). Ayres had followed the example of Jackson Pollock. She painted on a large scale, on the floor, using household enamel paint. The link between the two artists was underlined by the *Vogue* piece. Pollock's paintings had been used as a backdrop to a fashion story photographed by Cecil Beaton for the magazine seven years earlier. Ayres's loose, organic early work was also in tune with a contemporary form of painterly abstraction labelled tachisme, after the French word for a mark, blot or blob. Tachisme developed in Paris during the late 1940s. It had its roots in French existentialism, in that it was concerned with signalling the individual subjectivity of the artist through works that bore the marks of the experience of making. Understood in the post-war context, Ayres's art is likely to have seemed liberating, shaking off the dead weight of history and revelling in the physicality of paint.

Ayres trained at Camberwell School of Art from 1946 to 1950, where she found some stimulation in the classes of Victor Pasmore (whose art was moving away from tonal figuration towards international modernism) and in French painting, particularly that of Sonia Delaunay. In her final year Ayres was selected for the first *Young Contemporaries* exhibition, and began to exhibit with the London Group. Seven years later Ayres showed a series of paintings in the exhibition

Gillian Ayres
Antony and Cleopatra, 1982
Oil on canvas
289.3 × 287.2 (113⅞ × 113)
Purchased 1982

Metavisual, Tachiste, Abstract: Painting in England Today held at the Redfern Gallery. She was one of only three women to be included out of thirty artists (along with Sandra Blow). Ayres also exhibited in two other important group exhibitions of abstract art, *Situation* in 1960 and *New London Situation* of the following year, which included *Break-Off* (1961, Tate), in which thinly applied paint floats in patches and vaguely outlines forms on an otherwise empty ground. In the foreword to the 1960 exhibition, written by critic Roger Coleman, Ayres's work was linked to that of her husband, the painter Henry Mundy. Coleman argued that what he termed

their 'informal painting' had widened the parameters of abstraction.

During the 1960s Ayres painted with the new acrylics, before returning to oil paint. In the 1970s, the succulent, strong-coloured and heavily worked impasto for which she is now known began to appear. She experimented with format, painting a series of circular pieces inspired by a visit to Italy and its Renaissance art and architecture. Response to an environment also shaped her series of eighteen canvases for the Seventh-Triennale-India, organised by the British Council in 1991, where her vivid palette of pinks, purples and greens mirrored the colours she saw around her in Jaipur, and her

method of painting sometimes with her fingers was akin to that of folk artists in the area. Ayres has introduced imagery into her paintings, a repertoire of flowers, crescents, suns and stars. She has also varied the titles she uses, from the perfunctory *Red, Green, Blue, White* or *Painting 1* of the early group show at the Redfern Gallery, to more evocative literary titles. *Green fuse*, of 1982, is taken from a poem by Dylan Thomas, while *The bee loud glade*, from 1987, is from a verse by W.B. Yeats. Along with Bridget Riley and Tess Jaray Ayres was one of only three women out of twenty-five artists to be included in the exhibition *Ready Steady Go: Paintings of the Sixties from the Arts Council Collection*, at the South Bank Centre in 1992. Her contribution to contemporary British art has not always been acknowledged, which Ayres attributes to the fact that 'Our particular culture is happier with serious subjects and brown paintings. When people talk of pure decoration they talk about it as if it were something like an embroidered cushion.'[16] Ayres was nominated for the Turner Prize in 1989. Among her solo exhibitions have been shows at the Museum of Modern Art, Oxford (and touring) in 1981, the Serpentine Gallery, London (and touring) in 1983–4, and the Royal Academy in 1997.

JO BAER
born 1929

Jo Baer's exhibition at the Stedelijk Museum, Amsterdam in 1999 covered her career to date. Baer, who was born in Seattle, studied biology and psychology. But she also took subsidiary art courses, and in 1960 moved to New York where she began to make abstract paintings.

Baer's work was in sympathy with that of some of the artists she knew, including Sol LeWitt and Donald Judd. Her insistence on the painting's existence as a two-dimensional object, whose characteristics sprang from its own development, was in tune with Minimalist moves to redefine the painted canvas as an object existing on its own terms. Her practice of painting bands around the edges of her canvases emphasised their physical properties. Baer was also attentive to each work's interaction with its environment and with her other paintings. Her diptychs and triptychs extended this exploration of inter-relationships. Although Judd was eventually to reject what he saw as the inescapable illusionism of painting, Baer defended a painting's ability to

Jo Baer
Stations of the Spectrum (Primary), 1967–9
Oil and acrylic on canvas
each: 183.5 × 182.9 (72¼ × 72)
Purchased 1980

be as self-contained as any three-dimensional object, and argued her case in a letter published in *Artforum* in September 1970. What she termed her 'radical art' was part of a passionate political agenda; each of her paintings grew out of its own specific internal dynamic, representing her belief in equality and self-determination.

After she moved to Ireland in the mid-1970s Baer began to paint figuratively, disillusioned by the political ineffectiveness of abstract art. In her statement 'I am no longer an abstract artist' (*Art in America*, October 1983) she wrote: 'At the time the high-flying appeared both brave and bold. At this time it seems merely naive.' She stated that she did not want to make work that could be hung in an Esso or Shell boardroom. Mixing text and images, Baer's paintings now spell out blatant messages. *The Old Lie: Dulce et Decorum Est . . . Pro Patria Mori (Wilfred Owen)* (1997–8) depicts phalluses and missiles, and superimposes the figure of a crying child over long lines of war graves.

WILHELMINA BARNS-GRAHAM
born 1912

In 1940 Wilhelmina Barns-Graham moved to St Ives. She trained at Edinburgh College of Art from 1932 to 1937, where she won a scholarship. Her time there coincided with that of Margaret Mellis, who had gone to Cornwall before her. Barns-Graham also knew Barbara Hepworth, Ben Nicholson and Naum Gabo, whom she cited as the greatest influence upon her. She joined the Newlyn and St Ives Societies, exhibited with the Crypt Group in 1947, and in 1949 was a founder member of the Penwith Society.

Barns-Graham's work has often developed from her experience of places, from war-time St Ives, to Grindelwald, Switzerland, whose high glaciers she first saw in 1950, leading to a series of intricately plotted paintings evoking the transparencies and opacities of ice under light. She has also made completely abstract works, such as *Red Form* (1954, Tate), characterised by sharp geometric shapes and powerful colour. She taught at Leeds College of Art with Alan Davie and Terry Frost in 1956–7.

Wilhelmina Barns-Graham
Glacier Crystal, Grindelwald, 1950
Oil on canvas
51.4 × 60.9 (20¼ × 24)
Presented by the Contemporary Art Society 1964

Retrospectives of Barns-Graham's art have been held at City of Edinburgh Museums and Art Galleries (1989) and Tate St Ives (2000). But, she has tended to be marginalised, along with Mellis, in the mapping of modernism in Cornwall, as Nedira Yakir has discussed in her essay 'Cornubia: gender, geography and genealogy in St Ives Modernism' (in K. Deepwell (ed.), *Women Artists and Modernism*, Manchester 1998). There has also been some criticism of the wide variety of styles in Barns-Graham's work. Interviewed for the National Life Story Collection in 1994, the artist stated, 'I never went for anything I was successful at, I was always experimenting.' She was still in contact with Mellis, and spoke of the continuing development of her art: 'My colours today are more brilliant and even more free; I've gone away . . . from the Hard Edge.'

JENNIFER BARTLETT
born 1941

Jennifer Bartlett studied at Mills College, Oakland, California, where she met Elizabeth Murray, and at the Yale School of Art and Architecture. In 1976 she had a breakthrough solo exhibition at the Paula Cooper Gallery, New York. Bartlett exhibited *Rhapsody*, a group of 988 steel plates. They were covered with images, a house, a tree, a mountain, the sea, and geometric shapes, painted and drawn in styles ranging from child-like freehand to the absolutely precise. *Rhapsody* invoked Minimalist systems and repetition, but the piece interspersed the quirkily individual alongside the carefully conceptual. Using an array of techniques, Bartlett also made it impossible to determine a single 'signature' style, refusing the idea of unique subjective expression.

Bartlett began to paint in a variety of media, including oil on glass and casein on plaster. Her subject matter, often the play of light on falling water and lush, leafy gardens, recalled Impressionism. But traces of Pop Art also filtered into her work, perhaps instigated by two tutors at Yale, James Rosenquist and Jim Dine. Bartlett began to juxtapose sculptures which looked like everyday objects with her two-dimensional works. An installation commissioned for Volvo's Swedish

Jennifer Bartlett
At Sea Japan, 1980
Relief print and screenprint on paper, print
57.1 × 254.5 (22½ × 100¼)
Purchased 1981

headquarters in 1984 included paintings and drawings, but also rowing-boats and houses in metal and wood. Bartlett has also made paintings that disrupt categories, jumbling the figurative and the abstract. *Air: 24 Hours* (1991–2) is a series of pictures of domestic space and objects in which the patterns of grids, squares and stripes threaten to overwhelm the realism of the work.

Bartlett's solo shows include a 1982 Tate exhibition *At the Lake, Up the Creek, In the Garden*. The title suggests the enduring significance of place in her work. 'Up the Creek' indicates her American identity; it is also slyly humorous, as indeed is the title of *At Sea Japan* (Tate), meaning both a specific place, and also that one is without direction. She has also made paintings titled after people's addresses, including those of Eizabeth Murray and Elvis Presley. The blurring of boundaries that began with Bartlett's *Rhapsody* means that her own work continues to evade location in a fixed category.

HILLA BECHER
born 1934

Working with her husband, Bernd, the German artist Hilla Becher takes black-and-white photographs of pit-heads, blast furnaces, gas containers, coal bunkers, water and cooling towers, silos and lime kilns. The Bechers picture utilitarian constructions that were never supposed to be scrutinised for their visual qualities, and the photographs are always uninhabited, compounding their eeriness. The fact that they work in partnership (as do Nikki Bell and Ben Langlands, Fionnuala Boyd and Leslie Evans, and Patrick and Anne Poirier) suggests a claim for creative equality between men and women artists.

The Bechers organise their photographs in groups, or 'typologies'. Pictures of pit heads, for example, are placed together. The coolly abstract

Hilla Becher
Pitheads, 1974
Photograph on board
113.3 × 131.8 (44⅝ × 51⅞)
Purchased 1974

pattern of their work, and its formal clarity, is in sympathy with Minimalist practice. Their systematic building of an archive of images of sites affiliates them with archaeological concerns in some contemporary art. But the Bechers' dual authorship refutes the idea of the individual expression of the fine artist. It is a collaborative recording with dispassionate eyes. This is underlined by the label they gave to their work in one of their first books, published in 1970, *Anonyme Skulpturen* (Anonymous Sculptures). Their focus on industrial archaeology means that their work also functions as a historical document. They have recorded the decline of Western industry (and also the key role of industry in Germany's troubled twentieth century). Their melancholic photographs of dereliction are often prefaced with an account of the processes they were once part of, reminding us of work and workers who no longer exist. The Bechers have pictured parts of Britain that were once its industrial heartlands – South Wales, Manchester, Leeds and Sheffield.

Recent exhibitions of the Bechers' work have included two group shows in London, *The Epic and the Everyday: Contemporary Photographic Art* at the Hayward Gallery in 1994 and *Reconstructing Space: Architecture in Recent German Photography* at the Architectural Association in 1999. The Bechers were the German Federal Republic's representatives at the Venice Biennale in 1990. Their work can also be seen in the numerous books they have published.

NIKKI BELL
born 1959

Together with Ben Langlands, whom she trained with at Middlesex Polytechnic, Nikki Bell formed Langlands and Bell. Their strategy echoes that of artists such as the Bechers, but in Langlands and Bell's case it also mimics the organisations formed by professional architects.

Langlands and Bell make architectural layouts, plans and elegant white models. They also work with found objects. They are concerned with what they call 'Traces of Living', and this was the title for their first exhibition, held at Maureen Paley's Interim Art in 1986. Their installation of white chairs and tables, that appeared pristine, actually contained miscellaneous rubbish, including a dead bird and a loaf of bread with a dead rat protruding out of it, arranged beneath glass with the reverence accorded to museum artefacts. The resin seat of one chair held a collection of old combs, another contained a model of London's National Gallery. While the collection invoked the disorder of daily life, the immaculate furniture summoned up the perfect austerity of modernist architecture.

There is a pervading sense of nostalgia in Langlands and Bell's art

Langlands and Bell
from *Enclosure and Identity*
Friday Mosque, Yazd, Iran, 1996
Blind embossed print on paper, print
76 × 72 (29⅞ × 28⅜)
Purchased 1997

for the optimism of modernists like Le Courbusier, the belief that buildings can foster social improvement, but they have also exposed modernism's similarity to other architectures. In the catalogue foreword for their 1991 exhibition at the Valentina Moncada Gallery, critic Adrian Dannatt argued: 'Their work makes clear that a sleek German bank or American campus library have their own ideology, their coded purpose. Liberalism, Communism, laissez-faire capitalism take form not just in policies but in every floor plan.

The codes of power, of dominance and containment, are inherent to architecture regardless of styles or movements.' Langlands and Bell's focus on the way that buildings shape our lives links them to Catherine Yass and Andrea Zittel, and to theorist Michel Foucault who analysed how power operates through architectural space in *Surveiller et Punir* (Discipline and Punish) (Paris 1975). In 2002 Langlands and Bell became the official British war artists in Afghanistan.

ELIZABETH BLACKADDER
born 1931

The painter and printmaker Elizabeth Blackadder trained in Edinburgh at the University and College of Art. She is the first woman ever to become Academician of both the Royal Scottish Academy and London's Royal Academy. Blackadder has exhibited in many group exhibitions and solo shows, often at London's Mercury Gallery. A major exhibition of her work was held at Edinburgh's Scottish National Gallery of Modern Art in the winter of 1999–2000.

In Blackadder's compositions images and marks, often developed from still life, are placed across the picture plane, sometimes leaving large areas empty. The ambiguity both of pictorial space and of the forms occupying it, disrupts easy reading, and makes the viewer's gaze move carefully over the whole surface. Blackadder has cited Italian art (from the Renaissance to Georgio Morandi) and Japanese culture as influences. On visits to Japan she was struck by the spatial arrangement of temples, gardens and calligraphy, but also by cheap plastic objects, which she included in her work. She has also painted landscapes, flowers,

Elizabeth Blackadder
Still Life with Pomegranates, 1963
Oil on canvas
86.4 × 111.8 (34 × 44)
Presented by the Trustees of the Chantrey Bequest 1966

cats and portraits, including in 1988 a painting of the writer Naomi Mitchison (National Portrait Gallery, London).

Blackadder's beautifully finished and highly decorative works (the gorgeous, intense colour is sometimes enhanced by gold leaf, or painted on textured paper) have sometimes been seen as second rate. But she has been described by critic William Packer as 'one of the dozen or so most interesting, accomplished and truly radical painters at work in the UK'. Blackadder has been the subject of monographs by Judith Bumpus (Oxford 1988), and Duncan MacMillan (London 1999).

KATE BLACKER
born 1955

After training at Camberwell School of Art and then at the Royal College of Art, Kate Blacker came to the fore as one of a number of artists who revitalised British sculpture during the 1980s. Along with Bill Woodrow and Tony Cragg, Blacker made her work out of unorthodox materials, giving a new life to the junk she assembled and altered.

Blacker transformed corrugated iron from scrapyards into figures and landscapes. But while, in Blacker's hands, scrap metal could even become a beguiling *Geisha* (1981, Contemporary Arts Society), like Woodrow and Cragg she does not let us forget the origin of her materials. Although the corrugated metal wittily splays out to create the pleats of a fan the figure is holding, and Blacker has painted her wearing a bright kimono, she is anchored by a plastic bag full of sand. Blacker made a number of sculptures in which a female figure emerged awkwardly from man-made material that could be read as a feminist comment on the alienation of women in a 'masculine' urban space. Her recycling of rubbish can also be interpreted as a critique of Thatcherism, with its voracious consumerism (hence the irony of the title *Made in '84*), and as a comment on environmental damage. Blacker has made landscapes

out of corrugated metal. And she referred to the tradition of landscape painting in work painted in Cézannesque blues and ochres, and titled after his *Mont Saint Victoire* series.

During the 1980s Blacker made metal sets for the dancer Gaby Agis (she has also designed for opera). This led to a shift in her practice. Figures were no longer to be represented. Now the viewer's body was to interact with sheets of corrugated metal and plastic, which were polished, covered with gold leaf, or sprayed with car paint. Blacker used corrugated zinc to make the installation *Silver Screens* (1993). Sheets of metal divided the gallery up, one of which was painted with a silhouette of four men on horseback, a typical image from a Hollywood western. Moving between the screens, you were suspended in an indeterminate space of rippled surfaces and shifting reflections, materialising psychoanalytic accounts of how our sense of ourselves is shaped by the culture around us, such as the films we watch.

Kate Blacker
Made in '84, 1984
Painted galvanised steel
287 × 152.5 × 58
(113 × 60 × 22⅞)
Presented by the Patrons of New Art through the Friends of the Tate Gallery 1987

SANDRA BLOW
born 1925

Among the sixty-seven artists exhibiting in *British Painting in the Sixties*, held jointly at the Tate and Whitechapel Art Galleries in 1963, were three women, among them Sandra Blow. Blow was one of the leading artists involved in the development of abstract painting influenced by the work of the American Action painters. She combined their spontaneous energy with textures and associations suggested by her diverse materials, sand, straw, sawdust and sacking, in addition to paint.

Her work was in sympathy with some British artists working in Cornwall, including Peter Lanyon, Roger Hilton and Patrick Heron. Blow stayed in Cornwall in the late 1950s and settled in St Ives in the 1990s. She used to

Sandra Blow
Space and Matter, 1959
Oil on board
151.8 × 122.6 (59¾ × 48¼)
Purchased 1960

discuss her work with Anthea Alley, and now Wilhelmina Barns-Graham gives her regular critical appraisals. Traces of the Cornish landscape can be seen in Blow's structures, her sometimes muted palette, and the use of line, suggestive of hills, sand dunes or waves. She continues to experiment, and has worked with tea, ash, cement, plaster and polythene. Blow also works

vivid paints with panache. She embraced the new acrylics in the 1960s, and her understanding of strong colour is evident in paintings such as *Vivace* (1988, artist's collection), with its striking red.

Blow's artistic ambitions were encouraged by her Aunt Rose (whose own education had been thwarted by her family). She studied at St Martin's

School of Art, the Royal Academy (she was elected a member), and the Accademia delle Belle Arti, Rome. Her many solo shows include a series at Gimpel Fils from the 1950s, a retrospective at the Royal Academy in 1994, and at Tate St Ives in 2002. Blow has also taught at the Royal College of Art.

LEE BONTECOU
born 1931

Writing in *Arts Magazine* in April 1965, artist and critic Donald Judd described Lee Bontecou's work as 'explicit and powerful'. He found her large relief constructions 'threatening'. In a mixture of materials including canvas, leather, denim and rope, welded steel, found metal objects such as saw blades, and with voids lined with black velvet, they looked like orifices, particularly parts of the female body, and also weapons, mines and war heads. Her drawings depicted similarly sinister, suggestive imagery.

Much has been made of Bontecou's representation of feminine sexuality, her creation of what can be seen as a series of vicious 'vagina dentata'. This subject matter, and her use of fabric and metal, have echoes in the work of Cathy de Monchaux. But seeing Bontecou's art solely in terms of its 'femininity' downplays her contribution to art history. Judd saw her as 'one of the first to use a three-dimensional form that was neither painting nor sculpture'. Eva Hesse was another admirer. And Bontecou's art has developed, becoming organic, lyrical and more figurative. In works made of plastic the forms of fish and flowers seem to appear. Bontecou's strong

Lee Bontecou
Drawing, 1961
Drawing on paper
68.6 × 99.7 (27 × 39¼)
Presented by Leo Castelli 1962

political opinions have been a consistent influence on her art. Memories of the Second World War and the menace of the Cold War fed into her early work, while later pieces reflected her concern for the environment. For her friend, the artist Joseph Cornell, Bontecou's works were 'warnings'.

Bontecou trained at the Art Students' League, New York, and in Rome. From the 1960s onwards she

has had exhibitions at the Leo Castelli Gallery, New York. A retrospective was held at the Museum of Contemporary Art, Chicago in 1972, and a show toured from the Museum of Contemporary Art, Los Angeles in 1993–4.

LOUISE BOURGEOIS
born 1911

At the launch of Tate Modern in 2000, Louise Bourgeois's spider sat on a platform above the turbine hall. Behind it her three towers, *I Do, I Undo*, and *I Redo*, loomed. The works put into play an elaborate psychodrama. The monstrous spider recalled childhood nightmares. The towers made their visitors symbolically re-enact the arduous journey towards self-knowledge. Two of them bristled with mirrors at the top. After climbing the rickety staircases spiralling around *I do* and *I redo*, the self you saw reflected was multiple, fractured. Entering the interior of *I undo* meant that you were 'in the dark'. The towers brilliantly represented moments of movement and stasis, lucidity and blind uncertainty, we encounter in our lives.

The dramas of her own interior life are at the core of Louise Bourgeois's practice. She was brought up near Paris where her family ran a business repairing tapestries. Bourgeois has often stated that she felt bitter resentment because her father and English nurse were having an affair, and gave her little attention. But there were compensations. Bourgeois trained at the Ecole des Beaux Arts, and then at studios including those of André Lhôte and Fernand Léger. Her mother was a strong influence. In a collection of her writings, *Destruction of the father: Reconstruction of the father* (Paris 1996), Bourgeois recalled that her name was chosen 'because Mother was a feminist and a socialist; her ideal was Louise Michel, the French Rosa Luxembourg. All the women in her family were feminists and socialists – and ferociously so!' She has written that, following this upbringing, 'to be political seems a matter of course'.[17]

But Bourgeois's work is not a straightforward self-portrait. She represents the shadowy intricacy of the psyche and its processes through diverse media and methods (painting, drawing, printmaking, writing, sculpture, and installation). Furthermore, although Bourgeois's work is in tune with Freud's thesis that the relationship between parents and child is the formative influence on the individual, in the Freudian scheme, power is ultimately vested in the patriarch, whereas in Bourgeois's world the artist, creative power behind the work, is a woman. And she has paid tribute to her mother's influence in her work. In a series of etchings and a text, *Ode à ma mère*, published in 1995, Bourgeois described her mother as 'deliberate, clever, patient, soothing, reasonable, dainty, subtle, indispensable, neat and useful as an *araignée*'.

Bourgeois has expressed her desire to move beyond conventional understanding of the sexes. Writing in 1974 in *New York* magazine about *Femme Couteau* (1969–70, pink marble, private collection) she argued that the piece was about the blurring of gender definitions: 'the woman turns into a blade, she is defensive ... She feels vulnerable because she can be wounded by the penis. So she tries to take on the weapon of the aggressor ... It is important to show girls that it is natural to be sexual and that men can also feel helpless and vulnerable.'

In Bourgeois's *Femme-maison* drawings of the 1940s women's bodies are hidden from the waist up by small buildings. Perhaps these represent the restrictions of domesticity, or, following Freud, the lasting influence of our childhood environments upon us. The female body was distilled down to its essences, filling the glass vessels, in *Precious Liquids* (1992, Centre Georges Pompidou, Paris). In *Untitled* (1996) lingerie and an evening dress were suspended from clothes hangers fashioned out of beef bones, a meditation on the pleasures of decorating the female body, and its inevitable decline from youthful radiance. Like her mother, Bourgeois sews. This can be prettily beguiling, as in the pillow embroidered '*Je t'aime*' in scarlet thread letters in *Red Rooms* (1994), or disturbing, as in the gross, limbless torso, *Quilting* (1999, private collection), with its jutting breasts and poking tongue raggedly stitched in pink flannel.

Posing for a portrait by the photographer Robert Mapplethorpe in 1982, Bourgeois chose to be pictured with *Fillette* (1968, Museum of Modern Art, New York). The sculpture is a phallus, but its name translates as 'little girl'. The title feminises this symbol of potency, and Bourgeois was photographed with it tucked jauntily under her arm, like a walking stick. There are also works in which Bourgeois has turned the tables on men graphically. *The Destruction of the Father* (1974) represents a dinner table at which children have made a meal of their parent. In *Cell (Arch of Hysteria)* (1992), Bourgeois transformed her male assistant into a supine, tensed, headless figure, defenceless against the blade of a bandsaw. And some of her performance pieces have cast male art critics as bizarrely dressed figures wandering around at her direction.

Between Bourgeois's first solo exhibition, at the Bertha Schaefer Gallery, New York, in 1945, and the 1970s, she showed infrequently. Increasing interest came during the second wave of feminism. Two exhibitions toured from the Museum of Modern Art, New York (1982–3 and 1994–5), and among her retrospectives were shows at the Musée d'Art Moderne de la Ville de Paris (1995), the Museum of Modern Art, Oxford (1995–6), and the Serpentine Gallery, London (1998–9).

Louise Bourgeois
Cell (Eyes and Mirrors), 1989–93
Marble, mirrors, steel and glass
236.2 × 210.8 × 218.4 (93 × 83 × 86)
Presented by the American Fund for the Tate Gallery 1994

OLWYN BOWEY
born 1936

The portraitist Olwyn Bowey has painted the dramatist Harold Pinter, the writer Lady Antonia Fraser, and the politician and journalist Woodrow Wyatt. Her pencil *Portrait of a Woman* of 1970 was one of the few works by women artists to be included in *The Human Clay*, an exhibition selected by R.B. Kitaj in 1976. The drawing was bought by the Arts Council.

Bowey trained at the West Hartlepool School of Art and the Royal College of Art. Much of her practice is landscape painting. In the catalogue foreword for her 1969 exhibition at the New Grafton Gallery, Carel Weight described Bowey as 'a direct descendant of the English nature artists . . . Constable, the English watercolourists and John Nash, who concerned themselves with the intimate and rustic aspects of the country . . . rather than the dramatic grandeur of the storm, or the desolate and tremendous prospects that inspired Turner or Byron.' A focus on what Bowey has termed the 'neglected' suggests a sympathy with L.S. Lowry, whose

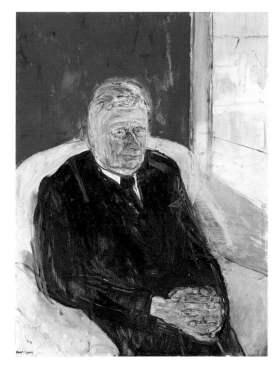

Olwyn Bowey
Portrait Sketch of L.S. Lowry, 1963–4
Oil on canvas
91.4 × 71.1 (36 × 28)
Presented by the Trustees
of the Chantrey Bequest 1964

portrait by her is now in the Tate Collection. And her 1960 joint exhibition with Sonia Lawson at the New Grafton Gallery included paintings such as *Railway footpath* and *Footbridge, Stockton*.

Bowey has been a regular exhibitor at the Royal Academy since the early 1960s, becoming an Associate in 1968, and exhibiting alongside Gillian Ayres, Sandra Blow, Jean Cooke, Francis Bacon and Peter Lanyon (among other artists) at the Academy's 1977 exhibition *British Painting 52–77*. She has also exhibited at the Leicester Galleries and the New Grafton Gallery.

SONIA BOYCE
born 1962

Sonia Boyce is one of very few black women artists represented in the Tate Collection. Photographed by Don MacLellan in 1997 (National Portrait Gallery), she cupped her hands to her mouth as if about to call out, and she has vociferously condemned the exclusion of black artists from the histories of art.

Of her training at Stourbridge College of Technology and Art between 1980 and 1983 Boyce recalled: 'on the degree course the tutors were dismissive. I was black, therefore I wasn't there. I drew my feet very big on a patterned background, "I'm here, you can't wish me away". Being a black woman is a perpetual struggle to be heard and appreciated as a human being.'[18] Boyce sought out mentors, learning from the work of Frida Kahlo, and being taught by Margaret Harrison, whose feminist figurative practice had a strong influence upon her, and (briefly) by Susan Hiller. During this period some black artists had begun to organise in response to discrimination. The First National Black Art Convention was held at Wolverhampton Polytechnic in 1982, and there Boyce met Lubaina Himid. Himid curated the exhibition *Five Black Women* held at the Africa Centre, London, a year later, which included Boyce and Veronica Ryan. Boyce's work in this show was noticed by the critic Sarah Kent, and then exhibited in a

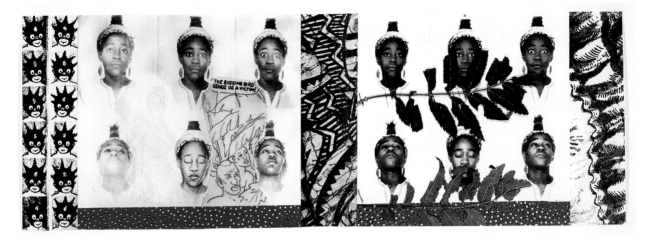

Sonia Boyce
From Tarzan to Rambo: English Born 'Native' Considers her Relationship
to the Constructed/Self Image and her Roots in Reconstruction, 1987
Photograph and mixed media
124 × 359 (48⁷/₈ × 141³/₈)
Purchased 1987

group exhibition at the Gimpel Fils Gallery, London.

Boyce's early work was figurative. Drawn in pastel, it often incorporated boldly patterned fabric and wallpaper designs, raising questions about the role of the decorative in art. It also put black women, often the artist herself, firmly at the centre of the picture. In *She Ain't Holding Them Up, She's Holding On (Some English Rose)* (1986, Cleveland County Museum Service) she appears with her family, her dreadlocked hair and the roses printed on her dress, a commentary on the national ideal of femininity. Boyce's work was shown in overviews of black art organised at this time: *Into the Open*, at the Mappin Art Gallery, Sheffield (1984), *The Thin Black Line* at the ICA London (1985), and *The Other Story: Afro-Asian Artists in Post-War Britain*, Hayward Gallery (and touring) (1989). She had individual exhibitions at the Black Art Gallery and Air Gallery in 1986, and Whitechapel Art Gallery in 1988.

By the late 1980s Boyce was making conceptual art in a variety of media including photography and installation. She often worked with text, in common with a previous generation of artists such as Jenny Holzer and Barbara Kruger, and a number of contemporaries, notably Tracey Emin. Having carefully composed titles for her pastel drawings, Boyce began increasingly to incorporate slogans culled from the media, the lyrics of popular songs, and her own writing. For The Photographers' Gallery exhibition *The Invisible City* in 1990, Boyce made *The Ticket Machine*. It dispensed postcards that gave verbal 'snapshots' of a city shaped by individual experiences and desires. The pleasures and power relations implied in the act of looking became a key theme for Boyce. In 1993 the 181 Gallery, London, staged an exhibition of her work *Do You Want To Touch?* The viewer was invited to feel the sensual works on show, as in *Plaited And Sewn With Red Satin Belly* (1993), fashioned from fabric and hair. Two years later, Boyce's installation *Peep* at Brighton Museum imposed a veil of tracing paper between the viewer and the ethnographic exhibits. Having to peer through sections cut out by the artist made the act of looking suddenly self-conscious; these artefacts from other cultures could no longer be easily consumed by the visitor's eye.

Making art from everyday objects, Boyce covered *Pillowcase* (1990) with texts taken from lonely hearts advertisements. *Black Female Hairstyles* (1995) shows, against multi-coloured backgrounds, a variety of hairpieces, from full wigs to the shiny twists and loops of different shades that are worn by some black women as accessories, changed according to event or outfit. Boyce has also drawn and photographed dreadlocks, plaits and white sitters wearing afro wigs, bringing the politics of identity into play. Along with sculptor Bill Woodrow and fashion designer Joe Casely-Hayford, she was invited by the London Printworks Trust in 1995 to work on the exhibition *Portable Fabric Shelters*, whose subject was homelessness. Boyce's installation included umbrellas, and a small tent which, she said, should 'appear as if you were getting into somebody else's head'.[19]

Boyce became Co-Director of the African and Asian Visual Arts Archive, and has taught at a number of art colleges. In 1997–8 she was the first artist in residence at the University of Manchester, and her work was shown at an exhibition, *Performance*, at the city's Cornerhouse.

FIONNUALA BOYD
born 1944

After meeting as students at St Albans Art School in the late 1960s, Fionnuala Boyd and Leslie Evans married and began to work collaboratively. They make paintings using photographs and slides as source material, which seem at first to be straightforward, slick figurative representation. When looked at closely, the world they portray appears warped. There are intense colours, distortions of space and scale, and figures and animals juxtaposed in strange, alienated relationships with each other and their environment.

Boyd and Evans are influenced by the dramatist Harold Pinter. Pinter has described how he was prompted to write *The Caretaker* after observing two people together, and this inspired Boyd and Evans, who began to use disparate figures in their work. They admire Surrealism, particularly the art of René Magritte, and distinguish their art from realism. In a statement accompanying their 1996 exhibition at Flowers East, they wrote: 'Representation is a language, and as such can lie and fantasise. Although most of our pictures represent credible situations there is no rule, and we often play with surreal spaces and situations.'

Fionnuala Boyd and Les Evans
The Wall, 1986
Acrylic on canvas
91.4 × 137.2 (36 × 54)
Presented by Philip and Psyche Hughes through Angela Flowers Gallery and the Friends of the Tate Gallery 1987

Boyd and Evans's work was first shown at the exhibition *Narrative Painting in Britain in the 20th Century* held at the Camden Arts Centre in 1970. Since then they have exhibited at the London gallery owned by Angela Flowers. They continue to work with the same polished technique (although they have changed media, from spray paint and acrylic to oil on canvas) but their subject matter has diversified.

As artists in residence for the Royal Geographical Society in the rainforests of Borneo they made a series of striking paintings of the lush vegetation. Recent portraits manage to combine rigorous scrutiny with a moving sense of the loneliness of the human condition, such as *The Listener* (1996), in which an old man tries to hold the attention of his female companion.

MIRIAM CAHN
born 1949

Miriam Cahn's large-scale black chalk drawings absorb the viewer in their dense, rubbed, grainy textures and feathery strokes, invoking the presence of the body, the touch of hair and skin. Cahn is concerned with the politics of representation of the body. In the catalogue for her 1996–7 exhibition *What Looks at Me: Surroundings*

(Bonner Kunstverein and tour) she wrote: 'no standing back in painter poses and "correcting, improving" until it became the masterpiece . . . I worked on the floor to forget everything, to see nothing, to be close to the personal, the feminine, to everything forbidden . . . I rejected distance. I rejected the assertion that art is gender neutral.'

Her drawings *Das Klassische Leiben* (Classical Loving) (1983) are a critique of the relationship between masculinity and femininity in fine art. A flurry of lines, suggesting rapid movement, depict a male figure struggling with a prone woman.

The expressive strength of Cahn's graphic work recalls that of Käthe

Kollwitz, and in 1998 Cahn was awarded the Käthe Kollwitz Prize by the Akademie der Künste, Berlin. The links between Cahn's work with femininity and identity and that of her contemporaries were explored in the exhibition *The Impossible Self* held at Winnipeg Art Gallery, Manitoba, in 1988, which also included Sonia Boyce, Astrid Klein and Avis Newman. Cahn represented Switzerland at the 1984 Venice Biennale.

Cahn has made work about history, war and the environment (in 1977 she was a woman's movement delegate to the Warsaw world peace congress). Her *Strategische Orte* (Strategic Places) (1985–7) represents a bird's-eye view of landscape, cityscape and dark, churning water, as if seen by a bomber pilot. Cahn's response to a more recent conflict was the series *Sarajevo* (1993), one of which represents a mournful face, eyes shut against the horror.

Miriam Cahn
City, 1985
Drawing on paper
272 × 379 (107⅛ × 149¼)
Purchased 1987

VARDA CHRYSSA
born 1933

Varda Chryssa moved from Greece, where she was born, to America, training at the California School of Fine Arts, San Francisco, before settling in New York in 1955. The city's hectic, blaring visual culture and the rampant consumerism of post-war prosperity fed into her work (mainly sculpture, but some paintings and printmaking). *Arrow: Homage to Times Square* (1958, Empire State Collection, Albany, New York) is a huge sign made out of rows of small aluminium bars.

Having apprenticed herself to a commercial signmaker, Chryssa began to make pieces in which a rainbow of lurid colours and a jumble of letters evoked the city's assault on the senses and its speeding pulse. In *Five*

Variations on the Ampersand (1966, Museum of Modern Art, New York) neon was enclosed in grey plexiglass to give the effect of impending night. In the monumental *Gates to Times Square* (1964–6, Albright-Knox Art Gallery, Buffalo) Chryssa vividly represented the chaotic visual culture of capitalism through a mixture of metal, plastic and neon. Tate houses her mixed media sculpture *Study for Gates No.4* (1967). Paintings and prints playing with fonts, letters, numbers and layouts developed from the pages of newspapers and magazines. Chryssa has also represented New York's long history as home to immigrants in a series of works about Chinatown. An immigrant herself, she was included (along with

Lee Bontecou) in the exhibition *Americans* at the Museum of Modern Art in 1963.

Chryssa pioneered the use of directly transmitted electric light and neon. Writing in *Art in America* in September 1988, critic Donald Kuspit described her metal sculptures as 'the grand, sophisticated, elegant conclusion of what such sculptors in welded steel as Julio Gonzalez and David Smith began'. Chryssa's work can be expressive and poetic. *Clytemnestra* (1967, Corcoran Gallery of Art, Washington DC), originally a part of *Gates to Times Square*, represents, in neon, the anguished scream of the character in Euripedes's drama when she learns that her daughter is to be sacrificed.

JUDY CLARK
born 1949

At the group exhibition *Reflected Images* shown at Kettle's Yard, Cambridge, in 1977, Judy Clark and Susan Hiller were the only women in a list of fourteen artists that included Victor Burgin and Michael Craig-Martin. Clark showed a self-portrait made up of a catalogue of 'female hairs/secretions', along with two works now in the Tate Collection, *Catalogue Female Skin and Catalogue Male Skin*. These are made up of prints taken from her own skin and that of a male friend, presented as if they were to be scientifically analysed. The drawings at the heart of each work show the areas of the body from which the prints were taken.

Clark's career began during the second wave of feminism. She has described her mixed media work as an investigation into the nature of taboo, particularly in relation to women. Her exhibition *Judy Clark Issues* held at Garage Art Ltd in London in 1973, focusing on bodily traces, fluids and

Judy Clark
Catalogue [female symbol]
3 Skin, 1973
Drawing on acrylic
38.7 × 46.4 (15¼ × 18¼)
Purchased 1973

functions, included the pieces *Bedroom rite/Stains, Menstruating, Ejaculations* and *Bed site/Skin deposits*. Clark's work is in sympathy with other feminist work of the period, such as Judy Chicago's *Menstruation bathroom* and *The Post-Partum Document* by Mary Kelly. It also pre-empted a significant strand of art by a later generation of women such as Tracey Emin, who has exhibited a dirty, cluttered bed, and stained appliqué blankets.

Clark trained at Portsmouth Polytechnic, and then at the Slade. She has lectured at a number of art colleges and has also worked as a designer of interiors and textiles, and as an arts administrator.

HANNAH COLLINS
born 1956

In 1993 Hannah Collins was nominated for the Turner Prize. She trained at the Slade, and, living in London, began to make drawings about city spaces. Her 1981 exhibition at Birmingham's Ikon Gallery was prefaced with a quote from Charles Dickens's *Little Dorrit* (London 1857), one of his fantastically evocative descriptions of a 'gloomy, close and stale' evening in the capital.

Collins began to make photographs of landscapes and interiors, working on a large scale (sometimes each image is wall-size) so that her pictures seem almost like paintings, or, when installed

Hannah Collins
In the Course of Time II, 1994
Photograph on paper mounted on muslin image
262.4 × 586 (103¼ × 230½)
Purchased 1995

free-standing, like stage flats, and envelop the viewer in their atmosphere. Collins initially worked only in black and white, sometimes adding text. The piece *Thin Protective Coverings* was first made in 1986. It is a picture of what looks like a makeshift shelter lined with cardboard (which Collins had seen along the Thames Embankment). Collins superimposed enigmatic writing such as 'Things covered and emptied', but re-worked the image the following year, finding that removing the words heightened, rather than diminished, the eerie bleakness.

Like Rachel Whiteread, Collins has made use of domestic space and furniture in her work. The lone woman *Violin Player* (1988) is in a room full of mattresses. And she has made sensual images of food, such as the pile of opened oysters in *Plural/wet* (1992).

Collins has worked in the Sahara Desert and Istanbul. Having recently introduced colour into her photographs, she has pictured India (citing as an influence the film-maker Satyajit Rai), juxtaposing images of the urban poor with glittering sequinned and embroidered fabrics. Collins has also photographed the roof tops and shop windows of Barcelona. Her work stills a moving world.

JEAN ESME COOKE
born 1927

Jean Cooke trained at the Central School of Arts and Crafts, Camberwell, Goldsmiths College, and then at the Royal College of Art under Carel Weight and Ruskin Spear (she later taught there). Her first solo show was held at the Establishment Club, London in 1963. In 1971 she shared a show with Olwyn Bowey at the New Grafton Gallery, and has exhibited at the Royal Academy – becoming an Associate and Member – and with the London Group. Although primarily known as a painter, she is also a sculptor and potter.

Cooke was married to the artist John Bratby for a number of years, a fellow figurative realist painter of what came to be labelled the Kitchen Sink school. The artists of this group pictured the mundane surroundings of everyday life, and sitters in ordinary dress. Cooke has often painted her environment, although this extends out to include her garden, and seascapes at Sussex. She also became known as a portraitist. Her 1955 painting of a bespectacled Bratby, sitting by a table covered with checked cloth with a cat at his feet, is in the collection of the Royal Academy.

Self-portraits are a considerable part of Cooke's work. In *Blast Boadicea* (1967,

Jean Esme Cooke
Self-Portrait, 1958
Oil on canvas
114.9 × 83.8 (45¼ × 33)
Presented by the Trustees of
the Chantrey Bequest 1959

Royal Academy) Cooke sits by her easel. In *Snow and Icons*, exhibited at her joint exhibition with Diana Cumming at the Woodland Art Gallery, Greenwich, in 1976 Cooke poses, brush in hand, dressed in a heavy coat and fur hat reminiscent of those worn by van Gogh in his self-portraits of the late 1880s, a reference which pays homage, but also places herself as an artist in his august company. In 1996, along with Maggi Hambling, Cooke was included in the exhibition *In the Looking Glass, An Exhibition of Contemporary Self-Portraits by Women*, held at the Usher Gallery, Lincoln.

DOROTHY CROSS
born 1956

The exhibition *Irish Art Now: From the Poetic to the Political* that toured America and Canada in 1999–2001 (beginning at the McMullen Museum of Art, Boston), included work by Dorothy Cross, who uses a mix of media and methods from video to taxidermy. In her work familiar objects (a Bible, a bridal train, a Guinness bottle) metamorphose; covered with cow hide, they sprout udders. While Cross may summon up the clichéd vision of 'the old country', all beer, religion and rural idyll, she actively engages in new cultural life there. She sat on the committee of the Irish Exhibition of Living Art during the 1980s (the organisation that Evie Hone had helped to found), and her work is in the collection of the Irish Museum of Modern Art, Dublin.

Cross draws on early twentieth-century Surrealism. Her work can be linked to that of Meret Oppenheim, whose *Object (Fur Breakfast)* (1936) is a teacup, saucer and spoon covered in fur. Cross made a teacup the focus of her video piece, *Storm in a Tea Cup* (1997). Oppenheim's shockingly sensual use of fur has its parallel in Cross's cow hides, although Cross takes the game of

Dorothy Cross
Virgin Shroud, 1993
Cowhide, muslin, silk, satin and metal stand
210 × 81 × 120 (79⅛ × 31⅞ × 47¼)
Presented by the Patrons of New Art (Special Purchase Fund) through the Tate Gallery Foundation 1995

suggestive ambiguity one step further with her use of udders. These symbolise female fecundity, but in Cross's work they appear stiff and swollen, and are also suggestively phallic. Cross was included in the exhibition *Fetishism*, that toured from London's South Bank Centre in 1995. She has made art in which stuffed snakes appear, sometimes

wrapped in bandages. These may represent a contemporary crisis in masculinity, and are both humorous and monstrous.

During a career that began as a student at Leicester Polytechnic and the San Francisco Art Institute, Cross has combined fine art practice with theatre design and teaching.

HANNAH DARBOVEN
born 1941

The weight of history preoccupies the German artist Hannah Darboven. Her subject is poignant and pertinent, given her country's troubled twentieth century, which encompassed two conflicts, the formation and destruction of a fascist regime, division and subsequent reunification.

In the 1960s Darboven lived in New

York where she met the conceptual artists Sol LeWitt and Carl Andre, and began to make diaries and notes. Darboven covers page after page with text that make manifest the passage of time (she has made work about Gertrude Stein and been likened to the writer in her experimental use of text). The word *Heute* (today) appears with

a line through it, registering the remorseless succession of the days. Despite the rigorous order of Darboven's notes they are impenetrable. She has invented her own mysterious system of notation, and fills many pages with meaningless scrawl. The difficulty of engaging with her work – it can't be 'read' as writing, but seems to suggest

that it should be read rather than 'viewed' – forces us to question our approach to interpretation. Darboven trained as a musician and also composes using a mathematical system, as Bach did. In 1997 she exhibited her drawings with those of the composer John Cage at the Staatsgalerie Moderner Kunst, Munich.

The statesman Otto von Bismarck, the writers Virginia Woolf and Jean-Paul Sartre, the artist Kurt Schwitters and the film director Rainer Maria Fassbinder have all figured in Darboven's art. The pages of notes in *Für Rainer Maria Fassbinder* (1982–3) are interspersed with photographs and postcards. There is a picture of a zeppelin, a woman in folk costume, and Goering inspecting German troops. A portrait photograph of a man in Nazi

Hannah Darboven
Card Index: Filing Cabinet, Part 2, 1975
Mixed media, drawing and paper on board
each 188 × 221 (74 × 87)
Purchased 1982

uniform appears repeatedly. Darboven plays upon our fascination with Hitler's ruthlessly bureaucratic regime (for example lists were made recording the progress of the persecuted to the death camps). 'Read' in the light of history, the banal-looking *Card Index: Filing Cabinet, Part 2* could hold sway over life and death.

CATHY DE MONCHAUX
born 1960

Cathy de Monchaux's wall and floor installations make use of suggestive imagery, all curving, parting folds, that appear as vaginal as one of Judy Chicago's place-settings for *The Dinner Party* (1979), albeit with a nasty twist – the vulval forms often peter out into sharp metal spikes – in place of the celebratory atmosphere. De Monchaux's materials are a marriage of opposites; elegant black ribbons and butch buckles and straps, velvet and muslin and leather and denim. Fabric can be delicately ruched, or brutally pierced with bolts, shiny brass contrasts with rusty steel.

De Monchaux has said: 'I don't think it's possible to work from a woman's perspective in terms of the way the world has been ordered. You have to find a way of dealing with that, or of inventing an alternative to that male perspective.'[20] She can be seen as part of a feminist move to reconfigure

sexuality and the female body for women. There is a sense of a subtle take on psychoanalytic accounts of sexuality, one of the greatest influences upon 'the way the world has been ordered'. Instead of Freud's phallic symbol of power, we look at row upon row of forms that at first appear explicitly feminine, but which, despite being rendered in loving detail, are difficult to categorise. They seem contradictory, hard where they should be soft, insistent when they should be acquiescent. It is as if de Monchaux has moved on from constraining binary definitions of sexuality, charting instead a more fluid sensual terrain, whose liberties are seductive and also dangerous.

De Monchaux has been influenced by Marcel Duchamp, making reference to him in titles such as *Once upon a fuck, once upon a Duchamp, once upon a lifetime* (1992). In 1995 she was chosen

along with Helen Chadwick and Cornelia Parker to represent Britain at the São Paulo Biennale in the exhibition *Something the Matter*. In the catalogue essay, critic Louisa Buck related de Monchaux's work to the writer Georges Bataille's definition of eroticism as 'a breaking down of established patterns'. Boundaries, and the possibility of pushing through and opening them up, is an identifiable theme in a number of de Monchaux's works. In *Defying death I ran away to the fucking circus* (1991) padded red velvet doors appear to usher you inside. While at the centre of *Wandering about in the future, looking forward to the past* (1994) a long pink leather slit is clamped shut with ribbons and rivets, suggesting that it is longing to yawn open.

Like several of de Monchaux's works *Once upon a fuck* looks like a decorative ladies collar (her preparatory drawings look like designs for lace).

Cathy de Monchaux
Wandering about in the future, looking forward to the past, 1994
Mixed media
357 × 800 × 8 (144½ × 315 × 3⅛)
Purchased 1994

But it is made out of metal plates bolted together, with fabric pressed tightly between them. The crushed material could be interpreted as a visual metaphor for the constraints of social conventions and physical restrictions suffered by women historically, particularly during the Victorian period. De Monchaux is fascinated by the Brontë sisters, and their exploration, in their writing, of the division between femininity as prescribed by their time, and femininity as they imagined it. The exquisite, almost obsessive craftsmanship of de Monchaux's work (and her odd collection of media) also recalls the leisure pastimes ladies were encouraged to pursue in the past, making painstaking decorative art works out of materials such as cut paper and human hair.

Recently de Monchaux has begun to use photographs in her work. Looking at *Assuaging doubt through others' eyes* (1997) entails peeping voyeuristically through narrow slits at a series of fifty small images that appear at first to be erotic photographs of wet, swollen forms, but they are actually pictures of a market full of flowers, fish and vegetables. De Monchaux is taking part in a game played by other women artists, from Georgia O'Keefe's early twentieth-century part-views of flowers, all protruding stamens and curling petals, to Helen Chadwick's *Bad Blooms* as the century neared its close. In *Fretting around on the brink of indolence* (1998), a row of light box photographs of a lush landscape is interrupted by an elaborate vaginal form, with multiple ripples of fabric echoing off it.

De Monchaux has written: 'Historically, as a female, one has been culturally conditioned to experience desire from the male perspective. I think that is true at least for someone my age. Maybe for a woman twenty years younger, something else is taking place. I hope so.'[21] She was nominated for the Turner prize in 1998.

TACITA DEAN
born 1965

In 1994 Tacita Dean made a film, *The Matryrdom of St Agatha* (in several parts), with Lucy Gunning in the cast. The starting point was the myths surrounding a female saint and her relics. *Girl Stowaway* (also 1994) developed from documents about a woman who travelled from Australia to England hiding in the hold of a ship. Dean's art tells stories which tail off into nothingness she shows us mysterious fragments, shadowy figures, and places haunted by their past.

Dean trained at Falmouth School of Art, the Supreme School of Fine Art, Athens, and in London at the Slade. Her early work took the form of narrative drawings in the storyboard format used to plan movies. She then moved on to film-making, as subject matter and form of practice. In the video and sound installation *Foley Artist* (1996, Tate) she reveals the hidden people who provide 'natural' sounds (footsteps, kissing) for films at the post-production stage. But she also revels in the romance of film, making stories about journeys – geographical and interior. The melancholic film *Disappearance at Sea* (1996, Tate) drew upon the story of the yachtsman Donald Crowhurst, who was lost at sea. Mesmerising images of a lighthouse lamp, and of the darkening ocean, blend with a soundtrack of waves and birds. In the audio piece *Trying to Find the Spiral Jetty* (1997), Dean recorded a scripted account of her attempt to locate Robert Smithson's Utah earth-work. Dean invoked the history of art's interaction with the landscape, and also represented herself following in the footsteps of an acclaimed artist.

Dean's images of obsolete structures, as in the filmed *Sound Mirrors* (1999) of Denge in Kent, are reminiscent of the art of Bernd and Hilla Becher. The film *Fernsehturm* (2001, Tate) was made in a revolving restaurant in Berlin, the passage of time signalled by the shifting light. The slowly turning building can be interpreted both as a memorial to sixties optimism about the space age and a metaphor for movement on a grander scale, that of the planets. Dean's exhibitions include the group show *Voice Over: Sound and Vision in Contemporary Art* at the Arnolfini Gallery, Bristol in 1998, and *Tacita Dean: Recent films and other works* at Tate Britain in 2001. She was nominated for the Turner Prize in 1998.

Tacita Dean
Fernsehturm, 2001
16mm colour anamorphic film with optical sound,
44 minutes
Purchased 2002

RINEKE DIJKSTRA
born 1959

The photographer and video artist
Rineke Dijkstra was born in the
Netherlands and trained at the Gerrit
Rietvald Academie in Amsterdam.
She worked as a portrait photographer
in the early 1990s before
developing her fine art practice.

From 1992 to 1996 Dijkstra worked
on the *Beaches* series, travelling around
the world – to Belgium, Croatia,
England, Poland, the Ukraine and the
USA – to take photographs of adolescents
alone by the sea. Tate owns three of
these images, in which there is a
fascinating interplay between
documentary photography (Dijkstra
cites Diane Arbus as an influence) and
a sense that the careful composition
of each piece is informed by both
Dijkstra's knowledge of art history and
the young person's desire to be seen in
a certain way. Some of these images
capture the poignant transition from
girlhood to womanhood. In *De Panne,
Belgium, August 7 1992* (1992, Tate)
the feeling of leaving the past behind
is underlined by the girl's bathing
costume, a stripy, high-necked affair
that seems to belong to a child from
an earlier era. Dijkstra has also made
a series of photographs of women soon
after giving birth. They are part of a
long history of mother-and-child images
in art, but their focus on the reality
(physical and emotional) of the
experience means that they particularly
echo the work of women artists on
motherhood (from Mary Cassatt to
Mary Kelly).

Dijkstra's work has been seen in the
group exhibitions *I am a Camera* at the
Saatchi Gallery in 2001 (with Cindy
Sherman, Sarah Lucas and Nan Goldin
among others), and *The Beach*, at
Vero Beach, Windsor, USA, in 2002

Rineke Dijkstra
Tecla, Amsterdam, Netherlands, May 16 1994, 1994
Photograph on paper, print
117.5 × 94.5 (46¼ × 37¼)
Purchased 1998

(alongside artists including David
Hockney, Wolfgang Tillmans and
Tracey Emin). She had a solo show
at The Photographers' Gallery, London
in 1997, and exhibited at the 49th
Venice Biennale in 2001. Recently,
Dijkstra has photographed young
soldiers in the Israeli army and the
French foreign legion, picturing them
during their training, a rite of passage
into a new life.

RITA DONAGH
born 1939

In Rita Donagh's paintings the personal and political are united, and the conventional skills of carefully measured figuration are brought together with mass media images and materials.

Donagh trained at the University of Durham and has taught at a number of art colleges including the Slade. In a self-portrait of 1994, *Slade*, she plays upon the school's long-held reputation as a bastion of traditional painting and drawing, emphatically inserting herself, a woman artist with palette, smock and intense gaze, into this distinguished history. To one side of Donagh's self-portrait is a patchwork quilt, rendered flat, so that it appears almost to be an abstract, geometric image. The quilt refers to Donagh's history, particularly her female antecedents (it was found in her mother's birthplace). It appears again in *Counterpane* (1987–8), veiling the outline of the victim of a terrorist bombing, although its rolls and peaks can also be read as mountains rearing up from the outline of the Irish coast.

In some of Donagh's works plans of the notorious Maze prison buildings known as 'H Blocks' materialise high over the Irish landscape, while in others key political players disintegrate into the pixillations of a media image. Her work on political geography and topography (an echo of work of artists

Rita Donagh
Counterpane, 1987–8
Oil on canvas
152 × 152 (59⅞ × 59⅞)
Purchased 1990

involved in the first flush of landscape art in the eighteenth century, a number of whom tutored some of the earliest Tate woman artists) was seen in the exhibition *Language, cartographie, et pouvoir* (Language, mapping and power) held at the Orchard Gallery, Londonderry, in 1996. Donagh's 'map' drawings and paintings blur borders, messing up any sense of a clearly defined terrain, and *Map of Ireland* (1980) is now in the collection of the Imperial War Museum. A retrospective toured from the Cornerhouse, Manchester in 1994–5.

MARLENE DUMAS
born 1953

In 'Women and Painting', published in a collection of her writings, *Sweet Nothings* (Amsterdam 1998), Marlene Dumas declared:

> I paint because I am a dirty woman.
> (Painting is a messy business.)

It cannot ever be a pure conceptual medium. The more 'conceptual' or cleaner the art, the more the head can be separated from the body, and the more the labour can be done by others. Painting is the only manual labour I do.

Looking at her often explicit oil paintings and ink drawings of male and female nudes it seems that her 'messy business' has been chosen to conjure up the tangle of desire, disgust, pleasure and fear that centres on such images.

Photographs of figures in fashion magazines and pornography are the source material for much of Dumas's work. Walking around her exhibition *MD: Marlene Dumas*, held at the Camden Arts Centre in 2000, there appeared to be a tension between the subject matter and the effect of Dumas's media and technique. In one of the most provocative paintings, *Miss Pompadour* (1999, private collection), a naked woman bends over, presenting her backside, while looking back at the viewer. Although the pose indicates that the model should be completely exposed, Dumas's bleeding, washy paint actually veils as much as it describes, and draws attention to its own physical presence instead. Languishing between the positions of sexual voyeur, art gallery audience, or perhaps even identifying with the figure, the viewer's stock reactions are stymied. It is a measure of Dumas's subtlety that her art has a pleasurable quality that belies both the complexity of looking at it, and the sometimes 'in your face' postures of her models.

Early in her career Dumas made a series of eight drawings of the female nude, *Defining the negative* (1988), whose theme was the difficulty of representing the subject for a woman. Dumas made her criticism of the work of some male artists clear in the statements she jotted on them, 'I won't pose for Mr Salle' and 'I won't eat off Mr Allen Jones' table'. While sexual display is also a key subject in Dumas's art, she puts different strategies into play. Her series of paintings of the male nude in a state of arousal, the oil *10 inch* and the ink and acrylic *Stream* (both shown at her 1999 exhibition *MD-Light* at London's Frith Street Gallery) redressed the balance, addressing desires other than those of the heterosexual male. Gender politics also informed Dumas's decision to paint, not a portrait of the celebrated founder of psychoanalysis, Sigmund Freud, but *Martha – Sigmund's Wife*

Marlene Dumas
Lead White, 1997
Oil on canvas
200.4 × 100.2 × 2.7 (78⁷/₈ × 39⁷/₈ × 1¹/₈)
Purchased 1998

(1984, Stedelijk Museum, Amsterdam), the overlooked female figure from history. The artist takes issue with and disrupts the sexual divisions set up in much cultural, social and scientific discourse; as she puts it, during the nineteenth century 'madness took on a female nature: woman = irrationality, silence, nature and body; man = reason, discourse, culture and mind'. [22]

Dumas's paintings of children are also unsettling. *The Painter*, of 1994, depicts her young daughter, Helena, naked, hollow-eyed, and with hands dipped in paint. The demure look of a

little girl is disrupted by her smudged scarlet makeup in *Child with lipstick* of 1992. Two 1994 oil paintings, *Cupid* and *Reinhardt's Daughter*, show an infant bent over on its back, eyes shut, and arms flopping over its head. Although they were developed from photographs of a baby sleeping, the small bodies lying in complete abandon appear to have given themselves up to death. While the first painting depicts a white child, the second is a dark-skinned baby. According to Dominic van den Boogerd in *Marlene Dumas* (van den Boogerd, Bloom, Cassadio, London 2000),

the title *Reinhardt's Daughter* refers to the American artist, Ad Reinhardt, whose black paintings 'approach the vanishing point of colour distinction'. Dumas has brought together the art historical and social resonance of colour.

Racial politics play a significant role in Dumas's work. She is white, and lives in Amsterdam, but was born in Cape Town, South Africa. In large, grid-like drawings, composed out of groups of small ink sketches of single heads, such as the *Black drawings* of 1992 (De Pont Foundation, the Netherlands), she exposes the way in which difference is crucial to our sense of identity. Individual faces are often blurry and indistinct, but when the heads are seen together separate identities become clearer, a visual analogy for the way in which we divide humans up into distinct types. Dumas has made images of famous black women, the performers Billie Holliday and Josephine Baker and the supermodel Naomi Campbell (subject of a series of paintings shown at the Venice Biennale in 1995). The artist has also represented her own identity shaped by images of otherness. In *Marlene, Helena & Billy* of 1993, her head, and that of her daughter, are juxtaposed with Billy Holliday's, in a pattern of portraits.

JENNIFER DURRANT
born 1942

Jennifer Durrant trained at Brighton College of Art and the Slade. From early in her career she admired the work of Henri Matisse and Agnes Martin. On travels to America she saw paintings by Mark Rothko, Morris Louis and Arshile Gorky, and met Clement Greenberg and Helen Frankenthaler. In response to these influences, Durrant developed her abstract painting. Working on large areas of unstretched canvas laid on the floor, she saturated and stained her surfaces with paint, following Frankenthaler's bold and fluent use of the medium. Durrant often blocked out areas with paper stencils before painting. Out of her subtle, although strong rather than delicate, layers of colour grew lyrical, sometimes organic forms. Although some critics have read Durrant's work as symbolic, and she has sometimes spoken of her art as a meditative 'search for self', she has also emphasised the vivid and direct visual pleasure that painting can give in titles such *Red decorative painting* (1978–9) and *Flashing light and dark colours* (1978–83).

Since her first solo exhibition at the University of Surrey in 1975, Durrant has had a series of shows including, in 1987, a retrospective at the Serpentine Gallery. In the exhibition *The Experience of Painting* organised by the South Bank

Jennifer Durrant
Other Cloud Painting, 1978
Acrylic on canvas
216.7 × 313.5 (103 × 123½)
Purchased 1981

Centre and the Laing Art Gallery, Newcastle upon Tyne in 1989, her work was seen alongside that of Gillian Ayres and Bridget Riley, among other artists. Durrant's painting *Arrival*, with its gentle, contemplative orchestration of pale blue, gold-yellow and mauve-grey, was installed below the East window in Lincoln Cathedral in 1990 as part of the exhibition *The Journey: A Search for the Role of Contemporary Art in Religious and Spiritual Life*. More recent works such as the series *Come home by weeping cross* made during the mid-1990s, in which paintings are cut across with skeins of fluid, eloquent, dark paint, have signalled a striking new direction in Durrant's art.

TRACEY EMIN
born 1963

Watching the video *The Interview* (1999), part of Tracey Emin's Turner Prize exhibition in 1999, the viewer is confronted with two versions of the artist. 'Bad Tracey', wearing black and clutching a drink, argues with 'Good Tracey', dressed in sporty, casual clothes. *The Interview* made the artist's distance from her media image clear. 'Bad Tracey' admonishes her 'good' other not to believe stories of her debauchery.

Emin has a reflective distance from her work – work which is too often described as a direct expression of her inner self. She has pointed out that her art is 'all edited, it's all calculated, it's all decided'.[23] What unites Emin's art is not its revelation of the titillating truth about her, but its sustained critical agenda. In the winter of 1993–4 Emin staged what she called *My Major Retrospective* at Jay Jopling's White Cube gallery. In 1994 she self-published a book, *Exploration of a Soul*, a detailed account of her first thirteen years, and in 1995 founded and ran the Tracey Emin Museum, between a hairdressers and a cafe in South London. The solo exhibition, biographical writing detailing struggles on the way to fame, and the museum dedicated to one artist are the forms through which great artists are canonised. But the canon has usually excluded women, so that Emin's relentless insistence on self-representation and promotion is an important intervention. In place of the history of the male artist and his path to greatness, we are given instead the life of a young woman artist writ large, snatches of her story blazing in neon, preserved in small display cases or painstakingly stitched and scrawled across blankets.

The story of Tracey Emin's life gives us one way of interpreting her work, but the story of her artistic influences and alliances suggests other readings.

Tracey Emin
Terribly Wrong, 1997
Monoprint on paper, print
58.2 × 81.1 (22⁷⁄₈ × 31⁷⁄₈)
Presented by the Patrons of New Art (Special Purchase Fund) through the Tate Gallery Foundation 1999

Emin trained at Maidstone School of Art and then at the Royal College of Art. She made figurative and expressive prints and paintings of female nudes, often sexually charged and influenced by Edvard Munch and Egon Schiele. Emin became interested in the potential for women to represent female experience. She admired Frida Kahlo, and developed her knowledge of the history of art and its social and political resonance. After a break following her studentship, Emin began to make art again in 1992. Her new work combined drawing and print-making with video, neon, sewn pieces and a use of everyday objects, locating her within an avant-grade trajectory from Marcel Duchamp to Arte Povera. The expansion of Emin's practice was fuelled by her collaboration with Sarah Lucas. At their shop in East London in 1993 they sold work directly to visitors.

Among the variety of works made by Emin, her appliqué blankets receive the least critical attention. This may be because they are the most subversive aspect of her practice. But it is not their explicitness that is problematic; the media have no difficulty poring over Emin's sexual history. It is their feminist resonance that takes the blankets beyond the critical pale. There are layers of meaning stitched into them, fabrics are combined with text, either written or sewn. Emin's mother and aunt sometimes help her to sew the blankets, and *There's a lot of money in chairs* (1994) makes use of a gift from her grandmother, decorated by Emin with appliqué spelling out 'Thanks Plum' (her grandmother's name). The artist has read from *Exploration of the Soul*, sitting on the chair during a tour of the United States, a performance that emphasised her female relatives' support of her work. Emin sewing in a circle of women evokes a traditional female domestic craft. Quilts were made, sometimes in groups, to mark

life events. Sewing also came to have a strong political and artistic dimension during the late nineteenth and twentieth centuries. Banners adorned with appliqué and embroidery had a key role in political activism. Paraded by the Trade Union movement, they were also made by campaigners for women's suffrage. Other women artists have made used of similar techniques. Sonia Delaunay worked at the interface between fine art and the decorative and domestic when she created her first abstract work, a blanket for her baby son, in 1911. Later, during the second wave of feminism, American artists Miriam Schapiro and Faith Ringgold used appliqué and patchwork quilting.

There is also significance in the surfaces of Emin's blankets. They can be stained or faded, witness to the wear and tear of life. The dirty fabrics have a textual equivalent in the 'dirty' words Emin often uses. By making 'impure' objects from soiled domestic fabrics and appropriating language used to belittle women, Emin exposes the ways in which femininity is defined today in language and in relation to the domestic. This was pushed further in the muck and clutter of *My bed* (1999, Saatchi Collection), a display of the dirty laundry we are supposed to keep hidden. The bed echoed Judy Chicago's *Womanhouse*, made in the early 1970s, whose *Menstruation Bathroom* overflowed with messy sanitary products, and also the history of artists' representations of beds, from van Gogh to Robert Rauschenberg.

For all its serious significance, we shouldn't overlook the sheer sensual pleasure of much of Emin's art. Crawling into the tent covered with names *Everyone I Have Ever Slept With 1963–1995* (Saatchi Collection) is an intimate, engrossing experience. In video pieces she has shown herself slowly dancing to The Doors, wearing a beatific smile (*Crystal Ship*, 1997), and swaying across a beach on horseback wearing a stetson (*Sundown – Riding for a fall*, 1998). Emin's contribution to the group exhibition *Out There* which opened the second White Cube gallery in Hoxton in 2000, a blanket entitled *I think it must have been fear*, appeared delicately beautiful against the gallery wall.

MARY FEDDEN
born 1915

Mary Fedden trained at the Slade in the mid-1930s, and, in a book about her work by Mel Gooding (London 1995) recalled the move from school to art college as 'like going from Hell into Heaven'. At the Slade she studied under the theatre designer Vladimir Polunin, and painted sets for Sadler's Wells.

The war interrupted Fedden's career. She worked in the Land Army, the Women's Royal Voluntary Service, and as a driver for the NAAFI in Europe. She also painted propaganda murals, and designed sets for the London theatre, an important source of morale-boosting entertainment for the city's population. She has described her life at this time as a strange mixture of hard work, fear and hedonism in Mavis Nicholson's *What did you do in the war, mummy?* (London 1995).

Fedden resumed painting in 1946. Her work has remained relatively unchanged: small-scale paintings of domestic still-life, sometimes with flowers, animals and birds, in rich but subtle colour, although there have been

Mary Fedden
The Etching Table, 1971
Oil on canvas
76.2 × 91.7 (30 × 36⅛)
Presented by the Trustees of
the Chantrey Bequest 1991

shifts towards a greater simplicity, and a bold use of black, in more recent years. Her precisely arranged, complex compositions often recall those of Winifred Nicholson, where objects are arranged before a window that opens out onto a land or seascape. Fedden's work as a muralist includes commissions for the Festival of Britain (1951), and Charing Cross and Colindale Hospitals during the 1980s. Since her first exhibition, in 1947 at the Mansard Gallery in Heal's Department Store,

she has exhibited at the Women's International Art Club (becoming Chairman in the late 1950s), the Royal Academy (becoming an Academician in 1992), and with the London Group. Solo exhibitions have been held at the Redfern, the Hamet, and the New Grafton Galleries. But her first retrospective, at the Royal West of England Academy, was not held until 1996. Fedden has also taught, and in 1958 became the first woman painting tutor at the Royal College of Art.

HELEN FRANKENTHALER
born 1928

In the summer of 1952 Helen Frankenthaler took a painting trip to the coast of Nova Scotia with the critic Clement Greenberg. On her return to New York, in one day, she made one of the groundbreaking works of twentieth-century art, the painting *Mountains and Sea* (Collection of the artist, on loan to the National Gallery of Art, Washington, DC). Frankenthaler drew lightly in charcoal on unprimed canvas, and then poured thinned oil paint onto it as it lay on the floor. As the paint soaked into the cotton duck, it stained. It had a translucence similar to watercolour, and, as with watercolour technique, Frankenthaler left some areas bare. Although *Mountains and Sea* summons up a remembered landscape, with its soft greens, pale blues and apricot/pinks, the saturated areas of colour contrasting with unpainted gaps and the uneven pooled and splattered paint means that it constantly evades such a representational reading.

Many critics have agreed that Frankenthaler's stain technique, her emphasis on the purely optical effect of colour, influenced a number of major artists, such as Morris Louis and Kenneth Noland, and presaged a whole new direction in second-generation Abstract Expressionist painting (the 'Color-Field School'). Yet they are less sure about the significance of Frankenthaler's practice as a whole. Too often she is described as a disciple of Jackson Pollock, whose momentary, mid-century epiphany inspired a number of male artists. In fact, although Frankenthaler knew and admired Pollock, she took his discoveries and headed in a different direction. Her stains did not sit on the surface of the canvas like a skin, as Pollock's skeins

Helen Frankenthaler
Door, 1976–9
Lithograph on paper, print
58.1 × 78.1 (22⅞ × 30¾)
Purchased 1980

of paint did. While Frankenthaler's work was bold, risky, explosively energetic, and, like Pollock, she painted using her whole body, covering huge stretches of canvas, her work also had an element of elegant restraint that his did not. She brought a range of cultural knowledge to her art, which her privileged background had given her. And, during her long career, there have been great changes in her work. Frankenthaler swapped oil paint for the new acrylics. Drawing, and random blots and splashes, disappeared from her work in favour of simple abstract coloured shapes and lines. And it is her concentration on colour that most obviously separates her from Pollock. She revels equally in subtle, natural shades and dense floods of rich ravishing hues.

Interpreting Frankenthaler only in terms of colour-field painting means that key aspects of her art are over-looked. Some paintings refer to and re-work Titian, Goya, Chardin and Manet. These acts of homage also position Frankenthaler as the descendant of a long line of masters. And figurative and symbolic elements can be traced in some paintings. While *Mother Goose*

Melody (1959, Virginia Museum of Fine Arts, Richmond) has areas of apparently abstract staining, it also has passages of drawing conjuring up Frankenthaler's experience of being read to as a child with her sisters. *Natural Answer* (1976, Art Gallery of Ontario, Toronto) with its horizontal composition and earth tones is tied to the nineteenth-century American tradition of landscape painting. Titles such as *Holocaust, Red Square, Western Dream, Mount Sinai, Interior,* and *Woman's Decision* suggest real places, events and experiences.

Frankenthaler's critical reception has undoubtedly been coloured by the fact that she is a woman.[24] In 1957 her paintings appeared in *Life* magazine as a backdrop to a portrait photograph of the artist, illustrating the article 'Women Artists in Ascendance: Young Group Reflects Lively Virtues of U.S. Painting'. Frankenthaler, fashionably dressed, sits on one of her paintings, others line the walls behind her. Her work serves as a frame, a decorative setting, for her own striking appearance. In 1960 Frankenthaler and her artist colleagues Grace Hartigan and Joan Mitchell were labelled 'Vocal Girls' in a *Time* magazine article (they were in

their thirties at the time). A photograph of them laughing together at the opening of one of Frankenthaler's solo shows at the Tibor de Nagy Gallery, New York, held in 1957, suggests what an unprecedented force they must have been. Her achievements in the macho American art world of the 1950s and 1960s certainly opened the door for other women artists. Gillian Ayres recalls how she saw Frankenthaler's art 'at the first Paris Biennale in 1959, where she won first prize. I found her work very exciting. As a woman, it was always good to know there was someone as good as her around. She survived being with Greenberg and Motherwell, which can't have been easy. She's a pretty big dame.'[25]

The Tate Collection only houses three works by Frankenthaler, not even the paintings that made her name, but prints (by contrast Morris Louis and Kenneth Noland have three paintings each in the collection). This is not to discount her undoubted importance as a printmaker, evident in the monumental *catalogue raisonné* of her work in this medium (New York 1996). Frankenthaler has also sculpted in welded metal and worked with ceramics, and in 1988 she made a series of twelve exquisite screens. Constructed from metal plates housed within hinged bronze frames, their stunning colours (from ochre and pink to gloomy greens and kingfisher blues) were developed during Frankenthaler's experiments painting with pigments, chemicals and molten wax. Frankenthaler has also designed for the Royal Ballet. Her solo shows include retrospectives touring from the Museum of Modern Art, New York (1989–90) and the National Gallery of Art, Washington DC (1993–4). Frankenthaler represented America at the Venice Biennale in 1966.

ANYA GALLACCIO
born 1963

The group exhibition *Freeze*, curated by Damien Hirst at London's Surrey Docks in 1988, included work by Anya Gallaccio, who trained at Goldsmiths College (Abigail Lane, Sarah Lucas and Fiona Rae also exhibited). Her piece *Waterloo* was a square of dripped and drizzled lead on a warehouse floor, and a bronze cast of a child's jumper. The shapes of both were blurred by the physical properties of the medium. Gallaccio has developed a practice uniting the Minimalist concern with object specificity, with an inventive use of non-traditional materials learnt from Arte Povera.

But Gallaccio has added another twist to art history. She states that her art is made in what she termed in the catalogue for her 1992 installation at London's Institute of Contemporary Arts, 'a very feminine way'. She has shown a carpet of 10,000 roses, *Untitled Roses* (1992), and long strings of gerbera, *Head over Heels* (1995) (art concerned with flowers being an area in which women have conventionally been encouraged to work). She has also made pieces that play upon another supposedly feminine taste: *Stroke* and *Couverture*

Anya Gallaccio
from *Screen*
Broken English
August '91, 1997
Screenprint on paper, print
68 × 88.5 (26¾ × 34⅞)
Purchased 1998

(both 1994) were made with chocolate.

While Gallaccio's installations may initially appear deliciously opulent, they decompose and eventually destroy themselves before our eyes. She has argued that this is part of her specific agenda as a woman artist: whereas men have tended to impose their will on material, she would rather collaborate with it. Gallaccio's recent projects have included a vast installation, *Repens*, for the Compton Verney House Trust. Elegant patterns of mowed and planted areas were created in the grounds of a mansion designed by Robert Adam. As time passes the plants will break out from the clean, curving lines, to leave only chaotic traces of the artist's original work. Gallaccio has published a book on her art, *Chasing Rainbows* (Glasgow 1999). Her installation *Beat*, at Tate Britain's Duveen Galleries in 2002–3, featured a carpet of sugar and the trunks of oak trees, referring to the origins of the gallery (in Henry Tate's sugar business), the landscape painting housed within it, and Britain's history as a colonial power.

NAN GOLDIN
born 1953

Entering the small upstairs room housing Nan Goldin's first solo exhibition in London, *Thanksgiving*, which ran during the winter of 1999–2000 at the White Cube Gallery, the visitor came face to face with photographs pinned floor to ceiling. It looked like a teenager's bedroom. The lack of ceremony surrounding the images (there were no frames, or respectful spaces between them), and their small size, meant that you had to scrutinise them as you would snapshots.

Thanksgiving was made up of photographs taken by Goldin over the previous twenty-five years, a record of the people she knew. She also included some pictures of herself. The fascination of Goldin's work lies partly in its frankness, a candour that appeals to our voyeurism. We see people in intimate situations, crying, talking, drinking, laughing and having sex. Our appetite for biography and confessional autobiography guarantees Goldin an audience for her pictures, and this mode of reading is encouraged by the fact that she has collated them into books. But although the same people appear from time to time, the pictures do not add up to a coherent story about Goldin's characters, or, indeed, about Goldin herself. This is heightened by the fact that the artist often changes her installations as they move from site to site. Why, then, does she create a shifting narrative through an on-going process of editing and rearranging photographs? The replacement of the legible history of a wholesome nuclear family (often the subject of the snapshot) with Goldin's jumbled cast of slipshod outsiders offers a critique of the American dream. Her refusal to allow her pictures to fall into place as a

Nan Goldin
Nan one month after being battered, 1984
Photograph on paper, print
69.5 × 101.5 (27⅜ × 40)
Purchased 1997

chronological, linear autobiography can also be interpreted in terms of the collapse of the idea of fixed, universal truth in postmodern culture.

Goldin began to take pictures in her late teens, and trained at the New England School of Photography and the School of the Museum of Fine Arts, Boston. In 1978 she moved to New York and started to photograph the people she encountered in the city. These images formed the basis of her first major work, a show of approximately seven hundred slides entitled *The Ballad of Sexual Dependency* after a song in Kurt Weill's *Threepenny Opera*, accompanied by a soundtrack of mixed music, from opera to punk. She also published it as a book (New York 1986). Goldin exhibited the *Ballad* in galleries but also at cinemas and film festivals. Her media mixing followed in Andy Warhol's footsteps, and there is a debt to the downbeat, tacky, glamour of Warhol's Factory scene in Goldin's cheap hotel rooms, apartments and bars inhabited by friends, lovers, transvestites and drag queens such as *Misty and Jimmy Paulette in a taxi, NYC* (1991 Tate). The artist made Warhol's influence explicit in her exhibition at the Whitney Museum of American Art, New York, in the winter of 1996–7

(and tour). It was titled *I'll be your mirror*, after a song by Warhol's pop group, The Velvet Underground, that Goldin included on the playlist of her slide show. But Warhol is not the only precursor of her work. The type of seedy areas and people she portrays have been the subject matter of a long line of celebrated male photographers (from Brassai, to Gary Winogrand and Larry Clark), and an even longer list of artists (Degas, Toulouse Lautrec, Picasso et al). Goldin has worked with the Japanese photographer Noboyushi Araki; they toured bars and brothels and collaborated on an exhibition and book, *Tokyo Love* (Tokyo 1994).

Nan one month after being battered of 1984 is possibly Goldin's most striking self-portrait. It shows the artist following an attack by her boyfriend. Goldin carefully co-ordinated her appearance (the subject of endless pages of advice in women's magazines), but used her makeup to highlight, rather than hide, her injuries. The blood filling her eye matches her glossy red lipstick. Along with Helen Chadwick and Dorothy Cross, Goldin was included in the exhibition *Bad Girls* that toured from the Institute of Contemporary Arts, London, in 1993–4. The exhibition located her as part of a younger

generation of women artists who were influenced by feminist work of the 1970s, in that they asserted the political significance of the personal, but rejected the idealism of some earlier feminists and represented dejection, despair and uncertainty. Goldin's slide show of self-portraits *All by myself* of 1994 represented her descent into drug addiction, and the trauma of detoxification. She has also portrayed the decimation caused by Aids. Her photographs of illness and death achieve a stilled reverence that belies the transitory nature of their medium, paper reacting to momentary flashes of light.

Recently Goldin has begun to engage with wider aspects of human history (a photograph of 2000 shows Napoleon's fireplace, on Elba), and natural phenomena. She names as new influences the abstract artists Brice Marden and Agnes Martin. In *Self-portrait on bridge at golden river, Silver hill* (1998) we see her shadow falling across water, but the artist has disappeared from view. Goldin's work was seen in a major retrospective at London's Whitechapel Art Gallery in 2002.

LUCY GUNNING
born 1964

In 1996, video and film artist Lucy Gunning was one of three women among the thirteen artists in *Offside: Contemporary Artists and Football* held at Manchester City Art Gallery. Gunning's video *The Footballers* was filmed in the exhibition space. It showed two women kicking a ball, wearing white clothes that looked like a cross between dresses and doctors' coats (one was also sporting shin pads). Their 'play' brought the beautiful game into the hallowed home of high culture, and also recalled the surprisingly long and often overlooked history of women's football, the femininity of the 'players' being emphasised by their strange football strip.

In much of Gunning's work, women are the focus. In *Climbing Around My Room* (1993), a girl circles a space. Shuffling along shelves, scaling a wardrobe, she loops the loop, only to begin again. The action recalls childhood games, but also invokes a sense of domestic claustrophobia; she cannot break the circuit shaped by the room she occupies. In *The Horse Impressionists* (1994), Gunning tracks down women who mimic horses, and films them snorting, stamping and rearing. Again, the fantastic pleasure of such childhood games is invoked, particularly for girls, who sometimes

Lucy Gunning
The Horse Impressionists, 1994
Video
Presented anonymously 1997

develop an intense love of horses during their teenage years.

In the catalogue of Gunning's exhibition at the Chapter Art Gallery, Cardiff in 1998, curator Denise Riley evaluated her place in contemporary art. Gunning extends a line running from Minimalism's subversion of the monumentality of sculpture through to Bruce Nauman's video works. Riley argued that Gunning's particular contribution lay in addressing the exclusion of the feminine from language (something which she even represents literally – women are often wordless, but can grunt or neigh). Gunning's work explores the gap between the constraints shaping actions, and a wider field of possibility or fantasy. Since graduating from Falmouth School of Art and Goldsmiths, Gunning's art has been seen in a series of solo exhibitions at Matt's Gallery, London, and in the USA.

MAGGI HAMBLING
born 1945

Maggi Hambling was taught by Cedric Morris and Lett Haines in East Anglia, and then trained at Ipswich School of Art, Camberwell School of Arts and Crafts and the Slade. She is primarily a figurative painter, although she has made abstract works and used other media. Her art is redolent with rich colour and she manages both to suggest physical presence and the real world through the strength and weight of her drawing, and to transcend it, often including the imaginary and symbolic in her paintings of people and places.

Keenly aware of her art-historical predecessors, Hambling was a fitting choice as the first Artist in Residence to be appointed by the National Gallery in London in 1980–1. She worked from the collection (making studies after Manet, Matisse, Rubens and Rembrandt among other artists) and also painted a warder, *Mr McDonald* (National Gallery). She wrote on Velázquez for the magazine *Modern Painters* in 1987, her interest in Spanish culture stimulated by a visit to the country ten years earlier. Having watched bull fights, she painted a series of works depicting different stages of the ritual. In one painting a straining rope cuts across the canvas, dragging the body of the beast away. Hambling has referred to the animal in these paintings as a representation of herself, subverting the use of the bull as a symbol of masculine power in the work of Picasso.

Picasso's fascination with the minotaur is likely to have informed Hambling's work on mythical themes. In *Pasiphae and the Bull (Conception of the Minotaur)* (1987, collection Tim Curry), the black bulk of the bull thrown into relief by a hot orange background contrasts with the fragility of the female figure beneath it. In *A Minotaur Surprised while Eating* (which again Hambling has referred to as a self-portrait) the composition, and the unsettling transformation of paint into a bloody trail, are reminiscent of Goya's terrifying *Saturn* (1820–3, Prado, Madrid). In the catalogue foreword of Hambling's exhibition at the Serpentine Gallery in 1987, the writer Marina Warner remarked: 'Hambling, whose first love was the stage, has worn frocks only to perform, cultivated a deep voice, and elected to present herself as masterful ... Not for Hambling the female symbols, transitory materials, ephemeral forms and cyclical rhythms of contemporary women's art; her art exacts recognizably the same discipline and materials and sometimes subject matter – as the tradition practised by Old Masters from Rubens to Picasso. She sees no reason for this not to be female ground.'

Among Hambling's works are powerful portraits of women. Commissioned to paint Professor Dorothy Hodgkin by the National Portrait Gallery in 1985, she portrayed the scientist at her desk, the heavy dark frames of her glasses suggesting her ability to scrutinise and analyse, and her flurry of four hands, all engaged in different activities, a striking visual metaphor for ceaseless intellectual activity. A very different image of femininity is seen in the 1986–7 painting *Gulf Women Prepare for War*. Figures veiled in traditional dark dress wield their weapons in the desert. They are represented as self-contained and threatening, in contrast to the stereotypical images of 'peasant women crying in the streets' that often saturate media coverage of conflicts and were criticised by the journalist and war correspondent Kate Adie.[26]

Hambling donated the painting to the collection of art by women being formed by New Hall, Cambridge University, and her work is also owned by the Imperial War Museum. In *Shop Window, Red Light District, Barcelona* (1985, Calouste Gulbenkian Foundation, Lisbon) we see prostitutes parading themselves as different types of sexual fantasy. Hambling has also made a series of portraits, paintings and bronze sculptures of her lover, the legendary Soho habitué and artists' model, Henrietta Moraes, who died in 1999. Moraes is shown with a can of Special Brew beer, in a fury, and posing with a skull, in works that pay tribute to her exuberance, without glossing over her self-destructiveness.

Hambling is perhaps best known for the series of portraits of Max Wall which she began in 1981 and exhibited at the National Portrait Gallery two years later. *Max Wall and his Image* (1981, Tate) shows the clown and actor (he was an acclaimed Vladimir in Samuel Beckett's *Waiting for Godot*) in the artist's studio. Wall is resting, wearing his trademark heavy boots, the shadows behind him eerily inhabited by the distinctive silhouette of his comic creation, Professor Wallofski. Hambling has spoken of the importance of the clown 'in demonstrating to us the absurdities of life'.[27] Her first oil painting was of a clown, and her work on the subject was seen alongside that of Laura Knight, in the exhibition *Behind the Auguste Mask: an exploration of the Clown Character*, at Brighton's Gardner Centre Gallery in 1985. The darkness at the heart of comedy informed Hambling's paintings about laughter, including *Suicide Laugh* and *Laugh Defying Death* (both 1992).

More recently Hambling has portrayed a writer who made one of his central themes the masks we show to the world and the ambiguity of identity. Commissioned to make a monument to a long-time hero, Oscar Wilde, Hambling produced a series of bronze sculptures, paintings and a statue, a granite sarcophagus from which Wilde rises, and on which the passer-by can sit and imagine conversing with him on the way to London's theatreland. Hambling has also made work about specific locations, painting the skies over Suffolk. Over the past decade her stature has been recognised. In 1991 her first major American exhibition was held at the Yale Center for British Art, and in 1995 she was joint winner of the Jerwood Painting Prize.

Maggi Hambling
Minotaur Surprised while Eating, 1986–7
Oil on canvas
144.8 × 122.2 (57 × 48⅛)
Purchased with assistance from the Friends of the Tate Gallery 1987

ANN HAMILTON
born 1956

After studying textiles at the University of Kansas Ann Hamilton trained in sculpture at Yale University. She has become one of the leading contemporary installation artists. Hamilton's identity as a woman is a major factor in her work, she has said: 'My experience is female. That determines a lot of what I make. But I don't think I'm an essentialist.' [28]

Hamilton has put 'feminine' rituals and women's work at the centre of her practice. A particular kind of ritual, which Hamilton shared with another woman, has been a lasting influence: when she was small, Hamilton remembers, her grandmother would read to her. Now, the literature she admires and draws upon includes the writings of the feminist writer and philosopher Hélène Cixious and the poet and academic Anne Carson. Hamilton has incorporated writing, both texts and whole books, into her art, notably Jorie Graham's poem about Penelope at her loom, referring to both Hamilton's own personal history, and to art history (this figure from Classical myth was an important subject for Angelica Kauffman two centuries earlier), and Angela Carter's retelling of the story of Little Red Riding Hood. The raw materials Hamilton uses are also associated with femininity. In (*mattering*) (1997), billowing silk and bundles of typewriter ribbon were combined with a parade of live peacocks. Embroidery has appeared in a number of works, including (*bounden*) (1997), and (*kaph*) (1998). The fabrication of Hamilton's work often involves a series of tiny, repetitive tasks reminiscent of the craft techniques used by women in the home. And she often works collaboratively to make her installations, orchestrating groups that have included

Ann Hamilton
Mneme, 1994–6
Vinyl record and box
38.7 × 39.4
(15¼ × 15½)
Presented by the artist and Sean Kelly,
New York 1996

her mother, an echo of the tradition of women joining together to make quilts to mark important life events. To heighten the sense of the painstaking delicacy of the processes she uses, Hamilton often includes a lone figure in her installations, engaged in some sort of concentrated activity, such as sewing. These figures represent subject, object and witness, messing up the traditionally clear divisions and relationship between artist/model, art object and spectator.

Hamilton's desire to stimulate all-enveloping sensual responses to her installations in the gallery visitor can also be seen in feminist terms, informed by her awareness of the privileging of sight in much conventional fine art practice, and the transformation of women into spectacular objects. She has said: 'for me it's a question of trying to address some hierarchies and habits that determine how we assign certain perceptions more value or more authority over others.' [29] Hamilton's installation *Mneme*, made at Tate Liverpool in 1994, made use of a series of rooms in the warehouse buildings of the Albert Dock. The first held a glass display case, whose panes were fogged with condensation, preventing you from seeing its contents. Moving forwards, you parted and closed curtains as you went, and then, shuttled up in a lift through the floors towards daylight, where a man stood, turning and re-turning a record by hand. The different sensations, of being unable to see, and then being enclosed in fabric walls, transported in a metal lift, and listening to the record, were intended to stir up and leave a variety of sensory memory traces (hence the title of the work, which derives from the Greek word for memory). The installation de-stabilised the way that space is often pictured in art, as something that can be known and ordered by the artist, a sign of his mastery over the world around him. As curator Judith Nesbit argued, Hamilton, by contrast, has created 'a mode of picturing which is much less susceptible to the logic of diagrams. Hers is an invitation to enter an unframed image of the world – a space not of fixity but of fluidity, an unbounded, inverted perceptual field in which sight is no more important than any other sense.' [30] Hamilton has even sought to

invade our sense of smell: (*kaph*) (1998) includes bourbon whisky.

History and society are also addressed in Hamilton's art. She has said 'there is an absence in American culture of the recognition that our democracy began in slavery'.[31] In some works the text of a book is slowly erased by being burnt out line by line, or blotted out with hand-drawn lines of ink: 'By removing the mechanically produced text and replacing it with the mark of the body, a space was made that became the trace of the thing that's not in the history told in the book.'[32] Hamilton exposes the limits of language, its inability to express experience, and the partiality of the stories it tells. Hamilton is critical of life today in the prosperous West. Her *privation and excesses*, made as part of the Capp Street Project in San Francisco in 1989, was a room whose floor was covered with 750,000 copper pennies. They spread in great swathes before the viewer, and were soaked in honey, which leeched from their edges. Three sheep looked onto the scene, a lonely figure sat, wringing his hands over a hat filled with honey, and there were two pestles and mortars. The symbolism of the grinding drudgery of work and the miserly hoarding of wealth was offset by the sheer pleasure of the heady scent and luscious look of the piece.

In recent years Hamilton has made a number of video pieces, and she has also considered the radical change of returning to painting and drawing. She was included in the group surveys *Double Take: Collective Memory in Current Art* (along with Jenny Holzer and Rachel Whiteread among other artists) at London's Hayward Gallery in 1992, and *Blurring the Boundaries: Installation Art 1969–1996* held at the Museum of Contemporary Art, La Jolla, San Diego, in 1996. She represented America at the 1999 Venice Biennale.

SIOBHAN HAPASKA
born 1963

The Belfast-born sculptor Siobhan Hapaska trained at Middlesex Polytechnic and Goldsmiths College. In the context of art history, the polished forms of her sculptures such as *Land* (1998), shown in the British Council's exhibition *Landscape* in 2000, seem to derive from weathered, organic materials, and are descendants of twentieth-century abstraction. But Hapaska often uses fibreglass, making the viewer think instead of aerodynamic 'high-tech' designs. The weird, inconclusive protuberances that appear to be elbowing their way out of her sculptures even evoke the terrifying liquid-metal metamorphosis that takes place in the film *Terminator 2*. *Land* also looks like an alien planet, studded with still pools and arid air plants. Hapaska herself describes her work as 'lost', and it could be read in this light as representing the human condition as one of spiritual dislocation and desolation, despite our attempts to reach Utopia through technological progress.

The viewer's desire to reach towards some understanding of her work, which

Siobhan Hapaska
from *Screen*
Untitled, 1997
Screenprint on paper, print
55.7 × 88.9
(21⅞ × 35)
Purchased 1998

Hapaska both prompts and prevents, is suggested in some of her titles, such as *Want* and *Hanker* (both 1997). She has even made a holy figure to help us on our interpretative way. Her wax-work *Saint Christopher* (1995) may bless our journey towards understanding, but his legs, worn down to grotesque stumps, are evidence of the cost of taking a trajectory into the unknown. He was shown in Hapaska's exhibition *Saint Christopher's Legless* held at the Institute of Contemporary Arts, London, in 1995–6.

Religion is also 'sent up' in Hapaska's wax-work *The Inquisitor* (1997). A Jesuit priest holds an egg-shaped object that speaks in Latin. Hapaska ridicules the belief that Catholicism could offer anything more than a rhythmic, but redundant, soundtrack to life. The sense of entrapment in a meaningless relationship with the Church is heightened by the presence of another sculpture, *Delirious* (1996) (often shown alongside *The Inquisitor*). Trapped in stocks, like a criminal, this blob-being hums Elvis Presley's 'Love me Tender'. Between the priest with his egg, and the sentimental lump, there can be no real communion.

MONA HATOUM
born 1952

In his catalogue essay for Mona Hatoum's exhibition *The Entire World as a Foreign Land* which filled the Duveen Galleries at the opening of Tate Britain in 2000, the cultural historian and theorist Edward Said wrote: 'No one has put the Palestinian experience in visual terms so austerely and yet so playfully, so compellingly and at the same moment so allusively.' Hatoum's personal history gives us one way of understanding her work, against a backdrop of post-colonial politics. She was exiled from her home in Beirut in the Lebanon when war broke out in 1975. Transplanted suddenly to Britain, she trained at the Byam Shaw and Slade schools of Art. Hatoum found herself in sympathy with a group of artists and critics who had made their identities as the children of immigrants a focus of their work. She has acknowledged the strong influence of one such artist, Rasheed Araeen, upon her, in that he rationalised and theorised issues of otherness. In turn, he recognised Hatoum's importance when he included her (as one of only four women artists) in the exhibition *The Other Story* at the Hayward Gallery in 1989–90.

Maps and boundaries, the idea of home and its disruption or transformation into something unsettling and sinister, are key themes in Hatoum's work. The sculpture *Socle du Monde* (1992–3) turns the world upside down. Reading it as the world's base, rather than as an object sitting on the planet's surface, forces a radical shift of perception, both amusing and alarmingly disorientating. The instability of our sense of location is also materialised in a number of Hatoum's works in which maps figure. The boundaries she traces are fragile, made of iron filings which shift and ripple with regular waves of magnetism (*Continental drift* (2000)), or blocks of

Mona Hatoum
Incommunicado, 1993
Metal cot and wire
126.4 × 57.5 × 93.5 (49¾ × 22⅝ × 35¾)
Purchased with funds provided by the Gytha Trust 1995

olive-oil soap studded with beads (*Present tense* (1996)). The soap refers to the colonial project of stripping other countries of their natural resources in order to satisfy the huge Western appetite for luxury goods, revealing just how much the small details of everyday life are shaped by global politics.

Domestic objects become full of menace in Hatoum's hands, the comfortable and familiar become hazardous and painful to touch. The installation *Homebound* (2000), at first sight a collection of the clutter of everyday life (including a bedstead, a hamster cage, cheese grater, a table and chairs), suddenly crackles and buzzes with electricity. The random, fizzing energy could be read as a metaphor for the tense dynamic of relationships lived out surrounded by such objects, even though there is no representation of actual bodies. Hatoum

has also spoken of a desire to disrupt the idea of cosy domestic femininity: 'I'm destroying the idea that the home is part of this nurturing thing, the idea of the happy housewife . . . I come from a traditional background. Some people, such as my sister, like the smothering aspect of family life, but not me.'[33]

Hatoum's work is part of a long history of women artists engaging in the politics of representation of the female body, from Gwen John and Suzanne Valadon's modernist involvement in representing the female nude as artist, to the later second-wave feminist work of artists such as Carolee Schneemann, Barbara Kruger and Mary Kelly in which the artist's body was used in performance, mass-media methods were hijacked, or the body was represented through its visceral reality. In Under Siege (1982), Hatoum was naked and mud-covered, trapped in a small container. Over my dead body (1988) was a Kruger-esque billboard poster, exhibited on London's South Bank, in which the artist's face was scaled by a model soldier. In Recollection (1995), she covered a floor with balls of

her hair (a material which has also been used by Doris Salcedo), while to make the video projection Corps étranger (Foreign Body) (1994), shown at the 1995 Venice Biennale, Hatoum had an endoscope pushed into her body (an instrument which allows doctors to make internal examinations without surgery). The journey into mouth, vagina and anus and down through the slick tunnels of flesh was recorded and relayed. Hatoum was included as one of a number of contemporary Women Post-Minimalists in the exhibition Sense and Sensibility: Women Artists and Minimalism in the Nineties held at the Museum of Modern Art, New York, in 1994, and was described as following on from Eva Hesse in her transgressive combination of Minimalism's rationality and order with unruly bodily references.

There is a strong sense of the subversion of masculine authority in Hatoum's art. Socle du Monde was a homage to a sculpture by Piero Manzoni of 1961 with the same title, but it was as if Hatoum had submerged his work under her own dense clusters of

writhing, organic-looking, iron filings. In the video piece Measures of Distance (1988), a series of intimate letters in Arabic from the artist's mother were screened in front of photographs of her mother, naked. One of the letters told how Hatoum's father had been angry with her for taking the photographs. His response had been as if, in picturing her mother's body, his daughter had stolen his property (the piece was also, in part, a response to the representation of 'hysterical women crying over dead bodies' in media coverage of the Lebanon).[34] In the sensual and funny Van Gogh's Back (1995) we see a man's wet body hair coaxed into the fervid, spinning whorls that characterised the Dutch artist's painting style.

Hatoum shows us that even at the most intimate level our experience of being in the world is mediated by the wider political environment. She represents the uncertainties, and dangers, of today, particularly for women, with vivid and painful clarity, but also with great formal elegance and wit. In 1995 she was nominated for the Turner Prize.

SUSAN HILLER
born 1942

Looking into the vitrine of Susan Hiller's From the Freud Museum (1992–6, Tate), the eye lights upon rows of carefully crafted brown cardboard boxes, similar to those used by archaeologists to house their finds, containing a mysterious mixture of objects, images and texts. One box holds a pair of china cow creamers lying beneath a photograph of the American outlaw Jennie Metcalf, her demure dress and hat incongruous next to the gun she brandishes. Moving along, the attention is caught by another in which two books on the historical links between Arabs and Jews sit side by side.

From the Freud Museum originated when Susan Hiller was invited to make an installation at the museum in London dedicated to the founder of psychoanalysis. In a vitrine placed in the room that had been Sigmund Freud's bedroom during the last year of his life she placed 23 units, each within a box. Over the following few years the number of boxes reached a total of 50, individually titled and labelled (always displayed in a vitrine), titled From the Freud Museum. In her book After the Freud Museum, Hiller described how her 'starting points were artless, worthless artefacts and materials –

rubbish, discards, fragments, trivia and reproductions'.[35] By inviting us to examine what would usually be categorised as ephemera, unworthy of our attention, Hiller questions the value systems shaping our culture. From the Freud Museum may suggest that 'rubbish' and 'fragments' are, in fact, our collective 'unconscious', as significant as Freud's collection of precious objects. For critic James Clifford, this 'beautiful and unsettling work . . . supplemented Freud's masculine, European world view in a way that firmly prised open that tradition'.[36] But, as with all Hiller's art,

Susan Hiller
From the Freud Museum, 1991–6
Mixed media
220 × 1000 × 60 (86⅝ × 393¾ × 23⅝)
Purchased 1998

there is a refusal of the idea of a single, dominant, 'objective' interpretation; *From the Freud Museum* may be invested with myriad individual meanings by its many viewers, and the artist also included allusions to her earlier works and mementoes in the piece, giving it a personal resonance.[37]

Hiller first became known during the 1970s when, living in London, she developed an innovative artistic practice including group participation works such as *Dream Mapping* (1974); the museological/archival installations *Fragments* (1978), *Enquiries/Inquiries* (1973, 1975) and *Dedicated to the Unknown Artists* (1972/6); and pieces incorporating automatic writing, extra-sensory perception, photomat machines, wallpaper, postcards and other denigrated aspects of popular culture. All Hiller's art has its starting point in existing artefacts from our society. She excavates the overlooked and rejected and holds it up to the light and has cited her previous study of anthropology as a major impact on her art, in addition to Minimalism, Fluxus and aspects of Surrealism.

Three other large installations by Hiller are currently in Tate's Collection. The earliest, *Monument (1980/81)*, incorporates 41 colour photographs of commemorative plaques honouring Londoners who died while trying to rescue others; the photographs are arranged in a diamond-shaped cross pattern behind a park bench with headphones; the visitor may take a seat and listen to the artist's fragmented meditation on death, heroism, immortality, gender and representation. In this way, the visitor participates in the work, and temporarily becomes part of *Monument*, being observed by other visitors. Hiller's use of sound in

Monument was a new development. The intimacy of the artist's voice contrasts strongly with the photographs' picturing death as romantic, heroic and public, and its texture extends and inflects the meaning of the words spoken. On the tape the artist suggests that sound recording has an unacknowledged, uncanny aspect because it allows the dead to speak to us. The plaques photographed by Hiller were also an attempt to guarantee a kind of immortality. But there is a distance between the historical individual and their representation post mortem, as Hiller says on the soundtrack of *Monument*: 'You can think of life after death as a second life which you enter into as a portrait or inscription, and in which you remain longer than you do in your actual living life.'[38]

Belshazzar's Feast/The Writing on your Wall (1983/4) was the first video installation to be acquired by Tate. At its initial exhibition the Duveen Galleries were transformed into an unusually informal space, as audiences sat on the floor. The video programme at the core of this work was broadcast in Britain by Channel 4 in 1986, and the installation itself simulates a live transmission seen on a television set in a living-room. In *Belshazzar's Feast* Hiller investigates the state of reverie sometimes invoked by television viewing; the effects she created in the video programme may induce this state in the viewer, and so the work highlights the powers of human imagination. Like the prophet Daniel, who could interpret but not read the mysterious writing on Belshazzar's wall, the viewer may find that the images and the segmented soundtrack hint at revelation, yet remain

indecipherable. The artist whispers newspaper reports of alien beings seen on blank television screens when broadcasting has ended and sings in an improvisational style, and a child describes from memory the Bible story of Belshazzar's feast as depicted in Rembrandt's painting in the National Gallery. The accompanying visuals are a stream of manipulated images of fire. Shifting colours and shapes stimulate the viewer to sit in contemplation and summon images out of the electronic flames.

Hiller worked on the video installation *An Entertainment* for several years, filming numerous Punch and Judy shows across Britain, and completing the piece in 1990–1.[39] It consists of four cross-edited video projections encompassing the walls of a square room. At the time it was made, video projection was a new tool for artists and Hiller invented ways to achieve frame-perfect synchronisation. She also enlarged the images to a monstrous scale, creating an overwhelming environment of sound and image. Experiencing *An Entertainment* involves being dwarfed by puppets and surrounded by garish comic-book colour and screeching noise. The mythic themes and brutal slapstick comedy at the heart of this popular 'entertainment' for children are condensed and exposed.

Susan Hiller's work has been a great influence on younger British artists and her stature has been recognised by mid-career retrospectives at London's Institute of Contemporary Art (1986) and Tate Liverpool (1996), by numerous solo exhibitions and monographs, and by inclusion in major international group exhibitions.[40]

LUBAINA HIMID

born 1954

Daughter of a Comoran teacher and a Lancashire textile designer, Lubaina Himid was born in Zanzibar, Tanzania. She trained in Theatre Design at Wimbledon School of Art and the Royal College of Art. Painting in clear, vibrant colours, she weaves together stories of voyages, both actual and interior, and histories, both national and personal.

Himid is concerned with the legacy of colonialism and the politics of mapping. The paintings in her exhibition *Beach House* (Wrexham Library and Art Centre and tour, 1995) were of buildings on shores. For Himid, writing in the catalogue, 'The beach house is a site of conflict. Invasion and departure. Lost hope, abandoned lives, decimated civilisations', its role in the slave trade glossed over by the tourist industry. In her catalogue essay, artist Maud Sulter linked Himid's work to Jean Rhys's novel *Wide Sargasso Sea* (London 1966) which reworked Charlotte Brontë's *Jane Eyre* (London 1847) to tell the story of the first Mrs Rochester, the 'mad' woman from the

Lubaina Himid
Between the Two my Heart is Balanced, 1991
Acrylic on canvas
152.4 × 121.9 (60 × 48)
Presented by the Patrons of New Art (Special Purchase Fund) through the Tate Gallery Foundation 1995

colonies. The canvases shown in *Venetian Maps* (Harris Museum and Art Gallery, Preston, 1997) uncovered the African presence in a city that was one of the international centres of trade and culture. The Tate Collection's *Between the two my heart is balanced* is a transcription of a painting by the Victorian artist James Tissot, his white sitters replaced by two black women.

Himid was one of the very few women artists to be included in the

Hayward Gallery's exhibition *The Other Story* (1989–90). Part of a long-overlooked history of black women artists, she has curated exhibitions redressing the balance, among them the shows *Five Black Women Artists* (Africa Centre, London 1983), which included work by Sonia Boyce and Veronica Ryan, and *The Thin Black Line* (Institute of Contemporary Arts, London, 1985). She participated in the 1994 Havana Biennale, Cuba.

JENNY HOLZER

born 1950

Jenny Holzer's texts have been emblazoned across the media of mass-communication, advertising hoardings and electronic display boards, T-shirts and posters. The signs that we read and absorb without even realising become, in Holzer's hands, vehicles for darker messages. She began work in this way because she wanted to reach people in the everyday environment who knew nothing about art. Holzer's focus on language is in tune with post-structuralist theories, uniting art with writing, categorising

both as texts. Her work is also shaped by her experience as a woman. Holzer believes that women have harder lives than men, and have a greater tendency to engage with the real world in their art, because they are more aware of it.

Holzer's *Truisms* are a series of one-liners that appear to be common-sense beliefs, but in fact question our assumptions. Statements such as 'ABUSE OF POWER SHOULD COME AS NO SURPRISE' and 'MURDER HAS ITS SEXUAL SIDE' appeared in New York on t-shirts, posters and a giant

electronic display above Times Square in the late 1970s. They were a powerful intervention by a woman into urban space (Holzer has also collaborated with Lady Pink, one of the few women graffiti artists). The *Living* series of the 1980s was written in a single voice in a more neutral or institutional format. The works were cast as metal plaques or painted like commercial signs. By contrast, her *Inflammatory Essays* of the late 1970s and early 1980s were only to look like fly posters – unofficial, underground rants.

During the 1990s Holzer focused more intently on femininity and language. Using traditional sculptural media she created temple-like installations, giving a monumental gravitas to a specifically female voice. *Mother and Child* (1990) is carved in marble, but reads like a diaristic jotting of a woman's secret fears and desires: 'I AM SULLEN AND THEN FRANTIC WHEN I CANNOT BE WHOLLY IN THE ZONE OF MY INFANT. I AM CONSUMED BY HER.' Taking up her earlier *Truism* 'MURDER HAS ITS SEXUAL SIDE', Holzer developed a multi-media piece in 1993–5 about a woman being raped and killed, in which three voices, those of the perpetrator, victim and observer, all speak as 'I'. It had a heightened resonance in the context of the atrocities in the former Yugoslavia. Holzer represented America at the 1990 Venice Biennale, and was awarded first prize.

DESTROY SUPERABUNDANCE. STARVE THE FLESH, SHAVE THE HAIR, EXPOSE THE BONE, CLARIFY THE MIND, DEFINE THE WILL, RESTRAIN THE SENSES, LEAVE THE FAMILY, FLEE THE CHURCH, KILL THE VERMIN, VOMIT THE HEART, FORGET THE DEAD. LIMIT TIME, FORGO AMUSEMENT, DENY NATURE, REJECT ACQUAINTANCES, DISCARD OBJECTS, FORGET TRUTHS, DISSECT MYTH, STOP MOTION, BLOCK IMPULSE, CHOKE SOBS, SWALLOW CHATTER. SCORN JOY, SCORN TOUCH, SCORN TRAGEDY, SCORN LIBERTY, SCORN CONSTANCY, SCORN HOPE, SCORN EXALTATION, SCORN REPRODUCTION, SCORN VARIETY, SCORN EMBELLISHMENT, SCORN RELEASE, SCORN REST, SCORN SWEETNESS, SCORN LIGHT. IT'S A QUESTION OF FORM AS MUCH AS FUNCTION. IT IS A MATTER OF REVULSION.

Jenny Holzer
from *Inflammatory Essays* [no title] 1979–82
Lithograph on paper, print
43.1 × 43.1 (17 × 17)
Purchased 1983

REBECCA HORN
born 1944

As you look up at Rebecca Horn's *Concert for Anarchy*, a grand piano suspended upside down from the ceiling, it suddenly drops, spilling out its keys with a clash of discordant notes. The piano slowly re-assembles itself, only to repeat the performance. Horn gives objects new life, assembling them in odd combinations, and animating them with motors. Her art develops out of that of Marcel Duchamp and Joseph Beuys in its marriage of objects and performance, and its play on eroticism and sensuality. But Horn's practice is also informed by her awareness of her position as a woman artist. She has even made a 'reply' to Duchamp's famous *The Bride Stripped Bare by her Bachelors Even, (or Large Glass)* (1915–23, Philadelphia Museum of Art). In her *Prussian Bride Machine*

(1985, private collection) the separation and dominance of Duchamp's bachelors is disrupted. Horn includes instead a 'female' group of white, stiletto-heeled shoes. And, unlike Duchamp and Beuys, the things Horn uses to make her work are often beautiful: musical instruments, feathers and butterfly wings.

Horn was born in Germany, and her work has been shaped by the legacy of the Nazi regime. In 1999 in Weimar she made a memorial to those who suffered and died in the concentration camps. Horn's *The colonies of bees undermining the moles' subversive effort through time – Concert for Buchenwald Part 1* and *Part 2* represented terrible loss, mourning and memory with columns of ash, broken musical instruments, a haulage wagon once used in a camp which careered around

driverless, empty beehives, and glass shattered by falling stones. Horn has also made a work dedicated to the victims of the recent conflict in the Balkans. Her *Tower of the Nameless* (1997) was constructed out of ladders and violins in Hanover's Kestner Gesellschaft.

Literary history has been the subject of several of Horn's installations. *Orlando* (1988, Tate) takes as its title the novel by Virginia Woolf in which the hero/ine changes sex over the course of the centuries. While *Mme Bovary – that's me – says G. Flaubert* (1997, Private Collection) consists of a glass case housing a copy of Flaubert's novel about the reckless love affair and suicide of a bored young housewife in provincial France. Flaubert famously identified with Emma Bovary, and the piece represents his struggle to bring

her to life. It is splattered with ink spots, vivid representations of the frustrations and false starts the writer experiences. Next to the book are binoculars, which could be read as symbolising Flaubert's acute powers of observation, and black feathers, which could be another reference to writing (the quill pen) or a reminder of funeral decorations and Emma Bovary's death, one of the most agonised in literary history. Horn exploits the sensuous sheen and delicacy of feathers in many of her works, but she is also aware of their potential menace. *Black Widow* (1988), a bundle of dark feathers, springs open like a trap.

Horn has also made a number of feature films, with actors including Geraldine Chaplin and Donald Sutherland. These show her mechanical objects in motion, sometimes interacting with people. *La Ferdinanda: Sonata for a Medici Villa* (1981) includes a great mechanical fan of white peacock feathers slowly and elegantly unfurling in an empty room. *Buster's Bedroom* (1990), the story of a young woman's visit to the hospital where the movie star Buster Keaton was committed for alcohol abuse, features a wheelchair with the sinister power to pump whisky into its occupant. Some of Horn's machines have even taken over the role of the artist, drawing or painting. *The Little Painting School Performs a Waterfall* (1988) is made up of brushes mounted on metal arms, which regularly dip into cups of acrylic paint, and splatter it onto the gallery wall.

Referring to her mechanised objects as 'melancholic actors performing in solitude',[41] Horn summons up the pathetic aspect of objects that appear to be almost alive, but are trapped in meaningless movement, and of our own alienation in an increasingly mechanised world. Horn has often returned to the subject of the incursion of the technological and scientific into the biological. An early piece, *Overflowing Blood Machine* (1970), featured a naked man encased in lines of plastic tubing

Rebecca Horn
Concert for Anarchy, 1990
Painted wood, metal and electronic components
150 × 106 × 155.5 (59 × 41¾ × 61¼)
Purchased with assistance from the National Art Collections Fund and the Friends of the Tate Gallery 1999

through which red liquid, symbolising his blood, pulsed. And Horn has also linked her own practice as an artist, the magic she works when she transforms innate objects into moving things, with alchemy, by using the raw materials of the alchemist, coal, mercury and sulphur.

When she began her career in the early 1970s (after training at the Hamburg Academy and St Martin's School of Art) Horn was a performance artist. She used props to extend the body's sensory perceptions: long artificial fingers enabled the wearer to touch two walls of a room simultaneously, a 'unicorn' horn worn on the top of the head altered the sense of the body's height, and wings of layered feathers folded over the eyes, or

enveloped the body. Like a number of other women practitioners of the time, Horn was interested in representing the experiencing body, and stimulating senses other than sight, moving away from the representation of the female body as object or spectacle. The body of work she has built since then questions our understanding of our place in the world. Horn's exhibitions have included a retrospective that toured to the Tate from the Guggenheim Museum, New York (1993–5), and a show at the Irish Museum of Modern Art, Dublin (2001). Horn has won a number of international art prizes and exhibited at the Venice Biennale in 1997.

RONI HORN
born 1955

Roni Horn's multi-media work interweaves the conceptual and abstract with the personal. Her art ranges from photographic installations to more conventionally conceived sculptural objects to drawings and books. She uses text, and has taken inspiration from the poetry of Emily Dickinson and Wallace Stevens. In the catalogue essay for her 1993 exhibition *Rare Spellings: Selected Drawings 1985–1992* at the Kunstmuseum Winterthur, Switzerland, critic Dieter Schwarz quoted from Stevens's poem 'An Ordinary Evening in New Haven' as encapsulating Horn's work, a search for direct expression of things, undertaken despite the knowledge that reality is filtered through individual perception:

> The poem of pure reality, untouched
> By trope or deviation, straight to
> the word,
> Straight to the transfixing object,
> to the object
> At the exactest point at which it is
> itself . . .

Horn trained at Yale University. Much of her art has been made in response to her experience of Iceland, including the series of volumes *To Place*, which she has been working on since 1990, and the photographic works *You are the weather* (1994–5) and *Pi* (1998). The title of *Pi* refers to the mathematical constant that is the ratio of the

Roni Horn
Thicket No.2, 1990, reconstrcucted 1999
Aluminium and plastic
11.5 × 66 × 367.7 (4½ × 26 × 144¾)
Presented by Janet Wolfson de Botton 1996

diameter to the circumference of a circle. For Horn, this is a metaphor for the Arctic Circle, which has no real existence outside maps. It only exists, as the constant does, to relate two parts, in this case to relate us to the planet we inhabit. *Pi* is made up of a mixture of images, photographs of the sea, of interiors, portraits, television soapstars and stuffed indigenous animals. The photographs circle the gallery, creating a panorama.

Symbolic of the cycles of nature and the rounds of daily life, *Pi* juxtaposes the real and the fake and plays on the complex relationship between nature and artifice. It also raises questions about our relationship with our environment: Horn is critical of man's abuse of the natural world. In 1999 the Musée d'Art Moderne de la Ville de Paris held a retrospective of her work.

SHIRAZEH HOUSHIARY
born 1955

In 1985 Shirazeh Houshiary's work was shown in an exhibition of what was labelled 'new British sculpture'. *The Poetic Object*, held at the Douglas Hyde Gallery, Dublin, also included Richard Deacon and Anish Kapoor. At the time the three artists were all making their sculptures out of commonplace materials, which they charged with an emotional, spiritual dimension. Writing in the catalogue, Richard Francis drew parallels between their work and that of some modernist writers (the poets W.B. Yeats and William Carlos Williams were quoted) who used juxtapositions of ordinary language (rather than fanciful 'poetic' phrases) to create their poetry.

Houshiary was born in Iran and trained in Britain. She began making sculptures out of clay, straw and wood, before experimenting with welded steel, and then copper, lead, silver, gold and platinum. Houshiary has drawn upon Persian and Sufi sources, such as the writing of the thirteenth-century poet and preacher Julaluddin Rumi, the elegant forms of Arabic calligraphy, and also the intricate geometries of Islamic art. Houshiary was often the only woman to be included under the umbrella of 'new British sculpture'. This meant that, despite the complexity of her work, it was sometimes read as expressing her femininity. In the catalogue for *The Poetic Object*, Richard Francis argued that the arch and bridge forms that appeared in her work suggested a reclining body, and

Shirazeh Houshiary
Veil, 1999
Acrylic and graphite on canvas
190 × 190 (74¾ × 74¾)
Purchased with assistance from Edwin C. Cohen 2001

signified 'a sexuality perhaps denied by the artist'. By contrast, Kapoor's art was judged to be at its most beautiful 'when the vaginal form is subsumed within the masculine' 'mountain' or 'box-like' form.

Over the last few years, Houshiary has been making paintings. They appear, from a distance, to be monochromes. Moving up to them reveals Sufi incantations inscribed minutely and densely in ghostly traces of graphite and pigment. Houshiary was shortlisted for the Turner Prize in 1994. Her work was seen along with that of Agnes Martin (and nine male artists) in the exhibition *Negotiating Rapture*, held at the Chicago Museum of Contemporary Art in 1996.

TESS JARAY
born 1937

From the mid-1980s onwards, painter and printmaker Tess Jaray has taken her complex, rigorously executed abstract art out of the gallery and onto the floors and pavements of public spaces. She designed the paving at London's Victoria Station (1985), Birmingham's Centenary Square (1988) and Wakefield's Cathedral precinct (1991). Her interventions into the urban environment, re-shaping it in line with her own aesthetic project (she pays scrupulous attention to details such as the width of sand between each brick) are a satisfying conclusion to a century which began with women invading city spaces, demonstrating to claim political rights.

Jaray trained at St Martin's School of Art and at the Slade during the 1950s. Her pristine geometric abstract paintings are contextualised by the explosion of such art in the early 1960s (she had her first solo exhibition at the Grabowski Gallery in 1963, in the same venue and year as Pauline Boty's exhibiting debut). They developed out of Jaray's interest both in architecture and Islamic art. In the catalogue for her 1988 Serpentine Gallery exhibition, critic Richard Cork

Tess Jaray
Fifteen, 1969
Oil on canvas
223.5 × 431.8 (88 × 170)
Presented by E.J. Power through the Friends of the
Tate Gallery 1973

noted a fascinating link between Jaray's Islamic-influenced concourse at Victoria and the fact that the Orient Express still departs from that station. Jaray has identified a spiritual dimension in her work, and has said that her patterns 'echo' the mysteries of life. This links her to modernist abstract painting, such as the work of Mondrian, and also to its literature, including the poetry of T.S. Eliot, which Jaray has drawn on for the titles of some of her work.

Although it may seem a big step from two dimensions to the vast stretches of the public works, uniting all of Jaray's art, whether manifested in delicate, muted paint, or brick and stone, is her desire to evoke the rhythms of life through the vitality of her patterns. And some of her work makes obvious reference to natural forms. Her sixteen curve paintings of the early 1980s are like distant reverberations of the remembered forms of cobwebs, leaves, fossils and shells.

KARIN JONZEN
born 1914

In her book about her life and work (London 1976) the sculptor Karin Jonzen recalled: 'My father, seeing my future as a possible Punch cartoonist, packed me off to the Slade School of Art – to my great dismay at the time.' At the Slade she won a scholarship, and then undertook further training in Paris, and at the Royal Academy, Stockholm. She was awarded the Prix de Rome in 1939 (competing against Kenneth

Armitage), and, nine years later, she won the Royal Society of British Sculptors' award for a woman artist (founded by a bequest from Feodora Gleichen).

Jonzen makes figures and busts in terracotta and bronze. Her work may appear conservative next to some twentieth-century sculpture, but she described in her book making a deliberate choice of subject matter and

media as a student. Although Jonzen shared the distaste that a number of her contemporaries felt for what she called 'the white marble bodies of the Victorian era, third hand in conception, being attempts to improve on Roman copies of Greek sculpture', she did not believe that this should make her reject figuration. 'It seemed to me that to turn away from the figure altogether, as my contemporaries were beginning to do,

simply because one did not care for the way it had been handled before, was unthoughtful, akin to turning away from religious feelings simply because of the manner of the priests.' In the catalogue for Jonzen's 1974 exhibition at the Fieldborne Gallery, London, Carel Weight described her as 'one of the small band of important sculptors left in the country who derive their inspiration from the human figure and are strong enough to resist the trend of fashionable art.'

Jonzen won a number of public commissions, in London for the Festival of Britain in 1951 and the Barbican Centre, for the World Health Organisation in New Delhi and Geneva, for Selwyn College Chapel, Cambridge University, and for churches including St Mary-le-Bow, Cheapside, London, and Guildford Cathedral. Her portrait sitters have included Malcolm Muggeridge, Paul Scofield, Max von Sydow and Dame Ninette de Valois.

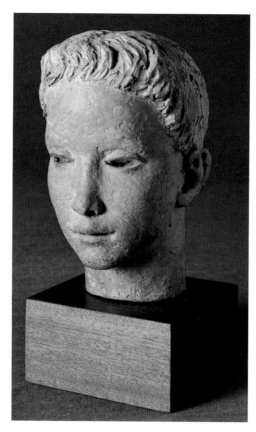

Karin Jonzen
Head of a Youth, c.1947–8
Cast material
16 × 10 × 14 (6¼ × 4 × 5½)
Transferred from the Victoria & Albert Museum 1983

MARY KELLY
born 1941

One of the leading feminist artists, Mary Kelly came to the fore with mixed-media work that explored women's lives. In *Post-Partum Document* (1973–9), Kelly focused on the experience of having a baby son. A section of this six-part work is in the Tate Collection. She juxtaposed the signs and traces of physical existence (stains, moulds taken from the body, pieces of blanket) and the symbolic and cerebral (diaries, medical texts, diagrams, sometimes scribbled over by her child). *Post Partum Document* (1975) skilfully evoked the subtleties of the relationship between Kelly and the infant, fluctuating between intense physical intimacy, and the abstract and intellectual. In a strategic move away from making iconic images of motherhood (such as

those painted by Berthe Morisot and Mary Cassatt), Kelly's piece represented an evolving, and, in some ways, unrepresentable, relationship, refusing the idea that the mother-child bond is simple, instinctive and 'natural'.

Kelly has also focused on female labour in the collaborative installation (with Margaret Harrison and Kay Hunt) *Women at Work* (1973–5, Tate). *Extase* (1986; part of a larger series, *Interim*, of 1984–9) explores the representation of older women, beyond child-bearing age. Kelly was artist in residence at the women's college New Hall, Cambridge University, in 1985–6. She helped New Hall to acquire *Extase*, which led to their formation of a collection of women's art (with work by Mary Fedden, Ghisha Koenig, Tess Jaray, Sylvia Melland,

Cornelia Parker, Kate Whiteford and Laetitia Yhap).

But Kelly does not only explore femininity. Her installation *Mea Culpa* (1999) interrogates our response to reports of political atrocities, and she has also looked specifically at modern masculinity. In *Gloria Patri* (1992) she represented the chasm between images of maleness in military institutions (authoritarian, fearless and strong), and the experience of soldiers. A series of aluminium shields were over-written with male voices, transcriptions of the fragmented memories and fleeting emotions of daily life. In today's conflicted world Kelly's exposure of the fragile humanity behind the armour is much needed.

ASTRID KLEIN
born 1951

The exhibition *Photography in Contemporary German Art: 1960 to the Present*, at the Walker Art Gallery, Minneapolis, in 1992, showed Astrid Klein's work with that of Bernd and Hilla Becher and Hanna Darboven. Photography's popularity among German practitioners now has been influenced by the history of innovation in the field led by the Bauhaus. For artists who have felt the need to engage with the legacy of Naziism, photography is redolent with its role in propaganda, and its significance as historical document.

Klein trained in Cologne. She takes media photographs and alters them, often adding text, creating distinctive black-and-white images. This has an obvious American parallel in the work of Barbara Kruger. But whereas Kruger's work has the stridency of newspaper headlines and advertisements, Klein's art is mysterious and darkly nuanced. Her texts seem to float or ripple across compositions. They appear half-hidden or 'embossed' onto objects. Both artists share a feminist agenda. For Klein, this

is played out in her questioning of photographs as truth. Her exaggeration of technical procedures, so much so that the blurry, grainy pictures sometimes completely stymie interpretation, foreground the fact that photography is a form of representation, rather than a simple reflection of reality.

Klein's work contains a menace that can be linked to German culture. The expressionistic, sinister atmosphere of her images summons up inter-war cinema, particularly the work of the

director Fritz Lang. The shadowy figure in silhouette that often inhabits Klein's compositions is perhaps a descendant of Lang's child-murderer in the film *M* (1931). When Klein does allow clear daylight into her pictures, it is only to reveal the real darkness at the heart of the world. The piece *Marche ou creve* (1980–1) developed from a photograph of four hanged black women. Klein sliced up the image, but the violence she wreaked was only a pale echo of the horrific historical event.

BARBARA KRUGER
born 1945

In 2001 Barbara Kruger had an exhibition at the South London Art Gallery (which Georgiana Macdonald, Lady Burne-Jones had helped to found). Her installation *Power, Pleasure, Desire, Disgust* bombarded the viewer with giant white words on black backgrounds projected onto ceiling, walls and floor, and a cacophony of voices from a succession of faces on screens. The texts and speech seemed to come from characters who either crowed with conceit (and were addressed to 'poor

forgettable you'), or bemoaned their marginality. Kruger portrayed the subject in the style of today's media, the self-congratulatory paeans that are celebrity interviews, and the envy that 'ordinary' people are supposed to have for the 'perfect' bodies and lifestyles of the rich and famous,

Barbara Kruger designed for Condé Nast magazines before she became an artist. The experience of working as a commercial graphic artist spurred her fascination with the power of the

media over consumers, and determined the materials she began to use, collaged photographic images and text. Although the identity of the 'we' and 'you' she has addressed in all of her work is not specified, it often implies a gendered speaker. Thus *Your body is a battleground* is stamped across a woman's face. *We won't play nature to your culture* pictures a reclining woman, leaves placed over her eyelids, blinded by her representation as an object, part of nature, while in *We don't*

need another hero a young girl prods at a boy's flexed bicep.

In an article first published in *Creative Camera* (Summer 1983) Laura Mulvey argued that Kruger's works have 'an immediate, emotional impact. But they can also be taken, more slowly, as a complex comment on the place of scenario and representation in male-dominated relations under patriarchy. She builds on and assumes issues developed by feminist insistence on representation as political and feminist appropriation of psychoanalytic theory as a means of understanding repression.' But, as Mulvey points out, rather than simply critiquing masculinity, Kruger shows us that the status quo can be debilitating for both sexes: 'Patriarchy freezes women into representation and, in doing so, fossilises men.'

Barbara Kruger
Untitled (We Will No Longer Be Seen and Not Heard), 1985
Lithograph on paper, print
each: 52 × 52
(20½ × 20½)
Purchased 1986

MARIA LALIC
born 1952

The painter Maria Lalic took part in the exhibition *Blue: borrowed and new* which inaugurated the New Art Gallery, Walsall in spring 2000. The subject of the show was the use of colour in modern and contemporary art. Lalic's three works were from her *History Painting* series. Working from a Winsor and Newton chart, dividing the invention of different colours into historical periods (from cave painting to the twentieth century), Lalic made monochrome paintings in which all of the colours from each era are painted onto canvas in a succession of glazes, one on top of the other.

Lalic trained at the Central School of Art and Design and the Chelsea School of Art. Her practice developed out of student encounters with the work of American artists, including Agnes Martin and Eva Hesse. She absorbed the Minimalist stricture that the art object should refer only to itself, and

Maria Lalic
History Painting 8 Egyptian. Orpiment, 1995
Oil on canvas
60 × 60 (23⅝ × 23⅝)
Presented by the Patrons of New Art (Special Purchase Fund)
through the Tate Gallery Foundation 1997

also took on board one of the trajectories of avant-garde painting that runs like a thread through the twentieth century, from Matisse's work with colour in the 1910s to the development of duochrome and monochrome painting by Barnett Newman and Ellsworth Kelly (Lalic showed in the exhibition *Mostly Monochrome* at the Green on Red Gallery, Dublin, in 1996). But Lalic has fused these approaches with their polar opposite, the idea of 'history painting'. Her work can be counted as 'history painting' not because it represents events or allegories figuratively, but because it makes concrete the history of the medium, paint, and of the practice of painting itself.

There is more to Lalic's art than rigorous formality. The paint builds up on her canvases like archaeological strata (we can trace the evolution of each canvas in the drips and dribbles on its sides). The colours have their own emotional and psychological charge, intense and ungovernable, and Lalic describes herself as 'ambushed' by them no matter how objective she tries to be. And although her titles are simply lists of the colours used, they can read like rhythmic incantations. The full title of the painting she submitted for the Jerwood Painting Prize in 1997 reads:

> **History Painting 16**
> **Greek. Vermilion**
> **Red Lead**
> **Verdigris**
> **Massicot**
> **White Lead**

ABIGAIL LANE
born 1967

Abigail Lane's work is cheeky, gory and spooky. Since finishing her training at Goldsmiths and showing in Damien Hirst's exhibition *Freeze* (1988), she has papered gallery walls with buttock prints (*Bottom Wallpaper*, 1992) and bloody marks (*Bloody Wallpaper*, 1995). Bodily traces appear in photographs shown at her first solo exhibition *Making History* held at the Karsten Schubert Gallery, London in 1992. Lane is pictured wearing chopines (wooden over-shoes worn during medieval times to protect slippers from street grime), whose soles have been inked up to mark her steps. In the photographs she walks away, leaving marks where she has been.

The trail left by Lane should be an indexical sign, a direct trace or imprint deriving from contact. This type of sign was an important part of second-wave feminist art, used by Mary Kelly in *Post-Partum Document* (1973–9), as it offered a way to signify the body, without offering it up to the viewer's gaze. But Lane does not configure these signs as somehow more truthful. She subverts our expectations by replacing the print of the chopine, which we expect, with a foot print (the base of the chopine is formed into the shape of a bare foot, leaving a 'naturalistic' print,

Abigail Lane
from *Screen*
Dinomouse Sequel
Mutant X, 1997
Screenprint on
paper, print
56.9 × 88.2
(22³⁄₈ × 34³⁄₄)
Purchased 1998

rather than an impression of the sole of a shoe). In common with a number of contemporary artists, Lane plays on Freud's theory of the '*unheimlich*' (the nearest translation being uncanny or unhomely), the ability of the familiar, often the domestic, to be transformed into the unsettling and strange.

With Andy Warhol, Robert Gober and Virgil Marti, Lane's work was shown in the exhibition *Apocalyptic Wallpaper*, at the Wexner Center for the Arts, Ohio in 1997. Colour photographs made in the same year picture people in rooms, the images made uncanny by stuffed wild animals lurking outside their windows and doors. Lane has also drawn on our fascination with detective, supernatural and horror stories. In the installation *The Incident Room* (1993)

the head and arms of a waxwork woman, lit by lamps, emerge from a pile of earth like a corpse at a crime scene. Her solo show at the Institute of Contemporary Arts, London in 1995 invited the visitor to unravel a fictional murder story. At her exhibition at the Victoria Miro Gallery, London, held in the autumn of 2001 Lane exhibited a set of painted film posters for her own unfinished film projects, and a garden shed. Peering inside, you saw a plume of smoke rising from a pair of shoes. It recalled the film *The Wizard of Oz*, a cosy reminder of childhood, but also summoned up horrifying photographs of the charred remains of bodies that supposedly spontaneously combusted.

EILEEN LAWRENCE
born 1946

Eileen Lawrence
Prayer Stick, 1977
Watercolour and mixed media on paper
243.8 × 15.2 (96 × 6)
Presented by the Contemporary Art Society 1979

Writing in the catalogue for Eileen Lawrence's 1992 retrospective at the Usher Art Gallery, Lincoln, critic Sarah Kent noted a change in her art. Lawrence had recently begun to paint in oils (rather than watercolour). She was using more intense colour, and, as Kent described, while the images she used were still about 'evocations of place, and ... references to earlier cultures and belief systems ... instead of ranging the elements in rows, she situates them within a visual narrative. Emphasis has shifted from the consideration of nature to a discussion of culture.'

Lawrence trained at the College of Art in Edinburgh, and her work is now in the Scottish National Gallery of Art there. She began her career painting things she saw or found in the highlands, birds, feathers, eggs, reeds, twigs and shells, on paper she made herself. Her work was included in the Scottish Arts Council exhibition *Inscape* in 1976, which explored poetic meditative responses to the landscape. Lawrence sometimes writes poetry, and her art has been compared to Japanese Haiku verses in its quiet, exquisite precision. Her *Prayer Sticks* are titled after Tibetan prayer sticks, which are raised on the roofs of houses like spiritual signs. Some were installed in Lincoln Cathedral in 1992.

Like a number of women artists, including Nancy Spero, Lawrence began to work with the symbolism and imagery of ancient goddesses. Her shift to looking at cultures reflects a wider feminist concern with how women have been represented. The symbolic resonance of Lawrence's paintings also ties in with Freud's exploration of the role of myth in the psyche, and Lawrence's use of dream imagery and automatic writing (like Louise Bourgeois and Susan Hiller) can be seen in the light of some feminist readings of Freud, arguing that tapping into the suppressed subconscious is analogous to recovering the suppressed voices of women.

LILIANE LIJN
born 1939

Lilian Lijn studied archaeology and art history in Paris where she taught herself to draw, and where her first exhibition was held at La Librairie Anglaise in 1963. Three years later Lijn moved to London. She began to experiment with light and movement, and materials including plastics, acid and fire, and became associated with the Kinetic art movement (she was included in the 1993 Barbican exhibition *The Sixties Art Scene in London* along with Bridget Riley). Lijn's earliest moving mechanisms, *Vibographie Poem Machines* (1962–8), are cylinders or cones covered with excerpts from poems. As they rotate the words seem to make patterns, are read out of sequence, and form new relationships in the mind of the viewer.

Liliane Lijn
Space Displace Koan, 1970
Mixed media
Presented by
Mr and Mrs Louis A. Tanner 1999

Tate also houses Lijn's *Liquid Reflections* (1967–8), which is a 'multiple'. Two perspex balls move randomly on a revolving disc containing a mixture of oil and water. The light playing on the piece and its steady movement are gently hypnotic. Making multiples was part of the project to bring art cheaply to large audiences through mass-production that united a number of artists at this time, among them Lijn's then husband, Takis, and Mary Martin. All three took part in the *Unlimited Multiples* group in 1969.

Lijn wrote in the catalogue: 'When a sculpture is made in a factory and does not depend on the *touch* of the artist for its magic, there is no reason why it should not be produced in unlimited quantities. The only reason for a limited production is a commercial one: scarcity makes precious.'

During the 1980s Lijn's work became explicitly feminist. She combined her industrial materials with 'feminine' materials and methods, such as beads and weaving. She made sculptures of goddesses, and pieces wearable as

head-dresses, which were shown at the Venice Biennale in 1986. Lijn sees these as linked to her earlier work in that they attempt to infuse our technological world with a feminine poetic symbolism. Her essay 'Imagine the Goddess! A rebirth of the female archetype in sculpture' was published in the journal *Leonardo* (1987), and in her autobiography *Crossing Map* (London 1983) she wrote: 'The artist, at all times an outsider, is as a woman an outsider even among artists.'

SARAH LUCAS
born 1962

Sarah Lucas was part of a group of Goldsmiths graduates who revitalised British art in the 1990s. In her work, jokes that seem to be one-liners segue into a serious interrogation of cultural representations of sexuality. Lucas specialises in what has become a staple feature of the tabloid press, innuendo about women's bodies. *Two Fried Eggs and a Kebab* (1992) is an arrangement of foods whose names are slang terms for the breasts and vagina, on a table top. But Lucas de-stabilises the role of the sexes in such humour. Writing in 1905, Freud argued that the smutty joke functioned as a form of exchange between men, enabling them to bond with each other, while, at the same time, excluding and objectifying women. In Lucas's work, a woman is making, rather than just taking, a joke. And, representing the penis as an arrangement of a cucumber and two oranges in *Au naturel* (1994), she plays on the long history of male artists, notably Gauguin and Picasso, representing women as or with fruit.

Photographs are an important part of Lucas's practice. She has made self-portraits, picturing herself with fried eggs laid on her chest, cigarettes hanging from her mouth, standing by women's underwear flapping on a

Sarah Lucas
Pauline Bunny, 1997
Mixed media
95 × 64 × 90 (37⅜ × 25¼ × 35⅜)
Presented by the Patrons of New Art
(Special Purchase Fund) through the
Tate Gallery Foundation 1998

washing line, or wielding a salmon. With her dead-pan stare, heavy boots, jeans, lank hair and no make-up, Lucas resolutely refuses a femininity founded on decoration, in favour of bare-faced aggression and ambiguity.

In *Beyond the Pleasure Principle*, installed at London's Freud Museum in 2000, Lucas played on the psychoanalysts' account of the interdependence of male and female sexuality. Chairs 'wearing' male and female underwear were linked by a long strip-light, symbolising an erection. Lucas's work was tongue in cheek, but, by emphasising the constructed, social nature of Freud's

theories (she used furniture and clothes, not bodies, to represent masculinity and femininity), she exposed them as forms of representation. Joking aside, she has made a series of works featuring limbs protruding from chairs that are unsettling in their fragility and pathos. In the Tate Collection's *Pauline Bunny*, the skinny black-stockinged 'legs' dangle, splayed, in a failed attempt at sexiness. Lucas has also exhibited cakes. Covered with pictures of her work in edible ink, featuring her face, her cigarettes, her toilet, they subverted a most 'feminine' of activities, cake decoration; a punchy commentary on cultural consumerism.

AGNES MARTIN
born 1912

It was not until she was nearly fifty that Martin began to make the work for which she is known, paintings and drawings of grids. She was born in Saskatchewan, Canada, the daughter of Scottish Presbyterian pioneers, and emigrated to America at the age of nineteen. After teacher training she travelled to New Mexico, where she taught and painted. Martin's early work experiments with figuration, surrealism, and abstraction. Settling for a while in Taos, New Mexico (where Brett also lived), she painted her surroundings, as in the watercolour *Landscape-Taos* (1947, Jonson Gallery, University of New Mexico, Albuquerque).

Martin's flat, geometric grids are anti-natural, anti-real. Their refinement and precision was very different to the gestural, effusive work of some of the Abstract Expressionists who were Martin's friends and contemporaries, although she has spoken of her admiration of Mark Rothko and Barnett Newman, and what she sees as their 'revolutionary' and transcendental search for 'an entirely objective reality that may be totally abstract'.[42] But although Martin may seem to have pursued this to clinically calculated extremes, the subtle variations in her work betray the hand of the artist. There are tremulous lapses in pressure and control, and faint irregularities caused by the weave of canvas, or the uneven texture of paper. The small variations in Martin's grids and lines evoke the natural world, in which intricate systems contain endless variety. And it is telling that she chose to quote Gertrude Stein, who was known for her experimental, poetic manipulation of linguistic structures, in the catalogue for one of her earliest exhibitions, at the Betty Parsons Gallery, New York, in 1960 (her first solo show

Agnes Martin
Morning, 1965
Acrylic and pencil
on canvas
182.6 × 181.9 (71⅞ × 71⅝)
Purchased 1974

had been held there in 1958). Stein wrote: 'In which way are stars brighter than they are. When we have come to this decision. We mention many thousands of buds. And when I close my eyes I see them.'

In 1967 Martin left New York. She returned to New Mexico, where she built an adobe house and lived alone. She stopped painting, only picking up her brushes again in 1974, when she was sixty-two. When Martin began to work again, she began to alter her grids. In some, only vertical lines were present, and then, only horizontals. Although she worked on square canvases, the compositions formed by her lines were never quite square, but rectangular, in order to 'destroy' the square's authoritative power. The lines began to vary in size and placement, creating shifting rhythms. Martin also changed media, from oil to a mix of acrylic, gesso, Indian ink and pencil, in shades of grey, but also in modulated white, dark blue and terracotta (she has also used gold leaf, and made a series of *Black paintings*).

As the critic Rosalind Krauss has pointed out in her essay 'Grids'[43] the grid is not just a twentieth-century phenomenon. It manifested itself in nineteenth-century treatises on optics and symbolist paintings of windows. But it became particularly significant in modern art. As well as being the focus of Martin's work, it appears in the art of Carl André, Ad Reinhardt, Mondrian, Jennifer Bartlett, Louise Nevelson, Eva Hesse and Bridget Riley among others. Krauss pointed out that while the grid is an emblem of modernity, it has also been seen by artists as a 'staircase to the Universal': 'The grid's mythic power is that it makes us able to think we are dealing with materialism (or sometimes science, or logic) while at the same time it provides us with a release into belief (or illusion, or fiction).' For Krauss, the fact that the grid holds its components simultaneously together and apart 'allows a contradiction between the values of science and those of belief to maintain themselves within the consciousness of modernism,

or rather its unconscious'. Looking at Martin in art-historical terms, some critics have also seen links between her work and Minimalism, in her use of repetition and creation of non-hierarchical systems. But she has argued that there is a crucial difference in her approach: 'the minimalists are idealists . . . they're non-subjective. They want to minimise *themselves* in favour of the ideal . . . they prefer being absolutely pure . . . But I just can't . . . You see my paintings are not cool.'[44]

Martin adheres to the same project today, using the seemingly implacable structure of the grid to create quiet, subtly inflected, rhythmic meditations. Her colour range has widened to include strong red and blue, and softer shades of yellow, blue and pink. She continues to be influenced by the Chinese philosophy, Taoism, which teaches detachment and humility, and the existence of a transcendental

reality. The titles she uses sometimes suggest a stilled contemplation of the simple and natural – *Grass, Desert Flower, Plum Tree* – and they can be celebratory – *Lovely Life, Happiness-Glee*. Although she is sometimes seen as a reclusive figure, Martin has written and lectured on her work, and has published a collection of her writings (Winterthur 1992). She quotes Wordsworth, the Chinese sage Chuang Tzu, Saint Augustine and Blake, and, in a piece of writing, 'The Untroubled Mind' (produced in collaboration with Ann Wilson), she argues for an artist's need for freedom, in words which still seem surprising when spoken by a woman:

If you live by inspiration
then you do what comes to you
You can't live the moral life,
you have to obey destiny
You can't live the inspired life
and live the conventions
You can't make promises[45]

Critics searching for signs of femininity in Martin's work have suggested that its delicate nuance, and the resemblance of some compositions to pleated, stitched or textured fabric, could be read in this light. Martin prefers to compare her art to music, and sees it as similar to singing.

Betty Parsons helped to establish her reputation early on, but it was not until much later that Martin was given solo exhibitions at museums. Retrospectives have toured from the Stedelijk Museum, Amsterdam (1991–2) and the Whitney Museum of American Art, New York (1992–4). And there is now a permanent gallery devoted to her work at the Harwood Museum at the University of New Mexico, Taos. In 1997 Martin won the Golden Lion for Contribution to Contemporary Art at the Venice Biennale.

DORA MAURER
born 1937

In the winter of 1997–8, the Hungarian artist Dóra Maurer had an exhibition of recent work at the Ludwig Museum, Budapest, which travelled on to the museum dedicated to the early twentieth-century artist and theorist, Josef Albers, in Bottrop, Germany. Her geometric, abstract paintings, in gouache and acrylic, with their precise lines and pared-down palette, grew out of Albers' earlier work on colour theory, developed during his days at the Bauhaus. Maurer has a similar feel for the subtle vibrations that can emanate from the most economical of colour ranges and compositions. She has introduced dynamic elements, diagonals, curves, loops and lines that seem to pulse with rhythm and to play out complex mathematical and spatial calculations.

Dóra Maurer
Seven Foldings, 1975, published 1978
Intaglio print on paper, print
57.8 × 40 (22¾ × 15¾)
Purchased 1985

Maurer worked as an experimental film-maker in the late 1960s and 1970s. This was a period in which post-structuralist theorists proposed that language and representation actually constructed meaning, rather than reflected it, and that interpretation shifted with different readers or viewers. The ramifications of this, an awareness of the political power of representation, infuse Maurer's films. In *Let's look for Dózsa* (1975) she assembled a variety of portraits of a historical figure. The different visions and versions of one man exposed portraiture as fiction, rather than as a record of historical fact. In *Remembering* (1977), alternative versions of the same story were played out, exploring the hypothesis that 'The culture consumer may produce his own versions of the object presented to him.' In her printmaking, Maurer also sought to articulate a process of change, a fundamental aspect of human existence, this time by either cutting into or folding the plate and taking 'phase prints' after each small alteration.

While Maurer's paintings may seem completely divorced from her earlier practice, a single current can be seen to unite them. In the film *Learned Perfunctorily Movements* (1973), the camera focuses on a woman who repeats a series of tiny motions while reading. The commonplace, small gesture is acted and re-enacted, and made the obsessive focus of the artist's scrutiny. Recent paintings by Maurer have been made to occupy built environments, outside and away from the gallery. With similar intent, but using very different methods and media, Maurer has sought to explore the relationship between art and everyday experience.

MARGARET MELLIS
born 1914

As a student at Edinburgh School of Art from 1929 to 1933 Margaret Mellis won two awards. She continued her training in Paris under André Lhôte, making a particular study of colour. There she met the artist Adrian Stokes, whom she married in 1938 and moved with the following year to Little Park Owles, Carbis Bay, near St Ives.

Mellis began to make collages at the suggestion of Ben Nicholson, who had arrived in St Ives with Barbara Hepworth in 1939. *Sobranie Collage* (1942, Tate) is constructed out of a mixture of papers, printed pieces (a tobacco lid and a label for woollen underwear), and pattern drawn by the artist herself. These are arranged in an abstract geometric composition that indicates Mellis's knowledge of modern French art. In the same year Nicholson included her work in the exhibition *New Movements in Art: Contemporary Work in England*, at the Museum of London. Mellis continued her work as a constructivist in reliefs such as *Construction in Wood* (1941, Scottish National Gallery of Modern Art, Edinburgh).

In her work on women in St Ives (published in K. Deepwell (ed.), *Women Artists and Modernism*, Manchester

Margaret Mellis
Number Thirty Five, 1983
Painted wood
54 × 75.5 6 (21¼ × 29¾ × 2⅜)
Purchased 1987

1998), Nedira Yakir characterised Mellis's art as 'explorations of colour, time, space and fragility', from her early collages to her later paintings of flowers such as *Blue Anemone* (1957, Tate), and the driftwood objects she has made since the late 1970s. Venues for Mellis's solo exhibitions have included the Artists' International Association, London (1958), The University of East Anglia, Norwich (1967), and the Redfern Gallery, London (1987). The catalogue essay for her show in 2001 at Austin Desmond Fine Art, London and the Newlyn Art Gallery, Cornwall was written by Damien Hirst, who recalled admiring her work and visiting her studio as a student, and protested at her continuing obscurity, asking 'why hasn't someone noticed Margaret Mellis's contribution to British Art?'

ANNETTE MESSAGER
born 1943

Emerging from the intellectual ferment of 1960s Paris, Annette Messager refused to be confined to conventional fine art media, choosing to work instead with 'bricolage'. Paintings, drawings and photographs were juxtaposed with collected images and objects, often incorporating needlework and knitting, and assembled in albums and boxes. Messager's use of 'feminine' craft-based skills led to criticism that she was defining women's art, derogatorily, as decorative.

Along with artists such as Louise Bourgeois, Kiki Smith and Robert Gober (fellow exhibitors in *Corporal Politics* held at the MIT List Visual Arts Center, Cambridge, Massachusetts, in the winter of 1992–3), Messager has reinvented the representation of the body. Far from perfect and on display, Messager's bodies are fractured, and even sometimes completely absent. In the eighty-six photographs *Les Tortures Voluntaires* (Voluntary Tortures) (1972), she focused on the painful, damaging beauty 'treatments' women undergo. The body has disappeared completely in *Histoire des Robes* (Story of Dresses) (1991). All that remains are garments in glass coffins, conveying the social significance of dress, and also the separation of bodily adornments from the humans who inhabited them. Messager has depicted sexual fantasies in her series *Mes Dessins Secrets* (My Secret Drawings).

Annette Messager
The Pikes, 1992–3
Steel, fabric, glass, paper and mixed media
300 × 800 × 112 (118 × 315 × 44)
Presented by the Patrons of New Art through the
Tate Gallery Foundation 1998

More recently, Messager has shifted her sights to childhood. Her *Effigies* of the late 1980s and 1990s are installations made from discarded toys and clothes. They hauntingly evoke the waste, wear and shedding of past selves that is a part of growing, a far cry from clichéd images of childhood innocence and beauty. *Les Piques* (The Pikes) (1992–3) also incorporates toys, impaled on a forest of poles. Maps behind them plot today's world, lacerated by conflict, a forceful indictment of global politics. Messager's work appeared with that of Louise Bourgeois, Marlene Dumas, Tracey Moffatt, Cindy Sherman and Rosemarie Trockel (among other artists) in the exhibition *Présumés Innocents: L'art contemporain et l'enfance* (Presumed Innocent: Contemporary Art and Childhood) at the Bordeaux Museum of Contemporary Art, in 2000.

LISA MILROY
born 1959

Rows of things, light bulbs, shoes, records and fans, fill Lisa Milroy's early work. She trained at Goldsmiths and was one of a group of artists responsible for the resurgence of painting in Britain. Reacting against the stern figuration of the London School and the influence of American abstraction, a new generation sought to blur the boundaries between realism and abstract and conceptual concerns, sometimes adding doses of levity and sensuality to the mix.

Milroy is fascinated by the stuff of everyday life (as were her influential predecessors such as Edouard Manet). But the satisfying solidity of her paintings does not mean that they can be read as realistic. Her compositions all have in common a complete lack of hierarchy between the objects represented, and they are not shown in natural settings, but against blank backgrounds. They sometimes appear to be lying across the surface of the canvas, or are spaced into constellations, alternating between deep recession and proximity. What always comes to the fore is their paintedness.

In the 1990s Milroy explored new subject matter. A Japanese Geisha smiles down from *Kimono* (1996). *Sky* (1997–8) is a painting of deep blue space and clouds. *Kimono* represents a woman decorated for display and

Lisa Milroy
Shoes, 1985
Oil on canvas
176.5 × 226 (69½ × 89)
Presented by
Charles Saatchi 1992

purchase. She signifies today's consumerism, and also has an art-historical resonance, referring back to the Japanese prints popular in nineteenth-century Paris (both Edouard Manet and Berthe Morisot put prints in portraits, and Milroy has also made the prints themselves her subject matter). *Sky* could be read as a parallel work, concerned with the commodification

of nature in contemporary society, but it is also a painting of emptiness. Having pushed to these extremes, in 2000 Milroy made works explicitly about the practice of painting itself, in a nod perhaps to Philip Guston. These include *Painting a Picture* and also *A Day in the Studio*, which lays out, story-board style, the routine of the artist going about her work.

TRACEY MOFFATT
born 1960

Tracey Moffatt makes allegorical photographs, films and videos. They are symbolic and mythic, but also rooted in reality. Moffatt draws on cinematic conventions. She is influenced by Hollywood films, and her art has some similarities with the work of Cindy Sherman. But

where Sherman presents intimate, staged images of individuals, Moffatt combines artifice (intense or faded colours, dramatic poses, clearly faked sets) with the eye of a documentary film-maker, and an engagement with wider society, picturing groups as well as solo sitters.

Like Sherman, Moffatt has put herself in her pictures. In the group of nine photographs, *Something More* (1989), she appears as an impoverished Asian woman, a stereotype in a sexily torn cheong-sam, who dreams of escape from her rural home, but is

murdered en route to a city (Brisbane). Made in the same year, the film *Night-Cries (A rural tragedy)* represents a fraught relationship between an old woman and her daughter, tied together in frustration and isolation. In *Scarred for life* (1994), photographs and text tell of traumas suffered by children and adolescents.

Moffatt's parents were Aboriginal, but she was adopted by a white couple. She has explored the complexities of Australia's colonial history and post-colonial 'urban Aboriginal culture' in her work. The film *Nice colored girls* (1987) juxtaposes images of young contemporary Aboriginal women out on the town, seducing and stealing from sailors, with the relationship between their ancestors and the colonial invaders. *Up in the sky* (1997), a series of twenty-five stills taken in the outback, is a disturbing dream-like evocation of a bleak, uncertain terrain. But Moffatt also has a sensual, humorous side. To make *Heaven* (1997), she gave video cameras to her female friends

Job Hunt, 1976

After three weeks he still couldn't find a job. His mother said to him, 'maybe you're not good enough'.

Tracey Moffatt
from *Scarred for Life*, Job Hunt, 1976, 1994
Off-set lithographic print on paper, print
80 × 60 (31½ × 23⅝)
Purchased 1998

and asked them to film male surfers undressing. Interviewed in the catalogue for her exhibition at the Centre Cultural de la Fondacion 'la Caixa', Barcelona and the Centre National de la Photographie, Paris (1999–2000) Moffatt said that the piece was 'for all the women in the world who like to "look"'.

ELIZABETH MURRAY
born 1940

In 1995 the painter and printmaker Elizabeth Murray curated an exhibition *Artists Choice: Modern Women*, drawn from the collection of the Museum of Modern Art, in her home city, New York. Murray selected works by women artists including Lee Bontecou, Chryssa, Helen Frankenthaler, Frida Kahlo, Louise Bourgeois, Georgia O'Keeffe, Louise Nevelson, Agnes Martin and Bridget Riley. She explained her motivation in the catalogue. As a student at the Art Institute of Chicago in the late 1950s and 1960s, she wrote, 'I knew of only a few women artists and had no women role models.' This exhibition was to pay tribute to women who had 'opened the door into art-making a little further for us to walk through – they have

Elizabeth Murray
Untitled (Black Cup), 1984
Hand-coloured lithograph on paper
150.4 × 92.1 (59¼ × 36¼)
Purchased 1985

widened our consciousness of what art can be, and who can be an artist, a real artist.' Since her student days Murray has been a close friend of Jennifer Bartlett, who owns some of her work.

Some of Murray's subject matter, her paintings of cups, have been shaped by her experience as a woman. In Mark Rosenthal's article 'The Structured Subject in Contemporary Art' (Philadelphia Museum of Art Bulletin, Fall 1983), Murray is quoted as saying: 'Cup is a specially meaningful symbol for me – it has a hard exterior and a soft interior – it is a container, it is open, it is feminine.' Early work also sometimes referred to the history of modern art. A 1972 painting Madame Cézanne (one of a series) develops some of the formal aspects of Cézanne's work, but also focuses on the woman's experience of modelling for her artist husband. Murray then began to break out of the rigid format of the frame, combining objects, sewn fabric and even bits of furniture with her painted surfaces. Now she paints on irregularly shaped pieces of canvas cut to her own templates, or pieces of wood that overlap and jut out. The paintings look like signs, sliced up, jumbled and reassembled, a kind of visual puzzle vividly evoking the cacophony of the city.

Murray's exhibition at the Pace Wildenstein Gallery, New York in 1999 carried on her exploration of today's raucous but exciting urban visual culture in dazzling concoctions of garish colour.

MARY NEWCOMB
born 1922

Mary Newcomb's work was seen with that of Winifred Nicholson at the exhibition Two Country Painters held at the LYC Museum and Art Gallery, Brampton, Cumberland in 1979. Like Nicholson, Newcomb depicts nature with gentle lyricism. Unlike Nicholson, Newcomb had no formal art training. She studied Natural Sciences at Reading University in the early 1940s, and then worked for the Field Studies Centre, Flatford Mill (in an area known for its associations with John Constable), as an illustrator. Newcomb began to combine farming with painting. Her first solo show took place when she was nearly fifty years old, and a retrospective toured from the Abbot Hall Art Gallery and Museum, Cumbria, in 1996.

Newcomb has a scientist's eye for structure, both natural (plants, insects and animals) and man-made (railings, pylons and bridges). But her work is not entirely realistic. It is, as Ben Nicholson described it, imaginative. And, although her paintings might seem similar to the untutored work of Alfred Wallis, Newcomb's 'simplicity' is deceptive. She plays games with proportion and perspective. Flowers, bordering her field of vision, appear as large as military aircraft in Troops moving in for a spring

Mary Newcomb
People Walking amongst Small Sandhills, 1983
Oil on board
69.5 × 81.1 (27³/₈ × 31⁷/₈)
Presented by the Trustees of the Chantrey Bequest 1997

exercise (1976). While her palette may be pared down, it can also surprise. She does not only paint subtle, tonal English landscape: farm machinery, road signs and municipal flower beds also attract her.

In 1992 an exhibition The Rural Poetry of Three English Women Artists, at the Crane Kalman Gallery, London brought Newcomb and Nicholson together with Mary Potter. Poets she has admired and drawn upon include John Clare, who worked in the eighteenth century, and the twentieth-century Welsh poet R.S. Thomas.

AVIS NEWMAN
born 1946

To make the five canvases for her installation *Figure who no one is . . .* (1983–4) Avis Newman worked from life drawings of female nudes, which she drew and re-drew until she was left with a flurry of marks, scribbles, stains, lines and blotches. During the process both the identity of the figure, and Newman's identity as an artist able to create a coherent vision in her art, dissolved.

Newman's deliberate ambiguity allies her with some feminist work on the politics of representation. In the catalogue for a 1994–5 exhibition at the Saatchi Gallery (where Newman's work was seen alongside that of Paula Rego and John Murphy), critic Sarah Kent quoted Newman saying: 'I'm using the body as a vehicle for discussing boundaries', and that her concern was with 'the body of art, of identification and of knowledge, rather than the physical body'. As Kent points out, Newman's art is in sympathy with Roland Barthes's analysis of images as texts (see his *Image-Music-Text*, London 1977), spaces in which a variety of signs and symbols merge and clash. Psychoanalytic theory also illuminates

Avis Newman
The Day's Residues III, 1982
Drawing on paper
101.5 × 136.2 (40 × 53⅝)
Purchased 1985

Newman's work, and Freud's account of subjectivity as fluid and unstable. The artist referred to Freud in the title of a group of drawings of 1981–2, *The Day's Residues*, in which readable signs half emerge from darkness, echoing Freud's accounts of unconscious desires and fears brought to the surface by psychoanalysis.

Newman's more recent installations have included *Vicious Circle* (1993), representing an emotional loop of hope, desire and despair. Near-black and near-white canvases absorbed or reflected the light, repulsing the viewer's attempts to relate to them.

Books and portfolios on stands seemed to offer an explanation, but their blank pages made reading impossible. In 1995, at an exhibition at the Ikon Gallery, Birmingham, and Camden Arts Centre, London, Newman exhibited a series of paintings, *Webs*, and a group of *Boxes*. In the paintings, broken lines floated in free-fall around a void. The gilt and gesso frames of the boxes suggested that their contents were precious, but inside were feathers, pigment, graphite and pebbles. The installation was a melancholic meditation on the refusal of indifferent media and matter to hold or express meaning for us.

THERESE OULTON
born 1953

Thérèse Oulton, who trained at St Martin's School of Art, and the Royal College of Art in London, came to critical attention during the early 1980s as part of a group of painters concerned with the landscape and the natural world.

In the exhibition *Landscape, Memory and Desire* at the Serpentine Gallery, London (1984–5) Oulton's dark, atmospheric oils were located as part of a British tradition stretching back to the late eighteenth and early nineteenth centuries, to the work of

Thérèse Oulton
Deposition, 1989
Oil on canvas
195.6 × 177.8 (77 × 70)
Purchased 1990

J.M.W. Turner and Francis Danby. Oulton was also described as mining a new and rich seam expressive of female desire by some critics (one of her paintings was titled *Midas Vein*). In a later series of paintings, *Letters to Rose* of 1986, Oulton conjured up an imaginary female correspondent (perhaps drawing on literary history, from Samuel Richardson's fictional eighteenth-century letters sent by Clarissa Harlowe to her friend Anna Howe, to Anne Frank's journal, written during the dark days of the Second World War, addressed 'Dear Kitty'). Oulton's paintings, in which readable forms seemed just out of reach, could be an analogy for an obscured women's history. In 1987 she was nominated for the Turner Prize.

At Marlborough Fine Art, London in 2000, Oulton showed paintings exploring the passage and representation of time. The titles of *Still, Slow Motion* and *Fade-Out* (all 1999), and their format (suggestive of an unfurled strip of images), refer to film. By making us focus on a series of static images, in which we can see each individual 'frame', Oulton reveals the small differences that distinguish each part from the next. They can be viewed in the light of the twentieth-century theorist Walter Benjamin's account of the 'optical unconscious', the ability of the camera to capture what the eye does not notice. Once again Oulton seems to be directing our attention to the power of paint to reveal what is hidden.

ANA MARIA PACHECO
born 1943

After training and teaching at the University of Goias, Brazil, Ana Maria Pacheco was awarded a scholarship to the Slade, where her tutor was the figurative sculptor Reg Butler. Pacheco also works as a painter and printmaker. She portrays men, be-suited and blank-faced, or naked and wounded, stolid, sometimes sinister women, and acrobats, angels and amazing animals, all of whom appear to be acting out games, rituals or stories. Pacheco's representations of male oppressors and torture victims led to her inclusion in the exhibition *Women's Images of Men* alongside Elisabeth Frink at the Institute of Contemporary Art, London, in 1980. But she is also interested in the power play between women, and has drawn upon biblical accounts of Salome and Judith, and the female accomplices who instigated or aided their violence, in her work. The unsettling experience of being among Pacheco's characters, when carved in wood, is heightened by their shiny porcelain teeth and artificial eyes.

Pacheco was the first sculptor and non-European to be given a residency at London's National Gallery. Her exhibition in the winter of 1999–2000 centred on a dramatically lit group of life-size figures carved in wood and painted, entitled *Dark Night of the Soul*.

Ana Maria Pacheco
from *As Proezas de Macunaima*
As Proezas de Macunaima 11, 1996
Drypoint on paper, print
8 × 9.3 (3⅛ × 3¾)
Purchased 1996

The focus of the tableau was a naked man, kneeling, tied to a post, his body pierced with arrows, and a hood over his head. Pacheco takes up the tradition of Baroque Catholic church sculpture (in which broken limbs and wounds are depicted with gruesome realism), and the strain of fantastical Latin American art that developed out of the Spanish influence (the eighteenth-century Brazilian sculptor Alejadinho is an important precursor). These strands are combined with a simplicity of form and expressive strength signalling her knowledge of European modernism.

Pacheco has won international art prizes for her achievements in different media. Her work has been seen in numerous solo exhibitions, and in churches including Winchester Cathedral and St John's Roman Catholic Church, Bath. She has also taught, and was Head of Fine Art at Norwich School of Art for a number of years.

CORNELIA PARKER
born 1956

The collection of debris that makes up *Cold Dark Matter: An Exploded View* (1991) appears to be caught, haphazardly, in mid-air. Looking closer, a careful compositional arrangement is revealed, circling around a single light bulb. Cornelia Parker could be making a metaphor, that this constellation of junk (the remains of an old garden shed filled with jumble-sale bargains, exploded and then reassembled) represents earth's evolution out of the mysterious matter which makes up the universe, brought to life by the sun. Among the swirl of objects is a copy of Marcel Proust's novel *A la recherche du temps perdu* (In Search of Lost Time), a meditation on memory and the passage of time, which suggests another potential reading. Parker is perhaps alluding to the modernist interest in suspending the everyday in a poetic framework, from Proust's quotidian reveries, to the work of Stephane Mallarmé, who turned a lace curtain, observed against the light, into a poem. Parker's beautifully conceived suspension of battered, scarred and charred fragments seems, then, to have a literary provenance. Some of her works have titles borrowed from the writings of T.S. Eliot and Minor White, while for the piece *Words that Define Gravity* (1992) she cast the dictionary definition of 'gravity' in lead, and threw the separate words off the white cliffs of Dover, literally taking apart and transforming the basic components of language. Parker has the alchemical power to turn base matter into art.

Parker's work can be understood in relation to currents in late twentieth-century sculpture. She has some affinity with the group who came to be known as 'New British Sculptors' in the late 1970s and 1980s (including Tony Cragg and Bill Woodrow). Breaking with the sculptural tradition of the monumental and processes such as carving, their work combined conceptual titles with found objects, bringing wider associations of contemporary life and society into play. Also an influence (as with Mona Hatoum) is the Arte Povera artist Piero Manzoni, who used the most economic of means to create works of complex significance, and has a clear parallel in the charged simplicity of Parker's practice.

A fascination with objects, their historical and memorial significance, and the way in which institutions (not only museums, but also social institutions, such as marriage) imbue them with significance, has shaped a long series of Parker's works. Her *Avoided Objects* includes a set of four photographs of the sky from 1999. They seem banal, but they have been taken by a camera in the collections of the Imperial War Museum that was formerly owned by the commandant of Auschwitz concentration camp. Like Susan Hiller and Sarah Lucas, Parker has also worked at the Freud Museum, intervening in a place devoted to celebrating the memory of the father of psychoanalysis (her practice of presenting pieces in vitrines is similar to the strategy sometimes adopted by Hiller, and used influentially by Joseph Beuys). Parker included Freud's furnishings, a distinctive cushion and rug normally preserved in his museum, in an exhibition made in collaboration with the actress Tilda Swinton, *The Maybe*, held at the Serpentine Gallery in 1995. Also on show were an odd collection of seemingly unprepossessing objects, a stocking, a quill pen, a pair of ice skates. If these were anonymous, they would not merit a second look, but the stocking once belonged to Queen Victoria, the pen to Charles Dickens and the skates to Wallis Simpson, giving them a magical power to draw the attention. Parker plays upon our need for secular relics to replace those of religion. But by breaking these objects out of their usual 'frame' (the museum display forming a narrative of a famous life), Parker opens up the possibility for a flood of different associations.

The Maybe included a piece which captured the attention of gallery-goers and the media alike, a glass case in which Swinton lay, apparently asleep. It suggested several possible layers of interpretation. There is the story of Snow White, in which a girl lies in a glass coffin, under an evil spell, and can only be awoken by a prince's kiss. Snow White is a children's story, but also a symbolic tale of female sexual awakening. And by displaying a living woman in a case usually used for museum artefacts, Parker also summons up the history of woman as iconic art object, pleasurable to look at, only to make such an act of looking problematic. Walking around the piece, the fascinating proximity to Swinton was undercut by an unsettling awareness that she might open her eyes.

Parker's exposure and destruction of received functions and meanings has parallels with feminist practice, particularly its critique of social rituals and values. *Wedding ring drawing (circumference of a living room)* (1996) is made out of two gold bands stretched into fine wire. It is a simple, delicate, but succinct meditation on the way in which domestic life and sexual relations are bounded by social conventions, while even the title of *Twenty Years of Tarnish (Wedding Presents)* (1996) suggests that marriage is more to do with wear and decay than dewy-eyed sentiment. *Embryo Firearms* (1995) and *Embryo Money* (1996) relate developing life to the as yet blank metal templates for guns and coins, questioning the attribution of enormous power to objects which begin their lives as lumps of metal. Parker was nominated for the Turner prize in 1997, the year of the first (and only, to date), all-woman shortlist.

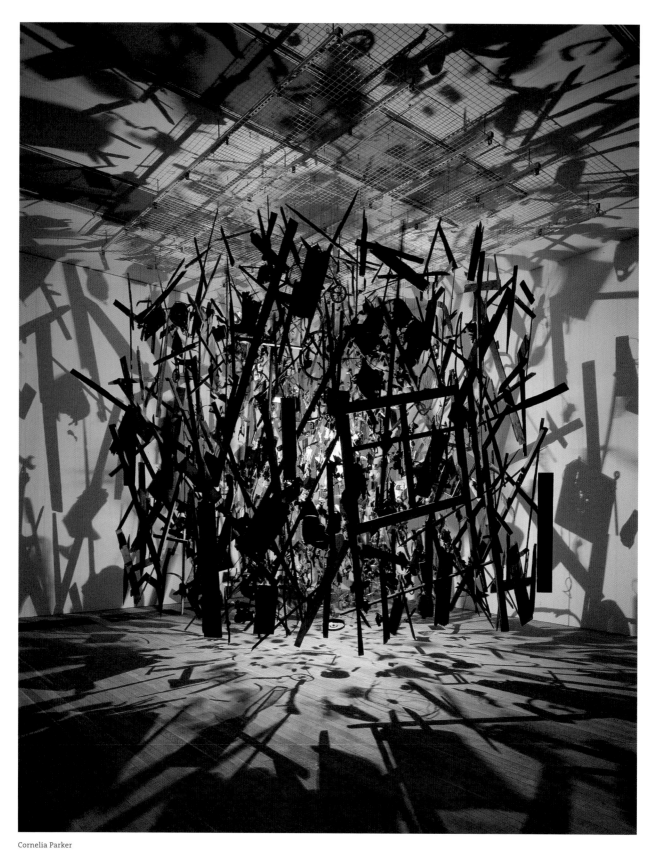

Cornelia Parker
Cold Dark Matter: An Exploded View, 1991
Mixed media
400 × 500 × 500 (157½ × 196⅞ × 196⅞)
Presented by the Patrons of New Art (Special Purchase Fund)
through the Tate Gallery Foundation 1995

WENDY PASMORE
born 1915

There is one painting by Wendy
Pasmore in the Tate Collection, and
over one hundred by her husband,
Victor Pasmore. Wendy Blood was born
in Dublin, and trained at Chelmsford
School of Art in the early 1930s. She
has exhibited her work at the Women's
International Art Club, where she was
a member from 1955, at the London
Group, which she joined three years
later, and at the Royal Academy.
Pasmore has also taught, at colleges
of art in Sunderland and Leeds.

At her retrospective, at Molton &
Lords Galleries, London, in 1963, Pasmore
showed twenty-four oil paintings.
There were some early still lifes, but
the majority were abstracts, including
a series of works in which what she
termed 'graphic' or 'linear' motifs were
enclosed in circles or ovals. Some of the
paintings recall Cubist experiments
with fractured form and restricted
palette. Others, with their clustering of

Wendy Pasmore
Oval Motif in Grey and Ochre, 1961
Oil on wood
53.3 × 58.4 (21 × 23)
Purchased 1962

small marks covering the picture plane,
are similar to the *Little Image* paintings
of Lee Krasner, or cells viewed through
a microscope. In her more recent
paintings, of the 1980s and early 1990s,
Pasmore has developed a looser
calligraphic mark-making style,
suggesting that she shares with her

husband an interest in Japanese art.
These paintings were shown at a 1997
exhibition at the Air Gallery, London.
Pasmore's work is in the collections of
the Arts Council and Leeds Education
Committee.

MARGOT PERRYMAN
born 1938

In 1970, Margot Perryman's work
was seen in a group show including
Margaret Mellis at the Richard Demarco
Gallery, Edinburgh. *Arcade* was
purchased by Tate from the exhibition.
In the catalogue, Richard Demarco
described Perryman and Mellis as
'among the rare class of woman artist
who defies the definition of "woman
artist". They are simply painters who
happen, thankfully, to be intelligent
women who have stuck (despite the
difficulties of this man's world) to
their self-appointed task of painting
paintings.' He quoted the critic Bryan
Robertson on Perryman's work:

Margot Perryman
Arcade, 1969
Acrylic on canvas
172.7 × 147.3 (68 × 58)
Purchased 1970

'inspection of any one painting shows at once that what appears to be a blank surface conceals only momentarily a lot of lively action expressed in very subtle terms of edges, alignments, disproportionate and unexpected scale'.

Perryman trained at Harrow School of Art and the Slade. From 1965–6 she lived in New York where she came across American post-war abstraction, and worked her way through various facets of it. The amorphous shapes, and areas of thin, staining paint she began to use (that characterised the paintings she showed at her 1965 solo exhibition at London's New Art Centre), suggests that she had seen the work of Helen Frankenthaler and Morris Louis. Later, when she had returned to Britain, Perryman moved towards hard-edged geometric abstraction, in which black rectangles and squares were played off against areas of muted colour.

Perryman has taught at a number of art colleges. She has had a series of solo shows at the New Art Centre, London, and has also exhibited at the John Moores exhibition (1965) and with the London Group and the Scottish Society of Women Artists in Edinburgh.

Recent solo shows have included an exhibition at Churchill College, Cambridge, in 2000.

ANNE POIRIER
born 1942

Anne Poirier, and her husband and work partner, Patrick, cite formative years spent in France following the Second World War, among rubble and ruins, as the motivation behind their focus on history and memory, places and their construction in the imagination.

The Poiriers began to work together in the late 1960s. They visited sites of classical history such as the Emperor Nero's Domus Aurea, a palace built beneath the Coliseum. Recording and reinventing places they had seen, they made and assembled a mosaic of models, maps and moulds of statuary. The collections were intended to coalesce in the viewer's mind into a fantastic vision, conjuring up sub-strata of mythologies and meanings hidden from the conscious mind. Their effect was heightened by the manipulation of scale. Your eye could sweep over a Lilliputian model of an entire city, or be brought up short by the awesome Piranese-esque immensity of a pillar's foot. But the Poiriers do not only work with the past. From 1979 to 1980 they made intricate plans for a Circular Utopia of 140 white ziggurats. Housed within were to be 'Utopian texts, themselves classified by a bizarre and complex method that is not yet fully understood'. Such schemes recall the imaginary libraries of the Argentinian

Anne Poirier
Villa Adriana, in Memory of Antinous, 1979
Plaster and mixed media
20.3 × 114.9 × 114.9
(8 × 45¼ × 45¼)
Presented anonymously through the Contemporary Art Society in memory of Mrs Amy Colls 1981

writer, Jorge Luis Borges.

From 1989 to 1992 the Poiriers worked on *De la fragilité du Pouvoir* (Of the fragility of power), a collection of stone forms that appeared to be fragments of massive sculptures and collapsed columns, pierced with arrows. The scene recalled Shelley's poem *Ozymandias*. More recently, they have worked on a smaller scale, photographing arrangements of punctured globes, fruit, furry with mould and dead flowers.

Withered petals appear in a series of photographs of 1996, their surfaces scratched or burnt with words, 'sex', 'fragility', 'wounds' and 'vanitas'. The Poiriers have said that they have been influenced by the American film-maker David Lynch, whose trawl through the dark underbelly of wholesome American suburbia in the 1986 film *Blue Velvet* is presaged by a line of perfect roses and tulips.

FIONA RAE
born 1963

Encountering one of Fiona Rae's paintings, the eye sets off on a crazy obstacle course. It is as if the artist has rummaged through a jumble of source material to construct her visual vocabulary, from Matisse's cut-outs, to Philip Guston's cartoon paintings, the heroic gestures of de Kooning and Pollock, and the juicy impasto cooked up by Gillian Ayres. These have been part-digested, only to be regurgitated onto Rae's action-packed canvases. But Rae knows that, by using the visual culture around her, she is not merely reiterating. Something new is formed.

Rae trained at Goldsmiths College in London. Her work came to the critical fore with Damien Hirst's *Freeze* exhibition in 1988, and was included in the Royal Academy's 1997 show *Sensation*. She has also been included in important group shows of contemporary painting, such as the 1996 exhibition *About Vision: New British Painting in the 1990s* held at the Museum of Modern Art, Oxford (Rae and Lisa Millroy were among three women out of a total of nineteen painters), and *Hybrids*, held at Tate Liverpool in 2001. Rae was nominated for the Turner prize in 1991.

Looking at Rae's work, the potential for multiple readings becomes apparent. As she says, 'interpretation changes, it is open-ended'. Paintings such as *Untitled (emergency room)* and *Untitled (parliament)* (both 1996) have a plethora of possibilities. The mottled black-and-

Fiona Rae
Untitled (emergency room), 1996
Acrylic on canvas
213.5 × 198.5 × 4.4 (84 × 78⅛ × 1¾)
Purchased 1998

white surfaces of both are punctuated by a constellation of circles of varying size and colour. The dizzy glare and title of the first perhaps evoke the intense experience of hospital treatment. 'Parliament' is where voices clash in political debate, and also the name of an influential funk group who were known for the shoddy razzmatazz of their stage costumes (Rae's circles could then be read as records). What becomes clear is that Rae wishes to open up the possibilities for painting now, with her rich, risky work in oil and acrylic.

PAULA REGO

born 1935

The Portugese artist Paula Rego has taken up what is sometimes dismissed as an old-fashioned, academic form of art practice, making polished, figurative and narrative pastel drawings, paintings and prints, and turned our expectations of this tradition on its head. She pictures children's stories and nursery rhymes, infusing them with an inventive, playful and often sinister edge. She also creates strange scenes of painful experiences and odd relationships, revolving around desire, domination and fear, in which women are the main protagonists.

Rego trained at the Slade. Her early work mixed collage and gestural painting. While it may not appear very similar to her practice of today, she has said that what unites all of her art is the idea of automatism developed out of Surrealism, the belief that the subconscious mind can be tapped into through art. Other influences are also apparent in her work. A number of critics have noted that the sexual tension that suffuses such pictures as

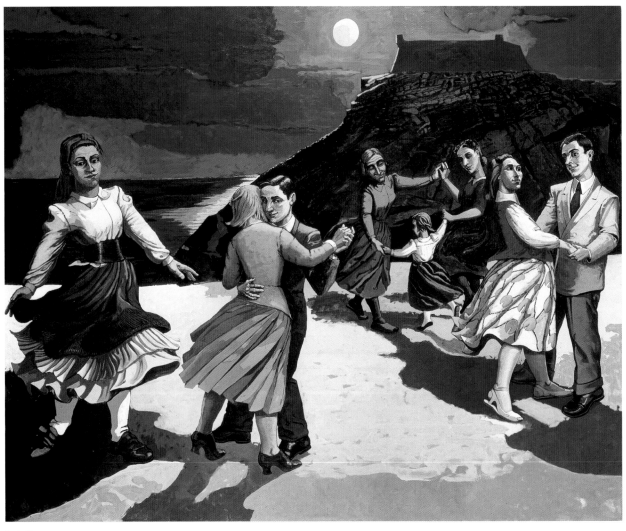

Paula Rego
The Dance, 1988
Acrylic on paper laid on canvas
212.6 × 274 (83¾ × 107⅞)
Purchased 1989

Girl lifting up her skirts to a dog (1986), and *Snow White and her Stepmother* (1995), in which a young woman is being helped into (or out of) her white knickers, recalls the work of Balthus, while Goya's influence can be seen in some of her nightmarish, fantastical works, and her predilection for etching echoes his brilliant use of the medium.

Rego is admired for taking on past masters, working from museum collections. At Dulwich Picture Gallery in 1997-8 her attention was captured by the work of Murillo. And like Maggi Hambling, Rego has worked at the National Gallery. In the early 1990s she produced a series of works in response to the paintings there, including a stunning transcription of Philippe de Champagne's *The Vision of Saint Joseph* (*c.*1638), in which an angel visits the sleeping saint. In Rego's version, a young woman artist is painting the religious story on a large canvas, while her model for Joseph, an old man, dozes. Painting a woman artist into the National Gallery's picture is a clever commemoration of Rego's presence there, and also recalls earlier women artists who worked in the gallery's grand halls, from Mary Severn Newton in the early 1860s, to late-Victorian Slade students who were sent to copy works there. As an artist who has managed to reinvigorate narrative painting for our age, it is, perhaps, not surprising that when Rego was invited to take part in the exhibition *Encounters*, held in 2000, in which artists (three women, including Louise Bourgeois, and twenty-two men) were asked to work from art in the National Gallery, she made a

series of pastels after the work of the great eighteenth-century story-teller, William Hogarth.

Story *re*telling has been an important form of practice for women artists and writers. It offers a way of challenging old narratives, re-presenting femininity and the experience of being a woman. Rego (like Lubaina Himid) has been influenced by Jean Rhys's novel *Wide Sargasso Sea* (London 1966) a re-telling of Charlotte Brontë's *Jane Eyre* (London, 1847) that gives voice to the first wife Rochester spurned. Rego named an ambitious pastel populated by a large cast after the book. And her focus on fairy tales and nursery rhymes is in sympathy with the writing of Angela Carter. Like Carter, rather than simply subverting these childhood entertainments, Rego has restored the scary sadism that was originally such a striking feature of them. Her *Nursery Rhymes* etchings, published in book form (London 1994), show a girl held tightly in the embrace of a lascivious black ram, a farmer's wife chasing after three sightless, mutilated mice with a cruel knife, and a brutal old woman thwacking the bare backsides of the children spilling out of her shoe.

Rego's strong, sturdy, female characters can be seen in a feminist light, although their bestial behaviour and malevolence often make it impossible to see them simply as a celebration of female empowerment. In *Dog Woman* and *Grooming* (both 1994), women crouch on the ground, baying and licking themselves. Scale is sometimes distorted so that female figures are much bigger than men.

Girls and women are shown pushing men around in *The Family* (1988), and holding them in poses that are fiercely possessive rather than protective, as in *After Hogarth (Wreck)* (1999). In a series of works at Dulwich Picture Gallery, and based on the nineteenth-century novel *The Sin of Father Amaro* by the Portugese writer Eça de Queirós, a female angel with stiff skirts cutting into the space around her wields a hefty sword. The priest is shown, as Rego put it, being 'taken in hand' by two women.

But Rego also pictures her contemporaries. In her striking portrait of the feminist writer Germaine Greer (1995 National Portrait Gallery), the sitter's red dress (by Jean Muir) contrasts with the dark leather sofa she sits on, heavy, capable hands clasped and head tilted as if deep in thought. Rego has also made harrowing works about abortion. Her series *Untitled* (1998–9) depicts young women undergoing this miserable, painful experience. Their plight is thrown into stark relief by back-street paraphernalia, buckets and worn furniture. *Untitled* can be seen in the light of Frida Kahlo and Tracey Emin's graphic explorations of a woman's experience of miscarriage and botched abortion. Rego's work is also tied to the situation in her homeland, where abortion is illegal. The Roman Catholic strictures followed there have recently led to the shameful spectacle of users of an illegal abortion clinic being prosecuted in a mass trial. Rego has said: 'My work is about revenge – always.'[46] She was nominated for the Turner Prize in 1989.

BRIDGET RILEY
born 1931

Bridget Riley came to the fore in the early 1960s with a series of dazzling black-and-white paintings, such as *Fall* (1963, Tate). She trained in London at Goldsmiths College and the Royal College of Art. Her first solo exhibition in 1962 was held at Gallery One. Over the next few years her reputation grew. At her 1965 New York show at the Richard Feigen Gallery her work sold out before the exhibition opened. And she was included in *The Responsive Eye*, a show that toured from the Museum of Modern Art, New York, in 1965–6

(along with Agnes Martin). Riley's work was even plagiarised and printed onto fabric. She had become a key part of the Op Art scene.

But although Riley has often been seen in the context of the Sixties, she was always more influenced by her passionate relationship with the art of the past than by contemporary practice. The catalogue for her first ever exhibition lists Ingres, Matisse, late Bonnard and Seurat as artists she admired. In 1989 she curated a National Gallery Exhibition in the *Artist's Eye*

series, bringing together old master paintings (by Titian, Veronese, El Greco, Rubens, Poussin and Cézanne) to explore their use of colour. And she has often mentioned two artists who are important to her, Cézanne and Mondrian. She curated the exhibition *Mondrian: nature to abstraction* at the Tate Gallery, London in 1997.

Riley is also influenced by music, and uses terms such as harmony, rhythm and phrasing to describe her art, and literary sources, notably Marcel Proust's novels concerning remembered

Bridget Riley
Nataraja, 1993
Oil on canvas
165.1 × 227.7 (65 × 89⅝)
Purchased 1994

sensation. She has written vividly about her childhood in Cornwall: 'Swimming through the oval, saucer-like reflections, dripping and flashing on the sea surface, one traced the colours back to the origins of their reflections. Some came directly from the sky and from different coloured clouds, some from the golden green of the vegetation growing on the cliffs, the red-orange of the sea-weed on the blues and violets of adjacent rocks ... This entire, elusive, flickering complex was in turn subject to the changing qualities of the light itself.'[47] A collection of her writings, *The Eye's Mind: Bridget Riley, The Collected Writings 1965–1999*, has been published (ed. Robert Kudielka, London 1999).

During the late 1960s, Riley began to work with 'warm' and 'cool' greys, heralding the introduction of pure colour to her paintings (although she had made colour studies from early in her career). Tate's *Late Morning* (1967–8) is typical of these works, with its stripes that seem to radiate light. The stripes were twisted, or curved in languid waves, in the works of the late 1960s and 1970s, culminating in the exquisite orchestrations of the *Song of Orpheus* series of 1978. A visit to Egypt in the late 1970s led to an introduction of colours seen in ancient paintings and artefacts there. Riley has also accepted commissions. In 1983 she made a wall painting for the Royal Liverpool Hospital, and a ballet titled *Colour*

Moves for the Ballet Rambert. Finding that the use of stripes was limiting her enquiries into colour, Riley began to introduce a strong diagonal to her compositions, influenced by studying how the past masters activated groups of colours: 'Titian's diagonal is a bold thrust – Veronese's is as gentle as a silken cord.'[48] Riley's diagonals cut across her vertical stripes, making slanting rectangles of shimmering complexity.

Beyond her relation to past masters, what other interpretations of Riley's work are possible? She has said that the fact that she is a woman artist is unimportant: 'I have never been conscious of my own femininity as such, while in the studio. Nor do I believe that male artists are aware of an exclusive masculinity while they are at work – not even Renoir, who is supposed to have said that he painted his paintings with his prick. (To me this remark expresses his attitude to his work as a celebration of life).'[49] But she has known some major women artists of her time, and has broken new ground for women. She was a friend of Prunella Clough, and a letter sent to Barbara Hepworth in 1975 survives (Tate Archive), in which she wrote: 'As an artist, your example has always been a source of encouragement and your great achievements I deeply respect.' In 1968 Riley became the first woman to win the international painting prize at

the Venice Biennale. And when Tate Modern opened, a room was devoted to her work. Reviewing her exhibition at the Serpentine Gallery in *Artforum* in November 1999, critic Rachel Withers suggested another way of looking at her work. Perhaps Riley's repetition of 'standardised units' in her compositions, which she plans, but which are always then painted by studio assistants, could be seen as 'materialising '60s and '70s commodity design and display', drawing on Riley's experience as a draughtsman for an advertising agency, before she established herself as a fine artist.

Recently Riley has worked on a larger scale than ever before (there are paintings over five metres wide). The palette of some paintings is a pastoral mixture of greens, blues, yellows and creams; others bring together magenta with pink, blue and green, or a hot orange-red with yellow and purple. Curves and circles have been sliced through with strong diagonals, creating broken waves and points. They are reminiscent of Matisse's cut-paper compositions (Riley plans them by cutting and arranging coloured paper shapes on curvilinear grids), and they also evoke flickering light through leaves, and reflections on water. Riley has said: 'You must be prepared to go wrong ... If I explore something and keep an open mind I may stumble across something which can be developed.'[50]

SUSAN ROTHENBERG
born 1945

Having trained at Cornell University, Ithaca, the Corcoran School of Art and George Washington University, Washington DC, Susan Rothenberg worked as an assistant to two women artists, Nancy Graves and Joan Jonas. She had studied sculpture, but began to paint with acrylic, working at the interface between figuration and abstraction. Like a number of her

contemporaries, Rothenberg followed a Minimalist path (focusing on process and procedure), but dispelled its austerity by introducing imagery.

During the 1970s a horse appeared in Rothenberg's paintings, sometimes divided up with criss-crossing lines, or into segments of colour. In her biography of Rothenberg (New York 1991), Joan Simon quotes the artist as

saying that she chose the animal as it seemed 'neutral', she had no emotional response to horses, but that she was also aware of its potential psychological and symbolic resonance, that it could serve as a 'surrogate' human being. She pursued this dimension in dramatic works such as *The Hulk* (1979, Museum of Contemporary Art, Los Angeles) in which the animal is swamped by a

treacly darkness. Despite being seen as part of the 'Neo-expressionist' school, Rothenberg avoided the grand historical themes and histrionics of other painters who shared this label.

At the end of the 1970s, Rothenberg stopped working with horse imagery, and began to formulate a wider vocabulary of personal motifs, and to work in oils. Heads and hands appeared, and human figures, often caught in motion. These included one of the greatest figures in twentieth-century art, Piet Mondrian. In *Mondrian dancing* (1984–5, Saint Louis Art Museum), Rothenberg painted him taking part in a pas-de-deux with a smiling woman, perhaps the artist herself (she feels a spiritual kinship with the Dutch painter). There is a delicious irony about the fact that Rothenberg turned a key abstract artist

Susan Rothenberg
Vertical Spin, 1986–7
Oil on canvas
330.8 × 286 (130¼ × 112½)
Presented by the Patrons of New Art
through the Friends of the Tate Gallery 1987

into an image. Since moving to a ranch in New Mexico with her second husband, the artist Bruce Nauman, in 1990, a menagerie of birds and dogs have fought their way out of the embattled surfaces of Rothenberg's paintings.

VERONICA RYAN
born 1956

For Veronica Ryan, the idea of containment and the container, an essential concern of her work, is a metaphor for wider contemporary issues of displacement and alienation.

Ryan was born in Plymouth, Montserrat, in the Caribbean. She trained in London at the Slade and the School of Oriental and African Studies. Her objects and installations have been constructed out of diverse materials, bronze, lace, dried flowers and even dust. What look like vessels are sometimes housed in geometric structures, as if they were archaeological finds (a 1987 piece was titled *Fragments from a lost world*). The sense of a forgotten past is also symbolised in *Empty compartments full of dust* (1993), which contains the detritus emptied out of a vacuum cleaner. Here, psychoanalysis and feminism come into play. The dirt, usually swept out of sight, can be read as the 'subconscious' of everyday life, the hidden chaos

Veronica Ryan
Mango Reliquay, 2000
Carrara marble, lead and mango stones
37 × 137 × 61 (14⅝ × 54 × 24)
Presented by Tate Members 2001

beneath the clean surface of things. Ryan has been influenced by the feminist theorist Julia Kristeva's work on the abject, her attention to mess **and** waste, which offered a critique of the image of the body as pristine spectacle with impermeable boundaries.

Ryan participated in the exhibition *Trophies from the Civil Wars* at the Grand Army Plaza, Brooklyn, in 1994. Her sculpture *Compartments/Apart-ments* contained the debris from its own making. Directing attention to what should have been discarded, Ryan exposed history as a form of representation, a fiction, created by often brutal editing. The piece extended a theme that Ryan had worked on earlier. *Territorial* (Arts Council, 1986) is a plaster and bronze piece whose edges are curled up and hidden from view, rendering impossible any attempts to take its measure and slot it comfortably into context. In addition to several solo shows, Ryan has had work in exhibitions curated by Lubaiana Himid.

CINDY SHERMAN
born 1954

As a girl, Cindy Sherman dressed up as an old woman and walked around her suburban American neighbourhood. Later, when she was first making her way as an artist in New York, she would change her appearance before she went out, dressing in androgynous clothes so that she could travel unhindered. Now Sherman is known for photographs in which she transforms herself. She enacts and records what the psychoanalyst Joan Riviere described in 1929 as the 'masquerade' of womanliness. Riviere theorised that there was a gap, a critical distance, between a woman and the image of femininity she projected. Sherman works in this space, creating from her box of tricks, her store of costumes, make-up and props, a never-ending parade of 'different' people.

Cindy Sherman
Untitled Film Still #48,
1979, reprinted 1998
Photograph on paper,
print
76.2 × 101.6 (30 × 40)
Presented by Janet
Wolfson de Botton 1996

Sherman's career began during the second wave of feminism. Some critics of the period were building on earlier feminist writing, and on psychoanalytic theory, to unpick the formation of masculinity and femininity. They argued that it was society and nurture, not nature, that created sexual identity. In her essay *Visual Pleasure and Narrative Cinema* (1975) the film critic Laura Mulvey argued that Hollywood films were one of the mediums responsible for ideas of gender difference. [51] By offering up the woman on screen as a passive spectacle for the male gaze, films inculcated the female viewer with the same subject position, 'to-be-looked-at-ness'. Sherman's early black-and-white photographs, *Untitled Film Stills*, can be interpreted in the light of Mulvey's writing. Each is inhabited by a single female figure who looks as if she is a character in a film. She can be blonde or brunette, surrounded by a forest of skyscrapers,

or lolling like a starlet on a bed. The stories we imagine for these women reveal how much we read into appearance. And the fact that one artist can embody a whole cast of 'film stars' foregrounds a woman's skill at manipulating her image. Sherman's pictures of her 'selves' were interpreted in the light of the work of an earlier generation of women artists, including Claude Cahun, Frida Kahlo and Dorothea Tanning, in the exhibition *Mirror Images: Women, Surrealism and Self-Representation* that toured from the MIT List Center, Cambridge, Massachusetts, in 1998–9.

Art history has also been a rich source for Sherman's identity games. In a series of works made during 1989–90 she masqueraded as famous figures from paintings, from Caravaggio's *Bacchus* with wreath and grapes, to a female sitter in an Ingres portrait, reclining in the corner of a salon in silk and jewels. These pictures draw attention to their constructed-ness. Make-up is crude and heavy, and the sets are clumsily put together. Sherman makes us acknowledge how art is a fiction, by revealing the rough edges

that are usually edited out. There is also the additional feminist twist that, in reconstructing these images, Sherman steps into the shoes of the masters.

Sherman's imagery became darkly disturbing in photographs from the mid-1980s and early 1990s about dirt, death, decomposition, sex and obscenity. *Untitled 250* (1992) is a disjointed, legless figure that appears to be the sister of one of Hans Bellmer's dolls. She displays her smooth-skinned breasts, swollen belly and genitals to the viewer. But her head is a wrinkled fright mask with wispy white hair. *Untitled 263* (1992) is a crude take on Courbet's notorious painting of female genitalia *The Origin of the World* (1866, Musée d'Orsay). Sherman's work pictures a model of a female torso, from the waist down to the top of the thighs. The lower limbs, which in Courbet's work are 'naturally' cut off by the edge of the canvas, are brutally lopped off in Sherman's piece, leaving splayed stumps that rest on a swirl of fabric. And, weirdly, a model of the corresponding section of the male body is tied to the female section with a large bow.

These elaborately repulsive images can be read in the light of the theory of the grotesque developed by the critic Mikhail Bakhtin. Bakhtin interpreted the celebrations of the medieval poor, often involving displays of crudity centred on the body, as a subversive transgression of the social order. The grotesque was particularly associated with the female body, and so for some women critics and artists taking up the 'grotesque' has offered a powerful critique of idealised femininity. Sherman has complained about surrealist images of the female body: 'Whenever there is a female figure, she's still *always* beautiful.'[52] By exploring just how repellent she can make her pictures, she seems to have followed to the letter what Bakhtin considered to be one of the ultimate manifestations of the grotesque. Her *Untitled 250* (1992) could be Bakhtin's 'senile pregnant hag' materialised.

In 2000 Sherman made a series of images of women that draw upon the conventions of the formal portrait photograph. They represent types seen by the artist on the West Coast of America – a biker chick with shades and tattoo, a superannuated glamour-puss with dyed-blonde hair – who appear ludicrous as they pose and smirk. By taking photographs that could represent real people (as opposed to film stars, figures from paintings and porn dollies), Sherman seems to be pointing to the possibility that in the privileged West the dividing line between grotesque excess and everyday 'normality' is being squeezed tight.

KIKI SMITH
born 1954

Working with wax, muslin, papier mâché, glass, bronze and steel, Kiki Smith's practice has developed from the innovative work of earlier artists such as Eva Hesse, who extended the media that sculptors could use. But rather than following Hesse into abstraction, Smith has explored the experience of living in the human body – and its representation in culture and history – figuratively.

Smith's first multi-media installation, *Life Wants to Live*, was shown in 1982 at The Kitchen gallery, New York. Like a number of other contemporary women artists (such as Nan Goldin), Smith examined the phenomena of domestic violence. She painted newspaper reports of women who had murdered violent partners onto cotton gauze (material used to dress wounds). And, like Goldin, Smith also made use of her own body. The paintings were exhibited with medical information (X-rays, Cat scans and stethoscope readings) collected while she and her collaborator, the artist David Wojnarowicz, fought each other. By undergoing and relaying the physical trauma the struggling female body suffers during a fight with a man, a struggle which the real female protagonists had actually won, Smith re-enacted and represented their

Kiki Smith
Untitled, 1990
Lithograph on paper, print
90.8 × 91.2 (35¾ × 35⅞)
Presented by the American Fund for the Tate Gallery, courtesy of a private collector 2000

pain, and also celebrated their survival against the odds.

This piece presaged much of Smith's later work. She makes sculptures of bodies, which can be fragmented or whole. Full of fragile pathos, they are also imbued with a weighty sense of presence. And they have an unfinished appearance, as if they have not yet fully emerged from the matter from which they are formed. Smith's sculptures can be seen in the light of feminist moves to re-imagine the body, not as a smooth, immaculate whole, but as an ungainly, fleshy, leaky jumble of different parts. She also sees the broken body as a metaphoric representation of the conflicts and divisions fracturing our world (something she became conscious of when she undertook training to become an emergency medical technician, and worked with the sick and injured). And like a number of other women practitioners, such as Judy Clark and Helen Chadwick, Smith works with the idea of the abject, the mess that transgresses the body's boundaries. A number of her female figures leak.

The figure in *Tale* (1992) crawls on all fours, leaving a trail of what looks like shit behind her. Other figures spill long strings of bright glass beads which look like drops of liquid, yellow for urine, red for blood.

Smith has also made work about reproduction and birth. In 1986 she made male and female urogenital systems in bronze, using the traditional material of fine art to cast what is normally the subject of medical models. She has pictured curled-up foetuses, printing the images in order to make an analogy between the processes of repetition in art practice and that of human reproduction, and, in the late 1980s Smith made a group of over two hundred writhing lead-crystal sperm, each translucent form shaped by her own hands. A bronze baby of 1987 was the first whole figure she made. Six years later her wax *Mother and Child* was shown at the Venice Biennale. They are a pair, male and female, but they are engrossed in their own bodies, and ignore each other. The female figure guzzles the milk trickling out of her own breast, while the male sits on the floor, hunched over, sucking on his own erection. They nurture and create nothing. Smith shows us that the search for sustenance and pleasure are selfish activities, and that we are each, separately, trapped in our prisons of flesh. Human mortality has remained a key theme in her work from the early piece *Hand in a jar* (1983), a latex hand covered in algae, which looks like it has been severed and left to rot in the type of container used to collect biological specimens. Smith's work was seen alongside that of artists including Louise Bourgeois, Annette Messager and Robert Gober in the exhibition *Corporal Politics*, held at the MIT List Visual Arts Center, Massachusetts, in 1992–3.

An avid student of art history, particularly ancient art and Gothic and northern Renaissance religious work, Smith has explored the mythological and mystical use of the female figure. Like Nancy Spero, she has researched ancient cultures and their deities. The sturdy, standing bronze female figure *Untitled* (Roses) 1993–4 has branches, leaves and blossom bursting fantastically from her back, a potent symbol of female fecundity that recalls ancient fertility figures, and the Greek myth of Daphne, who changed into a tree to escape Apollo. Her sculptures of biblical women include a group of figures of the *Virgin Mary* (1992) showing Mary not beautiful or calmly maternal, but, shockingly, naked and flayed, the pain of her life vividly represented in her brutal exposure. At the opposite extreme, Smith has also made a series of tiny, delicately pretty 'faeries' with patterned wings out of tin, which she has photographed in a forest, among leaves and tree roots, making the kind of fake supernatural pictures that fascinated the early audiences of photography.

There has been a shift in Smith's art over recent years. She has worked with animal forms in response to ecological concerns, and has exhibited a series of collaged prints drawn from the fragile tracery of doilies, an unapologetically domestic, decorative, and therefore 'feminine' object, at her New York gallery, Pace Wildenstein. Speaking to the critic Helaine Posner, author of a monograph on her work (London and New York 1998), Smith said: 'I haven't stopped thinking about the body, I keep it open but I needed more space . . . In earlier feminism . . . there were words one didn't want to be associated with, like *gentle* – you didn't want to present yourself as a gentle person then. But getting older, and feminism having more possibilities now, it seems to me that maybe gentleness is in reality a good quality to have.'

NANCY SPERO
born 1926

Nancy Spero trained at the Art Institute of Chicago (where she met her husband, the painter Leon Golub), and in Paris at the Ecole des Beaux-Arts and the Atelier André Lhôte. Spero's early work dealt with themes of love, sex, family and maternity in expressive paint. The Vietnam war prompted a group of works on paper which criticised the conflict as a manifestation of patriarchal power games. Finding herself marginalised as a woman whose work was both figurative and political, Spero made *Codex Artaud* (1970–2), which was to be a model for her later practice. On thirty-three panels, forming a horizontal scroll, collaged images and text were combined which drew upon the raging prose of the French writer Antonin Artaud.

Spero saw a parallel between Artaud's isolation and her own experience as a woman in the art world. She began to use images of femininity, from ancient goddesses to modern-day women in the media, which she re-presented. In *Torture of Women* (1974–6) she collaged tales of the brutal oppression of women taken from Amnesty International reports with mythological figures. Spero was involved with the WAR group (Women Artists in Revolution), organising demonstrations such as a picket of the Whitney Museum of American Art, protesting at their inclusion of only 4 per cent of women artists at their Biennial.

Spero began to infuse her work with a gleeful subversion. *Notes in Time on Women* (1979) is a series of patriarchal texts overrun by female figures who dance in liberated abandon. *To soar 1* (1988) is a line of women with dildos speeding along the wall, while in *Let the Priests Tremble* (1998) women leap and somersault around the words 'too bad if they fall apart on discovering that women aren't men'. The pleasure in Spero's art is often heightened by her use of gorgeous colour, but she continues to combine the aesthetically pleasing with serious issues. In *Homage to Ana Mendieta* (1991) two bloody hand prints trailing down the wall express Spero's pain at the death of her artist friend. Her article 'Tracing Ana Mendieta', which appeared in *Artforum* in April 1992 included a quote from Mendieta's notes which could equally apply to Spero herself: 'Art for me has been a way to sublimate rage. In fact it has been necessary to have such a rage to free myself from confinement and the fury of confinement.'

Nancy Spero
Lovers, 1962
Oil on canvas
163.5 × 204 (63⅝ × 80⅜)
Presented by Janet Wolfson de Botton 1996

GEORGINA STARR
born 1968

There are two minor works by Georgina Starr in the Tate Collection: the video *English Rose* (1996) made in collaboration with Tracey Emin, Carl Freedman and Gillian Wearing; and the screenprint *You stole my look* (1997), which appears as part of the installation *Tuberama: A musical on the Northern line* (1997–8), decorating the wall of Old Street Station. *Tuberama* is typical Starr, a weird, inventive and amusing mix of animation, music, a life-sized set and an electric train. It tells the story of tube travellers who do not get where they intended to go (a common enough experience in today's public transport system). Rather than being grimly realist, Starr's imagination takes off, transporting her characters to a town called Dopplestadt, inhabited by their doubles. Starr revives a phenomenon that appears in literature, including Dostoevsky's novel *The Double* (1846).

Starr often appears in her installations. She becomes a figure with special powers, part of a musical extravaganza, or is seen at different ages. Both 'Georgina' and 'Little Georgina' appear in *Visit to a small planet* (1994–5), a multi-media work which includes a film script. It developed from a Jerry Lewis film, but Starr's piece is more to do with her memory and interpretation of the movie than its reality. 'Little Georgina' met an alien, who returns to see her sixteen years later. Her older self is an 'artist of sorts', who lives in her own 'rich fantasy life'. As the script cuts backwards and forwards across time, we see Starr visiting a studio where a male artist is painting a woman in a pose 'very similar to the Manet painting of Olympia'. The model complains, 'If you paid me a wage which wasn't from the 19th century I might stay still for longer.'

Starr's interior life is also the subject of *Hypnodreamdruff* (1996), and she is the focus of 'Starrwood', a theme park she designed in 1999.

The fact that Starr trained at the Slade gives extra punch to her focus on her inner life. The Slade was one of the earliest institutions in Britain to offer women art students full professional training, and a number of them, including Gwen John, explored their identities as both women and artists in their work. As a student Starr made a piece of music by mapping the resting place of paper darts which she had thrown, laying the pattern over sheet music, and playing the resulting notes on a record in the Slade building. She is the member of two bands, 'Pony' and 'Dick Donkey's Dawn'. Now Starr's own music might enter the collective unconscious as the soundtrack to secret fantasies.

SARAH STATON
born 1961

When Sarah Staton set up shop at the
Laure Genillard Gallery, London, in 1994,
her 'Superstore Boutique' stocked things
made by herself and her artist friends.
The goods ranged from bars of 'gender
soap', pink for girls and blue for boys, to
a survival kit for the armchair anarchist,
a cardigan, pipe and slippers stamped
with the Anarchist symbol. Staton's
store, which, since it first opened on
London's Charing Cross Road in 1993,
has had outlets in New York, San
Francisco, Tokyo, Bregenz (Austria),
Manchester, Middlesborough and
Bristol, is a tongue-in-cheek critique of
our branded age. It is also an ironic
comment on the marketing of artistic
genius in today's museums, when
gallery shops are major money-
spinners, and block-buster exhibitions
are seen as marketing opportunities
(for example, Tate's Cézanne-wiches,
sold at their mammoth show of the
artist's work in 1996).

There have been artistic precedents
for Staton's enterprise. Marcel Duchamp
posed as a shopkeeper selling erotic
toys at a Paris fair in 1936, Claes
Oldenberg and Keith Haring opened
their own stores, and Tracey Emin
and Sarah Lucas founded a joint
venture on Bethnal Green Road. Emin
also contributed sticks of peppermint
rock to Staton's store, which sold at £3
each. The opening of shops by 'Young
British Artists' can be understood as a
response to the recession they found
themselves in, which made it difficult
for graduates to establish themselves.
Staton's work is also part of a revival of
the making of multiples (made earlier
by artists such as Mary Martin and
Liliane Lijn), mass-produced affordable
art for all. Yet, ironically, Staton's
bars of soap now change hands for
around £400.

Sarah Staton
from *Other Men's Flowers* [no title] 1994
Letterpress on paper, print
61.2 × 47 (24⅛ × 18½)
Presented by Charles Booth-Clibborn in memory
of Joshua Compston 1997

Extending her multiples project,
Staton has gone into publishing prints,
selling work by artists such as Tracey
Emin and Anya Gallacio. Staton has also
recently made a series of *Anti-Paintings*,
replacing artists, canvas and paints
with bleach on denim, reversing the
process by which artists make their
mark by creating an image through the
act of erasure.

PAT STEIR
born 1940

Pat Steir painted figuratively while studying at the Pratt Institute, New York, in the late 1950s and early 1960s, making self-portraits and paintings of women. Influenced by Agnes Martin, she began to make abstract work, combining grids with landscape motifs, images, colour charts and elements of typography, highlighting the different registers of representation. In some, such as in *As I am forgotten* (1974, Honolulu Academy of Arts), flowers appear, but these are often crossed out. Steir offered aesthetic pleasure only to refuse it. Around the edges of these works paint dripped down, drawing attention to their existence as a form of representation. The drip also had a special significance in the recent history of American art, referring to Abstract Expressionism and Jackson Pollock.

Art history was to become the focus of Steir's work during the 1970s. She visited European museums, and made paintings in which the brushstroke, the ultimate sign or trace of artistic presence, was the focus, as in *Van Gogh/Goya* (1978, Sydney and Francis Lewis Foundation, Richmond, Virginia).

Pat Steir
The Wave – From the Sea – After Leonardo, Hokusai and Courbet, 1985
Drypoint and aquatint on paper
89.5 × 113.7 (35¼ × 44¾)
Purchased 1987

These works could be witty: her *Rembrandt's Hairline* series centred on a single line, curly and straight, of paint/hair. In the multi-panelled series of the early 1980s, *The Brueghel Series (A Vanitas of Style),* a vase of flowers was painted in a plethora of artist's styles, from figuration to gestural abstraction.

Steir's trawl through art history then focused on images of the sea, as in *Autumn: The Wave after Courbet as though painted by Turner with the Chinese in mind* (1985, Private Collection). From these works emerged her waterfall series, monumental canvases in which paint cascades down (initially in black and white, now in floods of vibrant colour). Steir now locates herself at the axis of three very different practices: traditional Chinese landscape painting, Abstract Expressionism, and Conceptual Art. Interviewed in the catalogue for her 1996 exhibition at the Irish Museum of Modern Art, Dublin, she has said that the unusual direction her work has taken 'is the feminist aspect of my work. Just because I'm a woman doesn't mean I'll be suppressed, even if my path is not the usual one.'

DOROTHEA TANNING
born 1910

Dorothea Tanning moved from her home in Illinois to New York in 1935. Although she was already a painter, she had to support herself by working as a commercial artist. A year later, the seminal exhibition *Fantastic Art, Dada, Surrealism* was held at the Museum of Modern Art. The work on show chimed with Tanning's own artistic inclinations, and after the outbreak of war she met a number of the Surrealist artists in exile,

Dorothea Tanning
Eine Kleine Nachtmusik, 1943
Oil on canvas
40.7 × 61 (16 × 24)
Purchased with assistance from the National Art Collections Fund and the American Fund for the Tate Gallery 1997

including Max Ernst, whom she married. She participated in a Surrealist exhibition at the Galerie Maeght, Paris, in 1947.

Although Tanning shares the Surrealist interest in the exploration of the psyche, her focus on images of the female body develops its representation beyond the work of her colleagues. Her paintings of the 1940s, such as *Eine Kleine Nachtmusik* and *Palaestra* (1949, private collection), show girls with unkempt streaming hair who have torn and crumpled their late-Victorian dresses. Their eerie presence dominates the gloomy corridors they inhabit. In the work in the Tate Collection the girls have ripped a monstrous sunflower apart. The paintings represent developing female sexuality as powerful and destructive. They also recall the violence of some children's games and stories (also explored by Paula Rego). By contrast, in *Maternity* (1946–7, Private Collection), an unhappy, isolated woman is trapped with a baby in a landscape of endless desolation.

In a self-portrait of 1942, given the title *Birthday* by Ernst, Tanning showed herself unlocking a door leading into halls full of other unlocked doors. The work can be read as a representation of Tanning's desire to reveal the hidden recesses of interior life in her art. She used the title of the painting as the title of her autobiography (Santa Monica, California 1986), in which she described a long career embracing design for the ballet, printmaking, and, when she was in her late fifties, a move into sculpture, using fabric and needlework. Her 1974 retrospective at the Centre National d'Art Contemporain, Paris included these soft sculptures, housed in a hotel room she had constructed. Further retrospectives have been held at the New York Public Library (1992) and at the Philadelphia Museum of Modern Art (2001), which included her 'imaginary flower portraits' painted in her eighty-eighth year.

SAM TAYLOR WOOD
born 1967

Looking up at Selfridges department store, on London's Oxford Street, in the summer of 2000, you noticed that its façade had completely changed. Wrapping six storeys of the building like a ribbon around a cake was a 900 x 60 foot frieze, *XV Seconds*, by Sam Taylor Wood. The work was a pastiche of one of the greatest relics of classical civilisation, the Elgin Marbles. Replacing the ancient deities were what the artist called 'modern-day gods', celebrities, disporting themselves in a palatial interior. *XV Seconds* was impressive in scale, but its slick appropriation of a famous artwork and starry cast made it appear no more than advertising, all glitz and gloss, nothing lasting.

Taylor Wood, who trained at Goldsmiths College, uses film as well as photographs (and, in early pieces, video). She brings a kind of magpie approach to the world around her, raiding a wide range of culture, from Andy Warhol to Abel Ferrara's 1992 film *Bad Lieutenant*. In the series *Soliloquy* (1998), Taylor Wood borrowed from art history to rework the format of the altarpiece, and drew on other artists including Velàzquez, whose *Rokeby Venus* she re-worked in a modern interior.

Perhaps Taylor Wood's most successful works are her video and film pieces. *Brontosaurus* (1995) draws crowds at Tate Modern. We watch a naked man frantically dancing in a cramped domestic setting, a scene teetering between funny and awkward. And in *Travesty of a Mockery* (1995), a couple in furious argument are literally divided, separated onto two gallery walls. The woman is an actor, the man merely reacting. It is a painful portrayal of the games people play and the scripts they act out in personal relationships. In her self-portraits, Taylor Wood takes off from the earlier work of Bruce Nauman. In relation to her female contemporaries, her images of self can sometimes be located between Tracey Emin's sexually excessive persona, and the in-your-face attitude of Sarah Lucas. In the photograph *Slut* (1993), Taylor Wood pictured herself laughing, a ring of love bites around her neck. She was nominated for the Turner Prize in 1998.

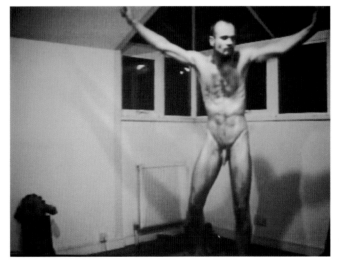

Sam Taylor Wood
Brontosaurus, 1995
Video
Presented by the Patrons of New Art (Special Purchase Fund) through the Tate Gallery Foundation 1999

ROSEMARIE TROCKEL
born 1952

Rosemarie Trockel has transformed knitting into art. In *Balaklava Box* we see what she has done with what is usually seen as a feminine, domestic skill. The garments should be comfortable and familiar. Laid out in a row, they could be a cosy display of handicraft. Instead, they are sinister. Looking at the line-up recalls the masks worn by criminals and terrorists to conceal identity. Mouthless, they are marked with unexpected patterns, a Playboy Bunny, or a swastika.

Trockel has also made knitted pictures based upon the Rorschach tests sometimes used in psychiatry. A blob of ink on paper is folded in half, creating a symmetrical pattern. The patient is asked to speculate on what the resulting shape suggests to them, and the psychiatrist is then, supposedly, able to read their state of mind. By re-creating the tests mechanically (with a knitting machine), Trockel is making an analogy that psychiatry is similarly formulaic, producing

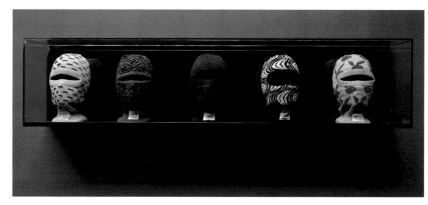

Rosemarie Trockel
Balaklava Box, 1986–90
Woollen balaklavas and mixed media
34.5 × 154 × 32 (13⅝ × 60⅝ × 12⅝)
Lent by the Froehlich Foundation, Stuttgart 2000

pre-determined diagnoses that reveal nothing (*Schizo-Pullover* of 1988 was an earlier dig, a knitted jumper with two necks to accommodate a split personality). Trockel's is an important critique of a discipline that has been used to categorise, and to pathologise, women. Her interest in sexual politics led her to include writing by Simone de Beauvoir in the catalogue for her major retrospective that toured from Hamburg's Kunsthalle in 1998.

During the 1990s, Trockel began to make videos and films, installations, and collaborative projects. In *Yvonne* (1997), family members and friends appear, each wearing a knitted garment made by the artist, evoking the rituals that many of us remember from our childhood, trying on clothes made by mother, aunt or grandmother. Trockel, who is German and trained in Cologne, represented her country at the Venice Biennale in 1999.

GILLIAN WEARING
born 1963

The video *Drunk* (1997–9), shown in Gillian Wearing's exhibition at London's Serpentine Gallery in 2000, focused on a group of street drinkers. Wearing is part of a long line of artists and writers who have portrayed dissolution and destitution in the capital (she has made most of her art in the south-east of the city, one of its poorest areas). William Hogarth's scenes of raucous eighteenth-century debauchery and dereliction include a baby falling from the arms of a gin-soaked mother. During the Victorian period, Charles Dickens

created a parade of grotesques, including the drunken nurse Sairey Gamp, while Dorothy Tennant, Lady Stanley's sentimental images of the urban poor were intended to attract sympathy. (There is a further link between the Victorians and Wearing, in that Thatcherite policy and its trumpeted return to 'Victorian Values' in the 1980s generated the unprecedented wave of homelessness in London that Wearing trained her camera upon.)

What is different about Wearing's vision of these city dwellers (and a

defining feature of her practice, which all revolves around filming and photographing people) is its dispassionate, contemplative quality. There is little comedy in *Drunk* to break the tension as we watch the group aimlessly gather, disperse, argue, stumble and scuffle. Neither does the piece offer us a reassuring moral or didactic stance, the distance of disapproval differentiating us from these unsavoury characters. The artist has cited the British tradition of 'fly-on-the-wall' documentaries as a strong

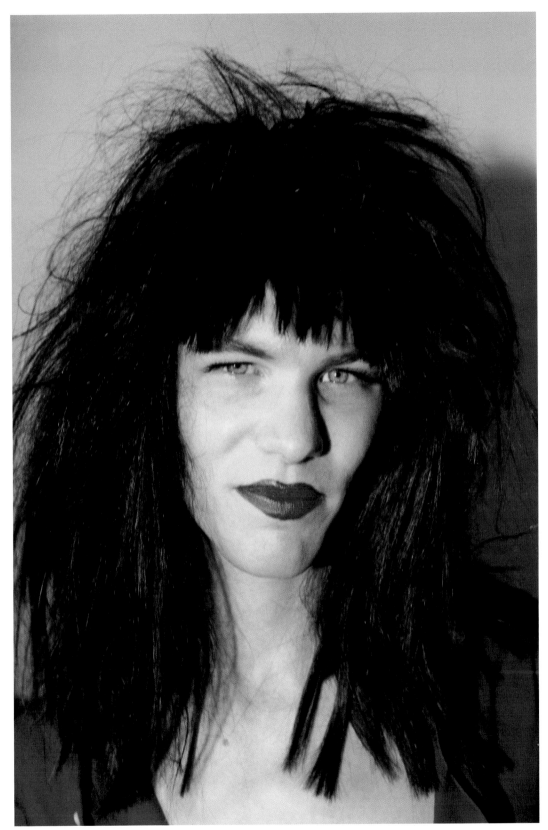

Gillian Wearing
Confess All On Video. Don't Worry You Will Be in Disguise. Intrigued? Call Gillian
Version II, 1994
Video
Presented by Maureen Paley, Interim Art through the Patrons of New Art 1998

influence. By taking up some of the conventions of this form of film-making, but at the same time refusing to create a clear, critical standpoint or story line, Wearing exposes our expectations of 'true life' tales and frustrates them. At the same time, *Drunk* also appeals to our taste for the distasteful. Wearing feeds this desire by allowing us to look in safety at a feature of our urban environment we usually hurry past. Turning the tables, she has also made us face figures of social authority by placing us, as viewers of the video *60 Minutes Silence* (1996), in front of rows of uniformed police.

Questioning the way in which we interpret appearance is a strong theme in Wearing's work. In the series of photographs *Signs that say what you want them to say and not signs that say what someone else wants you to say* (1992–3), people hold pieces of paper on which statements were written. A smart young man, in suit and tie, holds a sign saying 'I'm desperate'. There is often a striking disjunction between the writing and the individual holding it. In the video *Homage to the woman with the bandaged face who I saw yesterday down Walworth Road* (1995) Wearing re-enacted a scene she had observed, a woman walking along a South London street with her face mysteriously bound, highlighting the reactions of the people she passed, which ranged from anger to curiosity.

Watching the video, it seems that what captured the attention was the fact that the covered face made it impossible for passers-by to 'read' this individual, hence the mixture of hostility and a need to find out about her.

Looking beneath the surface, Wearing has also explored the psychological complexities of close relationships. In *Sacha and Mum* (1996), a mother and daughter move in a series of bewildering clinches from embracing to fighting. In *10–16* (shown at the Chisenhale Gallery in 1997) adults lip-synched to recorded interviews with children. The piece proved to be especially significant for Wearing, who was nominated for the Turner Prize on the basis of it, and, in 1997, became the second woman to win the prize. *2 into 1* (1997) shows a mother and her two eleven-year-old sons talking about their relationship. As in *10–16*, Wearing switched their voices, so that the mother lip-synchs along to her children's voices, and they, in turn, mime her speech. Filming members of a family mouthing each other's words is a witty representation of the scripts that family members adhere to, the roles they play, in order to maintain the fiction of domestic harmony. Wearing's videos also reveal tension, cruelty and control in these relationships, emanating from both directions, parent to child and vice versa. And in both *Sacha and Mum* and *2 into 1* the film-making is not seamless

and invisible. The video of the two women is sometimes played backwards creating a fractured jumpiness, and the speech of the mother and children has been manipulated. Again, Wearing emphasises that her medium is a form of representation, not a reflection of a truth.

Perhaps the most compelling of Wearing's works to date are *Confess all on video. Don't worry you'll be in disguise. Intrigued? Call Gillian* (1994) and *Trauma* (2000). The title of *Confess all* is a text that appeared in the personal column of London's *Time Out* magazine. Those who responded were filmed telling of involvement in crimes such as theft and sexual assault. Each speaker wore a wig or a joke-shop mask. The black humour of the ridiculous disguises did not diminish, but added to the disturbing atmosphere of this exposé of the idea that confession can somehow lead to absolution. Masks also cover the faces of the participants in *Trauma* (again respondents to an advertisement), speaking of youthful experiences that left emotional scars. Unlike the masks in *Confess all*, which suggested criminal attempts to conceal, these masks were of smooth young faces, symbolising the continuing presence of the younger, traumatised self in the adult. Wearing distils the painful distance between human experience and what can comfortably be spoken of.

KATE WHITEFORD
born 1952

The Scottish artist Kate Whiteford works with symbols. These can be ancient, derived from archaeological finds and ruins, or drawn from a repertoire of simple signs – a fish, a shell, a spiral. They appear almost to have been excavated from the dense darkness of her charcoal drawings, or sing out in the dazzling red and green she favours for prints and paintings because she wants her works to 'burn themselves into the retina, creating an after-image in the mind'.

Whiteford trained at Glasgow School of Art. On a scholarship to Rome she saw frescoes which had a profound effect upon her art, and began to incorporate imagery found in Roman and Celtic cultures into her work. In 1994 Whiteford took part in the exhibition *Time Machine: Ancient Egypt and Contemporary Art* held at the British Museum. Her large painting, built from separate panels, was a response to the False Door of Ptahepses (*c*.2450 BC). Its architectural size, saturated colours and calligraphic marks invoked the staggering presence of what was believed by the ancient Egyptians to be the portal through which the spirit passed from this world into the next.

Whiteford's approach to history is informed by developments in critical theory and art practice. Her work with sign systems, and emphasis on the role of the viewer in interpretation, suggest a sympathy with some literary theory and its accounts of the play of meaning. A 1997 touring exhibition was titled *The*

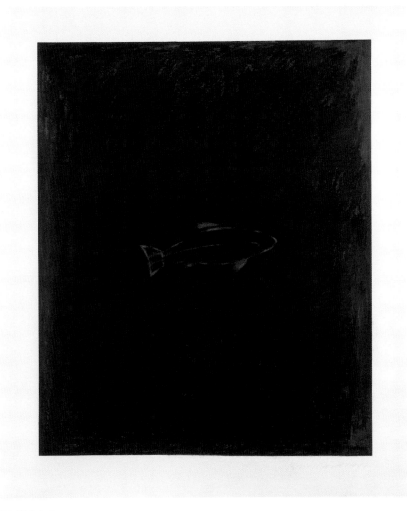

Kate Whiteford
Shadows – Fish, 1987
Drawing on paper
131 × 112.6 (51⅝ × 44⅜)
Purchased 1990

Power of Words and Signs. She has also created land works, including, recently, a piece developed from her drawings of a curvaceous sofa in the collection of Harewood House in Yorkshire, which she located on a hill surrounded by the landscape Capability Brown created. Whiteford's work drew a clever parallel between the constructed nature of both the house and its environment. And it intervened in a site known by some of the earliest women artists in the Tate Collection, Angelica Kauffman and Frances Scott, Lady Douglas.

RACHEL WHITEREAD
born 1963

Rachel Whiteread has cast the interior of a Victorian terraced house, its concrete form haunting the space where an entire row had been. She has made a bath out of rubber and polystyrene that has the enigmatic presence of an ancient sarcophagus, and prints that capture the implosion of monumental high rise blocks of flats. Whiteread works in the space between absence and presence, she makes the spaces and objects we think we know unsettling and unfamiliar.

Soon after she graduated from Brighton Polytechnic and the Slade, in 1989, Whiteread made *Ghost*. This was a cast of an ordinary London living-room in white plaster. The piece created a tension between the reading of it as a lived-in space (its cramped size, and the recognisably cheap, utilitarian fireplace) and its strange beauty as a work of art. On another level, this was a room turned in on itself, its 'back' to the viewer, keeping its secrets. Such work participates in a wider fascination with the underlying strangeness of the everyday, theorised by Freud in 1919 as *Das Unheimliche* (the unhomely). Freud argued that the unhomely, or uncanny, is a concealed or repressed part of the homely or familiar, and it is this unsettling dual nature of our surroundings that Whiteread explores in works derived from the trappings of domestic environments, houses, rooms, wardrobes, beds, hot-water bottles and sinks. She has said 'We begin to die as soon as we are born',[53] and has compared her art with the making of a death mask. When we scan the surfaces of Whiteread's work, and are brought up short by the imprint of the slightly bent pages of a book, or the pitted surface of an old door, it is as if we are seeing the unique features of a human

Rachel Whiteread
Untitled (Air Bed II), 1992
Polyurethane rubber
122 × 197 × 23 (48 × 77½ × 9)
Purchased with assistance from the Patrons of New Art
through the Tate Gallery Foundation 1993

face cast posthumously, and tracing the contours of brow, lashes and lips.

While she was a student Whiteread made casts of her own body, moving on to make sculptures about spaces and objects. Such a shift locates her within a particular development in the history of twentieth-century sculpture, a move from the figurative representation of the human form towards more abstract and formal spatial concerns. But Whiteread's art never tries to attain the discrete purity of high modernism. She has taken up and developed some of the themes and modus operandi of minimalism and post-minimalism, making floor pieces of metal tiles which recall Carl Andre's work, and casts of the spaces under and around things can be seen as a development from

Bruce Nauman's cast of the space beneath his chair.

Whiteread first came to the critical fore in 1993 with *House*, a concrete mould of the interior of a Victorian terraced house in East London. Occupying the space where the real house had once stood, *House* attracted tens of thousands of visitors, but was, nevertheless, destroyed by the hostile local council after less than three months. As with all of Whiteread's work, it managed to create a feeling of a lived-in and used space triggering intimate memories of similar interiors inhabited by its viewers. Its importance also lay in what people thought it might be saying about contemporary social and political issues concerning our changing cities and communities,

and government policy on housing (graffiti daubed onto the piece during its short life included 'Homes for all'). *House* also tapped into our changing understanding of the built environment at the end of the twentieth century. It can be seen as a materialisation of some critical interpretations of the urban environment, not as fixed, mapped and knowable, but as a nuanced and fluid terrain formed and represented differently according to individual experience. Just as a room can be full of personal memories and associations, so our streets can seem inhabited by the ghosts of other buildings and their inhabitants.

Whiteread's gift for creating ambitious monumental sculpture that engages widespread interest has won her prestigious public commissions. Her work on memory and loss made her a fitting choice to make a memorial for the Austrian Jewish victims of the holocaust. Sited in Vienna's Judenplatz and unveiled in 2000, *Holocaust Memorial* is at once austerely grand and moving. It is a cast of a library filled with row upon row of books. The symbolism of the fact that the pages of the individual volumes are discernible, but each permanently closed to us, as are the double doors on the front of the sculpture, is clear and affecting. The memorial offers no consolation; it is brutal and bunker-like in its appearance, but not clumsy, pompous or heavy-handed. Whiteread has also taken part in a project to fill an important space in the heart of London, a plinth in Trafalgar Square, empty for 158 years. A group of sculptors were each asked to make a work to occupy the site in turn. Whiteread's *Monument* was a resin cast of the plinth (the largest piece ever to be cast in this material) that was placed on top of it, upside down, in the summer of 2001. The work was translucent, and changed colour according to shifts in light. It was a meditative, poetic representation of the space, and Whiteread described it as 'a pause . . . a quiet moment' in the midst of London's heaving bustle of traffic and tourists.[54]

Whiteread was awarded the Turner Prize in 1993 (having first been nominated in 1991). Four years later she was included in the *Sensation* exhibition of 'Young British Artists' at the Royal Academy, and she also represented Britain at the Venice Biennale. She has had a number of solo exhibitions, including *Rachel Whiteread: Shedding Life* at Tate Liverpool in 1996. In 2001 an exhibition toured the Guggenheim Museums in New York, Berlin and Bilbao, and a second was held at London's Serpentine Gallery.

ALISON WILDING
born 1948

In 1999–2000 Alison Wilding took part in the Tate project 'At Home with Art'. With other artists (including Angela Bulloch, Tony Cragg and Anthony Gormley) she was asked to make a sculpture in response to a particular home, which could be mass produced and sold at Sainsbury's Homebase stores. The family that Wilding visited was Hindu, from Sri Lanka and Singapore. Wilding's china sculpture represented what she termed the 'hybrid' nature of the household, a fusion of different cultures. It looked as if it had a function (as a bowl, or kitchen utensil), but it also seemed intriguingly different from other domestic objects, as if it wasn't quite at home among them.

Wilding (who trained at Ravensbourne and the Royal College of Art) often uses austere, unlovely,

Alison Wilding
On the Day, 1986
Leaded steel, copper and brass
45 × 87.5 × 26 (17¾ × 34½ × 10¼)
Purchased with funds provided by the friends of Nancy Balfour
OBE in honour of her 80th birthday 1991

matter-of-fact materials (rubber, stainless steel, electric cable), which she transforms into enigmatic sculptures that have a poetic grace. She has even made delicate works on paper about one of the most ungainly of animals, the elephant. Reconciling what seem to be contradictory and separate elements is at the heart of Wilding's work. It is sophisticated, but often simple in construction. It reveals and conceals. *Drowned* (1993) only shows the metal structure beneath the atmospheric green haze of its covering in certain lights. The brass ball at the heart of

Echo (1995) is sometimes invisible to the viewer. While the innards of *Wired* (1997) are suggested, they poke out of its surface, but are ultimately obscured by cloudy rubber.

Wilding's sensual play on interiors has been read in feminist terms. Writing in the catalogue for her 1988 exhibition at the Karsten Schubert Gallery, critic Marjorie Allthorpe Guyton argued: 'The complexity of this schema of inner space in the artist's work is close to the imagery of "the feminine poets", Plath, Dickinson and others, where both the protection

of the inner space and the affirmation of its potential in an unreceptive world are major themes.' Others have seen her work as part of a contemporary trend towards the sublime. Along with Hannah Collins, Susan Hiller and Bridget Riley (among other artists) she was included in the exhibition *Sublime: The Darkness and the Light* that toured from the Hayward Gallery in 1999–2000. Wilding was nominated for the Turner Prize in 1988 and 1992.

GILLIAN WISE
born 1936

Gillian Wise (who exhibited under the name of Wise-Ciobotaru from 1972 to 1990) trained at Wimbledon School of Art and the Central School. She is one of the British constructivists who emerged during the 1950s and 1960s, following on from the pre-war work of Barbara Hepworth, Ben Nicholson and Naum Gabo and the post-war generation of Mary Martin and her husband, Kenneth, Victor Pasmore and Anthony Hill.

The constructivism that resurged among Wise and her contemporaries shared some of the Utopian ideals (making art a part of everyday life) that had defined the movement in revolutionary Russia (Wise studied on a British Council scholarship at Leningrad's Repin Institute from 1969 to 1970), the Bauhaus and de Stijl. Wise corresponded with the American artist and theoretician Charles Biederman, who called for an art of reliefs and constructions, devoid of illusionism. But the work of Wise and her British colleagues had some special characteristics. Women artists were, unusually, an important presence, and particular emphasis was given to man-made systems and mathematics.

Gillian Wise
Relief Constructed from
Unicursal Curve No.2, 1977
Plastic, metal and wood
81.3 × 81.3 × 4.1 (32 × 32 × 1⅝)
Transferred from the
Victoria & Albert Museum 1983

Wise's *Relief Constructed from Unicursal Curve No. 2* (1977, Tate) explores the equilibrium between thirty-six squares. Her work typically uses industrial materials, such as rubber, aluminium, perspex and vinyl. It sometimes incorporates prisms salvaged from submarine periscopes, again suggesting a British context, referring to the important role the sea surrounding the British Isles played in the Second World War.

Throughout her career Wise has made art for buildings and spaces outside the gallery. In 1961 she made

a screen for the temporary buildings that housed the Congress of the International Union of Architects. With Anthony Hill in 1968 she created a screen for the Cunard Liner *Queen Elizabeth II* (she had shared an exhibition of relief sculptures with him at London's Institute of Contemporary Arts five years earlier). Commissions followed for Nottingham University Hospital (1973–4) and Unilever House (1982). In 1991 Wise moved into a new area of technology, designing computer images for Textum Ars, Paris.

CATHERINE YASS
born 1963

Institutions, their relationship with
identity, and how individuals are
shaped by them, preoccupy Catherine
Yass. She takes photographs of people,
but her subjects are always part of
wider networks. And sometimes her
pictures are just of institutional spaces
themselves, empty and eerie (she
photographed Bankside power station
while it was being stripped down and
transformed into Tate Modern). Yass
manipulates her films, overlaying
positives and negatives to make
areas of blurring and dense colour,
incandescent blues, greens, pinks,
yellows and oranges. Her pictures have
a hallucinogenic, dreamlike quality, of
heated energy or heavy oppression.
Mounted on light-boxes, they glow
with heightened presence and depth.

Yass trained at the Slade and
Goldsmiths. Her first solo exhibition
was held at the Tavistock Clinic for
Psychotherapy in 1991. Projects followed
at Springfield Hospital in 1995, and
(with artists Zarina Bhimji and Tania
Kovats) for the Public Art Development
Trust in 1997. Yass's training and her
subsequent work, picturing institutions
such as medical organisations, can be
interpreted in the light of Michel
Foucault's theory of institutions. For
Foucault, all institutions (art college,
hospital, and asylum) are involved in
the same 'exercise of power'. They
position the people within them into
hierarchies, giving them a place in the
order of things, creating within them a
sense of themselves and their relation
to the people around them. Yass has
trained her camera on organisations
that are a key part of our lives.

Other organisations to have
come under Yass's scrutiny include
government, business and the British

Catherine Yass
Corridors, 1994
Photographic transparency and light-box
89 × 72.5 × 14 (35 × 28½ × 5½)
Presented by the Patrons of New Art (Special Purchase
Fund) through the Tate Gallery Foundation 1996

Arts Council. Her pictured spaces
include the Prague metro, and Tokyo's
capsule hotels, mini rooms stacked row
upon row, so that their occupants look
like products on a supermarket shelf.
And in 2001 an exhibition of Yass's
work, *Star*, was part of the Tenth Indian
Triennale in Mumbai. Images of an
empty cinema, its tiered seats hot
orange and yellow, were juxtaposed

with portraits of 'Bollywood' actors.
Their faces are seen clearly, thrown
into sharp relief by hazy backgrounds.
There is a sense that the stars have
surfaced as individuals for a moment,
and were caught by Yass's camera,
only to be re-submerged in the surreal
world of their films.

LAETITIA YHAP
born 1941

Laetitia Yhap is known for her portraits (Helen Lessore and Sir William Coldstream both sat for her) and for paintings of fishermen at Hastings, Sussex. In the catalogue for the exhibition *Laetitia Yhap: The Business of the Beach 1976–88* (Laing Art Gallery, Newcastle upon Tyne and tour, 1988–9) she wrote about her training at Camberwell School of Art. Yhap found working in the life room difficult, because she was told: 'Women could not by their nature be objective and I began to be aware for the first time that I was female and in a minority.' A travel scholarship to Italy in 1962–3 has left a lasting influence, and on her return Yhap studied at the Slade

For the next decade Yhap experimented with subject matter, formats and media. She made a series of works in which there was no human presence, painted in watercolour and in a hybrid of her own invention, Liquitex and egg tempera. In about 1974 the human figure returned as her chief subject, when Yhap began to focus on the fishing community at Hastings. These new works were painted on the irregularly shaped supports that had resulted from her experiments. Some look like shields, or the wide screen of a cinema (perhaps invoking the great director Luchino Visconti's film about fishing, *La Terra Trema* 1946), or circles that look like roundels, suggesting both

Laetitia Yhap
Michael Balling Up Old Net, 1984
Oil on board
120.5 × 149.6 (47½ × 58⅞)
Presented by the Trustees of the Chantrey Bequest 1984

portholes and Yhap's knowledge of Renaissance art history. Yhap depicts the rituals that make up the fisherman's day, maintaining boats and nets and gutting fish, and she refers to the tough practicalities of the job in the frames she uses for some paintings, made of rope and weathered wood.

Yhap's attention to quotidian tasks does not mean that she overlooks the drama of her subject matter. In *The Skeleton* (1980–1) a man gingerly untangles a skeleton hauled in with the catch. The scene is made grimly

humorous by the fact that he is wearing pink rubber gloves. Yhap has paid homage to the artists she admires, Degas, Gauguin, Manet, Goya and Poussin, by making transcriptions of their paintings peopled with her own cast. In 2000 Yhap's work was seen in the group show *Order and Event – Landscape Now* at the Art Space Gallery, London, alongside eleven other artists (all male) including Jeffery Camp and Euan Uglow.

ANDREA ZITTEL
born 1965

Like Niki de Saint Phalle, the American
artist Andrea Zittel has actually
inhabited her work. She makes 'Living
Units' which are a cross between
storage cabinets and small studio
apartments, which she sells through
her company A–Z. Housed within them
are the paraphernalia of life pared
down to a minimum, cramped but
pristine spaces to fulfil all needs,
sleeping, eating and working.

Zittel moved to New York in 1990.
She arrived with few belongings and
took a job in an art gallery. She
designed and made uniforms for her
work, wearing each one solidly for six
months, before she made another.
Zittel then began to extend her project
to cover all of the practicalities of her
daily existence. The foundation of her
art can be traced back to the early
twentieth century, when the artists
and designers of the Bauhaus and the
de Stijl group focused on the material
aspects of everyday life. Zittel was
influenced by the Russian
Constructivists in her uniform designs,
which became geometric in order to
harmonise with the shape of the
fabric as it came from the factory. The
portability of Zittel's living spaces and
furniture, some of which can be rolled
along on wheels, have an antecedent in
Alexander Rodchenko's street rostrums
of the 1920s.

Although Zittel disclaims any
Utopian interpretations of her work,

Andrea Zittel
A–Z Comfort Unit with Special Comfort
Features by Dave Stewart, 1994–5
Mixed media
Dimensions variable
Purchased 1996

it can be read as offering incisive
critiques of conventional ideas of
artistic identity, and of our relationship
with consumerism and domesticity.
Zittel has collected and mended
discarded objects found on the street,
challenging the idea of art as the
creative production of a genius.
She then took the opposite tactic,
breeding birds to become the ultimate
author/artist as creator/god. Her
Breeding Unit for Averaging Eight Breeds
was exhibited at the Venice Biennale in
1993. Zittel has made furniture,

attempting to fabricate one piece to
satisfy all needs and, while living in her
units, she tests which facilities are
essential, and edits the superfluous out,
working against the trend to endlessly
accumulate. In terms of women's
history, Zittel's focus on creating the
conditions for a comfortable life
transforms what has often been seen as
a mundane feminine concern into fine
art. At the same time she explores just
how much we can be free of the
domestic duties that have filled
women's time over the centuries.

Artists acquired 1998–2000

Fiona Banner b.1966
Uta Barth b.1958
Christine Borland b.1965
Sophie Calle b.1953
Vija Celmins b.1938
Ceal Floyer b.1948
Laura Ford b.1961
Anna Gaskell b.1969
Anna Hope (Nan) Hudson 1869–1957
Sarah Jones b.1959
Emma Kay b.1961
Sherrie Levine b.1947
Sarah Morris b.1967
Carol Rhodes b.1959
Doris Salcedo b.1958
Hannah Starkey b.1971
Nicola Tyson b.1960
Kara Walker b.1969

Women whose prints are in the Tate Collection

Sheila Black
Romey Brough b.1944
Ghitta Caiserman-Roth b.1923
Audrey Capel-Doray b.1931
Monique Charbonneau b.1928
Sarah Charlesworth
Chloe Cheese b.1952
Margery Clinton
Susan Crawford b.1941
Angela Dallas b.1946
Sylvia Edwards
Lois Fine b.1931
Mary Ford b.1946
Vera Frenkel b.1938
Phyllis Ginger b.1907
Camille Graeser b.1918
Margaret Harrison b.1940
Liselott Henderson-Begg
Janice Jacobs b.1947
Angela Jansen b.1929
Barbara Jones 1912–78
Joan Key b.1948
Eleanor Koch b.1926
Janet Ledger b.1931
Catherine Lee b.1950
Adriana Maraz b.1931
Helena Markson b.1934
Enid Marx 1902–98
Brigitte Matschinsky-Dennighof b.1923
Linda McCartney 1941–98
Sarah Nekemkin
Yoko Ono b.1933
Valerie Parkinson
Margaret Priest b.1944
Lady Mary Rennell b.1901
Zsusi Roboz b.1939
Rebecca Salter b.1955
Edwina Sandys b.1938
Rosemary Simmons b.1932
Birgit Skiold 1923–82
Agathe Sorel b.1935
Carol Summers b.1925
Berenice Sydney 1944–83
Ann Travis b.1931
Marianne Unwin b.1930
Ha Van Vuong b.1914
Dee Villers
Judy Wong b.1949

Notes

Women and the Tate

1 Figures provided by Tate Information, December 2000.
2 Although in recent years a small number of artists from outside these areas have been brought into the collections.
3 See Ann Sutherland Harris and Linda Nochlin, *Women Artists 1550–1950*, New York 1976.
4 The list of male artists who focused on the female model during the early twentieth century is long, including, most obviously, Matisse and Picasso.
5 This does not apply to working-class women, many of whom had to take employment, but to the middle and upper classes, from whom nearly all Tate women artists were drawn up until the second half of the twentieth century.
6 Griselda Pollock, *Differencing the Canon*, London and New York 1999, pp.26–7.
7 That writing a book including all of the women in Tate collections could not ever be a straightforward supplement to the canon became clear in the planning stages of this book. Any attempt to divide Tate women artists into workable groups affiliated with established 'major' artistic movements was impossible, as women were at most marginal figures in these groups, if they were present at all, and they are represented haphazardly across the collections as a whole.
8 List of artists of Australian, Central and Latin American, African, Afro-Caribbean, Middle-Eastern or Asian origin or descent and artists who are strongly associated with those regions (having settled there and developed their work in the context of those localities) in Tate collections. Compiled by Tanya Barson, Tate Collections, 2002. Sixty-four men and seventeen women are listed.
9 Information from exhibition list compiled by Krzysztof Ceiszkowski and Tate Reports.
10 With Camilla Gray, Chamot curated the touring Arts Council *Retrospective Exhibition of Paintings and Designs for the Theatre: Larionov and Goncharova* in 1961. Her publications include *Nathalie Goncharova*, Paris 1972, and *Goncharova: Stage Designs and Paintings*, London 1979.
11 Judith Collins and Elsbeth Lindner (eds.), *Writing on the Wall*, London 1993.
12 However, there is a policy in place to build the collections in one area: in 2002 an Associate Curator was appointed in Latin America. Collecting art from a particular part of the world is a more manageable project than attempting to increase Tate holdings of women artists' work across the board. But, as discrimination against women cuts across nationalities, there is nothing to suggest that by highlighting an area such as Latin American art, while not specifically tackling the under-representation of women, the proportion of women's work will increase satisfactorily.
13 *National Gallery of British Art: Matter referring to the above gallery abstracted from the National Gallery Minute Book From January 7 1890 – May 1920*, minute dated 24 March 1917. Tate Archive.
14 *National Gallery of British Art: Matter referring to the above gallery abstracted from the National Gallery Minute Book From January 7 1890 – May 1920*, minute dated 5 July 1898. Tate Archive.
15 Figures taken from Frances Spalding, *The Tate: A History*, London 1998, and Tate Reports 1998–2000.
16 First published in February 1971 in *Arts Magazine*, republished in Louise Bourgeois, *Destruction of the Father: Reconstruction of the Father*, London 1998, p.97.
17 *Make*, no.72, October–November 1996.
18 *Independent*, 29 October 1996.
19 *Observer*, 22 June 1997.
20 *Daily Mail*, 18 June 1997.

Beginnings

1 Frances A. Gerard, *Angelica Kauffman: A Biography*, London 1892, pp.222–3.
2 The term 'amateur' first appeared in England in the 1780s, meaning a person who appreciated the arts of painting and music.
3 Diary entry for 27 April 1681, Diary of Charles Beale 1680–1681, National Portrait Gallery Archive.

4 Diary entry for 16 November 1681, Diary of Charles Beale 1680–1681, National Portrait Gallery Archive.
5 Diary entry for 14 July 1681, Diary of Charles Beale 1680–1681, National Portrait Gallery Archive.
6 *The Correspondence of Samuel Richardson*, London 1804, pp.267–70.
7 Lady Llanover (ed.), *The Autobiography and Correspondence of Mary Granville, Mrs Delany*, 6 vols., London 1861–2, reprinted New York 1974.
8 Wendy Wassyng Roworth (ed.), *Angelica Kauffman: A Continental Artist in Georgian England*, exh. cat., with essays by David Alexander, Malise Forbes Adam, Mary Mauchline, Angela Rosenthal and Wendy Wassyng Roworth, The Royal Pavilion Art Gallery and Museums, Brighton, London 1992, p.37.
9 Burney quoted in C. Barrett (ed.), *The Diaries and Letters of Madame d'Arblay*, vol.1, London 1892, pp.328–9.

Victorians

1 Anne Brontë, *The Tenant of Wildfell Hall* (1848), 1996, p.47.
2 Letter quoted in Pamela Gerrish Nunn, 'The Work of Louisa Anne, Marchioness of Waterford', in *Lady Waterford Centenary Exhibition*, exh. cat., Ford, Northumberland 1983, p.6.
3 Her thoughts were prompted by reading the published diary of the painter Marie Bashkirtseff. Denis Rouart (ed.), *The Correspondence of Berthe Morisot with her Family and Friends*, London 1986, p.177.
4 Ibid., p.82.
5 Published in Alain Clairet and Delphine Montalant, *Berthe Morisot: Catalogue de l'Oeuvre Peint* (1957), Paris 1997, p.104.
6 *Journals and Correspondence of Lady Eastlake Edited by her Nephew Charles Eastlake Smith*, vol.1, London 1895, pp.130–1.
7 Ibid., p.88.

Twentieth Century

1 The situation was different at Glasgow School of Art, where there were twenty-seven women artists teaching from the 1890s to the 1920s, although the majority were in applied arts.
2 In Michele Barrett (ed.), *Virginia Woolf: Women and Writing*, London 1988, p.62.
3 Fell, however, was the exception rather than the rule. At the mid-century only 3 per cent of children from semi-skilled manual backgrounds aged seventeen or over stayed in education. Women were few even among this small group as it was generally thought less important to educate them. See Joanne Bourke, *Working Class Cultures in Britain 1890–1960: Gender, Class and Ethnicity*, London and New York 1994.
4 There is debate about the definition of first and second wave feminism. This book follows the demarcations outlined by Valerie Sanders and Sue Thornham in their essays in Sarah Gamble (ed.), *The Routledge Guide to Feminism and Postfeminism*, London and New York 2001. The first wave encompasses the period from Mary Wollstonecraft's work in the late eighteenth century to the early twentieth-century activists for women's suffrage and the second wave, feminism from the 1960s into the 1980s.
5 Essentialism rejects the belief that the different genders, masculinity and femininity, are constructed socially and culturally, believing instead that these identities are innate and natural.
6 Reprinted in Linda Nochlin, *Women, Art, and Power and Other Essays*, London and New York, 1989, pp.145–58.
7 This was happening in the work of gay, lesbian and queer artists, such as Jo Spence and Rosy Martin in Britain, and Robert Mapplethorpe and Della Grace in the United States.
8 The 'grotesque' was theorised by critic Mikhail Bakhtin, who analysed the festivities of ordinary people during the medieval period, such as carnival, that emphasised the crude materiality of the body, as concerned with transgressing the social order. The subversive aspect of the grotesque was developed by a number of women during the late twentieth century including Sherman, Spence, the writer Angela Carter and the theorist Mary Russo.
9 British Library National Sound Archive, National Life Story Collection. Lives of the Artists. Eileen Agar interviewed by Cathy Courtney, 1990. Unless otherwise noted, all quotes are taken from this interview.
10 Excerpt from Cope's poem 'The Sitter' in Judy Collins (ed.), *Writing on the Wall* (London 1993).
11 Letter to Roger Fry of 23 November 1911 published in Regina Mailer (ed.), *Selected Letters of Vanessa Bell*, New York 1993.
12 Letter to Gerald Brennan (20 May 1921), Tate Archive.
13 Letter to Lytton Strachey of 24 November 1924 published in David Garnett (ed.), *Carrington: Letters and Extracts from her Diaries*, London 1970.
14 Letter to Gerald Brennan, 15 August 1921, Tate Archive.
15 *Prunella Clough, New Paintings 1979–82*, exh. cat., Warwick Arts Trust 1982.
16 Patrick Heron in *Prunella Clough: Recent Paintings 1980–1989*, exh. cat., Annely Juda Fine Art, London 1989.
17 Sue Hubbard, 'Prunella Clough: an Artist's Artist', *Contemporary Visual Art*, no.27, 2000, pp.42–7.
18 Delaunay quoted in a 1969 essay by Maiten Bouisset, in Jacques Damase (ed.), *Sonia Delaunay: Fashion and Fabrics*, London 1991.
19 Apollinaire writing in the *Mercure de France* in January 1914, quoted in Damase 1991.
20 André Lhôte (and others), *Sonia Delaunay, ses peintures, ses objets, ses tissus simultanes, ses modes* (Sonia Delaunay, her paintings, her objects, her simultaneous fabrics, her fashion designs), Paris 1925.
21 Joan Eardley quoted in William Buchanan, *Joan Eardley*, Edinburgh 1976.
22 Sydney Goodsir Smith, 'Portrait of the Artist', an interview with Joan Eardley, *The Scotsman*, 19 August 1961.
23 Letter from Joan Eardley dated February 1958, quoted in Cordelia Oliver, *Joan Eardley RSA*, Edinburgh 1988.
24 Elizabeth Foster, *Joan Eardley*, BA Thesis in Fine Art, Glasgow School of Art 1994.
25 John Dalton, *Sheila Fell: Painter of Aspatria, Studio*, vol.156, July–December 1958, pp.144–7.
26 Ed. Ronald Goldman, London 1968.
27 'Sheila Fell – Notes' in *Painter and Sculptor*, vol.4, no.2, Summer 1961.
28 Elisabeth Frink interviewed by Norman Rosenthal in the catalogue for *Elisabeth Frink: Sculpture and Drawings, 1951–1984*, Royal Academy of Arts, London 1985.
29 Letter to the Editor, 13 February 1912, sent by Goncharova to several newspapers. Manuscript Division of the Russian State Library, Moscow. (This translation published in the catalogue for *Amazons of the Avant Garde*, Guggenheim Museum, New York 1999–2000).
30 Nikolai Rykovsky Archive, Manuscript Division of the Russian State Library, Moscow. The full text is given in the catalogue for *Amazons of the Avant-Garde* (see note 29).
31 See Jane Sharp, 'Redrawing the margins of Russian Vanguard art: N. Goncharova's trial for pornography in 1910', in Jane T. Costlow et al. (eds.), *Sexuality and the Body in Russian Culture*, Stanford 1993.
32 Barbara Hepworth, *A Pictorial Autobiography*, Bath and New York 1970. A third edition was published by the Tate Gallery in 1985.
33 British Library National Sound Archive, National Life Story Collection. Lives of the Artists. Eileen Agar interviewed by Cathy Courtney, 1990.
34 'Gertrude Hermes: Engraver and Sculptor' (obituary), *The Times*, 11 May 1983.
35 Diary excerpt, February 1965, published in 'Order and Chaos: From the Diaries of Eva Hesse', selected and introduced by Ellen H. Johnson, *Art in America*, vol.71, Summer 1983, pp.110–18.
36 Lucy Lippard, New York 1976, p.34.
37 Quoted in Lippard 1976, p.165.
38 Letter of 29 August 1925 in Linda Gill (ed.), *Letters of Frances Hodgkins*, Auckland 1993.
39 Quoted in E.H. McCormick (ed.), *Portrait of Frances Hodgkins*, Auckland and Oxford 1981, p.145.
40 Recording of Jane Saunders speaking in 1969, Tate Archive.
41 Letter of 15 July 1924 from Gwen John to John Quinn, quoted in Cecily Langdale, *Gwen John: With a Catalogue Raisonné of the Paintings and a Selection of the Drawings*, New Haven and London 1987.
42 Undated note among Gwen John's papers in the Musée Rodin Archive, quoted in Alicia Foster, *Gwen John*, London 1999.
43 Laura Knight, *Oil Paint and Grease Paint*, London and New York 1936.
44 National Portrait Gallery Archive.
45 Knight 1936.
46 Quoted in *Louise Nevelson Sculpture 1957–1987*, exh. cat., Pace Wildenstein, New York, Richard Gray Gallery, Chicago 1997, p.24.
47 Hilton Kramer, 'The Sculpture of Louise Nevelson', *Arts Magazine*, June 1958, pp.26–9.

48 Quoted in Laurie Lisle, *Louise Nevelson: A Passionate Life*, New York 1990, p.266.
49 Quoted in *Louise Nevelson Sculpture 1957–1987*, exh. cat., Pace Wildenstein, New York/Richard Gray Gallery, Chicago 1997, p.14.
50 Published in *The Flowers of Winifred Nicholson*, exh. cat., Crane Calman Gallery, London 1969.
51 '1920–1930 PARIS – Reminiscences by Winifred Nicholson' in *An Unknown Aspect of Winifred Nicholson: Abstract Paintings 1920–1930*, exh. cat., Crane Kalman Gallery, London 1975.
52 According to Ben Nicholson, writing in the catalogue for Winifred Nicholson's 1979–80 exhibition at Glasgow's Third Eye Centre.
53 The press reviews of Procter's work quoted in this piece are in the Tate Archive.
54 Anthony Bertram, 'Contemporary British Painting – Dod Procter', *Studio*, vol.97, January–June 1929, pp.92 and 97.
55 Mary Chamot, 'Ernest and Dod Procter', *Studio*, vol.6, July–December 1927, pp.248–52.
56 Undated latter from Dod Procter to Ernest Procter, Tate Archive.
57 Elisabeth Frink interviewed by Sarah Kent (1992), for the National Life Story Collection of the National Sound Archive.
58 Letter from Ethel Walker to Grace English dated 28 January 1936, Tate Archive.
59 Letter dated 17 April 1939, Tate Archive.

Women working now

1 Reported in the *Guardian*, 3 June 2002, p.10.
2 Statistics compiled by the Higher Education Statistics Agency published in the *Guardian*, 17 July 2001.
3 A report by the Equal Opportunities Commission in 2001 concluded that the 'decisive factor' in increasing the number of women in parliaments is 'special measures'. In Scotland and Wales, where such measures have been used, the proportion of women is much higher than at Westminster.
4 'Women and Cultural Policies', compiled by Danielle Cliche, Ritva Mitchell and Andreas Joh. Weisand of the European Research Institute for Comparative Cultural Policy and the Arts for the UNESCO Intergovernmental Conference on Cultural Policies for Development, Stockholm, Sweden 1998.
5 Danielle Cliche, Ritva Mitchell, Andreas Joh. Wiesand, *Pyramids or Pillars: Unveiling the Status of Women in the Arts and Media Professions in Europe*, European Research Institute for Comparative Cultural Policy and the Arts 2001.
6 Jones curated an exhibition, *Sexual Politics: Judy Chicago's "Dinner Party" in Feminist Art History*, at the Armand Hammer Museum, University of California, Los Angeles, in 1996, at which Chicago's piece was seen alongside the work of fifty-five other feminist artists from the 1960s onwards.
7 Katy Deepwell (ed.), *New Feminist Art Criticism*, Manchester 1995, p.99.
8 4 December 1997; the label has also been used in many other newspapers and magazines.
9 25 March 1997.
10 Julian Stallabrass has explored the fact that politics is not discussed in relation to the work of the group of 'Young British Artists' Emin is a member of in his book *High Art Lite: British Art in the 1990s*, London 1999.
11 Sarah Kent, 'YBA Women', in *Thames & Hudson World of Art Newspaper 45th Birthday Issue*, 2001, p.22.
12 Interview with Sarah Lucas by Carl Freedman in *Minky Manky*, exh. cat., South London Art Gallery, 1995.
13 London 1999, p.424.
14 New York 1859, London 1860.
15 Anya Gallaccio interviewed by Sarah Kent in 'Best Glade Plans', *Time Out*, no.1673, 11–18 September 2002, p.52.
16 Gillian Ayres quoted in the catalogue for her Royal Academy Retrospective in 1997.
17 'Select Diary Notes 1960–1979', in Louise Bourgeois, *Destruction of the Father: Reconstruction of the Father*, London 1998, p.72.
18 Quoted in 'Conversation Piece Extracts from a conversation between Sonia Boyce and Pitika Ntuli, October 1986', in *Sonia Boyce*, exh. cat., Air Gallery, London 1987.
19 Quoted in *Portable Fabric Shelters*, exh. cat., London Printworks Trust 1995.
20 Quoted in *Directions – Cathy de Monchaux*, exh. cat., The Hirshhorn Museum and Sculpture Garden, The Smithsonian Institution, Washington DC 2000.
21 Correspondence with Claire Schneider, February 2000, in *Cathy de Monchaux*, exh. cat., Albright Knox Art Gallery, Buffalo 2000.
22 From Marlene Dumas, 'The Bodyguard' (1989) published in Dominic van den Boogerd et al. (eds.), *Marlene Dumas*, London 2000, p.112.
23 'Show and Tell', Tracey Emin interviewed by Lynn Barber, *Observer*, 22 April 2001.
24 This aspect of Frankenthaler's critical reception, and notably her press compared to that of Pollock, has been discussed by Anne Wagner in her essay 'Pollock's Nature: Frankenthaler's Culture', in Kirk Varnedoe and Pepe Karmel (ed.), *Jackson Pollock: New Approaches*, New York 1999.
25 Gillian Ayres quoted in 'True Colours' by Sir Anthony Caro, *Observer Magazine*, 4 June 2000.
26 'Adie attacks "peasant women crying in the streets"', *Independent*, 9 May 2000.
27 Hambling quoted in *Max Wall: Pictured by Maggi Hambling*, exh. cat., National Portrait Gallery, London 1983.
28 Hamilton quoted in 'The Aesthetics of Wonder: An Interview with Ann Hamilton', *Border Crossings*, no.74, May 2000.
29 Ann Hamilton quoted in *Ann Hamilton, Projects*, exh. cat., Museum of Modern Art, New York 1994–5.
30 Judith Nesbitt, 'On entering mneme', in *Mneme*, exh. cat., Tate Liverpool 1994.
31 Hamilton quoted in 'The Aesthetics of Wonder: An Interview with Ann Hamilton', *Border Crossings*, no.74, May 2000.
32 Ibid.
33 Hatoum quoted in Simon Grant, 'You can come close, but you'd better not touch', *London Evening Standard*, 17 March 2000.
34 The piece is discussed in Renée Baert's essay 'Desiring Daughters', in Katy Deepwell (ed.), *Women Artists and Modernism* (Manchester 1998), along with that of some earlier women artists dealing with the same subject.
35 Susan Hiller, *After the Freud Museum*, (London (1995) 2000).
36 James Clifford interviewed by Alex Coles in Alex Coles ed., *Site-Specificity: The Ethnographic Turn, de-, dis-, ex-*, no 4, 2000, p.70.
37 Hiller has described objectivity as 'a fantasy our culture is heavily invested in'. Hiller in Barbara Einzig (ed.), *Thinking about Art: Conversations with Susan Hiller* (Manchester 1996), p.210.
38 This distance is underlined by Hiller's list on the soundtrack of the 'duration of the two modes of existence' of each individual. For example, David Selves – in the body – 12 years – as a representation – 94 years.
39 It was included in the 1995 group exhibition *Rites of Passage* at the Tate Gallery.
40 Hiller's work has also included writing and editing, for example 'O'Keeffe as I see her', *Frieze*, Summer 1993, pp.26–9 and *The Myth of Primitivism: Perspectives on Art*, London and New York 1991 (reprinted 1992,1993).
41 Horn interviewed by Germano Celant in 1993, in 'Rebecca Horn: The Inferno Paradiso Switch', Guggenheim Museum, New York 1993.
42 Martin quoted in Cindy Richmond's essay, 'Agnes Martin: The Transcendent Vocation', in *Agnes Martin*, exh. cat., Mackenzie Art Gallery, Saskatchewan, Canada, University Art Museum, Berkeley, California, 1995.
43 1978, re-issued in *The Originality of the Avant-Garde and other Modernist Myths*, Cambridge, Massachusetts and London 1986.
44 Martin quoted in John Gruen, 'Agnes Martin: "Everything, everything is about feeling … feeling and recognition"', *Art News*, September 1976, pp.91–4.
45 Agnes Martin and Ann Wilson, 'The Untroubled Mind', in *Agnes Martin: Paintings and Drawings*, exh. cat., Stedelijk Museum, Amsterdam (and touring), 1991–2.
46 Paula Rego quoted in 'Sunday Feature: The John Tusa Interview', BBC Radio 3, 3 June 2001.
47 Bridget Riley, 'On Swimming Through a Diamond', in the foreword for *Bridget Riley, Selected Works 1963–84*, exh. cat., Goldsmiths College, University of London 1985.
48 From 'The Colour Connection', Bridget Riley in conversation with Robert Kudielka, 1989, in Robert Kudielka (ed.), *The Eye's Mind: Bridget Riley, The Collected Writings 1965–1999*, London 1999.
49 From Bridget Riley, 'The Hermaphrodite', 1973, ibid.

50 Riley quoted in the foreword of *Bridget Riley – New Paintings and Gouaches*, exh. cat., Waddington Galleries, London 2000.
51 First published in *Screen*, vol.16, no.3, Autumn 1975, reprinted in Laura Mulvey, *Visual and Other Pleasures*, London 1989.
52 Cindy Sherman, note dated 10 May 1999, in *Cindy Sherman: Retrospective*, exh. cat., Museum of Contemporary Art, Los Angeles (and touring) 1998–2000, p.180.
53 Whiteread quoted in the foreword of *Young British Artists: John Greenwood, Damien Hirst, Alex Landrum, Langlands & Bell, Rachel Whiteread*, exh. cat., the Saatchi Gallery, London 1992.
54 Whiteread quoted in Maev Kennedy, 'Acclaim greets Trafalgar Square Sculpture', *Guardian*, 5 June 2001.

Select bibliography and further reading

Sally Alexander, *'Becoming a Woman' and other Essays in Nineteenth and Twentieth-Century Feminist History*, London 1994.

Ann Bermingham, *Learning to Draw: Studies in the Cultural History of a Polite and Useful Art*, London and New Haven 2000.

Rosemary Betterton, *Looking On: Images of Femininity in the Visual Arts and Media*, London 1995.

Rosemary Betterton, *An Intimate Distance: Women Artists and the Body*, London 1996.

Mary Lynn Broe (ed.), *The Gender of Modernism: A Critical Anthology*, Bloomington, Indiana 1990.

Norma Broude and Mary Garrard, *The Power of Feminist Art: Emergence, Impact and Triumph of the American Feminist Art Movement*, New York 1994.

Judith Butler, *Gender Trouble: Feminism and the Subversion of Identity*, London and New York 1990.

Clarissa Campbell Orr (ed.), *Women in the Victorian Art World*, Manchester 1995.

Mary Ann Caws, *Women of Bloomsbury*, New York 1991.

Whitney Chadwick, *Women, Art and Society*, London 1990.

Whitney Chadwick, *Women Artists and the Surrealist Movement*, London 1985.

Deborah Cherry, *Painting Women: Victorian Women Artists*, London and New York 1993.

Deborah Cherry, *Beyond the Frame: Feminism and Visual Culture, Britain 1850–1900*, London and New York 2000.

Judith Collins and Elsbeth Lindner (eds.), *Writing on the Wall*, London 1993.

Katy Deepwell (ed.), *New Feminist Art Criticism: Critical Strategies*, Manchester 1995.

Katy Deepwell (ed.), *Women Artists and Modernism*, Manchester 1996.

Katy Deepwell, *The Careers of Ten Women Artists Born 1897–1906*, exh. cat., Norwich Gallery, Norfolk Institute of Art and Design 1992.

Carol Duncan, *Aesthetics and Power*, Cambridge 1993.

Bridget Elliott and Jo-Ann Wallace, *Women Artists and Writers: Modernist (Im)positionings*, London and New York 1994.

Geneviève Fraisse and Michelle Perrot (eds.), *A History of Women in the West, Vol.4: Emerging Feminism from Revolution to World War*, Cambridge, Mass. and London 1993.

Sarah Gamble (ed.), *The Routledge Guide to Feminism and Postfeminism*, London and New York 2001.

Delia Gaze (ed.), *Dictionary of Women Artists*, London 1997.

Diana Gillespie, *The Sisters' Arts: The Writing and Painting of Virginia Woolf and Vanessa Bell*, New York 1988.

Germaine Greer, *The Obstacle Race: The Fortunes of Women Artists and their Work*, London 1979.

Jo-Anna Isaak, *Feminism and Contemporary Art: The Revolutionary Power of Women's Laughter*, London 1996.

Amelia Jones, *Sexual Politics: Judy Chicago's 'The Dinner Party' in Feminist Art History*, Berkeley, California 1996.

Lucy Lippard, *The Pink Glass Swan: Selected Feminist Essays on Art*, New York 1996.

Jan Marsh and Pamela Gerrish Nunn, *Pre-Raphaelite Women Artists*, Manchester 1997.

Laura Mulvey, *Visual and other Pleasures*, Bloomington Indiana 1989.

Lynda Nead, *The Female Nude: Art, Obscenity and Sexuality*, London 1992.

Cindy Nemser, *Art Talk: Conversations with Twelve Women Artists*, New York 1975, 2nd edn 1995.

Linda Nochlin, *Women, Art and Power and Other Essays*, London 1989.

Linda Nochlin and Ann Sutherland Harris, *Women Artists 1550–1950*, New York 1976.

Pamela Gerrish Nunn, *Victorian Women Artists*, London 1987.

Roszika Parker and Griselda Pollock, *Old Mistresses: Women, Art and Ideology*, London 1981.

Roszika Parker and Griselda Pollock, *Framing Feminism: Art and the Women's Movement 1970–1985*, London 1987.

Gillian Perry, *Women Artists and the Parisian Avant-Garde*, Manchester 1995.

Chris Petteys, *An International Dictionary of Women Artists Born Before 1900*, Boston, Mass. 1985.

Griselda Pollock, *Differencing the Canon: Feminist Desire and the Writing of Art's Histories*, London and New York 1999.

Griselda Pollock, *Vision and Difference: Femininity, Feminism and the Histories of Art*, London and New York 1988.

Denise Riley, *Am I that Name? Feminism and the Category of 'Women' in History*, New York 1988.

Hilary Robinson (ed.), *Visibly Female: Feminism and Art Today*, London 1987.

Sheila Rowbotham, *A Century of Women: The History of Women in Britain and the United States*, London 1997.

Sherman, Claire and Holcomb, Adele, *Women as Interpreters of the Visual Arts, 1820–1979*, Westport, Conn. 1981.

Kim Sloan, *'A Noble Art': Amateur Artists and Drawing Masters c.1600–1800*, London 2000.

Maud Sulter, *Echo: Works by Women Artists 1850–1940*, London 1991.

Maud Sulter (ed.), *Passion: Discourses on Black Women's Creativity*, Preston 1990.

Françoise Thébaud (ed.), *A History of Women in the West, Vol.5: Toward a Cultural Identity in the Twentieth Century*, Cambridge Mass. and London 1994.

Lisa Tickner, *The Spectacle of Women: Imagery of the Suffrage Campaign 1907–1914*, London 1987.

Helen Tierney (ed.), *Women's Studies Encyclopedia*, Westport, Conn. 1999.

Amanda Vickery, *The Gentleman's Daughter: Women's Lives in Georgian England*, London 1998.

Ann Wagner, *Three Artists (Three Women): Modernism and the Art of Hesse, Krasner and O'Keefe*, Berkeley 1997.

Mara Witzling, *Voicing our Visions*, London 1992.

— *Voicing Today's Visions*, London 1994/5.

Janet Wolff, *Feminine Sentences: Essays on Women and Culture*, Cambridge 1990.

Women's Art Show 1550–1950, exh. cat., Nottingham Castle Museum 1982.

Women's Art at New Hall, Cambridge. Catalogue compiled by Ann Jones, 3rd edn 2003.

Copyright

Prunella Clough © The Artist's Estate
Elisabeth Collins © The Estate of the Artist
Ithell Colquhoun © The National Trust
Janet Cree © Tim and Mark Platts-Mills, on behalf of the Estate of Janet Cree
Dorothy Cross © The Artist. Courtesy Frith Street Gallery
Hannah Darboven © The Artist. Courtesy Sperone Westwater, New York
Tacita Dean © The Artist
Sonia Delauney © L&M Services B.V. Amsterdam 20030805
Stanislawa de Karlowska © Tate, London, 2004
Cathy De Monchaux © Cathy de Monchaux
Rineke Dijkstra © Rineke Dijkstra and Marian Goodman Galery, New York
Marlene Dumas © Tate, London, 2004
Joan Eardley By kind permission of Joan's sister, Mrs P M Black
Florence Engelback © The Artist's Family
Mary Fedden © Mary Fedden
Sheila Fell © The Artist's Estate
Elsie Few © Crispin Rogers
Helen Frankenthaler © 2004 Helen Frankenthaler/Universal Limited Art Editions
Elizabeth Frink © Frink Estate
Sue Fuller © The Artist. Courtesy Susan Teller Gallery, New York
Anya Gallaccio Courtesy the Artist
Margaret Gere © Tate, London 2004
Evelyn Gibbs © Estate of the Artist
Edna Ginesi © Michael Parkin
Grace Golden © The Estate of Grace Golden
Nan Goldin © Nan Goldin
Natalie Goncharova © ADAGP, Paris and DACS, London 2004
Dora Gordine © Estate of the Artist. By permission of Kingston University
Laura Sylvia Gosse © Courtesy of the Artist's Estate/Bridgeman Art Library
Meraud Guevara © Tate, London 2004
Lucy Gunning © Lucy Gunning and Matt's Gallery
Maggi Hambling © The Artist
Ann Hamilton© Ann Hamilton. Courtesy Sean Kelly Gallery, New York
Siobhan Hapaska © The Artist. Courtesy Tanya Bonakdar Gallery, New York
Mona Hatoum © The Artist
Barbara Hepworth © Alan Bowness, Hepworth Estate
Gertrude Hermes By kind permission of Simon Hughes-Stanton and Judith Russell, children of the artist
Eva Hesse © Estate of Eva Hesse. Galerie Hauser & Wirth, Zurich
Susan Hiller © Susan Hiller
Lubaina Himid © The Artist
Frances Hodgkins © Tate, London 2004
Lilian Holt © The Artist's Family
Jenny Holzer © 2003 Jenny Holzer
Evie Hone © Estate of the Artist
Rebecca Horn © DACS 2004
Roni Horn © Roni Horn. Courtesy Matthew Marks Gallery, New York
Shirazeh Houshiary © The Artist
Thelma Hulbert Reproduced by kind permission of the Artistic Executors of the Thelma Hulbert Memorial Fund
Tess Jaray © The Artist
Gwen John © Estate of Gwen John, 2004. All Rights Reserved, DACS
Karin Jonzen © Martin Jonzen
Mary Kelly © Mary Kelly
Kathleen, Lady Kennett © The Artist's Estate
Astrid Klein © The Artist
Clara Klinghoffer Printed with permission of Michael J Laurence. Clara Klinghoffer.com
Laura Knight © Tate, London 2004
Winifred Knights © J.P. Monnington
Ghisha Koenig © The Artist's estate
Lee Krasner © ARS, NY and DACS, London 2004
Barbara Kruger © Barbara Kruger. Courtesy Mary Boone Gallery, New York
Maria Lalic © The Artist
Abigail Lane © The Artist, courtesy of Victoria Miro Gallery
Marie Laurencin © ADAGP, Paris and DACS, London 2004
Eileen Lawrence © The Artist
Helen Lessore Copyright Henry and John Lessore
Kim Lim © 2003. All Rights Reserved, DACS
Sarah Lucas Copyright the artist, courtesy Sadie Coles HQ, London
Agnes Martin © 2004 Agnes Martin

Mary Martin Copyright estate of Mary Martin
Dora Maurer © The Artist
Dorothy Mead © The Artist's Estate
Else Meidner © Ludwig-Meidner Archiv. Juedisches Museum der Stadt Frankfurt am Main
Margaret Mellis © The Artist
Annette Messager © ADAGP, Paris and DACS, London 2004
Lisa Milroy © Lisa Milroy
Tracey Moffat Courtesy of Tracey Moffat copyright 2004 and courtesy of Paul Morris Gallery NY
Marlow Moss The Artist's Estate
Marie-Louise von Motesiczky © The Trustees of the Marie-Louise von Motesiczky Charitable Trust
Elizabeth Murray © Elizabeth Murray
Avis Newman © The Artist
Winifred Nicholson © The Artist's Estate
Thérèse Oulton © The Artist. Courtesy of Marlborough Fine Art (London) Ltd
Ana Maria Pacheco © PRATT CONTEMPORARY ART
Cornelia Parker © The Artist
Wendy Pasmore © The Artist
Margot Perryman © Margot Perryman
Anne Poirier © ADAGP, Paris and DACS, London 2004
Beatrix Potter Copyright © Frederick Warne & co., 1903
Reproduced by permission of Frederick Warne & Co.
Mary Potter © Tate, London 2004
Dod Proctor © Tate, London 2004
Fiona Rae © Fiona Rae. Courtesy Timothy Taylor Gallery, London
Isabel Rawsthorne © Estate of the Artist
Anne Redpath © The Artist's Family
Paula Rego © The Artist
Germaine Richier © ADAGP, Paris and DACS, London 2004
Bridget Riley © The Artist
Susan Rothenberg © ARS, NY and DACS, London 2004
Veronica Ryan © Veronica Ryan
Niki de Saint Phalle © ADAGP, Paris and DACS, London 2004
Ethel Sands © Tate, London 2004
Helen Saunders © The Artist's Estate
Cindy Sherman Courtesy of the artist, and Metro Pictures Ltd
Kiki Smith © 2003 Kiki Smith
Nancy Spero © The Artist
Sarah Staton © The Artist
Pat Steir © Pat Steir
Dorothea Tanning © ADAGP, Paris and DACS, London 2004
Sam Taylor Wood © The Artist
Rosemarie Trockel © Rosemarie Trockel
Paule Vezelay By kind permission of Sally Jarman. Estate of Paule Vezelay
Maria Helena Vieria da Silva © ADAGP, Paris and DACS, London 2004
Gillian Wearing © The Artist. Courtesy Maureen Paley Interim Art, London
Kate Whiteford © Kate Whiteford
Rachel Whiteread © The Artist
Alison Wilding © The Artist
Catherine Yass © Catherine Yass and aspreyjacques, London
Laetitia Yhap © Laetitia Yhap
Andrea Zittel Courtesy of the Artist and Andrea Rosen Gallery

Every effort has been made to contact the copyright holders of the works reproduced. The publishers apologise for any omissions that may inadvertently have been made.

Photo credits

All works from the Tate Collection have been photographed by Tate Photography. Unless otherwise stated, photographic copyright in all other works is as given in the caption to each illustration.

p.16, left; p.109: Bridgeman Art Library
p.16, right: English Heritage Photo Library
p. 37: Westminster Libraries and Archives
p.38: The Royal Collection © 2004, Her Majesty Queen Elizabeth II. Photographer: Stephen Chapman
p.60, left: Science & Society Picture Library

Index

Page numbers in bold denote main entries, those in italics denote illustrated works.